They Write Their Dream on the Rock Forever
Rock Writings of the Stein River Valley of British Columbia

Annie York, Richard Daly and Chris Arnett

Talonbooks Vancouver 1993

Published with assistance from the Canada Council

Talonbooks
201 - 1019 East Cordova
Vancouver, British Columbia
Canada V6A 1M8

Typeset in Times by Pièce de Résistance Ltée., and printed and bound in Canada by Hignell Printing Ltd.

First Printing: October 1993

Canadian Cataloguing in Publication Data

York, Annie, 1904-1991.
 They write their dreams on the rock forever

 Includes bibliographical references and index.
 ISBN 0-88922-331-9

 1. Salish Indians—Art. 2. Indians of North America—British Columbia—Stein River Valley—Art. 3. Rock paintings—British Columbia—Stein River Valley. 4. Petroglyphs—British Columbia—Stein River Valley. 5. Salish Indians—Antiquities. 6. Indians of North America—British Columbia—Stein River Valley—Antiquities. 7. Stein River Valley (B.C.)—Antiquities. I. Daly, Richard Heywood, 1942- II. Arnett, Chris III. Title.
E99.S2Y67 1993 709'01'13089979 C93-091792-8

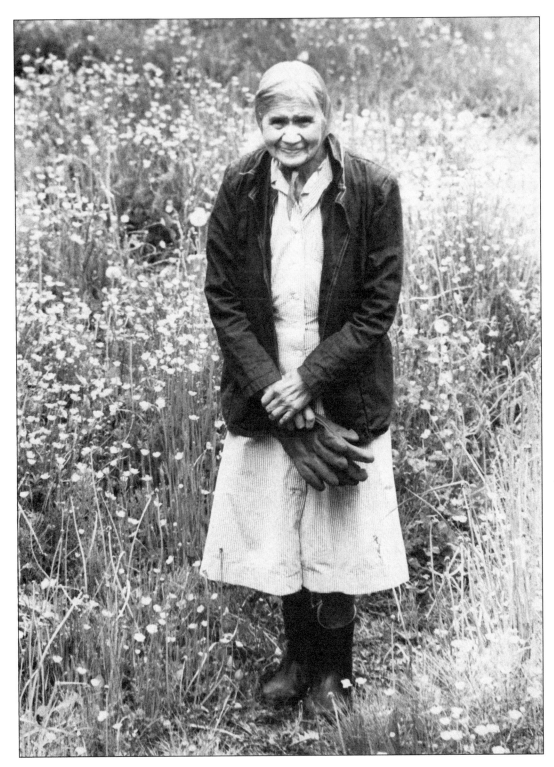

Fig. 1. Annie York. Photo by Jan-Marie Martell.

This book is dedicated to the memory of Zex'tko,

Annie Z. York
1904-1991

When my life ends,
I'll be just a memory on this earth.
My life must float like an Indian canoe
Downriver to the ocean when the sun is low...
I'll be just a memory when the sky turns red,
And the moon shines on the sea,
And all the birds on the ocean shall sing!

and to Tel<u>x</u>'an,

Arthur W. Urquhart

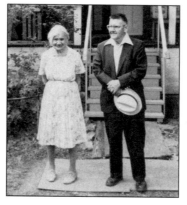

Fig. 2. Annie York and Arthur Urquhart. Photo by Richard Daly.

Contents

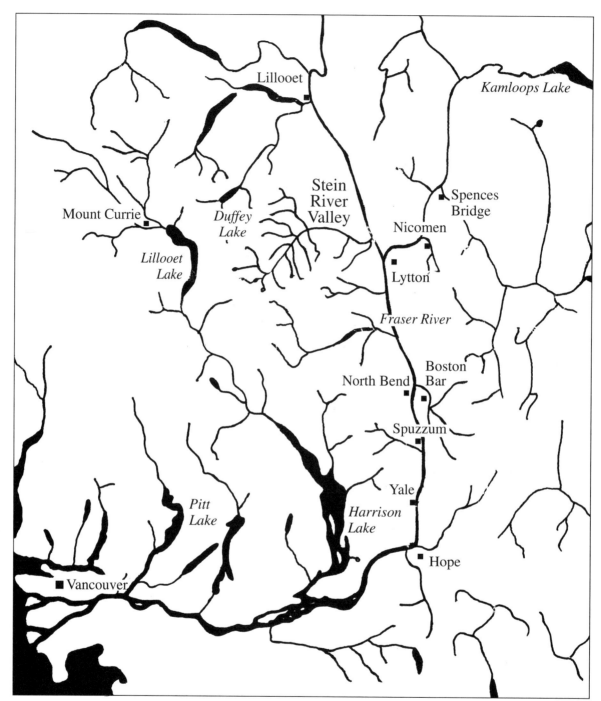

Fig. 3. Southwestern British Columbia.

List of Rock Writing Sites

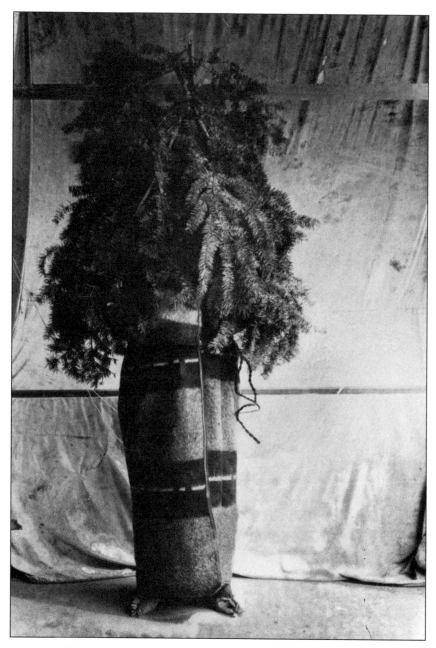

Fig. 4. 'Nlaka'pamux woman wearing costume worn by girl during her training. "During the first four days [of her training] she wore a rough head-dress of conical shape, made of small fir-branches, usually four, tied tightly at their lower ends and again loosely about halfway down. The branches that covered the back were longer than those in front. They were tied loosely in front so as to leave an opening for the face. These branches were worn on the head like a hat, and reached below the breasts" (Teit 1900:313). Photo by James Teit, 1914. Courtesy Musée Canadien des Civilisations/Canadian Museum of Civilization No.27099.

Preface

The subject of this book is the red ochre writing executed by Native people on the rocks along banks of the Stein River, a tributary of the Fraser near its confluence with the Thompson River at Lytton, in southern British Columbia.[1] In writing about this phenomenon we have found it necessary to reconcile the oral and written traditions of the different aboriginal and European cultures familiar to the three authors. Annie York expressed herself and her culture by means of the spoken word; Chris Arnett expresses himself by drawing, painting and writing on paper; and Richard Daly is the product of a tradition that turns words into things[2] by writing them down.

We have attempted to integrate these traditions in a form of dialogue that you can see, hear and read. The dialogue deals with the history, form, meaning and significance of one of the oldest and longest human traditions: recording experiences on stone for others to read. The core of the book is Annie York's detailed explanations of these rock writings. The tasks that Chris Arnett and I have set ourselves are to illustrate Annie's work and put it in as full a context as possible, particularly for a modern, urban readership.

Annie York, and Arthur Urquhart, the cousin for whom Annie kept house for sixty years, listened to all the old stories when they were very young. The old people sat them down in those infinitely long, dark, winter evenings of childhood and led them into the ancient stories. Arthur is not very forthcoming about the process, but Annie explained how, as she listened over and over again to the narratives, she could visualize the characters, the situations, the teachings given to the first humans, and the very real places where the stories happened. Now, many years later, Annie's telling of the same stories is food for the imagination of readers.

To explain the rock writings, Annie takes the reader into the realm of vision quests, where members of 'Nlaka'pamux and Lil'wat nations, and their respective neighbours, were encouraged by their elders to engage in a rite of passage, to make the ageless journey in search of strength and power from the living world around them. This entailed a separation from society—a solitary testing and initiation into other ways of being—then a return to society forged and strengthened by the new knowledge and experience. Going on a spiritual quest was associated with all training for special skills and talents, especially for determining who might become a shaman. *Shamanism* is the practice of striving to relate to the vast network of energies in the universe by psychic explorations into different meditational planes of being and neurological thinking processes. Since Paleolithic times this search for meaning has been driven by the thirst for knowledge and intellectual continuity in a universe marked by instability, motion, change and transformation.[3]

Spiritual questing, a central feature of shamanism in which the aspirant tries to experience the flux, motion and change behind the "things" of everyday life, is a constant theme in human history. Shamanism is one of the approaches used by those who seek these experiences and, like the scientific method, it has been recognized in many cultures for the materiality of its procedures, and the regularity of its revelations.

With the onset of the Industrial Revolution in Europe, and the subsequent era of colonial conquest

and applied science that diffused across the world, the shamanic search was gradually exorcized from everyday life, and relegated to the realm of the exotic and the mystical. Shamanic practices have been categorized by scholars as "magical," "animistic" and "supernatural"; by missionaries and colonial administrators these practices and beliefs were "paganistic," "satanic," "idolatrous" and "superstitious." All of these categorizing words are freighted with connotations that deny the everyday reality of this form of human activity, and lock it away in closed, and largely unexamined, cognitive categories that are labelled "irrational," "immoral," or both. Often these unexamined phenomena are erroneously dismissed as "nonsense":

> "Nonsense" is that which does not fit into the prearranged patterns which we have superimposed on reality. There is no such thing as "nonsense", apart from a judgemental intellect which calls it that.
>
> True artists and true physicists know that nonsense is only that which, viewed from our present point of view, is unintelligible. Nonsense is nonsense only when we have not yet found that point of view from which it makes sense. (Zukav 1980:117)

In aboriginal societies in the vast watershed of the Fraser River in British Columbia, the shamanic process was an ordinary part of life. The preliminary stages of shamanic training were common to most 'Nlaka'pamux, Lil'wat and their neighbours in so far as the majority of young people were sent out into the forests, after receiving stories and instructions from their elders—in Annie's words "to *s'lek*"; that is, embark on what is generally called "a vision quest." Those who succeeded in obtaining one or more spiritual guides and helpers through this process were in a good position to succeed in the practices of special talents—as fortune-tellers, healers, weavers, hunters, orators, historians, carvers or canoe-builders. Annie was trained in the healing skills of the *syuwe*, the herbal medicine doctor.

One special talent belonged to the shaman, or *syux'nam*:[4] the ability to heal the body by healing the patient's afflicted mind and spirit. Although many of the young men trained to become expert hunters, few were selected for the esoteric training of the shaman. Only those judged by the elders to be adequately talented were chosen. At one level, the training procedures, as well as the imagery and the understanding of ancient narratives and outlooks, were part of the culture shared by all members of the society. Then, as a young person progressed into more specialized training, the elaborations of knowledge, history and procedure that he or she obtained were pulled from the treasury of incorporeal family property. For example, everyone knew how to conduct a sweatlodge purification, but to induce specific moods for certain types of dreaming, elders taught their descendants which tree needles and herbs should be combined and burned on the red glowing rocks of the sweathouse. This was esoteric family knowledge, carefully protected from outsiders.

The protection of this "incorporeal property," and the mystique which it engenders, remains an aspect of authority and informal ranking among indigenous peoples of the region. This feature of the social structure grows more pronounced as one approaches the shores of the Pacific, and less pronounced as one moves upriver and away from the coast.[5]

When Annie York spoke of the private and esoteric nature of certain shamanic knowledge and the existence of a "royal" language of chiefs, she reflected the proximity of her village, Spuzzum, to more status-conscious coastal cultures "next door." It is unlikely that one would find such a degree of social distinction upriver along the Thompson, or on the Nicola Plateau. These distinctions, however, are matters of degree, related to the availability of regular local salmon runs and the distance of one's territory from major trade routes.

Shamanic knowledge was closely guarded by practitioners and by certain families. Decisions as to when and how much of this incorporeal property could be revealed to the wider community were made consultatively by the most mature and experienced members of the extended family. The caution and control relating to shamanic procedure, and associated rock writings, are rooted in an enduring and deep concern for the vulnerability of one's family to the psychic powers of witchcraft, or to accusations of practicing witchcraft. In recent centuries, censure by missionaries only exacerbated the cloak of secrecy which had enshrouded these practices for a very long time.

Today, confronted by inroads of other cultures, and by a century of administrative control by the Federal Department of Indian Affairs, even fewer indigenous people retain knowledge of these procedures. Those who *do* know will point out, for instance, that great strength and power can be derived from rocky places where water moves down through the mountains and hills on its way out to the sea. Such a place is the Stein, or *StI'yen*, "the hidden river," which disgorges into the Fraser near the present town of Lytton. For millennia people have gone to such places to allay their hungers—the hungers of the body, of the mind and of the spirit.

When one talks to Native people who have lived and dreamed in such places, in the hills and along the rivers, one is taken back in their stories to the beginning of conscious time, to their earliest accounts of human strivings for answers to the elemental questions about the human condition: Where did we come from, and why do we exist?

In the teaching stories that the old people use, one is taken to places where people first sought to make a living on the land, where they made their first efforts to feed themselves, to raise their children, to order the world around them and invest it with meaning. Here in southern British Columbia one is guided back in time to the ancient era which scholars have called "The Mythological Age": the era of the Transformer Beings who travelled the Fraser River and the adjacent coast, separating the first beings into humans and animals, instructing the early people how to live and work with one another and with the world around them.

The Transformers helped the Old One, the Creator, in his task of evolving and developing, often by trial and error, the creatures of the earth. Some of the first conscious beings were transformed into animals:

> The beings who inhabited the world during the mythological age, until the time of the transformers, were called spêta'kL. They were men with animal characteristics. They were gifted in magic and their children reached maturity in a few months. They were finally transformed into real animals. (Teit 1900:337)

Others were welded into humans with their present-day form. Both humans and animals were sometimes transformed to stone and left on the landscape to educate the coming generations:

> Most of the rocks and bowlders [sic] of remarkable shape are considered as transformed men or animals of the mythological period. (ibid.)

For the same reason, some were turned into stars in the sky (ibid.:341). Even today it is said that all the flora and fauna retain an elusive, human-like form of consciousness that harks back to the mythological era. Spirit-quest training, fasting, sweating, dreaming and other exercises prepare the acolyte to make contact with these forces of consciousness, these powers of the spirit. These spirit beings come to one in dreams, in many different forms. One form is what Teit (ibid.:339) called "a race of dwarfs who inhabit steep cliffs and forests":

They inhabit low, dense forests, or live in dense woods in the mountains. It is said that they never kill, steal, or chase people. Some people believe they are cedar-trees, or their spirits, and that they have the power of transforming themselves. They are rather fond of joking and playing tricks on people. (ibid.:340)

Annie York identified one of the rock writing panels in the Stein as dream portraits of these cedar people (see Fig. 143):

...they're spirit faces. The top one is Skaí'yep, from the cedar tree. You just try it some day in a lonely place. You sleep under the cedar. The bigger the tree, the better it is. It'll come to you. It's a beautiful song.

Cedar has other spirit forms too. Arthur and I seen the Xai'ḵaizeh. That's a cedar root that looks human...Then a third of the Cedar People might come to you too. TsakwI'iiken, and she has the form of a golden snake. She cries, just like a kid too. If you hear her singing, she's gonna follow you around. Not many see that one...

That cedar dreaming is where the real winter dance, the s'leḵ, comes from. Power comes out of that cedar in winter.

The teachings are given to the young as soon as they reach the age of understanding. Teachings come in the form of instructions and stories which speak of elemental things—of birth and death, of the stars, the earth and the sun, of fire and water. However, today's elders are forced to look for new ways to express these elemental things, and they do so increasingly in English, the mother tongue of many of their grandchildren. The grandchildren have changed; their experience of life and the land is quite different from that of their grandparents.

Although in some cases the old people only partially understand the *European* cultural connotations of the English words, they feel impelled to try to express the old teachings in what they believe is "Christian English" so as to communicate the ancient outlook, experience and concepts of their own culture to the wider world. In so doing they hope to reach beyond their own cultures to the majority of the population which remains largely ignorant of the richness of Native expression, and Native cultural history and values.

This is what Annie York has tried to do with the teachings presented here. Annie agreed to work on this project to show the outside world what Native people mean when they speak of the sacred nature of the Stein River Valley. She was well aware of the ambiguity in the local Native communities regarding the revelation of this knowledge to the wider world. In the end, Annie was ready to put some of her knowledge between the covers of books, thereby challenging the non-Native world to understand, appreciate, enjoy and, above all, respect the rock writing sites. In so doing she has contributed significantly to the treasury of our national heritage.

I would like, in closing, to thank Arthur Urquhart for his patient hospitality and his incisive grasp of Fraser Canyon history and human nature. I thank Chris' wife, Barb, and family for their forbearance and good cheer during the editing marathon around their kitchen table which disrupted house renovations and other artistic productions. We both appreciate the time taken to answer our plaguing questions by Kathy York, Nathan Spinks, the late Louie Phillips, Mary Anderson, Rose Fandrich, Willie and Ina Dick, the late Willie Justice, Amy Hance, Shirley James, Steve Paul, the late Andrew Johnny Sr., Rita Haugen and Rena Bolton. Researchers Gordon Mohs and Sonny McHalsie introduced me to Annie York, and also contributed information and helped in many ways. My thanks also go to Liv Mjelde, Jan-Marie Martell, Wendy Wickwire, Gerry Freeman, Professor Michael Jackson

and Louise Mandell for their informed help and encouragement; and to Edith Iglauer, Karl Siegler and Andrea Laforet for the hours they devoted to reading and advising on the never-ending manuscript. Chris also thanks Dan Savard, Nancy Romaine and Grant Keddie of the Royal British Columbia Museum for their help in locating many of the archival photographs that appear in this book. I am indebted to Sheryl Adam of the University of British Columbia library staff for her assistance in finding idiosyncratically catalogued materials from the past century; to Margaret Alfred of Moricetown who transcribed the tapes with such accuracy and intelligence; Peter Grant and Bruce Sims contributed significantly to the endless process of readying the final manuscript. Both Chris and I would also like to thank Kellie Hampton and Irene Niechoda of Talonbooks, both of whom spent many hours of inputting, designing, proofreading and putting up with last minute revisions by two far-flung co-authors. Chris would especially like to thank Kim Johansen of Pièce de Résistance Ltée., for her expertise in the time-consuming task of integrating the rock writings and illustrations into the final text with care and finesse. The project was partially supported by an independent scholar's grant from the Social Sciences and Humanities Research Council of Canada.

Finally I want to point out that some of the Stein writings are very weathered and difficult to distinguish by the untrained eye. Some of these faint writings were made available to us to study and to present to Annie York for explanation thanks to Chris Arnett's training and talents. Chris' drawings are more comprehensive than previous recordings of the Stein rock writings. Virtually his every dot and line had significance for Annie; consequently, the detailed drawings he made were extremely helpful and timely for this project.

As a result of years of acute observation, measurement, reproduction, and pure enthusiasm for the rock writings of southern British Columbia, Chris Arnett has developed an uncanny ability to see the figures in badly eroded, faded and smudged red ochre paintings. I have stood before some of the Stein figures, side by side with Chris and, while I have seen only indistinct forms, he has been able to read their iconography and record it with precision.[6]

Richard Daly
Hazelton, British Columbia

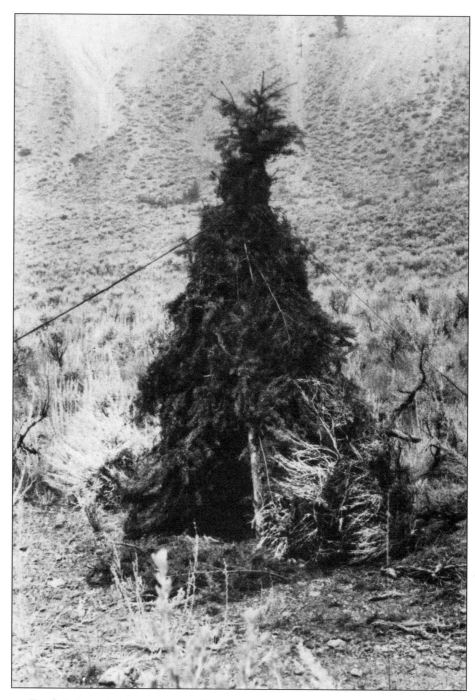

Fig. 5. Pubescent girls' tipi ('nxó'xwiiyaten). "Close by the hunting-lodge, or near an Indian village is sometimes found a temporary structure for the habitation of girls when coming to womanhood. It is conical, and made entirely of fir branches and tops. Four small fir-trees are placed in a square, and their tops tied together. The branches of the trees are knotted together and the open spaces filled with fir tops and twigs" (Teit 1900:198).

Annie Zetco York ('Nlaka'pamux Nation):

Long before the white people they had their own prophets in this life. And that prophet told the law everywhere. And wherever he is he write these things, whatever he sees. He travels to the Stein; he travels way, way down to the coast. Everywhere.

In the morning an old man preaches the young people what to do. It's to go up in these mountains like that Stein. They spend their life there and God is going to help them, to give them strength. The Indians claimed that place because, for thousands of years, that was just like a university to them.

They go up there [in the mountains], and they sleep, and this dream tells them. Then he writes his dream on the rock. That's left there forever.

We teach our young people to reverence things. In this life we have to have water, and we need fire to warm us. Air, food, moon, stars and sun. The rain comes, then snow. The snow melts into the rivers. It's the cycle of life. The Stein Valley is like Moses' mountain, or Rome to the Catholics. These are sacred places.

The reason why Indians strongly demand that that must NEVER be disturbed is because that writing—all those rock writings—they are there to remind the young people that there was a person with knowledge on this earth for thousands of years before people come from Europe.

Rena Bolton, Xwa'liqwia (Sto:lo Nation):

If you, young people, want to find out who you are today, you must go back into the history of your people to where your ancestors travelled on the river, and in the mountains.

The rivers are very sacred to us. All we produce, all we eat and drink eventually goes back, goes out the river to the sea. Even the dust and the fluids of our ancestors. In the ocean it's purified. It comes back as the rain and the mist. It comes back along the valleys as *slá'qem*, the breath of our ancestors. I hope you understand that this is something that is very sacred to us.

Rosie Adams Fandrich, who lives at the mouth of the Stein River
(Slaxa'yux 'Nlaka'pamux):

You see, that's a kind of history to us. If we were able to write long ago there would have been history made through there.

They go in there for maybe a year, and practice their work. And they come out of there and they're Indian doctors—what you call medicine men.

That thing in there, that whole valley is just like a giant church to me. Before I go in there, I say my prayers because I seem to be going into something sacred.

Yes, the Stein is a sacred place. It's like a church to me. It has been sacred for a long long time. I'm sixty-five and it was sacred in my father's time, and my father's father's. The whites are always talking about history. Well, that Stein is our history. Our history is in there. It is written in the rocks. The old ones put their knowledge in there. They taught the meanings and now it's just about all gone.

Yes, Annie is right. That Stein is like Moses' mountain. It reminds me of Moses with the Ten Commandments on the rock. Those rock figures are sacred like the Commandments.

If I have bad luck, or too much on my mind, I go into quiet places like that, and I sit. You can drum, and sing and dance if you like. Mostly I sit and I pray. After a while in there you feel better. You are surrounded by all of the Old People when you are up in those places. You can feel them around you.

Louis Phillips (18 April 1993, Lytton, B.C.):

K'ek'áwzik is over here, across the river, behind these hills. Can't see it from here. Powerful place. It's our school. Today the kids drop out of school. They learn from books. In our day we learned by listening to the land. The land talks if you know how to listen. K'ek'áwzik is where you graduate from. You know, the Bible says Jesus went into the wilderness for forty days and forty nights without food. That's why the Indians go for that Bible. It's the same thing with us. Our young people were sent up there to K'ek'áwzik for ten days. No food no water. If they stuck it out, they come out, graduated. The mountain, that place talks to them. Some it doesn't talk to.

Some are not successful. Sometimes it's like that place doesn't want to teach anybody. It hides away in rain and snow and fog. Even in summer time. That Wendy Wickwire and her husband, they wanted to take youngsters—14 or 18 year old in there, as a learning thing. That place didn't want them. Either it wasn't ready for them, or they weren't ready for it.

You were looking for those footprints in the rocks. It's the same. Either you're not ready to see them, or they just don't want to be seen now, not today. Sometimes they are ready to be seen, sometimes not.

That place has two faces, a helping face and a spooky place. When it doesn't want to help you, it hides its face. A lot of the time it hides its face and it's not a good place to be. Gets spooky in there, unfriendly.

When you go in any time to train, and you stay ten days, you listen to what nature says to you. You listen and learn and you can come out strong and protected. That's real Indian education. Kids today go to school. They don't know anything about listening to the land. Wherever you go in the mountains, the plants and herbs tell you what they are good for. You tell them what you need to know. Talk to each other. Every tree in that place has something to teach. You stay and learn all there is to learn in that place. Next time you go somewhere else and talk to all the plants in that place. You get knowledge and grow strong. K'ek'áwzik is the place our young people went to learn. They might stay up to ten days. Not eating or drinking. Learning on that mountain. Did they write their learning on the rocks? Maybe some did, in some of the places. Lots of writings in this country.

Some come to me now and want to be Indian doctors. You want to be an Indian doctor? They want answers right away. I laugh at them. Tell them to go out and sit on the mountain. Listen to nature.

For training to be an Indian doctor, it takes close to four years of going out and staying up in there. You go to a place and stay without food and water. You build your sweathouse there and you go in and spend the night. You learn there too. You can sing, you pray in the sweathouse. In the morning you put on you clothes and travel around that place and listen to the plants and all the living things. (Do this for about ten days.)

The next time you do this, you go five or six miles further. Do it again and learn all there is to learn at that place. You stop one time

on top of K'ek'áwzik, after that on M'kip and other places. It's powerful too. Then you move up the valley, five or six miles maybe, all the way up to Cottonwood, learning the *power* of each creek and the peaks in the area. After about four years you are trained. You have your powers. You tap into the power of the river and all the creeks and mountains. When you come back you've learned a lot of what the land can teach you.

Carl Gustav Jung:

As scientific understanding has grown, so our world has become dehumanized. Man feels himself isolated in the cosmos, because he is no longer involved in nature and has lost his emotional "unconscious identity" with natural phenomena. These have slowly lost their symbolic implications....No river contains a spirit, no tree is the life principle of a man, no snake is the embodiment of wisdom, no mountain cave the home of a great demon. No voices now speak to man from stones, plants and animals, nor does he speak to them believing they can hear. His contact with nature has gone, and with it has gone the prolonged emotional energy that this symbolic connection supplied.

This enormous loss is compensated for by the symbols of our dreams.

Johann Wolfgang von Goethe:

What higher thing can Man in life obtain
Than that the God-Nature should reveal itself to him,
And let the material merge into the spiritual,
As it holds fast what is begotten of the spirit?

A Note on Orthography

At the risk of sacrificing linguistic precision, we have rendered, as far as possible, the 'Nlaka'pamux words used by Annie York, in a "user friendly" manner, from the point of view of the non-specialist speaker of English. Native languages of this region possess a whispered quality, with softly aspirated sounds. Apostrophes (') have been used to denote glottal stops. The sign "x̲" denotes the "-och" sound in "Loch Lomond." The letter "x" denotes a similar sound, but emanating forward, in the mouth, rather than back in the throat. "K̲" and "'k" both denote a sharp, plosive k-sound. "I" denotes the sound of the English "I/eye." The double "ii" is the sound of "ee" in the word "meet." The double "uu" is a long "u" sound like "oo" in the word "woo." An accent (é) indicates stress.

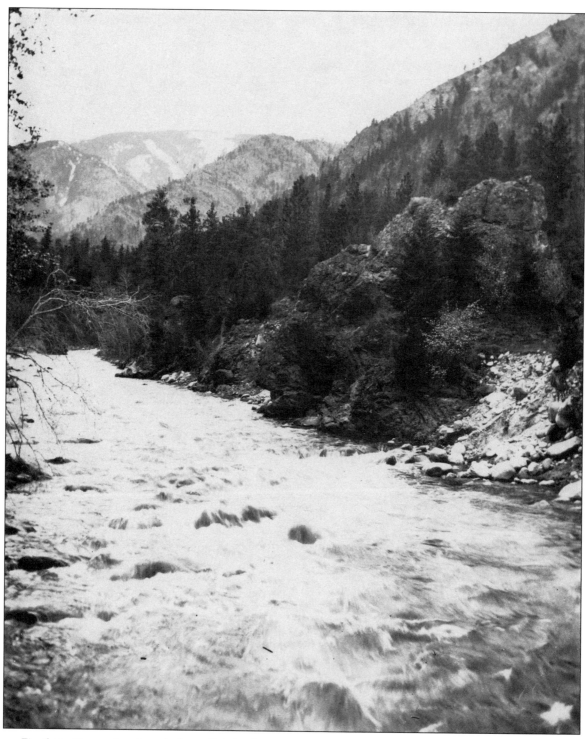

Fig. 6. Looking upriver from the lower Stein Bridge. The distant ridge climbs towards the mountain K'ek'áwzik, "the Indian College." Photograph by C. F. Newcombe, 1903. Courtesy Royal British Columbia Museum PN8855.

1. The Archaeology of Dreams:
Rock Art and Rock Art Research in the Stein River Valley

Chris Arnett

Shamanism was prevalent among the Thompson ['Nlaka'pamux]. This we can gather readily enough from their stories; and certain spots and localities are pointed out by the older Indians as the places where certain celebrated shamans underwent their fasts and training to gain their powers. There were several such spots on the banks of Stein Creek.[...] We find several groups of rock paintings along this creek, which are believed by the present Indians to have been made in the past by noted shamans. (Hill-Tout 1899; Maud 1978: 48)

Fig. 7. Rock writing of beaver at EbRk 1, Stein River Valley.

The mountain peaks, alpine lakes and streams found along the west side of the Fraser River from Spuzzum north to Lillooet have always been regarded by the 'Nlaka'pamux people as places associated with supernatural power. Within this area are certain localities which had their origin in the distant past when Beaver unleashed a great flood which drowned "the many bad shamans who continually wrought evil." As the flood waters receded, the bodies of these shamans and other "ancients gifted in magic" were either left to rot into the earth, or they drifted into lakes and creeks where they disappeared. Their spirits were said to have taken up residence in the places where their bodies dissolved. Those who were left on the ground became *xa'xa'óyamux* or "land mysteries"; while those who dissolved underwater became *xa'xa'étko* or "water mysteries." These places, inhabited by the ancient shamanic spirits, are *xa'xa'*— mysterious, haunted and magical, the wellspring of "nature power."[1]

The concept is explained by 'Nlaka'pamux elder, Louie Phillips:

> Some of the woods is kinda spooky, you know. There's something in the woods there that makes that place kinda spooky. And if you can get power from that thing that makes that place kinda spooky, well, you got nature power. That spooky place gives you that power. Not like goin' down the road here and listening to cars and trains. To get power you got to get way out, way out from civilization.

This power is not accessible to everyone and contact with it can be fatal. Most people avoid the haunts of the xa'xa'óyamux and xa' xa' etko and propitiate them with gifts and prayers. These "mysteries" are, however, "also of service to those who seek them and wish to gain wisdom from them, for many shamans have trained in these places..." (Teit 1912:333).

The most significant training ground for the 'Nlaka'pamux shaman, or *syux'nam*, on the west side of the Fraser, is the valley of the Stein River. Born in the snow-melt in British Columbia's Coast Range—the northwest extension of the Cascade Mountains—the Stein flows east, through a steep-sided, forested mountain valley to its confluence with the great Fraser River in the semi-arid country north of Tl'kamtciin/Lytton.

The Stein watershed, untouched by road-building or logging, is a physical microcosm of the 'Nlaka'pamux world view, such as was revealed by N'aukawili<u>x</u> of Spences Bridge to James Teit in 1898[2]: a world nearly circular in shape, bisected by rivers, level in the centre where people lived in lodges at the confluences of rivers, and extremely mountainous near its outer edge. Beyond the mountains the land was surrounded by lakes covered by mists and clouds. A red-painted trail to the west led to the spirit world.

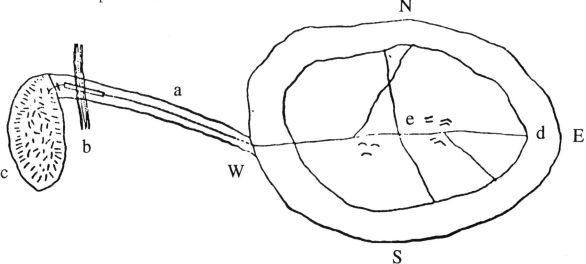

Fig. 8. Drawing of 'Nlaka'pamux world by N'aukawili<u>x</u> of Spences Bridge, 1898, adapted from Teit (1900: Fig. 290). Teit describes it thus: "a, Trail leading from the earth to the land of the ghosts, with tracks of the souls; b, River and log on which the souls cross; c, Land of the ghosts and dancing souls; d, Lake surrounding the earth; e, Earth, with rivers and villages" (ibid.).

Stein, the "hidden place," is a legacy from the land as it was, and as it is, to the First Nations: a land intact and healthy, capable of revealing its secrets to those with the will and patience to learn.

In an interview given toward the end of her life, Annie explained what the Stein River Valley meant to her, saying:

> Yeah, that Stein, that's a university. It's this way, you see. Okay, you're young, and when you're about ten, or fourteen or fifteen, your grandfather worries about you—if you're a boy. Or your grandmother if you're a girl. He doesn't just like you to be an ordinary person because, when you grow up to be a man, you going to be a hunter, a fisherman, a doctor. So they have to go up to the hills to learn aaaaaaall the different animals, their ways. And they have to go up to that Stein. Those that can, make it. They come from all over. Oh, from way up, as far as Thompson Siding, Spences Bridge—young men wants to. If they want to, they can do it. They travel. Oh, the Lillooet people can go there if they want to: they come out through the other way, and go there. They go from all the way down here, Spuzzum. There was an ooooooooold man lived here. He went there. His name's Mek'ekw, Black Cap. Hahaha hah! He's an Indian doctor, and that's where he trained.

A visible legacy of those who trained are the *ts'ets'ékw*,[3] the writings or records of dreams for which the Valley is famous, found inside rock shelters and caves, on boulders and cliffs, where the xa'xa'óyamux and xa'xa'étko dwell. Most of the writings are red ochre paintings, or pictographs, though there is a single rock carving, or petroglyph, and one tree writing, or arborgraph. The 'Nlaka'pamux people call them Ts'ets'ékw, which, in addition to "writing," can mean a mark or picture of any kind. Annie referred to all the Stein rock art, and the single tree writing, as "writings."

The Stein River Valley contains the greatest concentration of writing within the aboriginal territory of the 'Nlaka'pamux, including one of the largest rock art sites in Canada, a testament to the rich mythic and spiritual heritage of the Stein. Since 1897, when the first archaeological studies began in the valley, no fewer than seventeen rock writing sites, and one writing on a tree, have been identified.[4] These writings occur along twenty-seven kilometres of the Stein, from *Nk'mtsin* at the confluence of the Stein and Fraser Rivers, to a point upstream, just below *Nekw'nikw'ats* (Cottonwood Creek).[5] Most of the writings are found on cliffs or boulders at the base of rock talus slopes beside the aboriginal trail that follows the river through the mountains. The exceptions are two painted caves located high above the river on steep mountain slopes. In light of several oral reports of people living in the area, there are other painted caves in the middle valley. Much of the valley has not been explored for a long time. It is probable that other rock writing sites will be rediscovered.

As mentioned above, most of the known writing sites in the Stein consist of red-coloured paintings. The paint used to make these writings is made with powdered haematite, or red ochre, an anhydrous iron oxide (Fe_2O_3), combined, as Annie York tells us, with burnt pitch from the tamarack tree. When it was ready for use this material was mixed with saliva into a paste which was applied to the rock surface with the index finger or a small piece of buckskin. The red paint is called *luutsamen*, a word derived from *Tsul'amen*, ("red paint") a major source of haematite near Princeton, British Columbia.[6]

Annie York describes the preparation of the paint:

> You mix paint in a stone bowl. First, you take the stuff for the paint and heat it over the fire. Then you put it in the bowl and grind it. Up country they use it raw. This is red ochre. Its name is *ooyuyumxwen*. Black paint is made from charcoal and oil. There is another red paint

that you store in bags for painting the body [and the rocks]. It's made the same way, but you add burnt tamarack pitch. It's stored in bags and is called luutsamen.

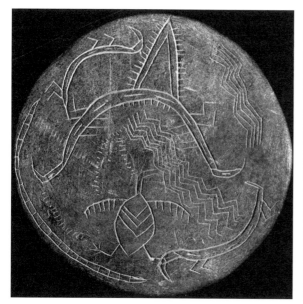

Fig. 9. Steatite paint palette with incised writings, from Lytton area. Courtesy Royal British Columbia Museum Neg. No.EbRj-y:506.

The colour red has important symbolic connotations to the 'Nlaka'pamux people. As Teit pointed out: "Red was the colour almost always used [in rock writings] as it was symbolic of life, goodness, good luck, etc."(1918:2). Besides signifying "good" in a general sense, the colour red "also expressed life, existence, blood, heat, fire, light, day. Some say it also meant the earth. It appears also to have had the meaning self, friendship, success" (Teit 1930b:418).

"Life," said Annie York. "The red is for life and the protection of your life, to protect yourself from other peoples casting sins [witchcraft], too."[7]

The Stein paintings are, for the most part, composed using lines of paint the width of a fingertip. In this respect they are not unlike rock paintings found throughout the territories of the various First Nations of British Columbia and beyond (see Chapter 4). Individual figures can range in size from a few centimetres to well over a metre in length or height, although such large examples are rare. The number of paintings at a given location can range from one to well over a hundred.

From the overall similarity in form it appears that there is little if anything to differentiate rock paintings found in adjacent aboriginal territories. Similarities can be traced to technique and to shared entoptic and hallucinatory sources of the imagery (see Chapter 4). However, ongoing analysis of more than four hundred rock painting sites in fourteen aboriginal territories of British Columbia indicates that there are distinctive stylistic traits to distinguish the rock writings of any particular region. For example, Stein Valley writing is part of what I call the Slaxa'yux sub-style, named after one of the five divisions of 'Nlaka'pamux-speaking people.[8] The distinguishing features of this regional style are stylized mountain goats, bighorn sheep, deer and humans with rectangular bodies often showing internal details, generally in the form of one or more chevrons to indicate ribs or, as Annie informs us, to signal colour. Other unique features are frontal, human-like

figures with rounded bodies showing interior details, with outstretched limbs bent upward at the elbows and knees. Stylized human-like figures with "T"-shaped heads, two-headed snakes, horned lizards and owls are also characteristic of Stein River Slaxa'yux writing. These features are common in the Stein River valley and at a few sites in the neighbouring territories of the Lil'wat and Stl'atl'imx, but are only rarely found elsewhere in the Interior.

In 1918, pioneer anthropologist, James Teit,[9] who lived at Spences Bridge, summarized what he had learned in the course of his life, about Interior Salish rock writing. He recorded this information in a remarkable letter to F. Kermode, then director of the Provincial Museum in Victoria in response to an inquiry about a Secwepemc (Shuswap) writing on Seymour Arm, Shuswap Lake. In this letter Teit compressed what he had learned from Native informants, including some who had written on the rocks themselves:[10]

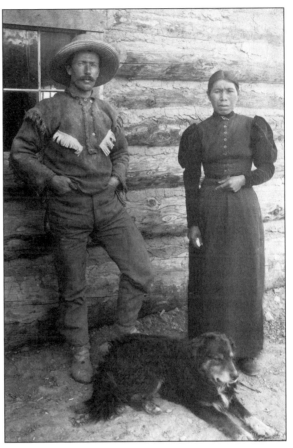

Fig. 10. James Teit and his first wife, Lucy Artko, Spences Bridge. Courtesy Department Library Service, American Museum of Natural History Neg. No.11686.

These paintings are to be found in places such as cliffs, overlooking or close to lakes and streams, near waterfalls, within and around caves, on the walls of canyons, natural amphitheatres and on boulders near trails, etc. Generally they are in lonely and secluded places near where Indians were in the habit of holding vigil and undergoing training during the period of their puberty ceremonies when they generally acquired their manitous [guardians spirits or sh'ná'am].

These places were resorted to because they were considered mysterious, and were the haunts of "mysteries" from whom they expected power. The mysterious forces or powers of Nature were believed to be in greater abundance and strength at these places and the novices desired to imbibe power and knowledge from these sources to help them in after years. They went through exercises, purified, supplicated, slept, prayed, fasted and held vigil at or near these places so as to obtain as much as they could of this power.

At the expiration of the training (or sometimes also during the same if they had any vision or experience considered extraordinary or specially important) the novice painted pictures on cliffs or boulders near by (or at) these training places wherever rocks with a suitable surface for painting on, could be found. Where these did not abound very few paintings were made, or the paintings were done on small smooth stones, or on debarked trees, etc. The paintings

Girls' lodge and fir branches hanging down from roof, Spences Bridge.

Crossing of trails, sacrifices of food, and pole, Spences Bridge.

Grave poles, Spences Bridge.

Vulva of Coyote's wife, Spences Bridge.

Face with tears, Tsix'paa'uk Canyon.

Fig. 11. Drawings of 'Nlaka'pamux rock writing by James Teit. After Teit (1900:Plates XIX, XX).

were largely in the nature of records of the most important of the novice's experiences whilst training, such as things seen in peculiar or striking visions and dreams, things wished for or partially obtained as manitous or guardians, etc., things wished for or desired to be obtained, things actually seen during training or during vigils which were considered to be good omens, [and] actual experiences or adventures of the novice, especially those in connection with animals. (Teit 1918:1-2)

By writing these things on the rocks the novice hoped to facilitate the acquisition of power and make it stronger and more permanent:

People usually made their paintings in secret and alone, and often offered prayers when making them.... (Teit 1918:4)

Teit's information on the role of rock paintings in the training process is elaborated seventy years later by Annie York, who learned about the writings in the Stein from the Nahlii brothers of Lytton—from Moses Nahlii, in particular:

Oh, he told me about those people that paint, and all those—but he said that most of those, it was God's servant[11] that did most of the first painting, and the people that learns to be a medicine man, they do too. They paint.

They go there, and they sleep, and this dream tells them. Then, he writes his dream on the rock. That's left there forever.

Annie explained that grandparents played a key role in training the individual:

The old people used to train the young in the mountains. All that old knowledge is connected to the origins, the creations, and they teach them that. They teach them about the red paint and how to put it on the rocks, and how to mark yourself with it for protection.[...] From the writings on those rocks they teach the young people how to live.

The grandparents gave the luutsamen, or red iron oxide paint, to the trainee to take with him or her into the mountains. Using either a small piece of buckskin, or fingers moistened with saliva from the mouth of the painter and dipped into the powdered haematite, the paint was carefully applied to the rock surface accompanied, as Annie points out, by a prayer:

You have to ask God to help you, that you gonna use this drawing in later life. That's going to be your strength too. And any kind of animal that you dream, that's going to be your power.

Not all rock writing was made in the context of the guardian spirit quest. When made "by a person gifted in magic," any writing could have supernatural power:

Occasionally paintings on rock were made by both novices and adults of any age for what seems to have been chiefly protective purposes, such as after a very striking dream (or an event) believed to portend evil, for the purpose of warding off disaster or evil happenings. Paintings of this kind were made near camps.

Paintings of manitous and men were also sometimes made in certain places near camps or overlooking paths and routes (on land or water) by which enemies or evil (such as certain sicknesses or harmful things) might approach. These pictographs, by reason of this connection with the manitous or guardian spirits of the people who made them, were believed to help in the protection of the latter. (Teit 1918:2-3)

Annie York was familiar with this type of writing:

That's to protect them. Yeah, sometimes if they want, they [enemies] can never pass it [the painting]. You can't pass it! Too strong. One person looks after an area. Too strong for anybody.[12]

Teit also pointed out (1918:3) that people recorded sightings of supernatural beings, ghosts or monsters which they recorded in paint—"partly it seems to protect themselves from possible harm, and partly to obtain power from [them], or obtain [one] as a manitou [sh'ná'am]."[13]

Writings could also be, according to Teit's informants, "of a monumental and historic character, either marking the spot where certain important happenings took place (such as battles), or narrating or recording in a pictographic way, some event important in the life of the person (or in the lives of the people) who made them" (Teit 1918:3). For example, Teit describes an instance of rock writing on Kamloops Lake which was said to have been "painted by the Shuswap to commemorate a victory gained at the place by the latter over a war party of Thompson ['Nlaka'pamux] Indians" (Teit 1900:339). Goodfellow (1928:24) describes another battle site in the Similkameen Valley which was associated with rock writings. Similarly, a painting at Tcut'awi'xa in the Similkameen Valley portrays men with hats mounted on horses and, according to the oral accounts, "depicts an incident connected with the coming of the first white men" (Harris 1949:23).

Fig. 12. Horse and rider rock writing at Tcut'awi'xa, Similkameen Valley. Photo by Chris Arnett.

At least one rock writing site in the interior of British Columbia was used to commemorate the deaths of important chiefs. Chief Bob Selqua of the "Pavilion Lillooet Indian Village" told Harlan Smith about paintings on a boulder located on the aboriginal trail on the north side of Pavilion Lake. Smith recorded that "[Selqua's] ancestors made these pictographs and that every time a chief died his son painted the pictures of a man on the rock. The pictures and stars around one of the men, indicated his greatness, according to the chief" (Smith 1932:8).

Annie also recognized this function of writing to record noteworthy events not associated with the dreaming process:

It's also the things that happened, and what year did it happen. Yeah, because they can't have a paper to write on.

Annie also added that writings could predict the future:

And some of those things tells you what is going to happen. And it tells you from here to the sky.

Large, strange-shaped boulders and other rock formations, representing supernatural beings transformed to stone during the Mythological Age—the time of Beaver, Coyote, the Bears and the Transformers—were also selected as sites for rock writing by 'Nlaka'pamux people:

Indians also frequently painted pictures on rocks which were thought to be metamorphosis beings (originally human or semi-human, semi-animal, or semi-God-like character) concerning which, there were stories in their ancient mythological tales or traditions. These rocks are generally boulders corresponding roughly to human and animal forms or to parts of the body, etc., or to rocks worn into peculiar or fantastic forms of various kinds, suiting in some way the story that is told of them. By painting on them, power in some degree, it was thought, might be obtained from them or their spirits... (Teit 1918:3)

Fig. 13. Spaeks ha snikia'p, the Coyote's Penis, near Spences Bridge. Photo by Richard Daly.

One of these sites is found at Spences Bridge in the vicinity of *Spaeks ha snikia'p* (Coyote's Penis) where the genitals of Coyote and his wife, as well as her woven cooking basket, were turned to three rock formations by Xwekt'xwektl. Xwekt'xwektl had tried to transform them totally to stone but due to the countervailing shamanic power of Coyote, the transformer was able to succeed only with the Coyote's penis, his wife's vulva and the basket kettle from which they had been

8

picnicking (Teit 1898:44, n.132; 1900:337). The two boulders representing the genitals of Coyote's wife and the basket kettle were later used as painting sites.[14]

Chief Baptiste Mischelle of Lytton described another Transformer site to Charles Hill-Tout. This was a site on Harrison Lake where, Chief Mischelle said, X̲wekt'x̲wektl punished an evil shaman "by transforming him into a smooth-shaped rock, whereon men might paint, which rock may be seen on the shore of the lake…with its painted figures upon it to this day" (Maud 1978:138).

Finally, there was an important category of rock writings referred to as xa'xa, or "mystery," which, Teit wrote, "have not been made in any ordinary way. Some have not been made by the hand of man"(Teit 1898:118, n.283). These paintings, described as "the largest and oldest paintings" were "pictures made and shown by the mysteries, or powers, or spirits of the places where they are to be seen. It is said that in some places these pictures appear at different times" (Teit 1918:5).[15]

Teit heard about two of these paintings near Spences Bridge. One was "above the Nequ'umin Waterfall"(see below) and the other was "on a rock facing the pool between the little and big waterfalls of Waterfall Creek near Spences Bridge" (Teit 1900:339). Of the latter paintings Teit added: "They were at one time very plain, but within the last few years have become obliterated. The Indians say that this is a sign that the spirits have left the place" (ibid.).[16]

Annie York was told that some of the writings in the Stein had been made by X̲wekt'x̲wektl, also called God's Servant or the Transformer, back in the mists of time. X̲wekt'x̲wektl, or X̲á:ls, as he was known by the Halkomelem-speakers toward the coast, is credited in a number of places on the coast and further inland with the making of rock writings, both carved and painted, as well as the creation of places where people made writings in later times (Boas 1891; Teit 1900:337; 1912:227; Elliot 1931:168; Jenness 1955:28-29; Bouchard and Kennedy 1977:13-14, 16; Maud 1978: 38; Hill and Hill 1978:103). These writings commemorate the Transformer's teachings on the arts of survival through proper social conduct and the efficient use of food resources, particularly salmon, and became the inspiration for dreamers in later times.

Fig. 14. Originally in the vicinity of the Coyote's Penis, this boulder representing the basket of Coyote's wife and its writing has yet to be relocated. It may have been destroyed by construction of the Canadian National Railway ca. 1911-13. Photo by Harlan I. Smith, 1898. Courtesy Musée Canadien des Civilisations/Canadian Museum of Civilization No.54947.

The Dating of Rock Writings

In the territories of the Salishan-speaking peoples, rock writings have been made from ancient times into the present century. The antiquity of the rock writing in the Stein was stressed by 'Nlaka'pamux elders who, when interviewed in the early 1920s, stated that the writings "had always been there" (Hallisey n.d.:4). The 'Nlaka'pamux and their Stl'atl'imx neighbours believe that the oldest rock writings in their territories date back to the Mythological Age, having been created by the land and water mysteries, or by the Transformer beings (Teit 1906:275; 1918:5).

Archaeologists include Interior Salishan rock writing as part of the Sqlelten Tradition, a 5,500-year cultural continuum culminating in the historic Interior Salishan people of the British Columbia Plateau (Stryd and Rousseau:1988).[17] The origins of Interior Salishan rock writing iconography can be clearly seen in linear, two-dimensional designs incised and painted on bone and stone artifacts dating from the last 3,000 years of the Sqlelten Tradition and its coastal counterpart (Sanger,1968; Stryd 1976; Borden 1976; Copp 1980).

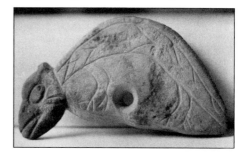

Fig. 15. Atalatl weight with incised writings, 2000-3000 years old, from Mission area, Fraser Valley. Photo by Wilson Duff, 1 May 1955. Courtesy Royal British Columbia Museum.

It is difficult, however, to establish the exact age of any particular Stein painting within this long tradition because, unlike buried cultural deposits which can be dated relative to each other through stratigraphy, rock writings are found in non-stratigraphic contexts, i.e. rock walls and boulders which do not allow easy temporal definition. In fact one of the reasons archaeologists have avoided serious study of rock writings is the inability to date them by absolute means.[18]

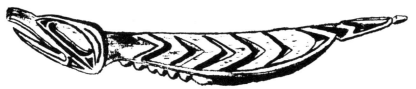

Fig. 16. Dog halter carved from antler. From "Grave 13" at Lytton, excavated by Harlan I. Smith in 1897. This grave and its contents date from 1200 to 200 B.P., during that portion of the Plateau Pithouse Tradition called by archaeologists "the Kamloops Horizon." The chevron design on the body is similar to the design on the much older atalatl weight and is also found in many Stein River rock writings. Chief Baptiste Mischelle and others identified the artifact as a dog halter used to keep the loop on a leash from slipping up and choking the dog (Smith 1900:442). Dogs were probably leashed at times when used in deer hunting (Teit 1900:245). The informants added that "the carving represents the manitou of the owner of the dog and was first seen in a dream" (ibid.). Although the Coastal influence of this piece has often been noted (Boas 1900:376; Smith 1913), it is more likely the product of an ancient artistic tradition common to both the Coast and Interior. Stylistically, the form of the head is reminiscent of carved antler pins and comb fragments from the "Historic Period Stratum" at Musqueam (Borden 1976:Figs. 8:34a, 8:34d). Drawn after Smith (1899: Fig. 114).

Rock paintings at individual sites can sometimes be dated relative to each other by comparing pigment loss, or "fading," which assumes that those paintings which are less visible are older, and by superimposition, whereby later paintings occur over earlier ones. Preliminary study based on the examination of pigment loss and superimposed imagery at rock writing sites in the Stein River Valley and elsewhere suggests that there are two distinct periods evident in Coast

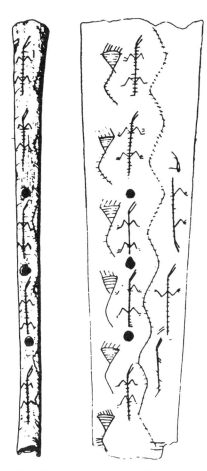

Fig. 17. Bone flute or drinking tube with incised writings. From St'atl'imx burial site in Lillooet, dating to 1840. Drawing by Doris Lundy, after Baker (1970: Fig. iii).

and Interior Salishan rock painting which can be distinguished on the basis of size and frequency of representation.[19]

The early period is characterized by single image and, less often, multiple image paintings which are larger in scale and generally more weathered-looking in contrast to the paintings of the later period which are smaller and usually better preserved. Stylistically, the early paintings are similar to the later ones, the only difference being their larger size and, in some paintings, slightly more emphasis on naturalistic representation. In general, they are more weathered, with pigment having been removed by means of water seepage, natural spalling of the rock surface, and lichen growth. Of course where there has been limited exposure to the elements, early period paintings can be well-preserved.

There are always fewer early period paintings at sites where they are found alongside examples of the later style. In the Stein most, if not all, early period painting is found at one large site, Ts'ets'ékw, in the lower Canyon (Figs. 68, 82, 85, 86 [bottom], 94, 102).

The later period of Salishan rock writing is much more prevalent than the earlier. It is typified by smaller-sized paintings, ranging in size from several centimetres to less than a metre, and include both single and multiple image paintings often arranged in a manner suggesting a narrative. Compared to that used in the early period, late period paint pigment is often well-preserved although, again, exposure to the elements can play a factor in the state of their preservation. At a number of sites, including the largest site in the Stein, late period painting is sometimes superimposed over early period paintings (see Fig. 94). The later period of Salishan rock writing was well-established and widespread by the first half of the nineteenth century and continued, albeit sporadically, into the twentieth century (Smith 1913:36; Teit 1918; Corner 1968:47). Repainting of rock writings continued in the B.C. Interior until at least the 1930s (Harrison 1961:29; Morgan Wells, p.c.).[20]

Support for a distinction in age between smaller rock paintings and large ones comes from native elders interviewed by Teit a century ago. These people acknowledged many rock paintings as having been made by themselves and their predecessors. They recognized them as belonging to various contexts: to youth training, as protective devices, as records of historic events. But they also identified "larger and older paintings" not made by themselves, but created long ago by people of the Mythological Age.

Based on a lifetime of living with 'Nlaka'pamux people and talking with men and women who had made rock writings, James Teit made the following observations concerning the age of rock writings in the 1918 letter:

Rock paintings in different places vary a great deal in age, as also do very often the different pictures on the same rock. As far as the Indians know, rock paintings have been made from time immemorial and until lately. A number of old men and women still living have made them. It may be said the practice of making these paintings commenced to fall in disuse about 60 years ago. Of course some have been made since then, and paintings are still made occasionally on small smooth stones and pebbles. Probably most of the rock paintings now to be seen, are between 60 and 100 years old, but in some places where the rocks or their situations are favourable to the preservation of the paint, no doubt are very much older. (1918:5)

Although Teit recognized the antiquity of the art, it is interesting to note that he dated most of the rock writings visible in his day as having been made between 1818—a decade after the first white man appeared on the Fraser River—and 1858, the first year of the Fraser River Gold Rush when thousands of European and American miners invaded 'Nlaka'pamux territory. If Teit's assumptions, which were based on information given to him by Native people, are correct, his observation suggests that events associated with the early colonial period stimulated the frequency of rock writing and, at the same time, ensured its demise.

The arrival of Europeans and Americans in search of furs and, later, gold, initiated a period of radical change in the aboriginal communities along the Fraser River. The most detrimental impact of this influx of newcomers was disease that killed thousands of people on the coast and further inland, disrupting the social order decades before the first white men were even seen. The presence of the newcomers and their technology also exacerbated patterns of traditional warfare which intensified with the introduction of firearms, steel knives, and horses and was compounded with the desire to gain control of the trading routes through which these and other valuable trade goods arrived. Perhaps, in response to the cataclysmic changes incurred by the encroaching influence of European culture during this period, there was an increased desire or motivation to make more paintings. Teit's descriptions of the paintings explained to him as protections used to ward off "disaster or evil happenings," "enemies" and "certain sicknesses or harmful things" indicate that they could have been directed at, or created as a direct result of, the disruption caused by the newcomers and the increased need for personal protection against physical and psychic danger.[21]

Corner, who has probably visited more rock writings in British Columbia than any other researcher, adds the following information:

Taking into account such background information as rock type, exposure, location, variation and distribution of designs it becomes doubtful that these rock paintings are as old as some people would like to believe. Of the many sites visited, only a few show evidence of pictographs painted over pictographs. If these paintings were very old, one would expect to see more of this practice, for early reports indicate that the Indians had complete disregard for the right of previous artists to take sole possession of a suitable rock surface. All the signs point to a period of painting which started spontaneously, flourished and then ended as quickly as it began. (Corner 1968:119)

A Century of Stein Valley Rock Art Research

Within the last century, non-Natives have shown an increasing interest in the writings along the Stein River, and have sought information about their origins and meanings, struggling to overcome

the barriers of time and culture. Possibly the first non-Native to show a scientific interest in the rock writings of the Stein River Valley was Charles Hill-Tout, a settler at Abbotsford who immigrated from England. Hill-Tout had begun amateur fieldwork in the Lytton area by 1895, first on his own initiative and then on behalf of the British Association for the Advancement of Science. Hill-Tout's principal informant was Chief Baptiste Mischelle of the Lytton Indian Band.

The results of Hill-Tout's research, published in 1899 (Maud 1978), focused on 'Nlaka'pamux culture in general. However, he made at least one trip up the Stein River where "older Indians" identified sites where famous shamans had trained and made rock writings. Like other early researchers, Hill-Tout was apparently only guided a few miles upriver to a site just short of the largest group of Stein writings. Nevertheless, at that location he was impressed by the writings on the face of a cliff, high above ground level. The height of the writings, he noted with a tone of cultural superiority common to his day, "to the Indian mind always adds to their mystery." Hill-Tout noted that the Stein writings had been "made in the past by noted shamans," but he did not obtain

Fig. 18. John J. Oakes sketching Stein rock writings at EbRk 1. Photo by Harlan I. Smith, summer 1897. Courtesy Department Library Service, American Museum of Natural History Neg. No.42821.

any further information about them. Since the local people did not volunteer information about the writings, he concluded that "the modern Indians seem to have no knowledge of the significance of these paintings" (Maud 1978: 48).

In 1898, Hill-Tout had his paper, entitled "On Some Rock Drawings from British Columbia," read to a meeting held in Belfast by the British Association for the Advancement of Science. This paper, which was never published, may have contained references to the rock writings of the Stein Valley (Maud ibid.).

In a letter written to a colleague in 1925, Hill-Tout communicated what he knew in general about the rock writings he had seen in the Stein and in Burrard Inlet near Vancouver:

Ideographic symbols such as these are always difficult to interpret because we are unfamiliar with the symbolism employed and because the Indians themselves seem doubtful about their significance. We have gathered this much however about such paintings or glyphs, that they are partly totemic, partly mnemonic in character. We know that Indian boys and girls

undergoing their solitary preparation for the acquisition of a guardian spirit or personal totem often recorded their dreams on rock faces. And many of the crude ideographs known to us would appear to have originated in this way.

The medicine men too are accredited with the cutting or painting of symbols of this nature. What exactly they mean I fancy is known only to themselves for the various Indian tribes seem to use their signs differently. There was no established system—such paintings or etchings are interesting apart from their significance as instances of the pictographic and ideographic forms of writing through which all independent graphic systems have to pass before they reach an alphabetic system. (Hill-Tout 1925)

Fig. 19. Drawing by Harlan I. Smith of rock writing from an unrecorded site in the lower canyon, August 1897. Courtesy Musée Canadien des Civilisations/Canadian Museum of Civilization. Unpublished fieldnotes of Harlan I. Smith.

In July and August, 1897, an American archaeologist named Harlan I. Smith, together with his brother-in-law, John J. Oakes, explored three rock writing sites on the Stein River, in addition to carrying out other fieldwork in the area (Smith 1899; 1932). Smith was one of many archaeologists and anthropologists employed at this time by the American Museum of Natural History in New York City, for ethnological and archaeological research work on the "Jesup North Pacific Expedition," which collected cultural data in eastern Siberia as well as along the North Pacific region of America. Organized and managed by renowned anthropologist Franz Boas, and financed by the Museum's president, Morris Ketchum Jesup, the Jesup North Pacific Expedition sought to investigate the question of prehistoric and historic relations between the peoples of both sides of the North Pacific Ocean.

A 'Nlaka'pamux man, introduced to us only as "Jimmie," who lived "a half mile north of Lytton," was hired to guide Smith and Oakes up the Stein River. Jimmie conducted them to three sites, one of which has yet to be relocated.[22] The two men made drawings of most of the paintings at the sites they visited. Smith also took photographs. Some of these drawings were subsequently published in Teit's first report for the Jesup North Pacific Expedition (Teit 1900) as Plate XX. These drawings are accompanied by brief interpretations obtained from 'Nlaka'pamux elders at Spences Bridge.[23]

Smith's black and white photographs of the Stein and other 'Nlaka'pamux paintings are the earliest known photographs of aboriginal rock writings in British Columbia.[24] In assessing these photos, one gains the impression that the paintings were as weathered in 1897 as they are in the 1990s, revealing almost no further atmospheric wear in almost a century.

Jimmie told Smith that the sites they visited were sought out by young men and women as part of their puberty training where they fasted, bathed and scrubbed themselves with fir-branches. It is interesting to note that he did not identify these youths as the painters/writers—which suggests that by 1890, Native youths in training did not, by and large, paint at writing sites; rather, they paid them visits because they were sites associated with supernatural power. Hill-Tout, who conducted his research at the same time, was told that the Stein paintings had been "made in the past by noted shamans" (Maud 1978: 45). We also have the experience of Mourning Dove, a Colville Native woman who underwent her spiritual training in the late nineteenth century. Mourning Dove's tutor and her mother encouraged her "to sleep at places where there were pictographs. These were specially designated spots of great power" (1990).[25]

14

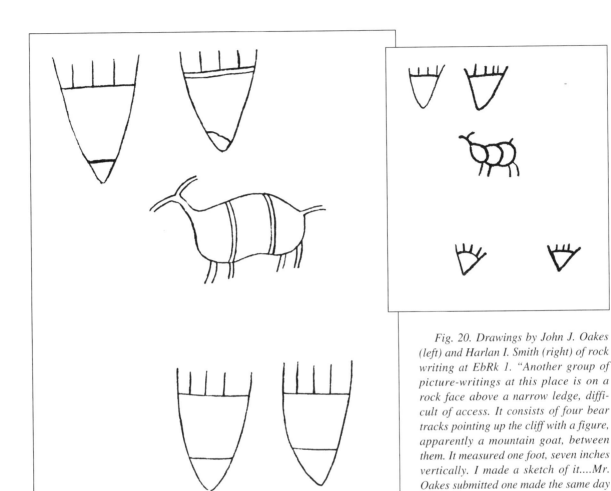

Fig. 20. Drawings by John J. Oakes (left) and Harlan I. Smith (right) of rock writing at EbRk 1. "Another group of picture-writings at this place is on a rock face above a narrow ledge, difficult of access. It consists of four bear tracks pointing up the cliff with a figure, apparently a mountain goat, between them. It measured one foot, seven inches vertically. I made a sketch of it....Mr. Oakes submitted one made the same day which differs but slightly from mine. I made six toes on the upper right bear track and five on the others, while he made five on each. He found cross bars on the heels of the bear track brought out by my photograph but lacking from my sketch. He made the bands on the goat figure slightly different from the way I did. This gives an idea of how faint and difficult to trace parts of these picture writings are" (Smith 1932:15-16). Drawings from unpublished fieldnotes of Harlan I. Smith. Courtesy Musée Canadien des Civilisations/ Canadian Museum of Civilization.

The Jesup North Pacific Expedition came and went. The archaeologists disappeared from the Stein River Valley for over sixty years. They left the valley to its traditional users, both animal and human; these users continued to include shamans and youths on spirit quests. Some of those who used the Stein as a place to dream during those years were Mek'ekw or Mechka of Spuzzum, Klemshu from Stein and Kanu from Spapium. Louis Phillips (p.c.) reported that Kanu, for instance, trained in the Stein at the turn of the century. He sought out a frozen lake somewhere in the valley where he lay down on the ice for ten days and nights, during which time he received a guardian spirit power to practice as an Indian doctor.

As Reverend Stanley Higgs observed during his post at the Anglican Lytton Mission in the late

1920s and early 30s, the 'Nlaka'pamux people, despite years of acculturation, maintained many of the older traditions. Concerning the activities of the 'Nlaka'pamux syux'nam, Higgs wrote:

Danny [Phillips, a young friend of Higgs] was the grandson of an old Indian doctor. Some of the old doctors, "shukaman" they were called, made good medicine, and when I came to know them I respected them. But many were typical of witch doctors, and were men or occasionally women of evil disposition motivated by a lust for gain and power. Some bad doctors, "ḵest tics shukanam," were clumsy and unconvincing, while others were intelligent, cruel and crafty. Danny's grandfather was perhaps neither clumsy nor intelligent, but he had a strong hold on his family. The Phillips band at that time paid smiling respect to the work of the mission, but secretly encouraged the return to primitive ways. (Higgs 1928-1940:161)

The 'Nlaka'pamux people also sought the valley's foodstuffs, materials, medicines, and its animals' meat, hides and furs. A few non-Native trappers and prospectors became temporary users as well. The 'Nlaka'pamux users of the valley were aware of the existence of the rock writings, especially the great collection of paintings alongside the trail at Ts'ets'ékw or "The Writings" in the lower canyon. In more remote areas, trappers and hunters sometimes unexpectedly came across other rock writing sites, and witnessed strange events there. One of these sites is a mysterious painted cave near a place named *Ts'íxmin*, somewhere in the middle valley, above the present-day cable-crossing. Here a trapper sought shelter and had a supernatural experience as related by the late Mary Williams of Lytton. Mary Williams recounted the event to Mamie Henry in September, 1985 (Bouchard and Kennedy 1988:118-19):

A trapper up the Stein sought shelter from the night in a cave. He lit a fire and promptly fell asleep on a natural rock ledge around the inside perimeter of the cave. During the night he was awakened by an unusual sound, tss-tss-tss. He looked up and saw that the walls of the cave were covered with pictographic figures that were now pulsating in the firelight. The man fell asleep again, but early in the morning he was awakened once more, this time by a voice saying, "Tsuxwikw! It is morning!"[26]

Fig. 21. Mary Williams of Stein with children on old lower Stein Bridge. Daughter Rita (Williams) Haugen in back of wagon, ca. 1930. Courtesy Rita Haugen, Lytton.

This cave may have been the one shown to another 'Nlaka'pamux elder, the late Willie Justice of Siska. When he was a youth, Willie was shown a painted cave high above the river by his father, Chief Jimmie Justice of Stein. The inside of this cave, Willie says, was "painted right around and up on top where the

entrance is. Just like it was painted yesterday" (Wickwire 1986:22). Also, like the cave described by Mary Williams, this one had a natural rock ledge "right around the inside."

In 1921 the rock writings piqued the curiosity of C.J. Hallisey, who later became Chief Magistrate of Lytton. Hallisey made a twenty-mile trip up the Stein River to locate and sketch the pictographs (Hallisey n.d.). He made seven sets of drawings which are recognizable as rock writings at Ts'ets'ékw and above Earl's Creek. In 1922, photographs of these drawings were sent by a man named W.B. Anderson of Victoria, to Harlan I. Smith, who was then employed by the Victoria Memorial Museum in Ottawa (Smith 1932:14).

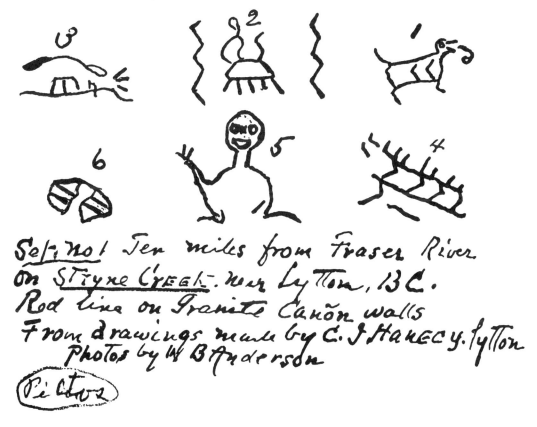

Fig. 22. Sketches of rock writings at EbRk 2 by C. J. Hallisey, 1921. Unpublished fieldnotes of Harlan I. Smith. Courtesy Musée Canadien des Civilisations/Canadian Museum of Civilization.

In the 1950s, during his retirement, Hallisey wrote a short account of his expedition. He was intrigued by the Stein writings, some of which he referred to as "hyroglyphics [sic] of a well-defined sameness which was quite clearly a written language the interpretation of which would open a fund of knowledge and exciting adventure" (Hallisey n.d.:2). Noting similarities between the rock writings of the Stein and other areas of the world, particularly Europe, he followed an old-fashioned approach that assumed that all culture was diffused from abroad rather than being generated in situ. Consequently, he attributed the origin of the paintings in the Stein River Valley not to the local 'Nlaka'pamux people, but to a nomadic group which he called "The Painters," who were

alleged to have travelled throughout the northern hemisphere "1,300 years ago," leaving, as signs of their passing, a distinct trail of rock writings from the Mediterranean Sea to North America.

Although this hypothesis cannot be taken seriously today, some of Hallisey's observations about the paintings are worthy of note and demonstrate the antiquity of the paintings and their continuing association with supernatural power:

> It is generally thought all these paintings were placed there by the Indians and not knowing for sure I made exhaustive inquiries amongst the old Indians. They informed me the paintings have always been there and that at times the "snyees" (spirits) put on fresh paint. This no doubt was caused by the spring moisture washing away the dust coverings.[27]
>
> No Indian would make camp under or near painted rocks regardless of how good the camp-site. (Hallisey n.d.:4)

Rumours of Stein Valley caves filled with rock writings began to circulate among non-Natives by the early 1920s. A letter written on 24 March 1923, by T.L. Thacker of Little Mountain (near Hope), to Harlan I. Smith, describes the discovery of a painted cave in an area which, based on particulars of the account, is probably located in the middle of the Stein. T.L. Thacker wrote:

> ...I have heard a somewhat fantastic tale as follows. A few years ago some Indians on the west side of the river, north of Lytton, were hunting goats near the lake where they annually go in the late autumn to catch fish through the ice.[28] A wounded goat disappeared in a crack on the face of some cliffs above the lake, and when the Indians followed it, they found it had taken refuge in a cave. When they entered the cave, and before dispatching the goat, one of them lit a candle and to their amazement they discovered that the walls of this cave were ornamented from top to bottom with paintings, of whose origin none of the tribe had any knowledge. This story I heard from Mr. Ewen McLeod, now Indian Agent at Williams Lake or Quesnel, and he obtained it from the Chief of the tribe, who is apparently loath to tell a white man exactly where the spot is. (Smith n.d.:Box 13, F2).

Other Natives were not as reluctant to share some of the valley's secrets with non-Natives. C.R. Southwell told me he was prospecting along the Stein River with his partner, Manis Wilson in 1931, when they met a Native trapper on the trail who showed them a painted cave. Southwell doesn't recall the exact whereabouts of the cave except that it was on the south side of the river and that "we had to climb a bit. On the left-hand wall there were three lines and some figures." Later, when he was working at the Lytton gold mine on Mount Roach, or *K'ek'áwzik*, Southwell asked the 'Nlaka'pamux foreman, whose name he recalls was Willie Charlie, about the cave and its paintings. Southwell recalled this discussion later, in 1988:[29]

> He explained to me that he was the last one to use the cave. Prior to him, the sons of chiefs had to spend a night in the cave, to communicate with their ancestors, that sort of thing, and he was the last one to use it. I asked him about the paintings and he said, "Well, you know those three red lines? The first one, that's the CPR; the second one, that's the CN; and when the third one is built, that will be the end of the world."[30]

Southwell's account demonstrates that the Stein rock writings made by earlier generations were sources of reflection, interpreted by some as prophecy. To Willie Charlie, the three parallel lines in the cave represented railways and told of the serious disruption of Native resources and the

destruction of spiritual sites caused by the construction of the railways along the Thompson River and through the Fraser Canyon country, and foretold the catastrophic consequences of further railway expansion.[31]

In September, 1961, the first trained archaeologist since Harlan Smith—David Sanger, a graduate student at the University of British Columbia—made a brief survey of the mouth and lower canyon of the Stein River for the Archaeological Sites Advisory Board of the Government of British Columbia. Guided by Andrew Johnny of the Stein, Sanger identified four rock writing sites—EbRj 5, EbRk 1, EbRk 2, and EbRk 8 along the river—as well as the carved rock writing or petroglyph boulder, EbRk 4, at the confluence of the Stein and Fraser Rivers (Sanger 1961). These sites were the first on the Stein River to be identified using the Borden Designation System, a system by which archaeological sites are located by means of four letters and a number which relate to geographic coordinates. Today this system is used to designate archaeological sites throughout Canada (Borden 1952).

A few years later, John Corner, an apiarist from Vernon employed by the provincial government, and a dedicated rock art researcher, visited the Stein River sites identified by Sanger. Corner made drawings of many of the paintings at EbRj 5, EbRk 2 and EbRk 8. These, and drawings from over one hundred other rock painting sites in southern British Columbia, appeared in Corner's *Pictographs (Indian Rock Paintings) in the Interior of British Columbia* (1968). To date, this is the largest survey of rock writings in the province.

By 1972 the logging industry was building roads into every watershed surrounding the Stein River Valley, and was removing the trees from all these areas. At this time the provincial Forest Service began studying the feasibility of logging the Stein Valley itself. A debate ensued, which found logging interests lined up against preservationists and aboriginal peoples. The controversy increased public awareness of the Valley's natural and cultural history as scientists, Native people and others began to record, explore and learn more than ever before, about the riches of the Stein watershed in the course of gathering information to bolster one side or the other in the debate about the future of the Valley.

Logging, and an access road through the lower canyon, were proposed for the Stein. When this information became public, the Heritage Conservation Branch of the provincial government sent out archaeologists Mike Rousseau and Geordie Howe to make a brief survey of the Stein River in September, 1979. Their task was to identify and record archaeological sites along a narrow margin of the aboriginal trail. The limited survey that they produced doubled the number of known rock writing sites along the river. These included

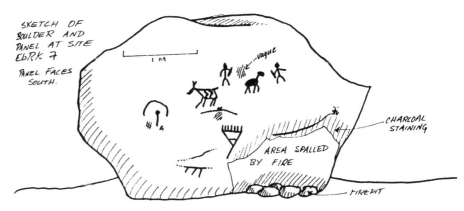

Fig. 23. Sketch of rock writings at EbRk 7 by Mike Rousseau, 15 Sept. 1979. Courtesy Heritage Conservation Branch, Victoria.

19

EbRj 130, EbRk 7, EbRk 3 and EbRl 1. The last is the rock writing site—or known site—furthest up the Stein River, some twenty-seven kilometres from its mouth (Rousseau 1979).

Logging seemed imminent. Prior to constructing a proposed logging access road through the lower Stein River Valley, the Boston Bar Division of the British Columbia Forest Products Ltd. hired a firm of heritage consultants. This firm, I.R. Wilson Consultants, was commissioned to undertake a "heritage resource inventory and impact assessment" along the proposed route. For the most part, this proposed road would follow the route of the aboriginal trail through the valley. Wilson conducted his impact assessment during the summer and autumn of 1985, recording other archaeological sites and identifying two more rock writing sites, EbRk 10 and EbRl 4, both of which are located within metres of the proposed road (Wilson 1985).

Meanwhile, the Lytton Indian Band countered with their own surveys (Lepofsky 1986; Wickwire 1986). In the same year that Wilson did his work, archaeologist Dana Lepofsky, working for the Lytton Band, found significant gaps in Wilson's survey. She found that Wilson's most glaring omission was his failure to locate and assess possible impact to the massive Ts'ets'ékw site, EbRk 2. This site is at the base of a towering cliff beneath a steep slope across which the proposed logging road would be built. This was easily the rock writing site most in peril if the access road were to be built (Lepofsky 1986).

As well, during January, 1986, an aerial survey by helicopter, piloted by Gerry Freeman, was conducted of the middle Stein Valley. The survey was assisted by anthropologist Wendy Wickwire, Ken Lay of the Western Wilderness Committee and 'Nlaka'pamux elder, the late Willie Justice. They tried to locate the cave which Willie had seen in his youth while travelling across this country with his father. They sighted a cave with rock writings on the face. This was located on a mountain, some 1,600 metres above the river in the middle valley. Willie stated that this was a different cave from the one he had seen.

Fig. 24. The largest group of rock writings are found here at Ts'ets'ékw ("writings") at the base of two granite cliffs. The proposed logging road would cut across the steep slopes of the lower canyon directly above each site. Photo by Chris Arnett.

In light of these discoveries, Wilson made an additional survey of the Stein in November, 1986, to survey the Ts'ets'ékw site. In April, 1988, more than two years after it was rediscovered, Wilson located and recorded the painted cave on the mountain which was subsequently designated EbRl 6. In spite of its pro-development bias, Wilson's revised study, dated February, 1988, with an appendix by the linguists Randy Bouchard and Dorothy Kennedy, was, for some months, the most detailed summary of Stein archaeology and ethnography available to researchers. However, this report also demonstrates the inability of "impact assessment archaeology" to understand the significance of the rock writing sites in their full setting. This omission seems obvious to aboriginal elders, as well as to other people who understand that a forest is composed of much more than marketable old growth trees. For one thing, this report failed to mitigate conflicts between proposed road construction and damage to rock writing sites.

Lepofsky identified five rock writing sites that would be seriously damaged by road construction:

> According to Wilson's recommendations, avoiding impact of falling rocks at specific pictograph site locations is enough to maintain the sites' heritage value. The natural setting is integral to the heritage of a pictograph site—it cannot be separated from it. To destroy the wild nature of a pictograph location would be to destroy the heritage value of that spot. It is absurd to talk about the heritage significance of a pictograph resulting from a spirit quest, when the pictograph would overlook a logging road. This would, in fact, be the fate of several pictographs if a road were constructed in the Stein. (Lepofsky 1986:54-55)

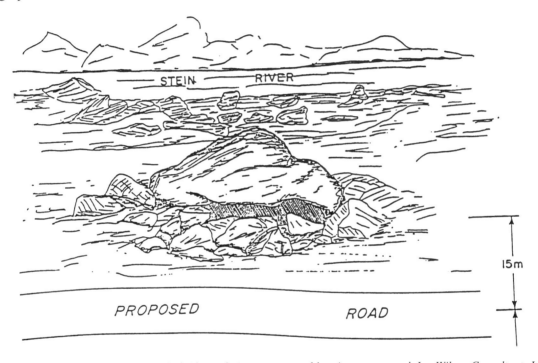

Fig. 25. Sketch of rock writing site EbRk 10 in relation to proposed logging access road. Ian Wilson Consultants Ltd. Courtesy Heritage Conservation Branch, Victoria.

In summer, 1988, I was fortunate to be able to work as a research assistant for Dana Lepofsky on the Stein Valley Archaeology Assessment Project, conducted on behalf of the 'Nlaka'pamux Nation Development Corporation. The project goal was to assemble available information on Stein prehistory in a way that could be used in the development of Native-based and Native-operated wilderness tourism in the Stein River Valley (Lepofsky 1988). During this period I located two additional rock writing sites: EbRk a and EbRk b, and completed scale drawings, begun in 1986, of all the rock writings at the 14 sites which appear in this book.[32] As I studied and sketched the writings I realized that the paintings and their setting became intimately associated in the mind's eye. I surveyed the physical locations; I studied the painted record of the dream visions; I speculated about the teachings they were intended to impart to travellers along the trails. In my estimation, all these factors are inseparable from one another.

Fig. 26. Anthropologist Wendy Wickwire interviewing members of the Paul and Hance families at Stein, July 1988. Photo by Chris Arnett.

On several occasions I accompanied anthropologist Wendy Wickwire while she interviewed 'Nlaka'pamux people of all ages as part of the ethnographic component of the project (Wickwire 1988). We visited homes at the Stein Reserve as well as in the Lytton area. Whenever possible, I brought up the subject of the Stein paintings. Much of the information we gathered, because of its value in future legal proceedings involving 'Nlaka'pamux land claims, cannot be cited in detail in this book. Many local people know of the existence of the rock writings, but most people are reluctant to talk about them—due in part to the association of rock writings with the supernatural, not always a favourite topic of conversation, especially with outsiders. A woman in Lytton told me of a rock writing site where her father and uncle camped in the first decade of this century. Throughout the night they heard spirit voices singing from paintings inside a hollow in the rock face. Another man underscored the ambivalent, often dangerous power of the rock writings when he described a lost painted cave in the middle valley which when you entered it, trapped you for four days. At the end of that time you either received power from the experience or you died. The hesitation to talk about the rock writings is also associated with the belief that the paintings were made by shamans or syux'nam, a fact which precluded further investigation for some of the people since it was felt that only those people who made the writings, or were schooled in their subject matter, could fully understand their content.

Herbert Kuhn, speaking of his research days among the rock writing sites of Europe in the 1920s, mentions the same phenomenon. He says the Spanish playwright, Lope de Vega wrote in 1598 that the rock pictures in the province of Salamanca were works of power and might that emanated from the demons said to inhabit the rock pictures, the *figuras de demonios*. Kuhn adds that he himself in 1923 had difficulty persuading local guides to accompany him to these rock art sites because malevolent spirits were said to hover near the paintings. Again, two years later, people refused to help him trace the pictures for the same reason. He found the same response among local people in other parts of Spain, in France, Scandinavia and Africa (Kuhn 1956:xxv).

Other people associated the Stein writings with historical events underlining their function as communicative records. A man who lives on the reserve at Stein heard that some of the paintings were made by 'Nlaka'pamux and Lil'wat warriors during the seventy-year feud between the two peoples, which was said to have ended about 1850. His account corroborates information James Teit received early in this century when he learned that paintings were sometimes made in the context of war as protection or to commemorate raids and battles.

Elder Rosie Adams Fandrich, another resident of the Stein reserve, in a recent interview with Richard Daly also compared the paintings to historical writings:

> You see, that's kind of history to us. If we were able to write eons ago, there would have been history made through there.

Rosie also knew of a painted cave somewhere in the Valley. She said that she had never seen the cave, probably because the old people "had a phobia" about a woman being too unclean to go to such places. Rosie explained that the power of menstruation was considered to work against the hunting power:

> That was a rule. When a lady is menstruating she can't go in there. The old people thought she was unclean and that it would make for bad luck. And the bears would go after you. (Interview with R.D., 21 Aug. 1993)

Napoleon Kruger, an Okanagan elder and pipe-carrier, who over the last decade has been active in preserving the Stein Valley and teaching people about its significance, has also spoken about the significance of the rock writings, or what he calls pictographics, when he spoke at the Stein Valley Festival at Tsawwassen on 4 August 1990:

> There's great, great things in the pictographics in the valley. There's many, many sacred pieces. They're all sacred to me and, I know, to many of our brothers and our relations. I know it means the same to them. They are sacred pieces because they tell us something, and in time we will know what they are saying. They are some of the things that may come about once again, and are just like your writing today—things that you wrote down, and things that your great great grandfathers wrote down. You'll still have it, and that means very much to you. Well, the same thing with that valley. There's so many things in that valley that mean so much to us, to our people.

One hot afternoon in Lytton, I talked casually with Rita Haugen, a relation of my wife's family. Rita had often accompanied her mother, Mary Williams, on food and cedar-root gathering expeditions up the Stein River. I asked if she knew who made the paintings:

> My mother knew who did them. She told us to stay away from them. She told us that if we looked at the paintings we'd get crippled. That's the Indian doctor stuff.

Opening an album of family photographs, Rita showed me a miniature sepia-tone photograph of an ancient wiry man standing next to a small child. It was taken years ago in the Stein River Valley:

> That's my grandfather.

I looked at the old man who gazed at something beyond the camera. Rita explained:

> He used to swim in the Stein every day, and he lived to be a hundred. He was an Indian Doctor.

There will always be mysteries about the Stein: some await rediscovery, while others remain forever hidden.

In 1991, the burial place of an 'Nlaka'pamux shaman was found in a painted cave, a thousand metres above the river, near the peak of a mountain. The shaman's bones lay surrounded by rough cedar baskets, beneath a pole wedged horizontally, parallel with the ceiling. Suspended from the pole, and hanging above his body are the buckskin pouches he carried in life, pouches which contain the substances of his training, including *luutsamen*, the red paint, symbolizing all that is good and protective, the life-blood of the people, the colour most pleasing to the spirits, the colour used to write figures on the walls and ceiling of his resting place, red figures to watch over his bones forever.

In 1988, Richard Daly showed my renderings of the Stein rock writings to Spuzzum elder, Annie York. The drawings provoked a flood of cultural memories in Annie, memories and teachings that make up the bulk of this book. Through Annie we have been given a unique opportunity to journey along an ancient aboriginal trail. Annie takes us up the Stein, back through time, to the dream country of the 'Nlaka'pamux shaman, to the ardent visionary world of youth, where an ancient, storied past co-exists with the present, where the ancient life force of the land speaks through the medium of dreams.

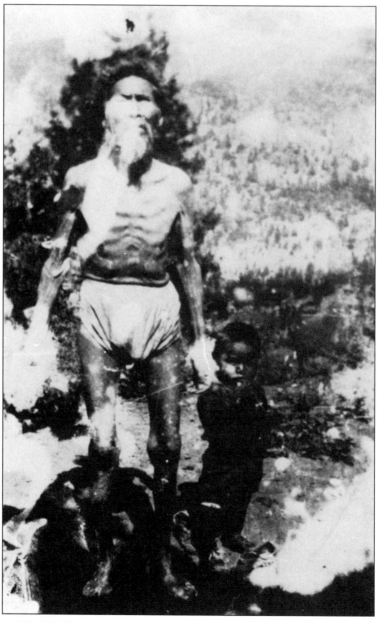

Fig. 27. Klemshu, a syux'nam from Stein, ca. 1930. Courtesy Rita Haugen, Lytton.

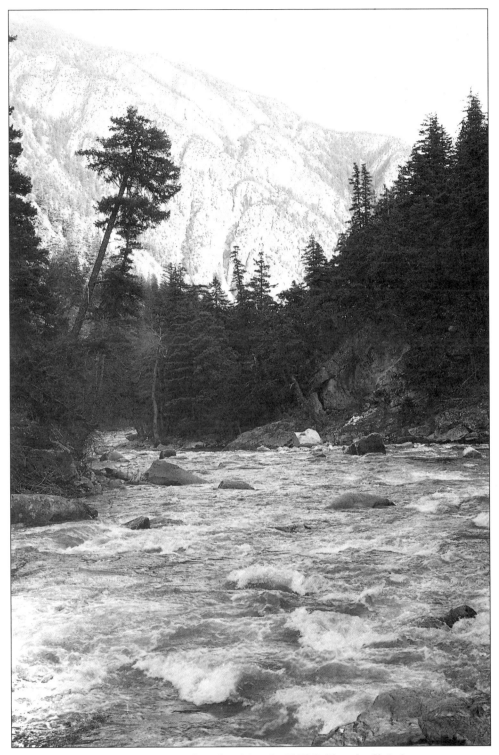

Fig. 28. Looking downriver towards rock writing site EbRk 8. Photo by Chris Arnett.

Fig. 29. Annie and Arthur as young people in mountains above Spuzzum.

2. Annie Zetco York and Her Students

Richard Daly

The house where Annie York and her cousin, Arthur Urquhart live is situated between two creeks that tumble off the east side of Broadback and on down into the Fraser River, near the settlement of Spuzzum in British Columbia. Annie regards one of these streams with particular affection. In the spring freshet and during the autumn rains which sweep in from the Pacific Ocean, this stream splashes and dances from rock to rock. Annie claims that it sings, not only to her but also to the stars, and that its music has given her strength for many many years. The creek changes its music as it changes its mood; and at the same time, according to Annie, the fir trees change the colour of their needles. These changes foretell the occurrence of weather systems, volcanic eruptions and earthquakes. Annie predicts changes from the sounds of her special stream, from the clarity and motion of the stars, and from the subtle alteration of hue in the conifers that overhang her garden.

In mid-summer however, the stream grows weak and silent, its rush and roar reduced to a whisper. The water itself disappears into its bed of moss-capped granite boulders. At times like these Annie tries to give back to the stream some of the force and vitality she has received from it during the more vibrant seasons. When it is hot and dry she goes out before sunrise and sunset. She stands on the bank of the stream and nurtures the enfeebled little brook with her prayers, her songs, a shovel, and a watering can filled from the stronger creek to the north—the one that Arthur has harnessed to the household plumbing, and which on the ordinance maps is appropriately called Arthur Creek. Annie nurses the stream and does her best to ensure that its bubbling songs will survive another season. Her grandmother taught her that if someone does not bear witness, does not return the power and the joy of the stream, then it will take its fresh sunlight on water and its joyful voices, and it will cut its channel somewhere else.

Zetco is the name Annie was chosen to carry through life. Zex'tko has been passed down from the grandparent to the grandchild generation in her family three times. Annie explains:

> It's been long enough now. I will be the last to carry Zetco. After me it's gonna be retired.
> That's our way. A name passes three times and then it's put away. After that it's time to create

a new name from our connections to all the living things. Zetco. Melting Away. Zetco. Now You See It, Now You Don't. Zetco. It's sunlight on the moving water for just a moment—it's very beautiful. Then it's gone.

A lot of women's names have to do with sunlight and water. That's the way it's always been.

Annie York was born in Spuzzum, toward the southern end of the Fraser Canyon, in 1904. Shortly thereafter, her father found work with the Kettle Valley Railway. During this period the family lived in the town of Merritt. Annie used to tell the story of how she saved her parents' lives while she was still an infant. It happened in Spences Bridge, beside the Thompson River, on the Sunday when Annie's screams and howls forced her parents to carry her out of the church before the service had ended. Minutes later the side of a mountain on the north bank of the river crashed into the Fraser River. The church stood in the path of the wall of stones, mud and water that swept up the south bank and into the village. The service ended abruptly and many members of the congregation perished amid rock and flood water. Annie and her parents had left the church only minutes before.[1]

Fig. 30. Church of St. Michael and All Angels, rebuilt on higher ground ca. 1906, after the landslide of 13 Aug. 1905. Photo by Richard Daly.

Annie also tells of the morning during a visit to Spuzzum in her youth, when she was sitting with her aunt and her grandmother. No one felt like talking that day. They applied themselves to their needlework in silence—anxious and worried because Grandpa Joe York was overdue on a hunting trip in the precipitous, crevasse-ridden country across the river. Suddenly Annie felt herself slip away from the room. She reported that she was able to look back and see herself and the others sitting around the room, sewing. Then she could see her grandfather's rifle leaning against a specific tree. She knew where that tree was, as she and Arthur had camped near it in the past. She returned to herself and told the aunts that Grandfather would be found, almost directly across the river on the shore. He would be safe but he had lost his rifle.

When Joe York eventually made his way down the mountains to the riverbank, he appeared at the creek mouth slightly upriver from the old Spuzzum Native village. He shouted until he attracted

attention. Chief Henry James paddled his canoe across to pick him up. Grampa Joe had indeed lost his rifle. After this manifestation of Annie's talent, the old people began to take a special interest in her training.

At the age of twenty-eight, Annie returned to her birthplace, where she cared for aged relatives and kept house for her cousin for the next sixty years. Hers was a tranquil life, but not a life devoid of event. It was a betwixt and between life sandwiched between World Wars, booms and busts, two little streams, the walls of a canyon on the bank of a wild and traumatic river at a point between two Salish cultures, and two ecological zones—the dry interior plateau and the lush wet coast—and between two other cultures initiated by a gold rush in 1858: the cultures of the so-called White and so-called Indian. Her life, as well, spans the two worlds of the state with its central agencies and its peculiar relationship to individuals, and the non-state, where citizenship is vested in kinship groupings and history is written on the face of the land.

The web of family relationships in which Annie and Arthur have lived, like many in this part of the world, was woven from a multitude of threads provided by the newcomers, as well as by those who were always here. Members of Annie and Arthur's family have steered their lives back and forth between the oral and the written, the psychic and the scientific, the gentry (of both cultures) and the working man and woman, as well as between book-learning and bush-learning; and between the ubiquitous freight trains that roar down the track and blare their horns for the level crossing, contrapuntal to the rhythm of traffic along the Trans-Canada, Highway One, and the singing crackle of the high-tension, hydro-electric transmission lines.

Annie's Native ancestors produced food and shelter in the valley bottoms and along the canyon walls in winter, and visited each other's earth lodges during the coldest months, for reasons that

Fig. 31. One of Annie York's teachers, "Grand Aunt Josephine" (right) and relations, Nicola Valley.

were social, familial, ceremonial and economic. Of course, such categories originated not in the local 'Nlaka'pamux culture, but rather in that of the European newcomers. The 'Nlaka'pamux would say that they visited one another to be sociable, and because it was enjoyable, informative, necessary, and essential to the giving and receiving of the hospitality and gifts which oiled the wheels of social and political intercourse.

In spring and summer Annie's forebears camped along the riverbanks as they fished and dried their salmon. In late summer and into the fall they climbed the mountain sides to hunt and snare; to gather berries, roots, nuts and medicines; and in various seasons young people would take to the mountains or the riverside to prepare themselves for whatever unique and special talent the elders had identified in their close examinations of their children's children from the time of birth. They might have within them the talents of a great weaver, or the qualities of a hunter, clairvoyant, carver, or healer.

Annie's "foreign" ancestors arrived from Iroquoia with the fur trade; and from the borderland between France and Catalonian Spain, travelling first to Mexico in search for gold, then to California—still for gold—then on the river bars on the Fraser of British Columbia, and finally north with the Cariboo and other, more ephemeral, gold rushes. Some ancestors came from Britain by steam packet and rail, like Annie's maternal grandfather, and Arthur's father and his uncle, who both emigrated from Scotland and found work with the CPR. Arthur's mother was an 'Nlaka'pamux woman. When both his parents worked, Arthur was looked after by an elderly Chinese railway labourer, Ah-ching, who was married to Paul Yo'ala's sister from Tikwiloose above the old Alexandra Bridge. Arthur grew up speaking a combination of Scots' English, Cantonese and Chinook—the *lingua franca* of traders and missionaries. He also understood the old stories told by his mother and grandmother in the Utamqt 'Nlaka'pamux language, though he did not speak it. For her part, Annie grew up speaking a conglomeration of Okanagan Salish, Mohawk, French, 'Nlaka'pamux and English—which she assumed, until she went to school, was the way everyone spoke.

Annie's mother, Lucy, was an upcountry 'Nlaka'pamux woman from Thompson Siding, near Spences Bridge. Her father was an Englishman known simply as "Mr. Palmer." Lucy Palmer had connections, through her 'Nlaka'pamux mother, to the Okanagan people and to a Mohawk Iroquois lady whose family moved west, from the Great Lakes, with the fur trade.

Annie's father, William, and Arthur's mother, Rhoda, were full siblings whose mother was a well-trained and skilled basket-maker called Chayéken. Non-Natives called her Amelia. Chayéken was a member of the chiefly family in Spuzzum, her brother being Chief Paul, "Híx'hena" (Giver of Big Gifts)—alternatively called Chief Jim Paul, and Chief Paul James. Híx'hena's son, Henry James, was the hereditary chief of Spuzzum until his death in 1954. Híx'hena's grandson, Jimmy Johnson, is the present chief.

Chayéken's aunt, and Annie's namesake, Zex'tko, married Pelek, brother of the Lytton chief. Pelek was a much-married man with wives linking him to a number of Native nations around British Columbia. Some people say that Pelek was a prophet and a relative of Annie's. Annie was adamant on both points. Pelek was *not* a relative. He was simply an in-law, married to her great great-aunt, Zex'tko. When Zex'tko died, Pelek moved to the Fraser Valley, then to the Native reserve under the Patullo Bridge at New Westminster. He returned to Spuzzum, bewitched, and was cured by Chayéken. He died in Spuzzum before Annie was born.

Nor was Pelek a prophet, according to Annie. However, he was a member of the family of the 'Nlaka'pamux prophet, Cixpintlen or Shikbiintlam, who predicted the arrival of the first Europeans.

Annie maintained that Pelek's brother, Chief David Spentlam and Pelek were grandsons of Chief David's namesake, Shikbiintlam, the prophet. To complicate matters further, Annie explained that Chayéken's sister was the second Zex'tko, the husband of Chief Dick, who managed the affairs of the village of Spuzzum whenever Chief Paul was absent, working on the Cariboo pack trains.

Through the family of Chief Paul, and his sisters, Chayéken and Zex'tko, Annie and Arthur have family ties to Sto:lo people dating back to an ancient avalanche that destroyed most of the population at Esilao,[2] or what Annie called Ashinaw, upriver from the present town of Yale.

Arthur's maternal and Annie's paternal grandfather, Jean Caux, came from the Catalonian Pyrenees. He followed various gold-rushes from Mexico northward. For many years he operated a pack train business and is known in British Columbian history as Cataline, a name derived from his beloved Catalonia. Cataline hauled mail and freight from the lower mainland area of British Columbia and Washington, as well as north to the gold fields of Barkerville, Omineca and beyond. Later he packed freight for the construction of the short-lived telegraph project of the Collins Overland Telegraph Company, north of Hazelton. Construction of the telegraph line, intended to connect North America and Europe through Siberia and Alaska, was abandoned when news of the first trans-Atlantic cable reached the Collins officials. Cataline is buried in the Gitanmaax cemetery above the confluence of the Skeena and Bulkley Rivers in Old Hazelton.

Chayéken later married a Spuzzum 'Nlaka'pamux man whose English name was Joe York, and who raised and trained his wife's children as well as his own.

William York, Annie's father, worked in various places along the lower Fraser. He was a contractor with the railway for a time in Merritt. Then the family moved to Pitt Meadows in the Fraser Valley. Annie reported that she spent most of her childhood in Pitt Meadows where her father worked, among other things, on the dyking system. Later, after the death of one of Annie's younger sisters, the family moved back to Merritt to be nearer Annie's mother's people, and to better safeguard the health of the youngest child, Kathleen.

Annie subsequently learned homecare nursing from the doctor in Merritt. While living in Merritt she assisted with the medical care of elderly people, as well as being a tireless community and church worker. The York family, like most, were threadbare during the Depression years. Kathy, Annie's youngest sister, recalls that Annie worked in a Chinese-owned potato farm while holding down her job nursing the elderly. Not only that, she worked most nights until well after midnight, making and repairing clothes.

Annie moved back to Spuzzum in 1932. One of the Spuzzum elders took her into the mountains to cure her "sickness of the soul." Annie reported that her whole being was lost and restless; she was irascible and could not concentrate on anything for more than a few seconds. She said that the old people told her a clipping of her hair had been stolen by someone who wished her ill. They told her this lock of hair had been tied to the top of a ponderosa pine where it blew in the constant wind at the confluence of the Fraser and Thompson Rivers. As the lock of hair blew in the wind, they told her, her soul responded with agitation.

Luckily, Annie came from a family of healers. Her grandmother Chayéken, Mrs. Joe York, had cured Pelek's soul-loss. Pelek had lost his mind when, as they said, "somebody worked on him" after he had tried to marry a widow on the north coast, without first asking permission from the widow's brother-in-law. Chayéken's brother, Híx'hena (Chief Paul) was a trained herbal healer and spirit dancer as well. The great-aunts from Annie's mother's family were also trained in the psychic and healing arts.

Annie's grandmother and her aunts arranged to have her cured. She was sent to the mountains with a grandfather, who encouraged her to embark on her own dream quest. Annie claimed that the mountains cured her. She grew reconciled with the life given her to lead. She learned to concentrate her thoughts and focus her mind. She lived in one place for the next sixty years. Her family were known as healers, and there was no shortage of people in need of help and curing.

Annie and Arthur recall how they tried always to find something to give the itinerants who had ridden the rails looking for work, and who appeared at their door almost every day in the 1930s. Arthur explained to me over a breakfast of Cheerios, brown sugar and boiled coffee one morning:

> Later they started two relief work camps here in Spuzzum. You might say we got every kind of human being. The men were put to work on road construction—pick and shovel work—and on railway track maintenance. Then the war came and I was recruited as a Special Constable, like the Home Guard, checking logging roads for suspicious characters, and guarding bridges.
>
> During those years we got the good, the bad and the eccentric. Every kind of man imaginable. That was when the Japanese families were interned in Spuzzum.
>
> Part of the war effort was cutting poles and railway ties. Spuzzum became a big pole camp. The Japanese men made up a large part of the work force. Annie taught Sunday School at that time, and the Japanese sent their children. We met them all. They were the very best of neighbours. They cut wood for us, and in the fall they hunted for wild mushrooms. The Japanese are like the Indians—they have a passion for the pine mushroom. They weren't allowed to leave Spuzzum. They had to check in regularly with the police. All they could do, apart from their work, was move around in the hills looking for mushrooms. Nowhere else.
>
> We had a German neighbour too. He was classed as an enemy alien as well, but he didn't have to check in as much with the police. He was allowed to go shopping in Hope and Chilliwack.

Even during the prosperous 1960s Arthur and Annie hosted destitute immigrants who would show up at the door, usually while making their way westward to seek work in Vancouver. One family was stranded in Spuzzum because the parents were forced to share one pair of shoes; that is, until Annie supplied them with footwear and clothes from the boxes and bags of spare clothing, bedding, crockery, bandages, and table linen packed away in the room which had been Aunt Rhoda's. Annie had foreseen the arrival of these people. They had come to her in a dream.

Annie and Arthur were preyed upon by marmots, pack rats, blue-jays, mice, squirrels, black bears, and Gypsies; however most creatures who have come to their door have been proper human beings, in the best sense of the word.

Andrea Laforet was one of the creatures who came to the door. She explained that she was brought to Annie by anthropologist Wilson Duff, after Gus Milliken had suggested Annie as a knowledgeable person to see about the renowned 'Nlaka'pamux basket-making tradition. Annie's version of the story is slightly different:

> One day Arthur walked in and said, "There's two little girls outside and they look hungry." So I said, "Bring them in and I'll fix them some tea and a cheese sandwich." It turned out that they had been sent by Wilson Duff. That's how we met Andrea. We couldn't get rid of her! Hahahaha! She came in and after a while people started to think she was my daughter!

Annie had an ardent desire to be a formally-trained nurse, but there was never sufficient money for schooling. Her father suggested she train herself to be an interpreter for the old people, translating from their languages to English. The need for communication across the cultures was felt by all, but especially by the old in their dealings with the clergy, the police and the Indian Agent. Accordingly, Annie learned to converse in several dialects and languages and also became an apt pupil/apprentice in the old ways, old stories and histories, and the old forms of healing. These teachings, which began in Annie's childhood in Pitt Meadows at the knee of her blind great-aunt, Annie Selbénik James, occurred in the context of everyday life: in the kitchen, the woodshed, the rowboat, the riverbank, up in the mountain berry patches, and during conversations on sedate journeys up and down the old canyon road in the family's 1926 Packard.

In Merritt, Annie used her language skills to translate for Native patients. Later, in Spuzzum, she worked with Arthur's mother, Rhoda, who had also acted as a translator in Lytton's St. Bartholomew's Hospital. At home in Spuzzum, Rhoda translated the speeches and lay sermons of Chief Henry James from the royal language of the leaders, to the common Utamqt 'Nlaka'pamux,

and also into English. Rhoda and her cousin, the chief, taught Annie the royal language of the chiefs. (According to Arthur, Chief Henry James never tired of telling his mother, Rhoda, as well as Annie, that they had no right to the royal language due to the white man's blood in their veins.) Despite this, he taught Annie this language so that after Rhoda's death, she could carry on translating for the chief. She carried out this task until Henry James passed away in 1954.

Annie explained that this "language" was a specialized vocabulary, used by leading families from various nations, especially to discuss important matters. Rena Bolton, a Sto:lo woman who grew up with her grandparents at Kilgard, near the old Sumas Lake, told me that her people were familiar with this language too. "It was something like a common language of the royal people up and down the coast in the old days, and I suppose, along the river too. It wasn't a different language, but most of the words wouldn't be understood by ordinary people."

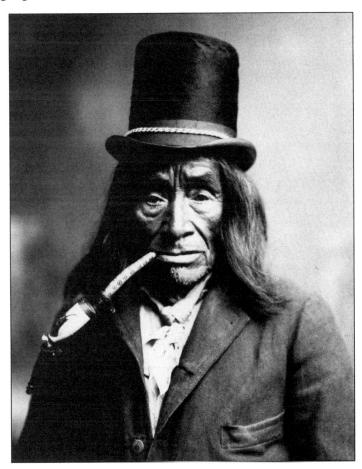

Fig. 32. Unidentified 'Nlaka'pamux chief from Kapatci'tcin (North Bend) in the Fraser Canyon, north of Spuzzum, ca. 1890s. Courtesy Royal British Columbia Museum PN1134.

I remember being told in my childhood, by Sechelt elder Dan Johnson, that the chiefs up and down the coast had no trouble talking to each other. He told me they had to be able to converse internationally in order to arrange marriages and keep the peace between nations. He said the endemic raiding that occurred in the period around the coming of the Europeans was caused by young men who obtained guns, and then usurped the managerial duties of the proper chiefs. He said they were upstarts who did not even know how to talk to chiefs.

Annie took great delight in tantalizing Dr. Laurence Thompson and other linguists with the odd word from this royal form of speech, but she refused to allow them to record it: "It's the chiefs' language," she said, "and no one else has the right to use it. I promised the chief I would NEVER teach it to anybody who was not in the chief's line. But, oh boy, I tell you! That Thompson would *love* to have it! Hahahaha!"

Annie was a good student and she served her elders well. She was very, very close to her great-aunt, who was also named Annie, and who was always called Grannie by her little grandniece. The elderly Annie Selbénik James lived with the Yorks to the end of her days. Annie's paternal grandmother, Chayéken, lived in Spuzzum, and her maternal grandmother died giving birth to Annie's mother. After the death of "Blind Grannie," "Grand Aunt Julia Snow" and "Grand Aunt Josephine" became Annie's teachers and protectors. She also learned from the Spuzzum chief, Henry James, and from other 'Nlaka'pamux and Sto:lo elders like Paul Yo'ala and the Nahlii brothers from Lytton.

During World War II Annie worked at various short-term jobs. She nursed the elderly in Spences Bridge, returning home down the canyon by bus, on her days off. She walked the tracks and crossed railway trestles on foot to carry out her duties as Deputy Returning Officer at election time. When Annie worked in Yale in the local hotel and store she had to walk to work if she missed the daily south-bound bus. The distance was ten miles down the old Cariboo wagon road.

One evening as Annie was coming home from Yale on the northbound bus, the vehicle hit an unmarked soft shoulder only a few hundred yards from Annie and Arthur's house. The bus plunged down the bank and rolled over and over until it came to rest on a bench above the river. Annie was badly injured and her recovery took more than two years of treatment with both traditional and modern medicine.

Arthur's anger about the accident still simmers. At the time of the accident he was a member of the road crew that had been attending to the road-widening on the hill where the accident occurred later the same day. His crew was ordered to remove the makeshift roadside barrier they had erected to warn motorists of the soft shoulder. A few hours later the bus, with Annie on board, drove into the unmarked soft shoulder and toppled down the bank.

When the accident occurred, Aunt Rhoda took Annie for dead and pulled a sheet up over her face. At this moment Annie had one of her out-of-body experiences:

Arthur's mother pulled the sheet up and covered my face. She thought I was dead! And I was. I passed away from this life. I remember looking down and seeing my body lying there under Auntie's sheet. And I saw the other life, where I was supposed to cross over. I seen people from Spuzzum I knew. They were kneeling and trying to get over across the bridge, but Archdeacon Small was patrolling the bridge. I saw Blind Grannie over on the other side, and Grandmother, and Grandfather Paul, Mariah too. I saw two syux'nam still trying to cross. *I* know their names! The light was beeeeeautiful.

But I came back. You know, I was in bed for over a year. I couldn't walk and I couldn't sleep. One day my brother came down from Merritt and he brought a syux'nam, and that man

worked on me. He says to me, "If you see something special in your dreams in the next two days, you gonna recover." He worked on me and, sheeesh, I went to sleep for two days. And I seen it!

"What did you see, Annie?" I asked.
"Hahaha! hah!"
On another occasion Annie explained this same experience in slightly different terms:

> Silver spruce shines waaaaaaaaaaaay up to heaven. You see it when you die. I did. I died once for an hour. After the accident. I seen Great Grandmother, Arthur's father, a bridge, an elderberry bush, and babies aaaaaaaaaaall over the sky.

After the war Annie became a journalist, contributing a series of articles to the local newspaper, *The Hope Standard*. These articles spoke about different aspects of nineteenth-century life in the Fraser Canyon. Annie composed her articles in her head, then told the stories and anecdotes to Arthur, who wrote them down with his fine penmanship and his elegant turn of phrase. Annie's sister, Kathy, told me of Arthur's unacknowledged role in these endeavours. To this day, Arthur himself staunchly maintains that the series of articles was authored by Annie. In this, as in so many of Annie's activities he has been a silent, but steadfast and talented, helpmate. I questioned him several times about his role in this venture. One day he told me:

> Well, Annie didn't have an awful lot of schooling, you know. She didn't read much, and writing was an effort for her. I helped her. I was sent to school in Yale. I told Dr. Thompson I graduated from Yale. He said, "Well, at least we have that in common." I had eight years of school at Yale, B.C. I tell you, that was about four years too many for the sort of challenges you face in the Fraser Canyon!

Annie gradually became an expert in the Native ways, with her accumulation of knowledge from the old people, a long lifetime of personal experience on the land, as well as hundreds of hours devoted to her roles as healer, caregiver and teacher. Her apprenticeship was complete. The irony of the situation, as Jan-Marie Martell notes in her film, *Bowl of Bone*, is that under the Canadian laws of the time, Annie was not technically a Native, by any of the various administrative definitions found in *The Indian Act of Canada*, and hence was not eligible for Native residential school education. Also, her parents were not "pure" Natives. They were designated by the distasteful term, "breed"; nor did they confine themselves to life on reserves. Thus, while her contemporaries were having their languages and cultures scrubbed out of them at the mission schools, Annie was learning hers, obtaining an informal Native education from Interior Salish elders who were happy to impart their knowledge to someone whose head was not cluttered by the partial learning and emotional problems gained in the notorious schools. Spences Bridge elder, Mary Anderson, also avoided formal government-regulated schooling. When Chris and I visited her in March, 1992, she told us, "I didn't go to school. That's why I know so much!"

Annie's training included learning the connections between the present century and the one that preceded it. For many of the children who were sent off to residential schools, connection to the oral memories of the elders was severed. Consequently, in the last few decades Native people seeking out their roots came to people like Annie, trained, first-hand, by the older generation. They came for clues about their family histories, their origins, their connections to places along the river, and to various contemporary families.

Not only Native people came to Annie's door. Linguists Dr. Laurence Thompson and his wife Terry, from the University of Hawaii, as well as their students from various universities, arrived in Spuzzum each summer to work with Annie, compiling an extensive dictionary and grammar of the 'Nlaka'pamux language, and studying the connections of the Spuzzum language with other 'Nlaka'pamux dialects and with the neighbouring Halkomelem language of the Sto:lo people. Archaeologists Dr. Charles Borden and Gus Milliken, as well as Fraser Canyon lapidiarian Ron Purvis, and others, came to Annie to discuss Native history. Other linguists such as Dale Kincaid, Randy Bouchard and Dorothy Kennedy also appeared at Annie and Arthur's house from time to time. Similarly, there developed a long and fruitful collaboration between Annie and ethnobotanist Nancy Turner, from the Royal British Columbia Museum, with Annie contributing significantly to Dr. Turner's publications on edible plants and medicines in British Columbia—most recently, *Thompson Ethnobotany* (Turner, et al. 1990). Specialists in Native technology and craftsmanship also turned to Annie for information and advice.

Fig. 33. Annie at rock writing site, the "McDonald petroglyphs" (DkRi 6) Anderson Creek. Photo by Jan-Marie Martell.

During these years Annie met Wilson Duff, Michael Kew, Jay Powell and other anthropologists from Vancouver. Annie, and particularly Arthur, were interviewed by Robert Turner of the Provincial Museum as well, in connection with the history of the Canadian railways. At the same time Annie took on a long-term apprentice: anthropology student Andrea Laforet. Dr. Laforet is

presently Ethnological Curator for the Pacific Region, at the Canadian Museum of Civilization in Ottawa/Hull. In the same period, Annie also began her cooperation with a young cinematographer, Jan-Marie Martell, who began work on a film about the problems and joys of living in both the modern global world and the world of Annie York. She visited Annie and Arthur extensively for over fifteen years as she worked on her project. *Bowl of Bone: Tale of the Syuwe.* The film which resulted was released to Canadian film festivals in the fall of 1992, and is obtainable on video cassette from the National Film Board.

From the beginning of the 1970s, Annie's "students" began to comprise a greater and greater part of her life. This was about the same time that the last of Annie's own family elders passed on. There was no one left from among her relatives who could go on teaching and advising her and, more importantly, no one from the old ways who could protect her from alien psychic energies. Now more than ever before, Annie herself was faced with having to be the protector of the young, the teacher, the imparter of knowledge—the elder. She became increasingly busy with requests for both cultural information and emotional reassurance, from both Natives and non-Natives.

At this time Annie fell ill. She was taken to Vancouver for surgery. During the surgery she had another out-of-body experience in which she was able to look down on herself on the operating table. She could see and feel her own elders around her. She met them in a warm and glorious white light amid fields of white flowers. Everything was white and luminous like the morning sun after rain. Annie was in tears. She wanted to stay with the old people, but once again they sent her back into her body, to finish her work. They said to her, "Five different people will come to you with special requests for help. Only when your tasks on earth are completed can you come back to us. You'll know when, but this is not your time."

And so, Annie came back and resumed her tasks in life. A number of these tasks had to do with us, the researchers. She threw herself with even more vigour into the work that we, her students, were requesting. Annie not only hosted her student visitors from the academic world; she also received many, many visitors from the surrounding Native community. Among these visitors were Nathan Spinks from Lytton; Virginia Minnabarriet and Sonny McHalsie who lived in the town of Hope; Albert Phillips from Chilliwack Landing and Chehalis; Ida John from Chawathal; and Mabel Joe, Mary Adjaxen and Mandy Jimmie from Merritt. When Andrea Laforet obtained her doctorate, Annie and Arthur attended the convocation in Vancouver, their chests puffed with the same pride as Andrea's parents who sat beside them.

More academics came to visit Annie, such as anthropologist Dr. Wendy Wickwire, historical geographer Professor Cole Harris and his assistants, Kathy Kindquist and Dr. Robert Galois, as well as the students who were working with Dr. Harris on the 1808 journeys of Simon Fraser. There were similar visits by researchers for various Native cultural issues and aboriginal rights projects.

I was drawn to Annie while listening to one of many taped interviews with her, which are stored in the archives of the Coqualeetza Education Training Centre in Sardis, to which I had been directed by the archaeologist Gordon Mohs, who himself had worked with Annie over an extended period—usually arriving at her door with a loaf of his sourdough bread or a pot of excellent homemade marmalade. Listening to that first interview, I had the uncanny feeling that I had always known Annie; her voice was immediately familiar. Then, a cousin of Annie's, Sonny McHalsie, who is of both Sto:lo and 'Nlaka'pamux ancestry, took me to Spuzzum and introduced me to Arthur and Annie.

It was one of those bright warm days in early summer, when every plant and tree is in full, fresh leaf. We turned off the northbound lane of the Trans-Canada Highway shortly after it crosses the green waters of Spuzzum Creek. We bumped across the railway tracks, turned up a driveway which was formerly part of the roadbed of the first Cariboo Highway, and pulled to a stop in front of a white house with a blue roof. The house is sandwiched between the railway line and the steep riverbank. Arthur and Annie came out and shook our hands. Suddenly we were inside, in the cool shadows of the living room. Shades of my own childhood—my father always spread old newspapers on the freshly washed floors "to save them from the dirt." Here too, I found shiny floors peeking out from between old newspapers: *The Merritt Herald*, 1981. *The Globe and Mail*, one day old. *Winnipeg Free Press*, three days old. From time to time the train crews throw off newspapers for Arthur.

Fig. 34. Annie and Arthur's house, Spuzzum. Photo by Jan-Marie Martell.

And the clock. The same clock that you hear in all the tape recordings of Annie's interviews. It chimes out the hours and the half hours, as regularly as the trains that roar by, shaking the earth as they snort and clang over the level crossing—seemingly right through the living room itself. You can talk through the chimes of the clock, but the trains are a different matter. They create their own particular hiatuses in every conversation.

Annie sits on the sofa by the front door, her hands clasping a crumpled white handkerchief in her lap. She motions me to sit beside her. Across the room is the sofa bed under the northwest window where Annie regularly talks to, and watches, the stars as they pass through the night. Sonny and Randall and Peter pull up chairs. Arthur sits momentarily at a small grey metallic typing table. After a suitable exchange of pleasantries, Arthur gets to his feet and goes outside where, before our arrival, he had been sharpening a long scythe, the one he calls his "bush hook."

Sonny explains who I am and Annie's first question is, "Do you have your Ph.D.?" We chat in a leisurely fashion, then move to the kitchen with its cream door frame and window sills that contrast with the warm reddish brown of the untreated cedar walls. Here we have a cup of tea and slices of raspberry jelly roll. Annie harangues at length against what she calls the brawling and fighting that goes on over access to fishing sites. She says that people used to be well-behaved, that the chief's word was law, and that the people obeyed the elders, who saw to it that the fish and the berries, the deer and the mountain goats were properly used and respected, that church was well attended, and that peace and good order prevailed.

The conversation switches to the mysterious people who are said to have lived down below the electrical capacitor station, on the side of Spuzzum Creek, in the corner before you reach the point that had the warriors' lookout house and the old cemetery on it. This was the cemetery visited and described by Simon Fraser in the summer of 1808. I learn that these were exotic people, who did not speak to the local population, yet had amazing powers. They would turn to the wall and say only one thing: Yukw! This was the way they achieved their ends with psychic power. They came from somewhere else; they were tall and fair-skinned.

Then Annie talks about how the young people were sent running down to the creek every morning before sunrise, to swim and scrub themselves with sand and the tips of Douglas fir boughs before saying their prayers to the Dawn of the Day and running home to begin the day's work. They did this every morning, winter and summer. Later, Sonny explains that he and his brothers had received this training from their father. I asked if he planned to train his own children this way. Sonny smiled and said, "I might just do that."

Fig. 35. Annie at the kitchen table. Photo by Jan-Marie Martell.

After this initial visit I stopped many times to chat, conduct interviews, and take Arthur and Annie on little trips up and down the canyon. We often spoke of driving into Vancouver, but somehow the moment was never auspicious. We made excursions downriver to Hope, usually at the end of the month so that the two of them could "cash in their beans," buy groceries, visit the laundromat, the barber shop and the feed store to stock up on the favorite breakfast food for the Stellar jays which gather at the kitchen railing in a raucous gaggle, demanding food each morning. Annie fed the jays while Arthur complained about the name, "They're blue jays," he protested. "It's much more accurate than having to go by the book and call them Stellar jays."

Sometimes we would step out for lunch or supper at the Kan Yon Restaurant in Hope, the Dogwood Valley truck stop, the Canyon Alpine cafe above Boston Bar, or the Alexandra Lodge or the Spuzzum Cafe near home. Other times we would visit upcountry, or drive to the Nicola Plateau to visit Annie's sister, Kathy, in Merritt. Once we took the cable car down into the heart of the canyon at Hell's Gate, where Annie became enamoured of a Scottish bagpipe player in a kilt. He

was a handsome devil and the two of them sat together on the deck, overlooking the rapids, and chatted at length. Later Annie explained that the man's wife came from a family in Chilliwack to which Annie herself had distant family ties.

In mid-October, 1988, Arthur and Annie, Sonny, his fellow researcher, Randall Paul, and I drove up into the mountains west of Spuzzum. Annie pointed out the berry patches on Broadback, the mountain goat terrain to the south, the hunting boundary between Spuzzum and the Sto:lo people, and where the old war trail ran over the top of Broadback between the Spuzzum people and the Port Douglas people at the north end of Harrison Lake. This was high border country between different Native nations, and it was an ancient site for dreaming and guardian spirit quests.

We stood around in the setting sun, sipping from a thermos of tea. The sun reddened our faces. Annie said a little prayer to herself, and a few moments later a snowy mountain goat appeared on an alpine slope across the valley. The goat was grazing high up to the southeast, moving slowly in and out of the edge of the shadow thrown by the Matterhorn-like peak of 'Tsem (Sharp), which is also known as Mt. Urquhart, named after Arthur's Uncle Allan, a railway man who lived for many years near Spuzzum Creek, and who, as road foreman for the CPR, was known by his 'Nlaka'pamux crew as Old *Ntéx'lehoops*, "He who watches over your shoulder." The vine maples blazed red. Underfoot a camomile-like flower cushioned the ground with a white fluff which Annie said her mother used as a stuffing for pillows. The bush around us was studded with incandescent clusters of scarlet mountain ash berries, a bouquet of which Annie took home to freeze until she needed it to stuff a turkey or a wild game bird.

Fig. 36. *Annie's hand and rock writing. Photo by Jan-Marie Martell.*

Annie sighed. "Jan brought us up here when she was making that film," she said. "Isn't it a beeeeeeeautiful place? I never thought I would see it again! You know, I watched them the whole time they were logging this valley. It made me sad. I watched the whole thing and they never saw me once!"

When we turned to leave, the mountain goat was standing in the sun, at the tip of the shadow thrown by that tusk-like peak. We drove down into the valley of Spuzzum Creek, facing a pair of impressive spires across the canyon on the eastern horizon, called 'Tsem-tsem by the 'Nlaka'pamux, and Spider Peaks by the non-Natives. These peaks are known locally as the place of thunder and lightning. They are also known as Thunder Peak, *Skeke'kya*. Stars began to appear as we wound down into the canyon. Here the twilight had already settled and deepened into the autumn night.

Some weeks before our trip into the high country west of Spuzzum this book had its portentous beginning when I unwittingly walked into a psychic competition, a grizzly bear and an image on the stone which told the archetypal story of the grizzly. I had made my second trip into the Stein Valley. While trudging along the trail in the middle valley of the Stein, toward dusk at the end of a long day, I was challenged by a belligerent grizzly bear. The bear approached to within two metres

of where I had become suddenly fossilized in my tracks; we scowled at each other and then the bear dropped to all fours and departed.

I stopped off to see Arthur and Annie on my way south two days later. I was eager to tell them my bear story but instead, as I arrived, Annie explained with indignation: "That man was trying to do you dirty with that grizzly bear. I seen it! It all come to me in a dream. So I got up—it was in the middle of the night—and I went out to the root cellar. I had my medicines so I did what I had to to protect you. That man has no business doing dirty things to my students. He should use his mischief on the ones that want to cut down all the trees!" I was idly thumbing through my notebook as Annie told me some of her experiences with the man she was accusing. I showed her a sketch I had made of rock paintings at EbRk 8 in the Stein Valley. She stopped talking about the competition over my well-being. The image that excited her most in my sketch was the figure which is often interpreted by outsiders as a European sailing ship. Annie said it was the first canoe, built by an old man under the inspiration of the Creator to save the Little Bears from the pursuing Grizzly Woman. She spent the afternoon recounting the story. As often happens, I did not have a tape recorder with me when I really needed it. This experience sparked my desire to locate drawings of all the Stein rock paintings, or "rock writings" as Annie called them, and ask Annie if she would be so kind as to read them for me, on tape. Within a few weeks I had located the drawings copied from the original rocks by Chris Arnett, artist and rock art researcher. Chris had compiled these drawings in the course of carrying out research for the preservation of the Stein watershed from clearcut logging.

Annie was a firm supporter of this campaign. She felt that logging should be done in the older, selective way. The forests, she said, are the lungs of the world, and they are the water pumps that keep the hills and valleys moist and green. They are the keepers of the soil and the stable core of the climate. The old trees are the elders, whose purpose in this life is to teach the young how to live and prosper.

"If they log right," she argued, "—and I don't like to see *any* trees killed—they don't have to plant the trees by hand. The little squirrel, he's nature's tree planter and he does a very good job so long as he's got a forest to live in."

Annie also felt strongly that the ownership and stewardship of the Stein and other valleys, such as the beautiful and bountiful Botanie Valley, be recognized as belonging to the 'Nlaka'pamux and their indigenous neighbours. The rock writings in the Stein, she maintained, and the newly discovered burial cave, were tangible signs of Native ownership to which Government should pay attention. She explained that these things are like your furniture: They show everybody who enters the house that the house belongs to you. By making a book about these writings, she said, we would show the world that "the Indians had their furniture in there for thousands of years."

Immediately I showed Annie the set of drawings made by Chris Arnett, she began to interpret them. She had learned a great deal about the Stein, about the dreaming process, and about the drawings from Moses Nahlii and his brothers in Lytton—workmates of Annie's father.[3] She also learned from the "grand-aunts": Annie, Julia and Josephine, from the old Spuzzum chief, Henry James, from Arthur's mother, from another aunt, Mrs. Clare—from all those who sent her on her own personal journeys. Annie learned the old trail language, the iconography of dream painting, and the esoteric "basket-writing" with which women communicated, one to the other across cultural and regional boundaries, by plaiting recognizable signs and symbols into the very construction of their baskets. They did so as signatures, and to reveal aspects of the traditions, unique powers and rich histories of their respective families.

I recorded Annie's interpretations of the whole set of drawings, together with one or two from other locations, as well as a sampling of petroglyphs (images carved into, rather than drawn or painted on, the rock). This process extended over a period of two years, 1989-91. The main body of this book "Rock Writing in the Stein" is comprised of Annie's explanations of the Stein rock writings. I have edited the material down to the present length by removing repetitions, and, delightful though they are, Annie's digressions. My editing was guided by Annie's concern that candid comments about other people, and very specific esoteric information that belongs only to her family, not be published. I have also used verbatim, as far as possible, Annie's syntax, speech rhythms and her distinctive voice.

Much has been previously written of a scholarly and scientific nature, based, to some degree, on information imparted by Annie York; yet so little of her voice and personality, due largely to the nature of scholarly convention, comes through to the reader.

Fig. 37. Annie's clasped hands. Photo by Jan-Marie Martell.

Annie wanted this Stein material published. She asked repeatedly, "When will our book be finished?"

On August 19, 1991, Annie left this world once more. This time the old people did not send her back.

•

One of my first lessons after Annie took me on as one of her students had to do with the beauty and continuity of life. Annie was talking about the beauty of Spuzzum Creek at sunrise:

When those old people get up in the morning they wash their face and they face the sun. Lots of people says that the Indians prays to the sun. No. They only say their prayers because the sun is the one that ripens food for them, so they ask God for the sun to remain on this earth as long as possible.

Same as the moon. The moon is the one that tells them when the water's going to get high. When the water is going to recede. When the water—what time of day it's going to be.

Same as when you look at the stars yourself, up in the sky. You wonder how nice it would be to get there. That's the way the Indians looks at it. The Indians looks at it this way: EVERY STAR has a connection to this earth, a connection to our life.

And if you go from here, your star is disconnected, but you still keep on going, and your life goes right through that black hole in the universe. It keeps on going and your life never dies.

They look at it this way. The hour you died here, there will be some other child born somewheres, an d that's your life. Your life never ends. God invents that for us, to be that way. He invented places for us to enjoy. That's why you should always pray when you see wonderful things.

The Fraser Canyon is famous for mountain goat wool blankets and for water-tight, finely plaited and imbricated cedar basketry, created by the women. Annie has woven different cultures into her life with the same craftsmanship displayed for generations by the Salish aunts and grandmothers on both sides of her family. The cultures woven into Annie's family are a microcosm of our contemporary heritage, both Native and non-Native. We are all richer, no matter what our background, when we understand some of the ways that human meaning has been woven, plaited, painted, sculpted and carved into the landscape around us for thousands of years.

Annie's family and we, her students, are now faced with the same dilemma that Annie herself confronted almost twenty years ago. There comes a time when the scales tip from being student or apprentice, to being teacher or master. It happens when we realize we have to find a way to pass on to those who come after us all that we have learned from our elders, and from our own life experience. This is the genetics of culture, and the genesis of the present book.

Fig. 38. Annie's hand and food-gathering basket. Photo by Jan-Marie Martell.

43

Red Ochre

I guess these people goes there, pick up this paint, you see. They had a big bag of luutsamen—red paint—and they took it up there. Whoever the ancestors was, I guess they tell them, "This luutsamen is what you're gonna use. And if you dream, you gonna draw your own dream."

— Annie York

EbRk 2.

EbRj 62.

EbRj 5.

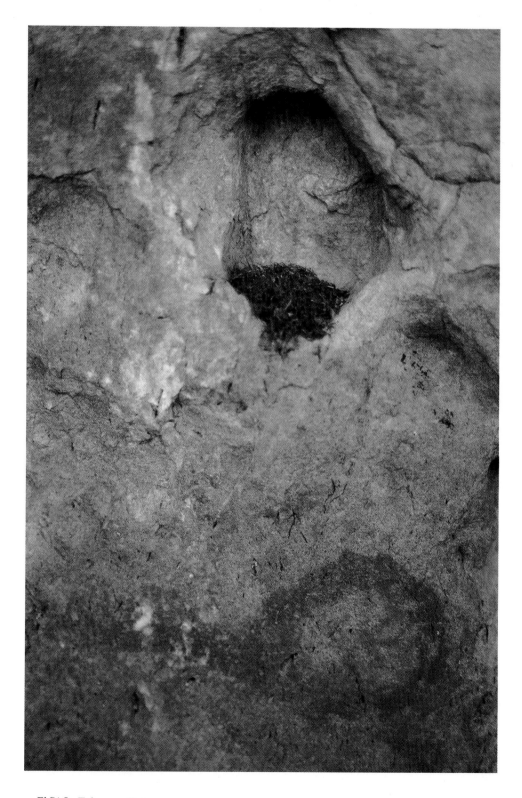

EbRj 5: Tobacco offering.

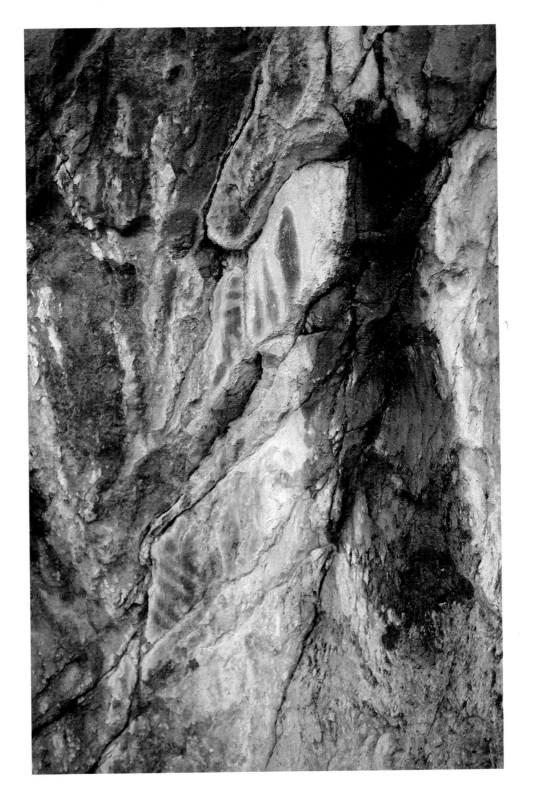

EbRj 5.

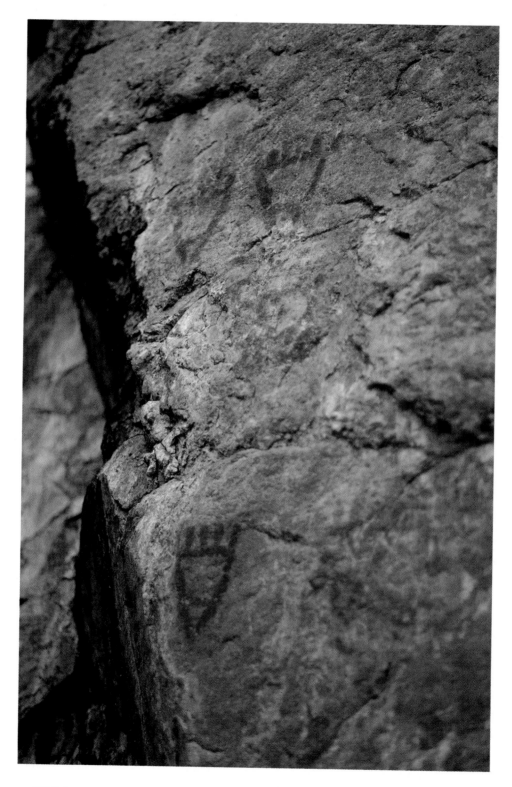

EbRk 1.

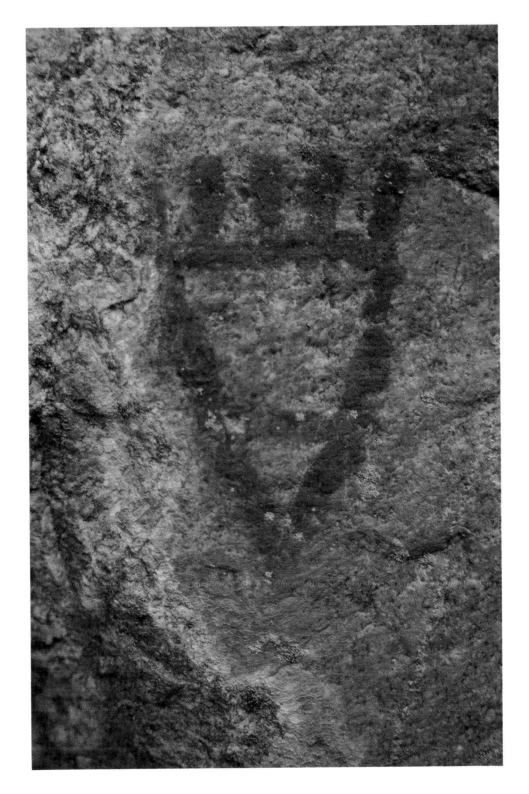

EbRk 1.

EbRk 2.

EbRk 2.

EbRk 10.

EbRk 8.

EbRk 8.

EbRk 8.

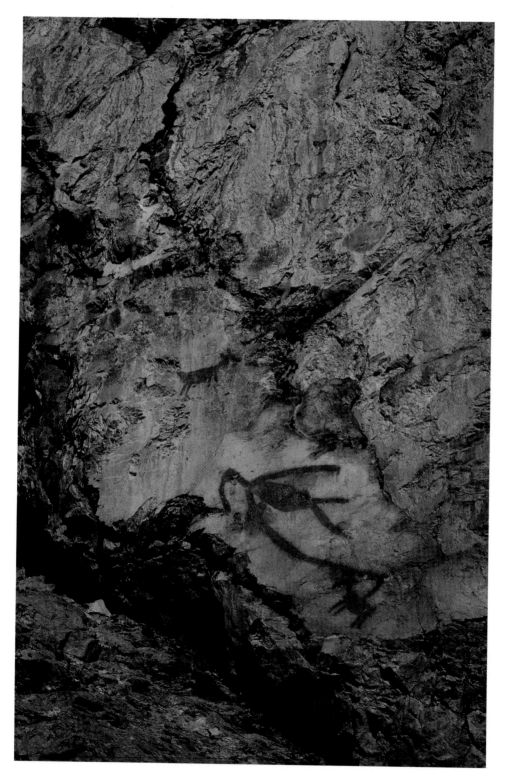

EbRl 6.

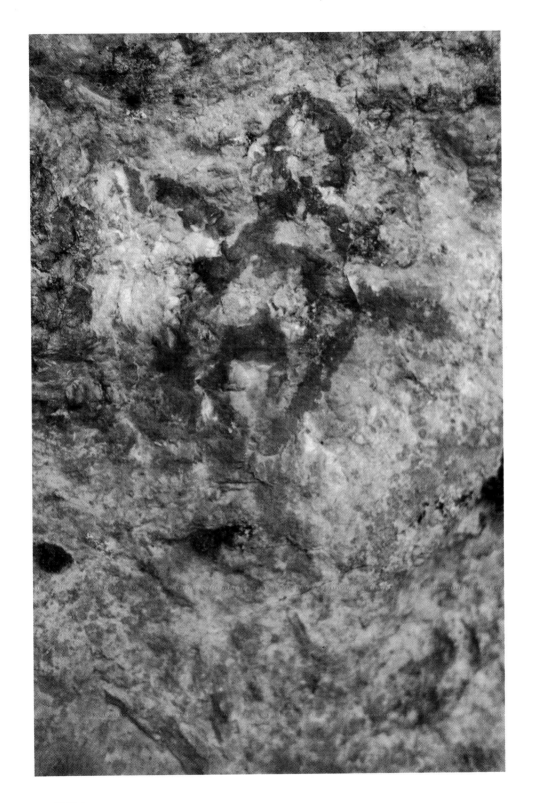

EbRl 6.

EbRl 6.

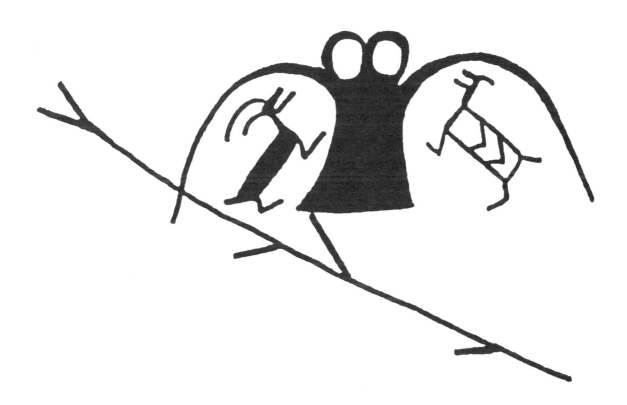

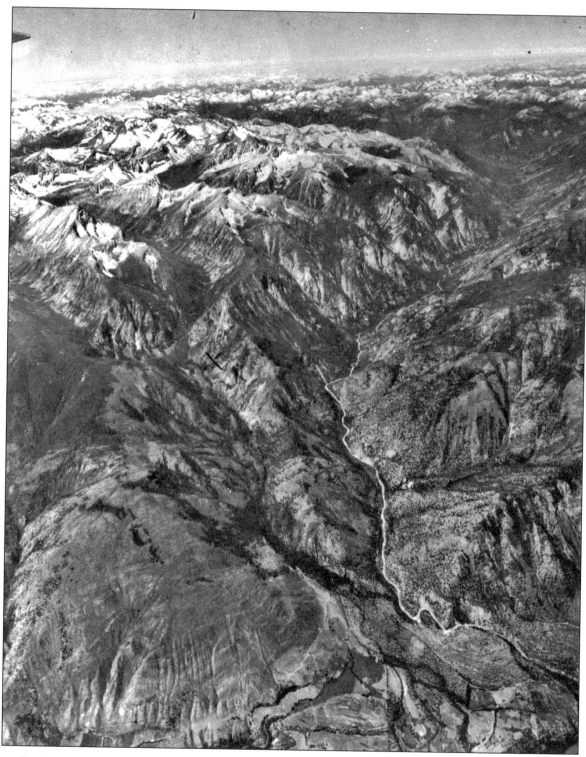

Fig. 39. Air photo of the Stein River Valley looking west from its confluence with the Fraser River, 1947. Courtesy B.C. Maps BC359115.

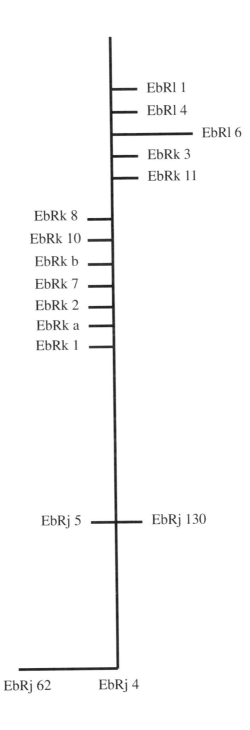

Fig. 40. Schematic map of Stein writing sites.

Fig. 41. EbRj 62. Photo by Chris Arnett.

3. Rock Writing in the Stein Valley

Annie Zetco York

A. Rock Writing at EbRj 62

Introductions to each site prepared by Chris Arnett.

On the west bank of the Fraser River half-way between Lytton—the ancient centre of the 'Nlaka'pamux world—and the mouth of the Stein River, a rock cliff juts toward the Fraser, overlooking a number of traditional fishing stations. The sedimentary rock at the base of the cliff has become the writing slate for both Native and non-Native cultures, and as such stands testament to two centuries of cultural contact.

This site was identified in 1973 by B. Corbett and D. Wales, during the Lytton Archaeological Project, a survey of archaeological sites in the area which was carried out under the direction of James Baker (Baker 1973). The paintings are located in an alcove and on vertical rock faces protected by an overhanging, seventeen-metre high bluff of sedimentary rock. The top of the bluff is an ideal look-out point and is covered with the basalt debitage of chipped stone tools. The town of Lytton is visible downstream.

In addition to the aboriginal rock writings, this site is noteworthy for the presence of Chinese calligraphy and drawings, made with black ink, in the vicinity of the paintings shown in Figs. 43 and 46. These Chinese writings and drawings, some of which have been executed on top of the aboriginal writings, are probably the work of Chinese placer miners, who came to the Lytton area in 1859, a year after the start of the Fraser River gold rush (Teit 1912:415). The Chinese are known to have worked the gravel terraces above this site and at least one man, Ah Chung, homesteaded nearby.

Most of the Chinese drawings and calligraphy (including the drawing of a human figure and what looks like a serpent) are located to the right of the recessed alcove with its aboriginal writings at the downstream edge of the site. In August, 1988, I visited this site with my brother-in-law James Burton who, after having lived and worked near Beijing for several years, is fluent in the Chinese language. He found many of the inked characters too eroded to decipher, particularly where sections of

calligraphy had disappeared due to the spalling off of certain areas. However, he was able to determine that the Chinese writing recorded the names of men, presumably the gold prospectors themselves, and the names of women—probably their mothers, fiancées or wives back in China. The best-preserved character, isolated from the other short texts, is the Chinese character for "clear/clean water" or "spring."

Fig. 42. Interpretive rendering of Chinese writing at EbRj 62 by James Burton.

Another group of characters, superimposed on the rock writings of Fig. 46, is a date which reads, "In the tenth year of the ruling emperor." Unfortunately, the emperor's name is obliterated, but it is possible to identify the approximate date of the Chinese characters by reference to the imperial genealogy.

The first Chinese arrived in 1859 which was the beginning of the tenth year reign of Shen Fung. He was succeeded in 1861 by Tung Chi, who reigned until 1875 when he in turn was succeeded by Guang Xu. Guang Xu reigned until 1908 and was succeeded by a child, the last emperor who was deposed three years later during the social revolution. The descriptive date written here refers either to the tenth year reign of Shen Fung, being 1859-60, the tenth year reign of Tung Chi, 1871-72, or the tenth year of the reign of Guang Xu, 1885-86. The Chinese writing thus dates between 1859 and 1886.

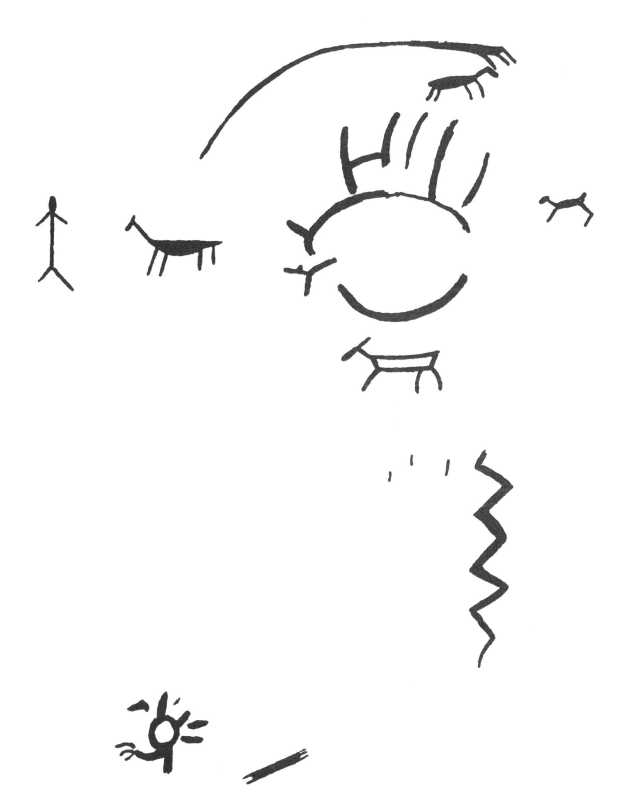

Fig. 43. Rock writing at EbRj 62.

Annie:

You see the line that looks like a bolt of lightning? Well, that's the earth, the foundation of the earth.

And here, see? One, two, three [three small lines to the left of the earth foundation]. That tells you it takes three days when God created this country. It took him three days to create it. That's the way the earth is.

The reason it zigzags is it's the first foundation, the second, the third, the fifth. You know what the Indians calls that? *Kii'féstik béx'shedin.* That's five béx'shedin. The commandments. I learned that from the old chief, and I tell you, he speaks a *very* educated language, that old man. Béx'shedin. Ho, ho, ho! Nobody will know what that means! It's the language of a leading family. I know it but I'm not allowed to teach it to anyone.

The five commandments? Well, before you do any very fine, skilled work, you gonna do these things first. You're going to bathe and you're not going to sleep at home in the house, if you are a man, or a woman.

I tell you, when women are going to have their periods they go out into the little house where the girls stay for their training. If women just stayed home, the Indians claims that they would spoil the hunting trip. And if you got that smell, other animals will go after you too. You have to be *very* clean.

Like our granduncle. He went over there where the little clearing was. He forgot about this commandment. You see, by this time the clergy preaches people, "Your style is *crazy*. It's pagan, your style." So they all stay in one big house, and our grand-aunt, Grannie, she has moccasins—she has awful big feet, that woman! She left her moccasins somewhere and her brother, Grand-Uncle [Louie Antoine] thought they was his and he took them. He put it on and he went over there and the grizzly went after him. He managed to climb a tree, but the grizzly scratched the heel of his foot. The smell of the woman's period will make a bear or a grizzly go crazy.

You keep yourself clean and you keep your mountain clothes hanging outside in the woodshed. I *never* broke this commandment. My grandmother, my mother, all the old people tells me that. "*Never* go into the mountains and *never* cook meals for your brothers or your father, because your health is not the same at those times." So you keep clean. Go to the sweathouse, but not in a public place.

And your bow and arrow, that must never be in the house. You hang that up outside on the scaffold. Your fishing tackle, your fishing basket too. The warriors though, they want to have their arrows with them always. That's why they have their own kiikwilee house [earth lodge], because no woman is *ever* allowed there. Here it was down the point between Spuzzum Creek and the [Fraser] River, the place where Simon Fraser visited. You said you seen it, that biiiiiiiig one? Yeah, it was a lookout for any invaders on the River. And the warriors worked with that one old lady. If anybody invades they have to deal with Kwiintko. She was the peace-maker. Later they called her Mrs. Garcia. She'd sense it. As soon as they heard of the invaders downriver. If you was coming up from Yale in a war canoe,

one of those Yale people runs from there up here, because Yale and Spuzzum are *very* close—even we borrow lots of words back and forth. Yale and Spuzzum, and the people from Skuzzy [across the Fraser River from Highway 1 at China Bar Tunnel]. I think that's because we lived very close to them. But the people of Spuzzum very seldom marries upriver until the white people come. Then they do it. After the preacher tells them, "You're no better than the next guy!" After that they got all mixed.

Anyway, Kwiintko commands the warriors' house. Nobody is to sit in her canoe, and her and the chief goes to the edge of the river and commands the warrior, "You're gonna go down to the right canoe and paddle across with this rope with the banner on it and tie it across the River. That's to tell the invaders to behave themselves."

I'm going to make that banner one day. I know it and I have the buckskin. If I live, I will. I was the only one that had that design on my basket.

The other commandments?

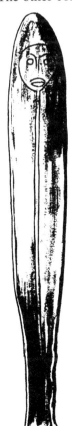

You must never kill anybody. Kwiintko and the chief, they enforced that. If invaders or enemies come to your place, you must treat them with respect, as you treat yourself. You give hospitality. Treat them like family. That's why today, if peo-

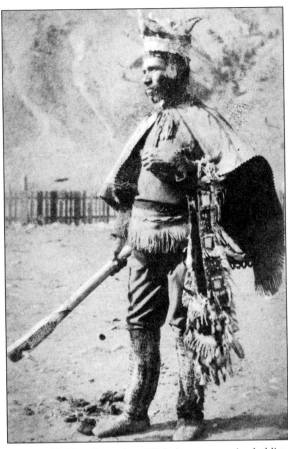

Fig. 44. Man dressed as 'Nlaka'pamux warrior holding antler spike war club with incised and/or painted skeleton "writings." Photo by James Teit, Spences Bridge. Courtesy Royal British Columbia Museum PN0739.

ple comes to my door, and they told me they want dried fish, or a place to fish, I tell them to come in and I give them a cup of tea, and I tell them where they can go. It's the *same thing* in the Stein, and *aaaaaaaall* over. You see, people travelled back then, to visit, and the young people from all over went up those mountains. When they were training, they *could*, they were allowed to go to all those places.

In the Stein they went from Mt. Currie, from Pemberton Meadows, from Harrison, from Lytton. Shikbiintlam [the Lytton prophet also known as Cixpintlen] says, "Those are all my people and you must never pen them in. They must have freedom to hunt and to fish all over, especially the young who come to do their dreaming." Sto:lo people could go to the Stein to dream. You seen their writing

Fig. 45. Copper sword found in grave near mouth of Spuzzum Creek, 1898. Drawn after Smith (1899:Fig. 82).

down there at Hope? The earthquake? They write it the same as we do. And people from Merritt and Kamloops, they wander around. They go there too. For dreaming you can go to other people's country.

Yeah, they all go there for their dreams, all for legendary dreams that they have. They go like that. Everybody, they go. They go to Botanie. They come the back way and get to Botanie and dig potatoes. That place got wild potatoes. Got everything. They get a biiiiiiiiig bagful, and they take it home. Same as the people from here. Sometimes they trade with fish for sago lily root up there. When the young go up for dreaming, the others might go for good things to eat, to trade and visit.

Other commandments?

You must never fool with somebody's wife. That's a commandment. And a woman must never commit adultery. None of that stuff, and no stealing either. Because they don't want that. You, yourself, you could come to Spuzzum in the old days and do all you like. Whatever you like, you can have it, but as soon as there's adultery or stealing, out you go from Spuzzum! And they won't let you come back. There was somebody up country writing like you're doing. He was a researcher, and he starts fooling around with Indian stuff, and they wouldn't let him come back again to that place. Stealing is another commandment.

You see these little figures? It's like the plants, you see. The Creator made them, the plant people. And the slopey line to the right. He makes that slope when he creates the plants. It's the slope of the earth. You see, the sun shines on the slope for the little plants.

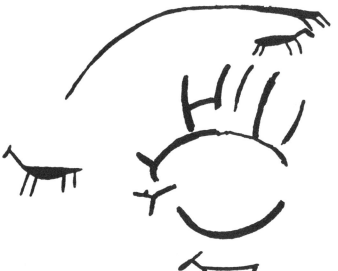

But over here, that's not a plant. That's an animal. A deer. The man dreamed the deer. It's his hunting dream. That's the man who dreamed [on left]. It's also God's messenger, giving humans the ways of hunting.

When that ancient gospel came, the messenger of the Creator, he taught the man the way to hunt. You see, an Indian is not like a white man. He's a hunter. He has to spend his time up in the mountain. That hunter could easily speak to an animal. When you are trained the animal don't run away from you. That's why that picture is like that. The animals are *very* close to them.

70

Richard:

What about that arching line over top of another animal?

Annie:

That means that in his dream the first hunter woulda liked to have something to kill the deer with. So the messenger, he asked them, "Which way you gonna have? Do you like the big deer or do you like the small one?"

Well, he always asks for the big one!

That arched line is over the head of the deer. It's a snare. Before, when they go hunting they use a snare. Then they sometimes shoot them later, with an arrow or a spear.

But you see these rays coming out of the circle? One, two, three, four. That's the time of the day. It's three, half past three. The rays on the left that are sort of like an "H," that's a half sign. By the movement of the sun across the sky that's halfway down in the afternoon. You see, in the morning the deer wanders around, then he goes off and lies in a shady place under the trees. But when you going out looking for them, you go in the afternoon when the sun is at halfway down. You wander around in the bush and you'll see it.

The little mark down low on the left side of the sun, that's the early part of the morning. That's the time that you might see the deer before he goes out and wanders around. The deer at the right of the day sign, that's what you might see at sunset, and the one below, that's the night. If there's a moon, you know, they wander around in the moonlight. The gap on the two sides of the day, that's the opening between the times. The opening between day and night.

This young man, he dreamed of hunting the deer. At that time these people get there early in the morning and the *whole crew* goes in the bush and chases them. One is hidden for the killing and the others, they all chaaaaaaaaasc the herd.

One man is on the hill. Like a person sits way down the hill at the killing point. He has to be a famous strong man because they use both the arrow and the spear. Grampa York told me that. That's what they do.

By the time they get themselves through the drive it's the afternoon. They flush them out when they're bedded down in the shade. If there's lots of people you start in the morning and drive them until afternoon. But if you are alone, you go out in the middle of the afternoon like this writing says.

They *never* hunt in the summer time. That was something that they very very rejected. The game would be scarce if they did that, and it doesn't taste good then. I smell it one time in summer and I don't like it.

And when you're going to dress a deer you have to know how. If you ever burst the gall bladder, the meat tastes funny. That's what you got to be careful with.

Fig. 46. Rock writing at EbRj 62.

That stroke at the top, it means the strongest life. The person who made it was strong in life and made it from three to six days—one, two, three, one two three—up in the mountains without eating.

Below that, you see, he dreams of catching animals. There's the little animal [uppermost of the next set of markings], and right below it is a snare, a *'káwisten* [which is staple-shaped]. People makes that 'káwisten trap, you know, to snare the animals. The curved line below the snare [right] is its cover. That's the thing that works. They make a great big hole that's only got a false cover. And when the animal steps on it, that thing goes uuuuuuuuuup, like this. A bear trap is made like that. It stays like that and if he wiggles it gets into the hole and he can't come up. On the left of that there's a couple of little lines with a wavy one over it. That means that a person waits about two or three days before he looks at his 'káwisten.

The tiny thing below that on the left? Maybe it's a plant.

Richard:

And the image below this?

Annie:

The slanting line on the left is the ground line. The man stands on the ground. You see him, with his headdress. That man is standing beside the pit snare. The snare is the triangle below him. Looks like a bear paw. I've seen that up here. Arthur pretty near walked into one of them once. The five lines coming out the top of the pit are the bait and the cover—the branches, they stick it in like trees so they can fool the bear, you see. The bear gets in there.

That messenger of the Creator tells the first human dreamer to stand there and learn about snaring. God told Adam and Eve how to live. He told them twice, "Don't touch that apple!" But humans always want to have their own way. It was the same with this first dreamer. The messenger was telling him, but he wanted things his own way. The prophet says to him, "Watch what you're doing when you go up there." But the man goes and wants things his way. Naturally, humans is that way.

And so he did that. The prophet gave him this invention and told him all what he was gonna use in this life.

Over his head there, you see? That's a hook. He uses that for everything. That thing gets into his brain—like when I'm going to the mountains I'd like to have a hook for goin' fishing. He wanted that hook in the worst way, that man. And he's thinkin' up in his brain. He's thinking that biiiiiiiiiig hook. But they only give him the little one, because he was greedy.

Down at the bottom, that's another type of snare they taught him.

Fig. 47. Rock writing at EbRj 62.

[Top left] In his dream the man sees God's messenger drawing the bow and arrow for him. He dreams the prophet drawing it and saying, "That's how you gonna make it." That messenger is funny. He draws what he gives you.

But over a bit to the right, see? That's the arrowhead. That's when he makes the arrowhead for humans. Right there. And below that is a big strong bow. They have small little bows for a young kid, bigger ones for a man. When he's got his full hunting power he can pull a bow that stretches from one palm to the other [arms outstretched]. You gotta be strong, then it can go "Zooooooooooooop!" You know that little mountain we passed going up the Nicola road? That's where the young boys around Merritt practised. The best ones can hit up top from way down the bottom.

There, you see? To the right of the arrow-head. It's a slant house. They use the *smuuts'k* to make the posts perrrrrrfectly equal. The smuuts'k is used for measuring the angle of the walls and posts. It's like a right-angle square. It fits exactly into a corner. The right-angle posts, *s'kútsamen*, have to be equal. To make a s'kútsamen is a *hard* thing, to make it proper with the right angle. You use the smuuts'k to make it a right angle, like in that slant house. You put up one post and use the smuuts'k to measure *ex-act* for the other post against it. When the s'kút-samen is finished it's a post holding the roof, and also a divider. It's a privacy. They are very thick and between them they have cedar bark or birch bark, all clamped like this. I seen my grandmother making it out of cot-

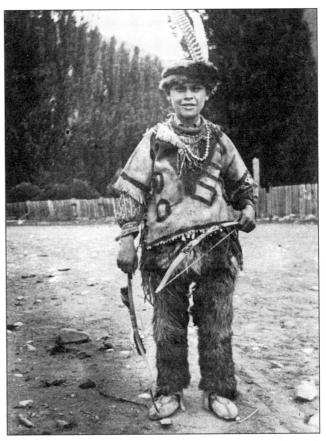

Fig. 48. 'Nlaka'pamux boy wearing "old costume" of painted buckskin shirt and holding two small bows of mountain sheep horn. Photo by James Teit. Courtesy Royal British Columbia Museum PN6734.

tonwood. They are clamped with stick pegs, and then grass mats they have like a curtain.

That man was dreaming of a house and the messenger asked him, "You want a summer place?" He said, "Oh! I want a big big house!"

So that's the slant house, the way the Indians here makes the slant house. The slant house is the one they use when the spring comes. It's *hwíixwiit'tíktiitxw*. It's got a flat roof and then a lean-to off it. The main roof is held up by four posts, forked at the top for cross pieces, and they tie it with cherry root. If it's cold weather like now, they might put a lean-to on both sides.

Below that is the beginning of a ladder or a dry-rack. *Kwushxw* is drying rack, and they have it up over the sleeping quarters, but not over where the girls sleep. Always on the older people's side. They have the dry-racks suspended and they keep the dry foods there so the mouse won't get it. They protect the strings with cactus, from the mouse.

You need the smuuts'k for a ladder too. [Ladder figure is below the slant house] The thing to the right of the ladder is its anchor rock, to prop it so it wouldn't slip.

Richard:

What do we have to the right of the anchor rock?

Annie:

He dreamed of the bow and how to string it. See that corner? That's where you start to string it. He goes like that, then he goes like this, and then he ties it.

[The image below the dominant bow and measurement device]: This thing, you see, it tells you that whenever you gonna see something dreaming, you gonna put your own marker there. That prophet told him, "You gotta put your marker on the rock." The man didn't want to do it that way. So the prophet says to him, "Okay then, that's gonna be a rough marker." You see it's rough-formed. You oughta seen up the hills here, above the mouth of that cave. It was marked. You'd think people was working there. It just sits there. Some of them's as big as this table.

It's an owner's mark. You can leave it with a trail message, or leaving something where you camp, or just to mark your camping place. My grandmother has our own camps marked that way.

Richard:

And the strong little figure on the right that looks like a tea kettle?

Annie:

Haha! No, that's not a tea kettle! It's a bird, a twin hatching out of a double yolk egg. You can see the tails. They're just bursting out of the shell there. Two little birds. Hatching.

It's there because, you see, that man that's dreaming remembers the first man dreaming. That man! When he was up there he always wanted *everything* with double on it. When the Creator showed him something and asked, "Do you want this? How do you like it?" He answered, "Yeah, I want it, but I want two of them." Every hunting animal he dreamed of was that way. "No," he was told, "You will never get two with one shot." It was so funny the way Moses Nahlii told that story!

But you see this strong bar? The man wants something in his dream to chop that up with, but he couldn't get it. It's a tree or a log. You see, he dreams of his kiikwilee house and he wants something biiiiiiiig to cut it with. But he couldn't get it! He was too greedy. There he is, below the log, wanting something big to cut it with. The Indian was greedy first, so they didn't always give him the good tools.

The white person was different. He wasn't greedy at first, so he got the tools. Of course he got greedy afterwards, but by then they'd got to do everything already.

Next to the man is a little animal in the bushes, but I think it's part of another dream. You see this is a boy's dream of snowshoes. The big thing at the bottom is his snowshoe. A boy's snowshoe is fatter than a girl's because he has to go up there in deep snow. There, in the centre, the upright part is his leg, and there's the strap for the foot. All the little lines, that's how they string it.

This dream has something from the log above. There, the young man wanted something big to cut with and he didn't get it. Now here, the prophet says to him, "You want something to walk on if it's a deep snowy day?" He says, "I want something that won't even touch the earth at all." Of course he couldn't have that. He got snowshoes. Snowshoes touch the earth. Maybe he dreams of snowshoes because when he was out there it was snowing.

This is the boy's first dream. You see the little thing above the snowshoe? The dot at the [right] end is the beginning of his life. The little circle below the line, that shows it was a full moon near the start of his dream and after a while he gets hungry in his dream. The little animal in his dream tells him, "Now you can eat." He has nothing to eat, so he shoots a squirrel or something—a bird. And he cooks it at an open fire. He sits there and he eats it. But that little animal, when he eats it that time, that becomes part of his power.

The dot where he starts his life—you see, if he goes up there and decides not to stay in the mountains and train, then he stays on that same line where he was born. But he thinks while he's up there, "Do I want to be a plain man?" You see, if I don't want to be, I will have to train, and the life is not easy, and I will start a new line for my life, like this boy did in this dream. That's like a regulation for a chief's family. Ordinary people don't have to follow that way.

But he decides to dream and he starts on the full moon, for his new life line. The tail on the moon is really the reflection in the water. Like I said to this woman who had so much bad luck, "For protection, your son must go to the water when the moon is full, and he has to follow it in my style." If I want to sleep at midnight, first I have to say my prayers. I keep waking and praying until the moon gets around to my pansies. That's where my last prayer is. The full moon is more powerful than the new moon.

Fig. 49. Rock writing at EbRj 62.

There's that cross. It signifies death and religion. It's the directions, the west, north, east and south. It's been on this earth many many years, that cross. Here it's on top of a little deer. You see, the deer is life to the people, life on this earth. They can't live without deer meat; they can't have shoes without deer. They use it for food, for sewing. They use the bones for a *lot* of things. The hooves they use for bells. The reason they have it written like that, too, is that it represents when God was on this earth, when his mother brought him and he was crucified. The Indians knows that for many many years.

And over here, beside it, there's a tree uprooted. Dead branches. Its life has gone, and that's in the cross too. The cross marks where you are and it reverences life and death.

Down below is a man, and what's over his head is what he's thinking all the time, or what he's wanting. What he's wanting is a bow and arrow for hunting birds. He dreams of goin' out and shootin' birds. There's the bird down below him. You can see it—it's flying. And there's another bird flying, toward the right side. He's dreaming of his bow and arrow and it's the birds he wants to kill.

Below the man is his sweathouse. They bow over the branches and tie them. You can even see the tie in the middle there.

Fig. 50. Rock writing at EbRj 62.

On the left is the sign of a one, two, three days' fast, and the fourth day—like a "T"—that's the day that's the hardest to make sometimes.

And there he is, lying down and dreaming about what he's gonna do. He's gonna build a tipi, see? It's got three sides and it's all coloured in. It's called *'nxó'xwiiyaten*, the tipi. All those little marks on the left of it, they are the stations or the times in the dream when he learned something more about building it. A tipi is not simple. A chief's tipi is bigger and a little different in how it's made. The common person's tipi is different again. This is the first tipi the young man is going to sleep in. A tipi has a natural life. Normally they put on the tipi a skirt of grass mats. But up in the mountains the cover is fixed different. It's made all of fir branches.

In his dream he walked toward it and as he walked he learned more things about it. Those dots are where he stopped and learned things. He learned all his own markings, of how the tipi poles would be carved and decorated. I seen that up at the lakes near Merritt myself. The markings on the poles come to you in your dream. Part of your power goes into that tipi because it's made for what you are.

On the right of the 'nxó'xwiiyaten it shows the five days he went without food before he had this dream. It also shows he dreams of his fish and how he needs a drying rack to dry them. In that same dream he dreams how to hang anything—fish, deer—how to dry it well.

Richard:

And to the right of the tipi and the drying rack?

Annie:

Well that's the nights he is dreaming, and the stars on those five nights. Old Paul[1] has that too, in his dream. He's got three or four of them, the stars.

Fig. 51. Sockeye salmon caught by Roi-pêllst, cut and hung on pole to dry near camp about one mile east of Spences Bridge. Photo by James Teit. Courtesy Musée Canadien des Civilisations/Canadian Museum of Civilization No.25005.

B. Rock Writing at EbRj 5

A short distance beyond the beginning of the Stein Trail, the Asking Rock looms up like a sentinel. Designated as EbRj 5, "The Asking Rock" is the best known writing site on the Stein River. Here, above its confluence with *Nzikzak'wxn* ("to fall a log across"), or Stryen Creek, the Stein River spills through an outcrop of sedimentary rock faulted into position through the valley's predominant granitic rock. On the south side of the river the trail passes beneath a weathered outcrop of this rock, which shelters shallow cave-like depressions hollowed out by the relentless erosion of the Stein River.

Most of the writings at this site are found inside the largest hollow, half-way up the rock face, directly overlooking the trail (Figs. 54, 55, 58). The weathered paintings, at the rear of this hollow, are grouped around a central fissure where water seepage has left a noticeable deposit of white calcium carbonate, which also covers some of the paintings. The rough surface of the painted area, covered with numerous cracks, lichen growth, natural erosion and human vandalism further obscures the paintings. A smaller set is found in another hollow at the base of

Fig. 52. EbRj 5. Photo by Richard Daly.

the outcrop next to the trail (Fig.60). The larger hollows in the rock act as echo chambers, reflecting and amplifying the roar of the river to the listener when he or she stands at a specific place on the trail or in proximity to the writings.

EbRj 5 was one of the rock writing sites shown to Harlan I. Smith and John J. Oakes in the summer of 1897 by the 'Nlaka'pamux guide called Jimmie (Smith 1932:17). Jimmie told Smith that the "shallow cave" with its painting was a "place where boys and girls went to fast during their puberty ceremonials." Jimmy also stated that the place was "where boys and girls came to wash with fir boughs" during the same training period. Jimmie also drew Smith's attention to a painting of deer or mountain goats connected by two curved lines to a three-metre vertical line marked with short diagonal dashes (Fig.55). "He explained," wrote Smith, "that this line represented a trail over the hill where the animal goes."

Smith and Oakes made six drawings of some of the rock writings and Smith took two photographs. Two of Smith's drawings were published in Teit (1900: as Plate XX, Figs. 15 and 16). Teit included interpretations of these paintings which he had solicited from his 'Nlaka'pamux informants who lived

Fig. 53. Section of large painted hollow at EbRj 5. Photo by Harlan I. Smith, summer 1897. In this black and white photo "writings" are difficult to see compared to the prominent vertical white deposits of calcium carbonate that is often a feature of rock writing sites. White was a "spirit" colour "and stood for ghosts, spirit world, dead people, skeletons, bones, sickness, coming from the dead" (Teit 1930b:419). Courtesy Department Library Service, American Museum of Natural History Neg. No.42823.

in the vicinity of Spences Bridge on the Thompson River. Teit was told that the large bulbous figure with antlers represented a "vision" (see our Fig.58). The wavy pair of horizontal lines behind the figure were "trails" and the two circles joined by a single line below were identified as "lakes connected by a river." The game animals (Fig.55) were said to be "mountain goats."

EbRj 5 was probably one of the sites visited by Charles Hill-Tout in the 1890s. The water-worn shallow caves and hollows evident in the sedimentary rock at EbRj 5 echo his descriptions of sites along the Stein where "certain celebrated shamans underwent their fasts and training to gain their powers." Hill-Tout wrote: "Worn and hollow places are pointed out here and there, and these are said to have been made by the feet of the aspirants after shamanistic power in the performance of their exercises" (Maud 1978:48).

The ledge inside the large painted hollow above the trail has two smooth elongated hollows large enough for a person to lie in comfortably and look at the paintings. An 'Nlaka'pamux elder from Lytton remembers when these natural stone beds were lined with fir boughs and laid in by women about to give birth.

His account corroborates information regarding the "birth rock," a large smooth granite boulder across the trail from this site where women "went to give birth and baptize their babies in the Stein River" (Thompson and Freeman 1979:71). Propped up at an angle by smaller boulders, there is enough space for a woman, lying on her back, to have access to the underside of the rock at a slightly concave spot, which is ideal for sitting with one's legs close to the chest, or straddled on foot-rest depressions in the understand of the main boulder. Once under the boulder the woman was not visible from the outside. She was sheltered from wind, rain and sun. After the baby was born it would be taken to the edge of the river and bathed in two round pools eroded into the rock of the river bank (Lepofsky 1986:45-46; Gordon Mohs, p.c).

Today, as in the past, when aboriginal people pass the rock writings at EbRj 5, they stop on the trail below the paintings and say a short prayer. For this reason the site has acquired the name, "The Asking Rock." Offerings of tobacco, sage and coins are sometimes left in the vicinity, along with the prayers and requests of the supplicant.

The incidents of leaving offerings at this site have increased dramatically in recent years since I first visited the site in March, 1986. Coin offerings have been found at another site in the valley which suggests, based on the date of the coin, that the custom dates back to as early as 1934. Teit records that it was a common practice in the past, for hunters to appease the spirits of the "land mysteries":

> Indians, therefore, when hunting in the vicinity of these places, visited them, and appeased the spirits by making an offering to them, thus insuring good weather during their stay, and good luck while hunting. These offerings generally consisted of a lock of hair, a rag from their clothing, a little powder, a few shot, a piece of tobacco, a stone, and so on. (Teit 1900:344)

The late Jules Adams, who lived on the flat adjacent to the mouth of the Stein River and often travelled into the valley, would stop on the trail at this site to say a prayer and ask for protection before proceeding upriver. Jules Adams' prayer passed from him to his daughter, Rosie Adams Fandrich of Stein. Rosie explained:

> "Oh, my Grandfather, Shuxshux (Grizzly), and oh my Grandmother, Spa'atch (Black Bear)! Take yourselves away from the paths that I will walk. I may startle you, and you hurt me. I am looking for food like you are. Your grandchildren are hungry. So I am in your country seeking food to sustain us. I beg you to remember the promise that we made to the Great Spirit that we would respect each other. And I am in your country. Let me hear only your passing, as you will hear mine."[2]

> My father taught me always to pray before going into the mountains. I always say that prayer. I say it in Indian, and it has real power that way. I taught it to my children. They know it. If you say that prayer first, you will never meet a bear or a grizzly. (Interview with R.D., 21 Aug. 1993)

After saying this prayer, the traveller crosses him/herself, and proceeds along the trail.

Annie:

Ah, The Asking Rock! It's one of those places where people go to pray and ask for help in what they need. There used to be such places all over. Like Brockton Point in Stanley Park [from the description Annie has in mind: Prospect Point, at the mouth of First Narrows, Vancouver]. That's an asking place. You go there and you say your prayer. You put your pebble in there, and you ask them not to be too windy when you gonna travel on the sea in your canoe, especially at night.

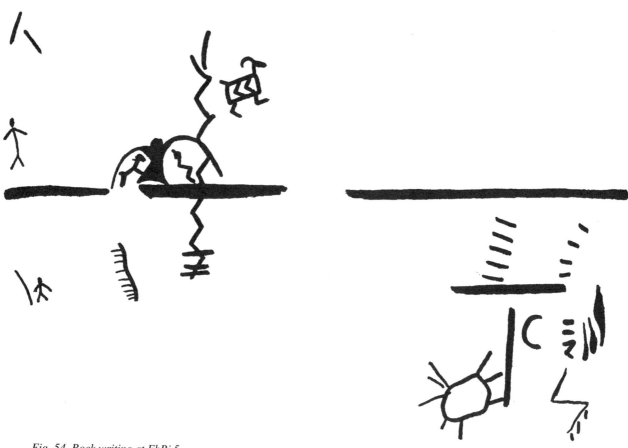

Fig. 54. Rock writing at EbRj 5.

On the left is the man who dreams. And he has the idea of stakes and props. See, they're over his head! Good for propping walls or fishing weirs or anything. If you don't have a prop, it'll come down.

He dreams the creation of the animals being brought to this earth. That's the owl figure, and the owl always connects with the moon. Under one wing the owl has the animal or the deer of life, and under the other one, the snake. The Indian always connects the snake with anything bad. The deer and the snake under the shadow of the owl.

The heavy line, in three parts, across from side to side is the surface of the earth. The owl is standing on the earth and the foundation of the earth goes through the earth and up in the air through his wing. The zigzags are the foundation of the earth. The three strokes across them at the bottom are the three days it took to create the earth. The foundation always goes up and down like that. I don't know why. I guess even the geologists sees it that way. It comes from underground and goes right up the mountains, sometimes through water, and up into the sky. It's like the earthquake. Those old people, they know it because their mind is very clean in those days. Whenever the earthquake is coming those old people knows it.[3] They know it in the moon.

That foundation line tells you about the earth. They put it zigzag, like thaaaaaat. God made the earth, you see. He made all the different colours of earth in this life. He made it, and you must respect what he made. That's why, whoever it was, drawed it like that.

84

On the right of the foundation is the mountain goat. When he was first created he was different colours and that's why you see him here with the stripes. The young man dreams this on the mountain, and the goat is across the foundation of the earth. That foundation line is the form and the guide for changing everything on this earth. The foundation moves and changes. Things are changing and in his dream he would like to see this coloured goat, what it looks like when it's all white.

Below the line of the earth [left side] you see the man. The line to the left of him, that shows that he's just starting to fast. The line on the right of him, with those—one, two, three, four, five, six, seven, eight, nine—nine hairs off it, they show he's done a nine-day fast. He's supposed to do ten days but he can only make it to nine. That's what associates with his fast, you see.

Richard:

Below the line for the surface of the earth on the right?

Annie:

First, you have the nine days of his fast again. And below that to the right is three ponds or swamps. Gee, it's pretty like that! I've seen it up there on the mountain—one big one, then nestled into it is the little ones. They come to him as he dreams of the universe.

You can tell he dreams of the universe because, below the line of the earth you have the sign for the nine-day fast, then another line for the surface of the earth, so this, below, must be out beyond the earth.

Below the second line of the earth is an up and down strong line. That divides the sun and the moon. You see the sun on the left and the crescenty moon on the right. The sun, you see, is always ahead of the moon, but the moon can tell you about the weather and the sunshine. The way the light comes off the moon with a sort of hook, that tells the weather. In summer when the moon sets with a hook, it means fine weather. In the winter, it means cold and dry. In between, like now, if it sets that way, it means wet. It's like he's got light on his back.

The two little lines and the squiggle below them, next to the ponds, that says that the weather change will be after two days, probably on the third day.

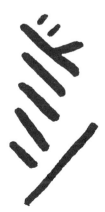

Below that, that double zigzag with three little marks, that shows that the dreamer couldn't make it to find out about the weather change. He had to quit and go and eat. That kind of zigzag means another day. But here, you know he only got to nine days so it means he couldn't get through to the tenth day. It's *very* hard to get through ten days. I've made it four days myself.[4]

The figure at the bottom there, that's another way of writing a nine-day fast.

Fig. 55. Rock writing at EbRj 5.

Richard:

The strong horizontal line near the top?

Annie:

That's the life line of the person that died. The grave box is sitting on that line.

The box could be carved, but it's usually not a box here at Spuzzum. It's a basket made from cedar bark. That's a *siis'hepxw*, that basket. In Spuzzum we had both the wooden boxes and the siis'hepxw baskets for the dead.[5]

They would put in that long knotted string in the coffin too. I'm not supposed to talk about this. It's very unlucky if you do. The old people, they would knot a different knot for a man, a different knot for a child, different knot for a woman, different knot for a widow, different knot for a widower.

They put it in the coffin with the body. It shows who they came from and how many children they had. It's made out of goat's hair. Before, they would put a jade stone on the string too, and it would be put around the person's neck. After this wasn't allowed by the missionaries, they'd just throw the string into the coffin secretly.[6]

The string has to be goat hair. If you are married in an Indian marriage, you kneel down on a goat blanket. You must never sit on it. Just your knees and your husband's. They use that because the goat is the king of the world. That's the way the Indians did that here. I don't know about other places, but here the goat is the thing that supplies blanket, supplies payment, supplies meat and fat, supplies clothes for death. That's why you must never put your—uh, sit on it. You just kneel.

The cross over it is for respect and power, for the directions and the passing of life.[7] There's the moon again, to the right of the coffin. That shows the date that the person died.

This is painted up there at the Stein because this man wanted to know how he should mark a death. He wants to know that teaching. When the prophet came, you see, he taught how to mark a death.

The cross shows the directions. The cross is at the head today, and it's always been. The body is buried with the head to the sun, the rising sun. That's the way.

Richard:

What is that other strong line below, parallel with the life line above?

Annie:

Yeah. That's his own life line and it was cut off at a definite time. Those two curved lines beside it, sort of a sketchy circle, well, they can tell you the time of death in relation to the moon or the sun, or both of them. The part of it on the left, that tells you the beginning of your life and your life ends right there, at the end of your life line. You see, the Indian says, "My life must float when I die." It's like the Indian song. It says, "When my life ends, when the sun shines into the ocean..."

When I'm going to pass from this life, my life floats like this. It never floats upward. It floats downstream. On the water. But if I'm just sick and I'm gonna get better, then it floats upward. That's what it tells you there. When you die, you never go upward. You go down to the sea.

That song is *real* Indian! It says:

> When my life ends,
> I'll be just a memory on this earth.
> My life must float like an Indian canoe
> Downriver to the ocean when the sun is low.
> When the sun is low over the ocean
> And the sky is red,
> And the sun sinks into the sea
> And the moon appears.
> The moon shines silver on the whole of the sea,
> And the moonlight shines down on me.
> That's the way my life ends.
> I'll be just a memory when the sky turns red,
> And the moon shines on the sea,
> And all the birds on the ocean shall sing!

Ha, ha, ha! Those birds! They'll be rejoicing because you're dead!

Fig. 56. 'Nlaka'pamux graveyard at Skuzzy Creek near North Bend, ca. 1867. This was probably similar to the one described by Simon Fraser when he was at Spuzzum in 1808, and the one described in 1861 above Yale, by Miss Sophia Cracroft, niece of Sir John Franklin. Annie had this to say about the photo: "This looks like the grave house at Five Mile Creek. I seen it when I was a little girl. Each family had a portrait carving of their ancestor. When the graveboxes were repaired, that's when they would also hire somebody to dress the ancestor carving in clothes. The other figures are the power of the family, like otter, bear and sun. The cross is old, before the white man. It's painted in stripes. That shows you

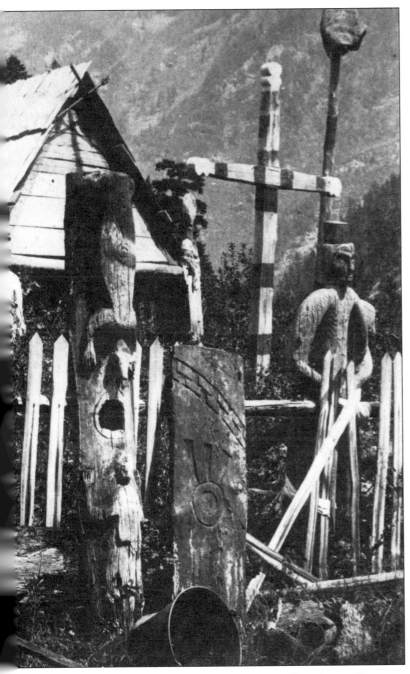

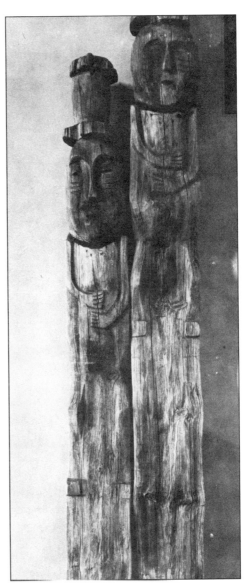

the directions and the round things on top are about the sun. The cross is related to the sun. To how it moves and gives us light and heat, and makes everything grow" (20 June 1990). What Annie calls the "power figures" would be the guardians of the family tomb. Courtesy Royal British Columbia Museum PN6671.

Fig. 57. Grave posts from 'Nlaka'pamux graveyard on east side of Fraser River, "about 4 miles north of Lytton," and just south of its confluence with the Stein. The grave figures were carved in a solitary place: If they were seen before completion, the carver would not be able to finish them properly. The figures wear top hats, indicating the high status of the deceased. Collected by Harlan I. Smith in 1897. Courtesy Royal British Columbia Museum PN8796.

There's more dream down below. Here, see? It's a mountain goat and a goat snare, and four dots—one, two, three, four—the tracks of the goat. And you see the little line under the goat, ha,ha,ha! That man wants the goat standing still all the time, and on the flat ground. But they told him, "No, you can't have it like that."

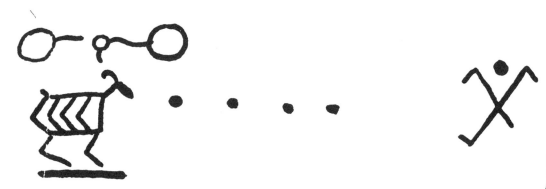

But that one, you see, he's got a dot and the "X" with the points turned up.[8] The "X" stands for so many days, and this goat, you see, the man wants so badly to kill this goat right away. This "X" with the dot, that stands for when he dreamed, but he said, "I want this goat IMMEDIATELY." They said to him, "Okay, we'll show you how a snare works, but that's all we'll show you because you always want too much."

Really, the "X with the dot is *very* hard to learn. It can tell all about time and dates. Depends on where the dot is, its size, if it's coloured in, how long the legs of the "X" are, if they are turned up. It tells you the time of month, the season. In every way it tells you. You can read the time of day in it, the length of the days, long or short. If you see that out on the mountain with a circle around it, it means when he dreamed and it shows he is determined to do that all year round. He might make a circle around it with little rays out of it like the sun for aaaaaaaaaaall year round.

Down at the bottom there, there's animals: a doe, a little tiny fawn, and an old buck. And he wanted the *biggest one*, of course! He said, "If I can get the biggest one I can feed myself for many, many days."

The line running off above the buck, that's the stick to cook it with. That prophet let the first hunter know about it. That's why the tree is there on the right. He also told that first hunter, "You can also use a stick from the tree to dry your deer meat on, and you gonna use a stick to barbecue on. In fact, you gonna use a stick for everything on this earth. At the same time, you must protect your tree and the forest."

He says to him, "Okay, here's your stick, right here. He gonna make your fire with sticks, and then you gonna chop the branches to use barbecuing. But you must *never* waste your tree."

That's what they said to him.

Fig. 58. Rock writing at EbRj 5.

There he is. He's standing by the river. He's a man, yet he has a deer horn on his head. He's a deer in the time of that legend life. He's called *Shemitz.* In the beginning he just walks like a human being. Some people don't eat deer meat on a Friday because he used to be a man. Walked upright.

If you're gonna dream a deer or bear, and that's gonna be your own power, then you're made to go and wash your face in the water of the stream. Then you can use that. You can dream it. Have you ever seen it as a power? I seen that on the Indians down the coast. They have that, with the deer horns too.[9]

Of course when you dream *that*, you going to be a hunter. The power of Shemitz, Deer Man, is strong, oh yeah. You see? He has a person's hands and fingers—one, two, three, four, five. But he's got hooves, not feet. You see, that man goes to the water all the time and washes himself clean. Then he dreams he can do it. He can put the antler on his head. This would be a young hunter going up in that Stein Valley, and he'd dream it in there.

You know, this hunter wanted a hammer very much in his dream, and that messenger showed him how. That's a hammer below Shemitz. That's used for meat. You hit the bone with the hammer to get at the marrow. In that legend it tells you. The man was wondering how he was going to crack the bone.

Fig. 59. Stone hammer (xep) from Lytton area. Courtesy Royal British Columbia Museum PN548.

91

In that legend time, when X̱wekt'x̱wektl came, [the messenger of the Creator who turned people and animals to stone] that man couldn't get the marrow out. So X̱wekt'x̱wektl says to him, "Here, I'll show you." He made a hammer like this. He hit the bone and the marrow came out. That's what the messenger did. He made a x̱ep. The word for hammer is x̱ep. The prophet did that for him. It's made of ground stone usually, or jade sometimes. You can use it for grinding nuts and stuff like that too.

This other thing up here, that's what they gonna use. They put those sticks up each end, like tipi poles, then a pole across. That's where they dry their meat. A drying rack. It's made like the one out here that Art made for my rose bushes.

This is a story of a dream of hunting power.

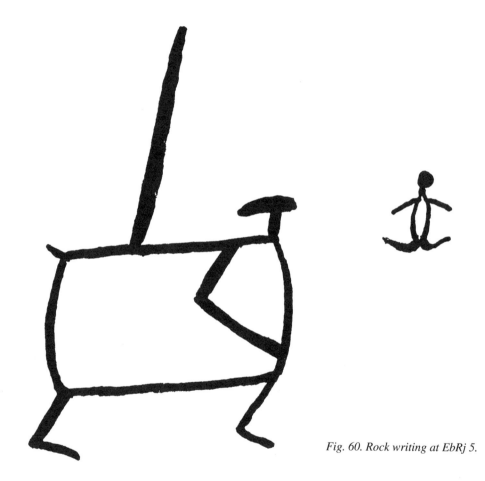

Fig. 60. Rock writing at EbRj 5.

The little man there, that's the one that dreamed that thing. It's not an animal, see? He just couldn't figure out what it was that he dreamed. So his Creator told him, "You gonna have a thing like that yourself. You are gonna make your fire in it one day."

Here's the stove pipe out the top, and at the corner, that's the axe, you see. Down below's the legs. The Vee-line inside, that shows you where the wood goes in from the top.

"This thing," he told the man, "You are not just going to get wood for burning. You gonna have to use an axe to chop it up for the fire inside."

This was the vision of the boiler stove that was coming to this land. That was in the Lytton prophet's drawing too, in Shikbiintlam's vision. Just like that. He drew things that were going to be invented. This was probably drawn in his time. You see, the fire, you're gonna put it inside. That prophet, he talked about that, and he talked about the telephone, about the airplane. Everything.[10]

Fig. 61. EbRj 130. Photo by Chris Arnett.

C. Rock Writing at EbRj 130

This rock writing site is located across the river and directly north of The Asking Rock. The site is composed of the same sedimentary rock fault as EbRj 5, facing it on the north bank of the river. The painting is located in an acoustical alcove, overlooking the river. In the vicinity of the site are a number of small, circular depressions, which may indicate the former presence of sweatlodges. The weathered writing was located by archaeologists Mike Rousseau and Geordie Howe in September, 1979. It is the only rock writing known at present on the north side of the river below the cable-crossing.

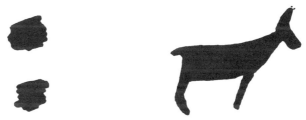

Fig. 62. Rock writing at EbRj 130.

Annie:
This is an animal looking to the sunset. It's not a deer. Its different. Could be an elk or a goat, or even a wild dog. But it has more hoof than dog feet.

But these two big dots, they're the place where the boy is supposed to camp and have his sweathouse. That's part of his training. And he has to do that when he goes out hunting too. He does that in two places, and then he will see an animal watching the sunset. That's the one he will get.

Rock Writing at Ts'ets'ékw

The greatest concentration of rock writings on the Stein River begins where the lower canyon narrows, several kilometres from the river mouth, beyond the Big Slide, a great talus slope of giant granite rocks. Here the trail passes directly beneath two great cliffs of granite which overlook the river. The two cliff faces are separated from one another by a precipitous slope and a 200-metre band of noisy rapids which marks the beginning of a sharp descent of the Stein towards the Fraser River. Numerous

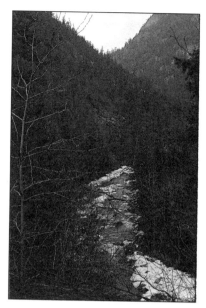

Fig. 63. Ts'ets'ékw, Stein River.

rock writings appear along the two cliffs, particularly at the upstream site. Between them is a third, much smaller site. Almost all of the writings are clearly visible from the old trail. The 'Nlaka'pamux name for this area is Ts'ets'ékw, or "the writings."

Some of the writings here are among the largest single paintings of their kind in the British Columbia Interior (Figs. 68, 85, 94). Although they are much weathered today and difficult to see, when freshly painted in the distant past, they must have been an impressive sight. Teit recorded that some Native people believed that many of the larger, older paintings, as these appear to be, were made during the Mythological Age and "are not the work of human beings, but are pictures made and shown by the mysteries or powers or spirits of the place where they are to be seen" (1918:5). The large figures at EbRk 2 are all identified by Annie as representations of the first men, animals and canoes, experimental prototypes of humans and others existing in the ancient Mythological Age.

High above the two main sites is the small waterfall of Christina Creek which can be seen, in its season, cascading down a rockface above a deep overhang. Between these two major sites there is as well a place on the river called *Nxétl'aws* ("Between the Middle"), a rock formation which, before it was dynamited by Federal Fisheries personnel, created a low waterfall before a deep pool. It is important to remember that James Teit's informants of a century ago regarded cascades, waterfalls, and pools as the haunts of xa'xa'étko, the "water mysteries."

These sites comprise one of the largest collections of rock writings in the British Columbia interior. They are found directly below the great mountain, *K'ek'áwzik*, often described as "the Indian College" and "the best mountain for getting your power" (Bouchard and Kennedy 1988:178). The late Louie Phillips was familiar with this mountain too: "When that mountain, K'ek'áwzik thinks you are ready for your power, it will tell you about your power."[11]

D. Rock Writing at EbRk 1

The furthest downstream set of rock writings at Ts'ets'ékw is found at the base of a tall, exposed granite cliff separated from the roaring rapids by a stretch of boulders, pools and twisted piles of driftwood. The writings are found in six major groups that cover a distance of eighty-five metres along the rockface. The downstream writings are sheltered beneath overhanging ledges. They are easily accessible from the trail, over moss-covered rock. The writings upstream at EbRk 1 are painted approximately seven metres above ground level on the vertical wall of the cliff. These may be the Stein paintings described by Hill-Tout, in his 1899 ethnography, as being "above the reach of the tallest man" (Maud 1978:48). Teit, referring to rock paintings in general, wrote that besides using ladders, "young men suspended themselves with ropes, to make their paintings out of ordinary reach or in some striking place" (1918:4).

EbRk 1 was the furthest upstream site which the guide, Jimmie, showed to Harlan Smith and John

Fig. 64. EbRk 1. Photo by Chris Arnett.

Oakes in 1897. Jimmie informed them that the place "was where girls washed with fir-branches during their puberty ceremonies." He identified writings of bear and bear-cub tracks, as well as an inscription which he said "represented a rattle" (Smith 1932:14-15).

Smith and Oakes made fifteen drawings and Smith took four photographs. Three of their drawings from this site appeared in Teit's Plate XX, Figs. 17, 21 and 22 (1900). Once again they are accompanied by interpretations solicited from Teit's informants in the vicinity of Spences Bridge. The frontal figure (Fig. 74) was thought by Smith to represent a woman, but Teit's informants interpreted this as "a vision." These informants also considered the horizontal zigzags of Fig. 71 to be "mountains and glaciers in valleys."

The furthest upstream set of EbRk 1 writings are also the highest. They are arranged around a diagonal bar of natural iron oxide stain (Fig.75). This "natural painting" was obviously given cultural significance. It was possibly the main reason that writings were made around it. Smith and Oakes thought that the natural stain was a painting and they included it in their drawings where Smith refers to it as "a rod." Smith's sketch of this painting (Teit 1900:Plate XX, Fig. 74) was also interpreted by Teit's informants. The circles and the triangular tracks were interpreted as "tracks of bear and bear cubs." The four curving lines falling from the bar of natural iron oxide were said to represent "a cascade"; and the strange figure formed by two concentric circles joined by a thick bar were thought to be "lakes connected by a river." This latter figure, according to Smith's guide, Jimmie, is the one that represented a rattle.

Fig. 65. Rock writing at EbRk 1. Photo by Harlan I. Smith, summer 1897. Courtesy Department Library Service, American Museum of Natural History Neg.No.42820.

The two major Ts'ets'ékw sites are the only areas in the Valley where grizzly bear images are found. They are more numerous at EbRk 1, a fact which may reflect the importance of that animal to those who dreamed at this location. Until recently, grizzly bears were common along the lower Stein River. The upper valley still contains well-used grizzly habitat. Elders recall special prayers made by their parents to protect themselves from harmful contact with the grizzly population (Rosie Adams Fandrich,

Fig. 66. Chris Arnett examining rock writing on cliff face at EbRk 1, 1987. Photo by Joe Foy.

Ina Dick, p.c.). Grizzly Bear was also a powerful being of the Mythological Age, as well as a strong guardian spirit of shamans, hunters and warriors (Teit 1900:355).

Grizzly bear tracks are often painted in pairs, both in the Stein and elsewhere in the Interior, which may reflect the special relationship between the animal and twins born to 'Nlaka'pamux women. A woman pregnant with twins "was generally made aware of the fact beforehand by the repeated appearance of the grisly [sic] bear in her dreams (Teit 1900:311). After birth, twins were called "grizzly bear children" or "hairy feet." They were considered to be "under the special protection of the grizzly bear and endowed him with special powers. Among these was the power of creating good or bad weather" (ibid.:311-12).

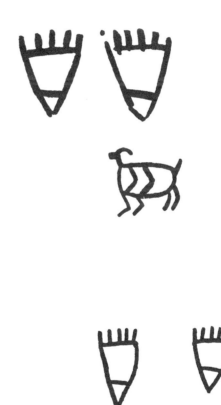

Fig. 67. Rock Writing at EbRk 1.

Annie:

Here, the man on the left, see? Ha! This man, he wishes for *craaaaaazy* things!

He wants a goat to have feet like a bear, ha,ha,ha,ha,ha! Xwekt'xwektl told him, "No. Because the goat is going to live up high in rocky ground, so he can't have feet like a bear. He's gonna have hooves!"

This writin' tells that story.

97

Richard:

What is the difference between the pit snare [Fig. 46] and the bear paw?

Annie:

Well, you see, the bear print has a heel. When it's footprints there's more than one usually.

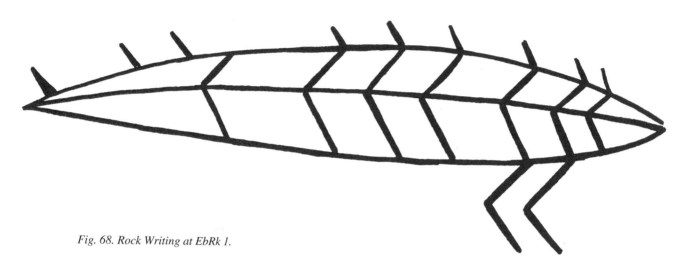

Fig. 68. Rock Writing at EbRk 1.

Annie:

This is ancient, about the time that X̲wekt'x̲wektl's grandfather was supposed to be building a boat, and he doesn't know how! At first he made it like you see here, and he found out when he sits in it, it wasn't very good.

This original dream was the old man's. He was the grandfather of the X̲wekt'x̲wektl boys. Or their granduncle. The X̲wekt'x̲wektls was the prophet and the messenger. They were brothers. They are up in the stars now. I told you.

The old man put ribs in his canoe, you see. He turned it over and he made ribs. Then he said to himself, "That doesn't work so good." So he turned it over and he started hammering it. And he had this here [the two chevrons at the bottom of the figure]. He turned it on that to hammer, but it won't stay there. So he was hammering and the brothers heard him. X̲wekt'x̲wektl said to his brothers, "Take me off your back." So they took him off and he stepped down, and his footprint is on the other side of Lytton, this side of Lillooet (see note 22, Chapter 3 below). He said to his brothers, "My prayer is going to go to our grandfather, so he will know what to do, and how to build his boat."

So he sat down, the little boy did, and he told his three brothers to pray with him. So they prayed with him. And the old man looked at what he'd built and he saw it wasn't right. So he turned it over again, like this. Then he made it different. This time he didn't put the ribs outside like the first time, like here. And first of all, he dug it all out.

By the time he got finished, those boys, X̲wekt'x̲wektl, got there. He had just built the first dugout canoe. He couldn't work it so good because he didn't have the birch there, like they have in other places. So he just dug it out. You see, he wanted the birch bark kind. That's why he tried to make it with the ribs.

98

The prophet prayed for him and he sent him a note to his heart.[12] The old man got it. That's when he looked at it and said, "That don't look right." That's when he turned it over and started building it all over again.

You know what he did? He made a hole in the canoe and covered it over! You see, he was determined to kill that Grizzly Mother person who was chasing the X̱wekt'x̱wektl boys.[13]

When the X̱wekt'x̱wektl boys come up to him they hollered, "Graaaaaaampaaaaaaa! The grizzly's chasing us! Save us! Take us across the river! We're getting soooooooo tired."

So he gets his new canoe and he takes the boys across. Then he told the boys, "Go to Grannie and she'll fix you a nice dinner. She's got *s'kebáx* and all the roots and good stuff from Botanie Mountain.[14] He says, "I told my wife already that you boys are coming." You see, he could tell, just like as if he had a telephone and I'd phoned to him that these boys were coming.

When he learned they were coming, he told his wife, "Clean some of the root stuff and some of the fish. Mix it and cook it. The boys is going to be hungry when they get here."

When the boys got to their grandma she had all the food ready for them. But she told them first to go have a steam bath and be very clean and say their prayers for this life. And they did that, and then they ate.

When he'd got them across the river there, he fixed it again, his canoe. He plugged the hole and when he sits in the canoe the other end went up in the air. So the hole was up in the air. He went back across the river and sat there in his canoe.

Grizzly came up to him and she said, "E'yiiiiiiiiii! I found the boys' parents. Their mother and father want them to come home!"

The old man said to himself, "That's a lie." He had gone to sleep, you know, and he had a dream about that. He knew his grandchildren were coming, and that their mother had died, and that their father had died. Grizzly had killed them.

"Just a minute," he says to Grizzly. "I'm fixing the canoe and I'll take you over." He just kinda loosened that hole there and made it a little bigger. Then he was sitting there, himself, and he said to the Grizzly, "Okay, now, you sit right there!"

He says to himself, "You sit there and plug up the hole!" Then of course when he paddled across the water, there by Lytton, these little fish, these bad fish—you know, the ones that can eat a person

Fig. 69. Model canoe carved from Nephrite with incised "writings" filled with haematite. From Lytton area. Courtesy Royal British Columbia Museum PN504.

in five minutes—they come up. Those fish was there and they eat out the insides of Grizzly Bear. Yeah. So she died. So Ndjimkaa didn't finish taking her across the river. He turned his canoe back and he took what's left of the bad grizzly and he push her into the river.

Another time he done that same thing on the other side of the river to get even with the man [Coyote] who was romancing with his daughter-in-law. Turned him into a rock.

The prophet come to him just as he finished speaking, and said, "Uh uh! You shouldn't a'done that, this time *or* the other time!"

Then he told him he could cross over and see his grandchildren. So Ndjimkaa' ate with the boys and he watched them sleep. The next morning the prophet still watched. The old lady gave the kids dried fish. Something for their lunches. Then they started off again on their travels.

Then that prophet got his message through to the old man. He says to him, "You gonna be aaaaaaaaal- ways smokin'." He took the old man and threw him up over there, up on that mountain near the Stein. That mountain's like a house. You can look at him up there when you're driving down toward Lytton from Spences Bridge. It's on the west side, across the Fraser River from Lytton.

He took and threw him over there and said, "You going to be always watching people, and once in a while, you gonna smoke."

That's because when he was fixing the canoe for Grizzly he was smokin' his pipe.[15] So they call him that name. *Ndjímkaa'huu'éxkt. Ndjim*, you see, is something burning. They call him Ndjimkaa'. So that prophet transformed him into a rock up there and he always seems to be smoking. And there was another man around when this was done to the grizzly, and he was thrown up there too. When he was being transformed he had taken water in his mouth and he was sort of gargling. You can hear it up there on that mountain even today: Grrrrrrr-uh-rrrrrrrrr! That's what Moses Nahlii said to me, and a white man heard it too, a prospector that lived here next door. He heard it too. That one's called Rumble Mountain.

In those days they smoked a mixture of *squay'yélaxw*—what the white people call mullein[16]—and kinnickinick. If you have asthma they let you smoke that. That old man, he was smokin' and fixin' his canoe. Afterwards, the Creator did that to him because, he says, "You did a little too much to Grizzly."

People called Xwekt'xwektl and his brothers by one other name too. What was it now? *MBETCHÍCHIIT!* Really they weren't little bears in those days. That was only their name. They were people who used animal names. Mbetchíchiit means little bears.

Ndjimkaa was transformed into a rock for another reason too. You see, it had to do with that can- nibal, that Opia'skáy'uuxw, and the young boy, Nglíksentem, after he come back from the sky.[17]

Opia'skáy'uuxw, that cannibal, he stole Ndjimkaa's wife and made her crack open human bones and take out the marrow that he loved to eat. He would cache them near his waterfall. Nicomen Falls it's called [northeast of Lytton where Highway 1 passes under the CPR tracks, and where the Thompson River turns west around the "frog rock"]. He kills them, and he puts them down there in the pool below the waterfall. Yeah.

But if you're a strong syux'nam yourself, you can defeat them. Any man who practised way up on top of that waterfall—way up there's a lake with niiiiiiiiice bulrushes around it.[18] If a man is a strong person and he practises there a long time he can kill those cannibals. It's got several heads, that one. A head this way, a head that way, another head. Four heads.

The old man, Ndjimkaa, had Nglíksentem kill the cannibal for him. You know, when that boy came back from the moon he became *very* powerful! He could do anything he put his mind on.

He come down along the river there and he run into this cannibal. The cannibal said to him, "If you're strong enough, you can try to defeat me, but I can defeat you!"

This was near the cannibal's waterfall. Across the river on the other side, down-river a bit, there's a mountain that's all rotted and different colours. That's where that old man, Ndjimkaa put his pipe down when the fight started. He put it on that mountain and he says to Nglíksentem, "You face this way!" It was smoky from the pipe and in the end the boy defeated that cannibal.

That's why he always has smoke on his mountain, summer and winter. Hahahahaha!

"You face this way," he said. Then the old man prayed. The cannibal got a long whip. He hits the boy and kicks him down into the pool at the bottom of the falls. But that boy turned himself into a swan. He flew up, and he started to fight again. They fight on top of the waterfall, in the smoke. He hits the cannibal's head, and the head comes off. He did it again. He did it until the cannibal had only one head left.

He says, "Now, I'm gonna be ahead of you. Can you defeat me now?"

Fig. 70. Nicomen Falls. Photo by Richard Daly.

A while after that was over, X̱wekt'-x̱wektl came back and caught that cannibal and says, "Okay, Cannibal. From now on, you gonna be a spooky place. You gonna spook somebody else from time to time."

That's when he says to the old man, "You see your children up there, and your wife? I'm gonna turn them as a rock, and you as a rock." And he turned them all into rock and that was the end of them.[19]

When that cannibal man was killed, they took and cut him up, all in pieces. They threw it all around. They threw one part to Honolulu. And they took some of his fire ashes and they throw that out there. And to Mexico and those places. So they're going to have volcano the rest of their lives.

I heard that same story, even among the coast Indians. That's how it goes. But one part of his rock was thrown to Ganges [Salt Spring Island]. That's why there's the spring, hot spring there. And I think it's his eye too, the white of his eye. They threw that to White Rock. That's why it's White Rock. They didn't leave them alone in one place.[20]

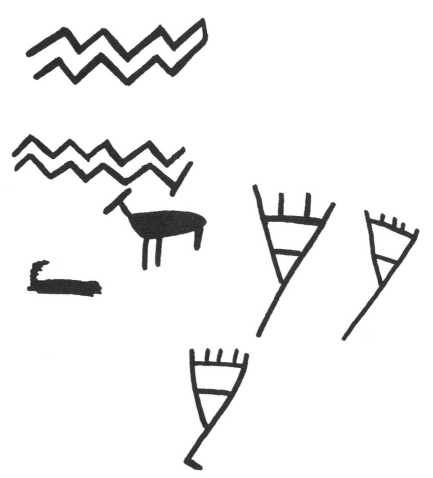

Fig. 71. Rock writing at EbRk 1.

This is another hunting dream. The thing at the top looks like a hunting bag.

The two sets of zigzags, that's a way of showing the number of days of his dreaming. The top one is three-and-a-half days, and the lower one is four-and-a-half days. You count them from point to point. It shows two dreamings with a total of eight days no eating.

He dreams the deer, see? Beside that is ancient animal tracks. Those old dreamed ones sometimes have those tails on them. Maybe that animal was dragging his feet, or it's in snowy weather. Remember Old Paul's drawings?[21] Some of his horseshoe prints were like that too. Maybe it's just the way they dream them.

In front of the deer is a deadfall log for snaring animals. Over to the right is a mysterious figure. If it was up the other way it would be a feather, but it isn't. It's a mouth and it shows that someone is speaking. It's X̱wekt'x̱wektl that's speaking. When you got no modern written words and someone is speaking, you have to write his mouth to show he's speaking. You can't write it any other way. He's speaking in the dream and telling the hunter how to get what he wants out of life.

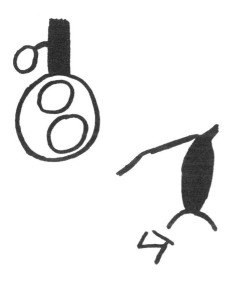

Fig. 72. Rock writing at EbRk 1.

On the right these are probably grizzly bear tracks because they are so narrow on the heel. The funny writing in between, that's the way you write it when you talk to somebody when you're all by yourself. You say, "Oh, look! There's a grizzly bear track. Oh yeah, it's really something!" Those Chinese-y lines, that's how you write that sort of thing.

The solid figure in the middle, that's a bird, you see. I know because he's picked up that long thing and he's going to make a nest. His feet's down below.

Above that is a nest in a tree, a nest for owls, with two eggs in it. It tells you that the Creator told the birds when they was created, how to build their nest in among the branches. That's when X̱wekt'x̱wektl came and watched them. God's messenger. Before he came and turned them all at once

into birds, they were human and talked like humans. Only their names was birds'. This is one of the creation stories of X̱wekt'x̱wektl that he's dreaming here. X̱wekt'x̱wektl was one of the gospels of God and he listened to all the chatter of the bird people and he turned them into birds. Like the little chickadee. That little chickadee and another little one. Always fussing and telling tales. Tse'gigii! is one of them, and Huuwii'hii! is the other. He turned them into birds and told them, "People's going to call you those tattle-tale names from now on."

"Tse'giigii! Tse'giigii!" That's what one of them says. You've heard it. The little lines under the bird, they show the song that he sings. You know a bird uses his feet as well as his beak when he's building the nest.

The writings here about the grizzlies and the birds, they are side by side because when X̱wekt'x̱wektl turned the Bird People into birds, he also turned the Grizzly People into grizzlies. You see, before that they were all human people. They just had animal names as their names.

Those Mbetchíchiit boys, the little black bears, X̱wekt'x̱wektl and his brothers—they were humans too. Their mother's name was Black Bear and their father had two wives. The other wife was Grizzly Bear. Grizzly got jealous of the other wife, the mother of the Little Bear Boys. She had her own kids, the Little Grizzly Boys.

Grizzly was *jealous*. She hit Black Bear and took her home and eat her breast. That's what she did! Then she killed her husband and eat part of his body too. Just put it in the hot ashes and cooked it. And when she did that, the littlest boy, X̱wekt'x̱wektl, was watching her. That's how he got the job of doing that for people. Oh, he looked at what was going on and he felt so sorry when he see his mamma's breast was cooked, and he said to his brothers, "Oh my mamma's breast, she's cooking it!"

So they have adventures and they trick Grizzly and afterwards they are safe and they grow up to

Fig. 73. Left print of Transformer's foot on boulder at Stein. Photo by Richard Daly.

be men. After all he'd been through, X̱wekt'x̱wektl got the power from the Creator, and after they grow big he's asked to watch over the people and check on them, all of them right down to the saltwater people. He was kind of a crippled child with power, and his big brothers took him and sat him on that rock this side of Lillooet. The impression of his lame foot is there in the rock.[22]

Afterwards, he checked up on the people. He does *everything* to them, and he usually overdoes it. Then his Creator tells him, "You should never do these things. I just told you to check on them, not to transform them so much into stone."

Yeah, that's what he did to them. Downriver, the Sto:lo call him X̱a:ls or X̱ax̱á:ls, and there too he transforms everything to everything.

It started when he saw Grizzly cookin' his mother. He said to himself, "I'm gonna turn you into an animal." And he did! Just like he did with the Bird People. But he should *never* have cursed her that she would go after people. That was the worst thing he did, because grizzlies still do that. But there's a day coming yet when the grizzly's gonna be different again.

These are old old stories about when the earth was young. They tell about the sun, the moon, the earth and the sky.

Fig. 74. Rock writing at EbRk 1.

See that one? It's a person. S'got hands. But this line here at bottom, that's the line of the ground. But that person, that's the story of Stánax'hew. That man that was turned into the sun. You see it in his head. The rays of the sun are coming out of his head. They turned him as a sun and told him to go up in the sky. There's this earth you see at his feet. They said to the earth, "Oh, you gonna suffer a looooooooooooong time to come!"[23]

There were four people whose names were Stars, Moon, Sun and Earth. Earth was their sister, you see. And she fought with her brothers. Sun, Moon and Stars moved out and lived somewhere else. The Creator turned them into what they are today and said to them, "Don't go deserting people! Stay there so people can always see you!"

He transformed the sister, Earth, into the earth that we know today, and that's when he said she had to be mother and home to the first real people and that she was going to suffer a lot.

The curly line inside him is what he's thinking. It also shows how bright and shiny he is. The tail thing is the way the sun shines down into the earth sometimes. The round thing between his legs, that's to show that one day in the future there's going to be a difference between a man and a woman. He's a man.

[After reflection, Annie offered an alternative explanation of this figure and, on one of my subsequent visits, when we reviewed the two versions, she stated that she preferred the second explanation. This interpretation follows.—R.D.]

It's about that man called Beaver.[24] That's what I think it was. You see, *Snúuya*, that's Beaver. When he was being joined to an animal he was doing mischief things at the mouth of Spuzzum Creek. They told him, "Okay, you doing mischief things. You think up mischief things, so you're not going to have a tail like the other animals'. You gonna have a *round* tail! Yeah, round and flat. And you gonna be always working with it, your tail and your teeth."

This happened at Spuzzum Creek, so I guess after that a young man went up to that Stein country and dreamed and draw it there. Every person, some young men, they traaaaaaaaaavel around these mountains. I tell you, George Henry from Lytton, he was one. He was related close to us.

The story of Beaver happened here, but it travelled upriver.

This drawing is Beaver as both man and animal. He's got arms and hands and human legs. He's got the tail. He has a fat tummy—you see, he went down to propose to a lady at Spuzzum Creek. He asked her to marry him, but that lady said, "I don't want a man lookin' like you! You got a big fat gut! S̲x̲'anek! Nanek! S'kusta!"

She called him *every* name! Said she didn't want a man who looked like that! She said, "You got a big gut! You got a big belly!! Ha,ha,ha,ha!!!!! You got a big backside!!!! And a big—— ha,ha,ha,ha!!!!!! You got a big tail! You got a slant eye!"

But she told him, "You are gonna carry aaaaaaaaaaaall kinds of legend stories always in your bones."

And it is! You know, I seen it. If you kill a beaver and you cook it, you see all those diiiiiiiiiiifferent shapes of bones. There's even one the shape of a woman's house. I didn't believe that until my grandmother cooked a beaver and I saw it. The white sucker-mouth, that fish—if you cook it, you see the stories in its bones as well.[25]

So that's what that lady said to Beaver. He said, "You needn't think you're gonna stop me with what you're thinking."

He stood up above her, put his back up like this. His head was against the sun so the rays come out around it. Nice sunny day like today. So then he went, "Whiiixw, whiixw, whiixw!" He went like thaaaaaaaaaaaaaaat. After a while there was a *great rain* come down. And in a few minutes that lady's kiikwilee house was half full of water. That lady was sitting there all miserable and making herself as small as possible.

He kicked her and she turned into a frog, a greaaaaaaaaaaaaat biiiiiiiiiiiiig frog. Beaver swallowed that kiikwilee house in water. He slapped his tail. That's why, ooooooooooonce in a while you see a beaver there at the mouth of Spuzzum Creek. You know, I seen it! One time Arthur was working on the highway and I got lonely, so I took my tatting and I walked down there, sittin' at the mouth of the creek.

I was lookin' at all my ancestors' graves and feeling sad, and I turned to look. Here was Beaver, cuttin' a tree. And beside him a biiiiiiiiiiig frog was there too, right at the creek.

I came home and I never told Arthur, but I told the old chief. The old chief really got after me. "When you see odd things," he says, "you don't tell it! If you do, you gonna get sick."

The curly line inside Beaver, that's his thoughts, about that lady, Frog-Woman. And the ground line is the flat where he's standing.

The man who dreams that—I guess he was trying to make what you want to do, easy. Looks like he dreamed just the one figure. That's what I was thinking about. The people knew all these stories, and most of these stories have been dreamed by other people. So they write it on the rocks. The story comes up in their dream, so they write it. Something like hippies! You ever seen one, a hippie? They eat that mushroom, then they dream about these things. Then they write on the wall just what they dream. The hippies.

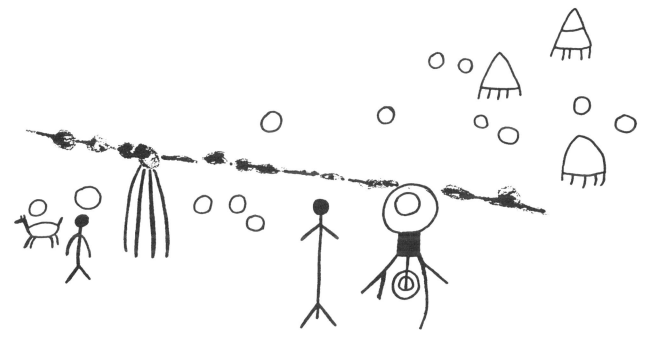

Fig. 75. Rock writing at EbRk 1.

All that writing there in the Stein! I don't blame the Indians wants to preserve it. It tells you from the beginning of this earth, when the earth was young, and these persons smart enough to write it in there, what they dream. That was the way it began.

[Upper right side] Three different animal footprints. The rounded one of the three, that's the bear, black bear, but the grizzly always have a sharp one. Up above that is the grizzly print. He always has the heel print. On the left? Oh, there's a brown bear and a black bear. It's the brown bear. Very similar to the grizzly.

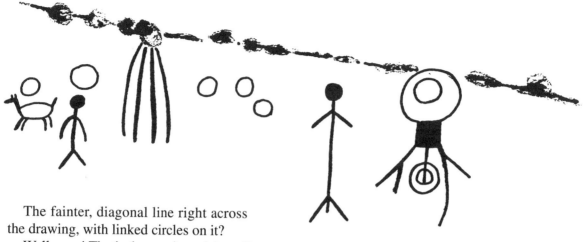

The fainter, diagonal line right across
the drawing, with linked circles on it?

Well, sure! That's the passing of time. One,
two, three, four. Five, six, seven. Eight, nine, ten, eleven. Eleven suns have risen. Each one is a sun
making its full journey over the day.

Down bottom left is the praising of the paws of Grizzly. You see, it's at the time of his cre-
ation, the creation of his footprints. They praise them. The reason this is here all by itself is
that this person was told, "When you go out hunting in the world"—it must have been a man
who done the dreaming—"if you see this footprint, it means you are going to dream about
some animal that is going to be your power."

[Left side] Look at this animal, and this is a man! The suns over them show the time of
day. The dreamer sees himself created about noon, and the deer he wants, it was created in the morn-
ing. Beside them is a woven grass mat tipi, for his sweathouse. He dreams its creation on this earth.
I seen that tipi sweathouse sign lots in my grand-aunt's rabbit-skin book from her own training. It was
a dream book—of the creations. Used to be all the Indians had those books—the deaths, the ances-
tors, the children, where they come from.

Next to the sweathouse, three circles: That's the three important times of day. It's also three days
passing. Then there's a man, tall, strong man, powerful. A doctor, a syux'nam. The three days were
his dreaming and it brought his power.

This syux'nam, you see, he dreams the world that's going to be. Beside him [right], at that time
there was no such thing as pots and pans and big hats. On top might be a hat or a big pan. He dreamed
aaaaaaaaaall the things to come. That's what he's dreamed. It tells you these things are coming. It tells
of the time that these things will bring. The bottom of that figure, here, it tells that you gonna have a
pot that hangs down—a frying pan, anything. This man here, this powerful man
is dreaming these things. He tells anything he dreams. He marked
it down, even if it hadn't come into being. The old people all
do that.

All the circles with the footprints,
that's hail. He dreams a big hail, and
some day we will have that. A big fall
of hail and there will be nothing on the
ground. There will be nothing to eat. That's

108

what's gonna happen. You see that Alberta? It has some of that. I have a friend there. She tells me one time they are as big as a golf ball. Her brother's garden was just cleared out. That's what it tells.

Richard:

What about the image that is said to be four metres to the right of these figures?

Annie:

Well, they do that. That means those dreams are *faaaaaaaaaaar* apart. That's why they do that. That far-off one, that tells the time of day. That man went dreaming to look for his power. His Creator came to him and told him at such and such a time you can eat, or go bathe. That's why he writes it like that. He was foretold all this before he did it.

If the long rays come out the right side of the sun drawing, it's late in the day. If it's from the top of the sun, that's noon. If it's the bottom of the sun, it's the full day. If it's just a few rays on the left of the sun, that's the morning sun. So in this drawing, it's late in the day. Afternoon, and it's a *very* hot day too, because you can see the looooooooooong strips of sunlight. So it's the summer.

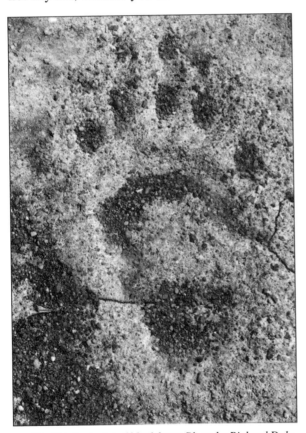

Fig. 76. Footprint of black bear. Photo by Richard Daly.

These are all separate dreams [Fig. 75], probably by one man. Because he can't go home until he dreams aaaaaaaaall those things. He dreams many times. I think it is one man because of that long line that shows a lot of time passing. Today the young people go up the mountains just for two days. Then they come down. Ha,ha,ha,ha! NOT IN THOSE DAYS, I TELL YOU!!! Some stayed months and years until they were fully trained. They did their dreams and they got their power.

Today is craaaaaaaaazy! People sweathouse themselves right outside their house! They tell everybody to go in there together. Even men and women together! I've watched them. Everybody goes there. Then they jump in the creek. Then others goes into the *same* sweathouse! Well, they *never* do that before! That is not training! It was *always* by yourself and far away in the mountains. They're taught by the old people what to do, but each one does that training all alone. Aaaaaaaall the whole thing.

You make the fire and heat your rocks yourself. And they teach you how to do it, like this, and put it into the hole, and they put sticks like this. And when you gonna—you say your prayer just before you go in there, and then you pull this cover over, and you throw the water on the rocks, and you sing.

You put on herbs to smell, the needles of a tree. Different families have different ones. You line up those little branches on the rocks with the sunrise and sunset. The ordinary one you use in the mountain is the fir. You might use sagebrush, but not for training. Only for sickness. Then you slap your skin with fir boughs, and of course you sing! There's a song for women, and a song for men. The way you sing is different for men and for women, and there's different individual words for each one that does it. If you are a young lady you gonna ask that sweathouse, you gonna call her, "Grandma! Grandma, I'm coming to get strength from this sweathouse, and you gonna help me get it." And when the boy goes in he must say, "Grandpa! Grandpa, I'm coming in here to get my power from you." I know how it's done. I watched old Mrs. Patrick from Yale. She showed me.

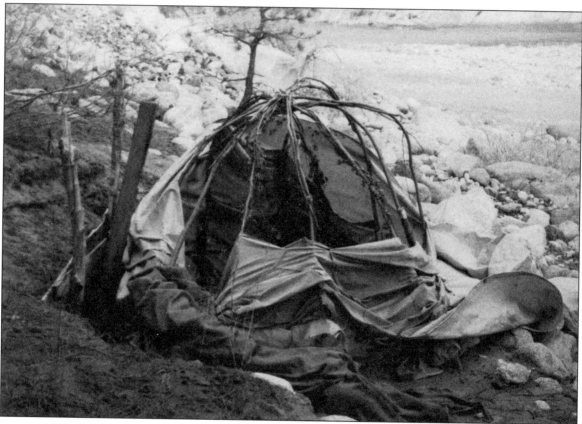

Fig. 77. Sweathouse at confluence of Stein and Fraser Rivers, 1987. Photo by Chris Arnett.

E. Rock Writing at EbRk a

I located this tiny group of faint writings in July, 1988, beneath a thin layer of moss, sheltered by a small, granite overhang with a narrow ledge a few metres above the old trail overlooking the river. All of the figures are painted with very thin lines suggesting the use of tiny fingers or a small brush. Another writing on this panel, not shown here, is a large smeared rendering of a mountain goat.

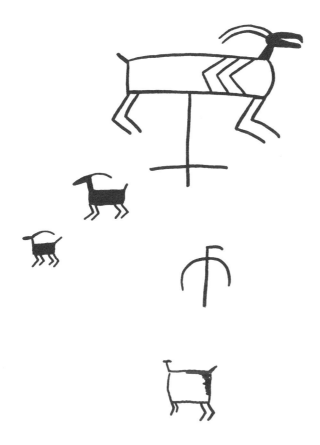

Fig. 78. Rock writing at EbRk a.

Annie:

The animals at the top, you see, the little one and the little one, and the huge one, that tells about the story of being greedy. X̲wekt'x̲wektl came to this person and asked him, "Which animal would you always like to have here on this earth? Do you want the little one, this size, or do you want the huge one?"

The man said, "I want the *big* one!" So X̲wekt'x̲wektl says to him, "You're too *greedy*!" And they made animals for this earth from the little size to the bigger. No huge ones. That's why."

They're hunting animals. Animals to eat. Could be they are deer. The big one has those stripes...

Richard:

Do you mean those chevrons, Annie?

Annie:

Yeah. That shows that in those first times the animals were different. Like when God created the first bear, they say he had a tail. X̲wekt'x̲wektl saw it and said to the Creator, "I don't like that bear to have a tail." So he says to the Creator, "Can you create him without a tail?" That game animal, you see, was probably from those early times. When they were created they had different colours and stripes. The stripes show that it was coloured. Different markings from now.

111

That thing under the huge one, that tells the dreamer what he's gonna do with the animal. It's his barbecue stick! It's a barbecue stick and it's holy. See, the cross and the four directions? You get your barbecue stick ready before you cut up the animal. And you never kill or cut up an animal without saying a prayer first. That was a command from the Creator of this earth.

The biggest game animal has like a beak on him. It might be that he's very ancient. You see, the dinosaurs had beaks, and the birds got it from them. Very long ago. This is a dream about animals very very long ago. They had old old bones at Skaha Lake. My last grand-aunt, Grand-Aunt Josephine told me. But that man, Ellison, he raked it all up and he burnt it. And that Okanagan's where the Ogopogo lives too. To my thinking that's a huge, huge bullhead. The biggest bullhead I ever seen in my life was at Pitt Lake. I was fishing as a little girl, and I looked at the beach. I got scared and I run home and cried all the way to my mother. I seen a funny-looking snake, as long as you can reach, and with all the markings, and those pin-like gills to breathe through. It must have been one of those old, old animals from when they were first created. When an animal looks very strange in these writings, that's a sign that it's a very ancient creature.

Richard:

The figure in the middle? Is it an eagle?

Annie:

That's showing you how the bow and arrow should be made. It's not an eagle figure. That's the way the bow and arrow is made. You see, it's in a legend. That man wants it a little straighter so he can fit it over his shoulder. That smudge above the bow and arrow, that might be his *ta'áda'iist*, his target. You get your bow and arrow and you try to hit that. There's one of those targets a little this side of Merritt, at Gweesgwenaa' [Canford]. I guess that woman— what's her name—Rowbotham—she had quite a collection of arrowheads from there.

The figure at the bottom, the square and chunky one, that's a bighorn sheep. The Indians used to make their clothes from it. Today they use sheep wool but that isn't right. And the horns, they make spoons out of that. Big spoons. I seen it. My grandmother had one. She didn't give it away in some potlatch. No, she give it to the Indian Agent. You know, those Indian Agents, they're terrible. They collect *eeeeeeeeeeevery-thing*. One man, he's got *hundreds* of baskets in a collection, and he's always poking at me to make him one, but I said no.

F. Rock Writing at EbRk 2

This site, with more than 160 individual images painted along a 120-metre section at the base of a brooding granite cliff, is one of the single largest rock writing sites in Canada. The writings are found under fallen slabs of granite, beneath overhangs, on boulders and across vertical rock faces from ground level to a height of seven metres.

Unlike EbRk 1, its downstream, more exposed neighbour, EbRk 2 is more like a sanctuary: the cliff being sheltered from the river by a boulder-strewn sandy grove of tall cedar, fir and cottonwood trees.

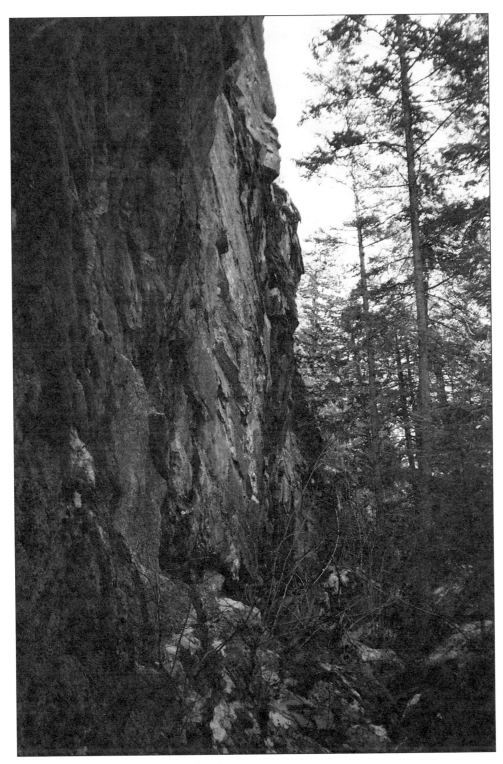

Fig. 79. EbRk 2. Photo by Richard Daly.

Still, the proximity of the cliff to the rapids adds the ever-present acoustic dimension found at other Stein sites. The sounds of the river echo back from the face of the cliff, giving voice to the place.

This large site was not revealed to early researchers by their Native guides, even though they were shown the EbRk 1 site 200 metres downstream. It seems curious that, having shown the archaeologists two rock writing sites where young people trained (EbRj 5 and EbRk 1), the guides did not continue a short distance upstream to reveal the largest group of writings in the valley. Today, local knowledge associates this location with the activities of Indian doctors (Shirley James, p. c.). There is no reason to believe that its use was any different a century or more ago. As discussed above, Indian doctors, syux'nams, such as Kanu and Klemshu from Spapium and Stein respectively, and Mek'cha from Spuzzum, and no doubt others, went up into the Stein River Valley to dream years after the nineteenth-century archaeologists, Harlan Smith and Hill-Tout, concluded their studies (Bouchard and Kennedy 1988:120; Rita Haugen, p. c.; and Annie York). Many of the writings at this site are identifiable as the guardian spirits of 'Nlaka'pamux shamans as described by Teit in his ethnography of 1900. If the number of paintings is relative to the sanctity, power or significance of a site, then EbRk 2 was the most sacred, powerful and significant site on the Stein River. Perhaps it was considered to be inappropriate or possibly too dangerous to show outsiders. The large sites of EbRk 1 and EbRk 2 were recorded by David Sanger in 1961; drawings of some of the writings appear in Corner (1968:42-45).

Not until the early 1920s did non-Natives begin to learn about the site. C.J. Hallisey, for instance, located this site "in the great granite belt" and made sketches of twenty-five of the paintings. He gleaned some information about these drawings from local elders:

> We lingered here for some hours, sketching and making fictitious guesses of interpretation. We noticed that no remains of campsites could be seen which we were to find out the reason later...no Indian would make camp under or near painted rocks regardless of how good the campsite. (Hallisey n.d.:3)

This is again indicative of the sacred nature this place and others held for the Nlaka'pamux people.[26]

The number of paintings of two-headed snakes at EbRk 2 is remarkable. No other rock writing site in British Columbia has as many clear representations of this supernatural being. Only two other sites in the Interior have recognizable paintings of this creature and only one painting is represented at each site. At EbRk 2 there are twelve—a strong visual statement of the importance of the two-headed snake at this particular locality: nowhere else in the valley are paintings of it found. On the coast, paintings of the two-headed snake exist at rock writing sites in the fjord country around Sechelt, Howe Sound and Burrard Inlet (see Gjessing 1952:70, Fig.6).

Most of the Stein images have two heads, large eyes, an open mouth with protruding tongue, spines along the back of the body and, somewhat incongruously for a snake, legs. This is also the way the creature was depicted in coastal art, in painted and sculpted form.

Among the Coast Salish the two-headed snake, as a supernatural being, "gave power almost exclusively to shamans" (Barnett 1955:147). This is echoed by Collins (1974:169-70) in relation to the Skagit people: "The two-headed snake, sulwa'us, was one of the most highly regarded of shamanistic spirits....This snake spirit was associated with the rainbow and also with thunder."[27]

After recording the various versions of the two-headed snake at EbRk 2 I asked Amy Hance, who lives on the nearby Stein Reserve, if she knew of a two-headed snake. She did, and she called it *klu'biíst* (The Pacific Rubber Boa, see below). Annie York did not identify any of the two-headed snakes at EbRk 2 as klu'biíst. She interpreted them in two different ways, sometimes as abstract "trail notations"

about weather conditions, and sometimes as cultural symbols relating to the double-headed serpent, good fortune and greed. She did, however, identify another prominent image at the same site, the so called "Stein Owl," as the klu'biíst, or, as she called it, "slug snake," in its dream form representing a powerful winged hunting spirit and the harbinger of death.

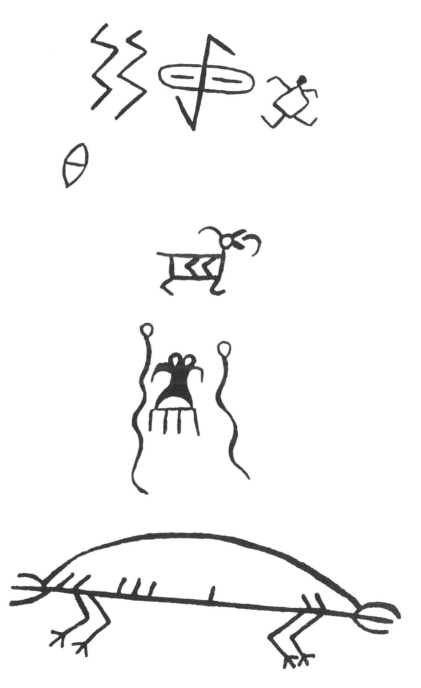

Fig. 80. Rock Writing at EbRk 2: Ts'ets'ékw.

Annie:

That big creature low down, that looks like an alligator. It's a sea animal. You can tell by its shape. That's the head [left], and that's the tail [right]. And the little lines on the body show the shell. All those seafoods got shells. Both ends are the same! It can have a head at either end. When the earth began it was like that. The animals were strange, until the Creator fixed them. This man got a wife like that back then. She's got a head on both ends! So when she was gonna have a baby there was no kids. So Xwekt'xwektl took a cherry wood. Cut it all into ribbons. You know cherry wood. After you get through cutting it, it goes all like this. Goes into a coil. So she took that when she's in labour, but she can't bring the kid around, so she took that thing and she hit herself right in the stomach to disappear her other head. Then she was confined and she bring the baby.

Those early people weren't made right. And *then*, when that baby was born, they didn't know how to do it. That string, you see—your navel string—Xwekt'xwektl run outside and said to his brother, "You go and look for some cut-grass. I know what to do!"

You see, a navel [umbilical cord], it has a little lump on it. But you must cut above that lump. If you cut it too close, you'll never grow big.[28]

Xwekt'xwektl took this piece of cut-grass and he wrapped a piece of sinew around the cord, and he used the grass to cut. Then he threw the grass away. You see, you could cut your finger with that grass. I could do surgery with it, ha,ha!

That was the first baby. So he told the woman, "Now people is going to be like that from now on."

He took the baby and he made a cradle. That's why the Indians have cradles. He took grass and this cotton stuff from inside like a cone, to line the cradle. You can roll it on your leg and weave with it.

This sea creature was dreamed this way. With a tail where his head should be. And his legs, they walk in opposite directions. But after that, Xwekt'xwektl fixed them all.

Oh, look! That animal like a deer, sort of. That ancient animal was always eating snakes. You see, in its mouth? Xwekt'xwektl told those first people, "Don't you eat anything that eats snakes!" Like, you know, a Dolly Varden trout? An Indian will never eat that. So he tells them not to eat anything that eats snakes or looks snaky because the snake is supposed to be evil. That's why when they sees a snake, most human beings, they screeeeeeeech! Some people won't eat steelhead because they sort of move like a snake, and me, I won't eat sturgeon. I don't like the look of it.

Above that animal there's that oval with the slits and the line up and down. That's really a weather-teller. The weather symbol. When you see that sort of shape in the sky, when the moon or the sun has a black mark here in it, you can tell that there's going to be bad weather. It's really a cloud and the up and down line is how the light and shadow comes through it. You often see that. One kind is the sun-dog. Every day it's been there—that's why we got this wet weather now.

That sign comes from when the sun threw out his little children.

116

You see the little person? That person is running away from the bad weather. Of course on the other side, that's the sign for a lightning storm, the two zigzags. Below that, that sort of football, that shows the thunder. You see, a thunder comes in a ball sometimes. It rolls onto the earth and it makes a big clap! It hits the earth and does that.

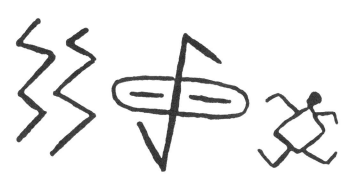

My mother said it went right through a house at Yale. They were clearing out a chicken house, and my mother heard the thing rolling in. She was brave enough. She opened the door as soon as she seen that thing and it rolled across the floor and went clean outside where it made a really big ditch. It's a wonder it didn't explode in the house.

Above the sea animal there's the earthquake signs, those two things with long snaky tails. Between them is the Siamese twins that's associated with the earthquake. The sun tells you, and the moon tells you about the earthquake. I'll show you some day. Moon comes out nice and a nice little star comes along. If she travels with the moon, beware! You can have an earthquake summer. When San Francisco was going to go down, I told Arthur, "You come and look at the moon and what she's gonna do, and at the little star!" In Vancouver when it was going to earthquake it goes like that too. That's how Indians can tell an earthquake. Of course today the stupid ones can't tell.

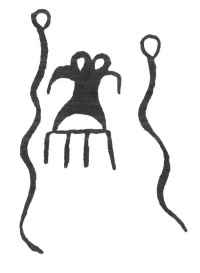

That Siamese twin sign between the earthquake symbols—that stands for a thing for measuring the size of the earthquake, and it stands for the twins. These two twin brothers were travelling together, and they went into a sweathouse. Afterwards, one starts fighting with his twin brother. People say to them, "Why did you people do that? You gotta get out of here. Earthquake'll come."

They don't listen. Then the people went away. The earthquake came and buried them both there. But X̱wekt'x̱wektl came along and took them out of the earthquake and throwed them up there in the sky. They became that star that races with the moon. He tells that star, "You're the first one I heard [after the quake]. So you're gonna follow the moon. You're gonna foretell Earthquake."

And they do that. I often see it when I don't sleep. I put my pillow up and on a bright night I watch the sky. They go together, that star and the moon, right through the night. Sometimes if it's going to be a biiiiiiiiiig earthquake, that twin star goes *straight ahead of the moon*. They don't stay behind. But if it's going to be just a little one, they just follow the moon.[29]

The northern lights is not here, but they have that too, the people do. On a northern lights basket. It's a day and night basket. You go to the museum and you can see that one. The design's got black on one side, the evening. The day is fair, cherry wood for the day. The night is dark. The northern lights is sort of jagged on the night, like teeth. I had that in my basket.[30]

And the straight one, with different colours, that means a rainbow. They have it like this [motioning parallel lines]. It's always black, white and brown. That northern lights is always white against the night side.

The lightning and the earthquake are both written sort of snaky. That's why you have X̱wekt'x̱wektl telling the first people never to eat things that eat snakes. Those things are connections in the dream. And you got to never eat meat every day. Not eating meat on Fridays didn't start with the missionaries. It is a very old Indian teaching. If you don't follow it, then one day when you go to eat meat it will be just like eating snake. Those Yukw people who lived down by Spuzzum Creek, they brought that rule about not eating meat every day too.

That earthquake sign is very ancient on this earth. It tells that in the end of human life we are not going to have earthquakes. The last people that's going to be here will devour ourselves with some kind of sickness, some kind of starvation. That's what the prophet, Shikbiintlam said. When people think of earthquakes they think of punishment for doing wrong. That's why that's here. The Indians were great people for believing that you're gonna be punished. If you don't do what you're supposed to, the weather can change, the animals and the fish can go. All that kind of thing. We're coming up to that right now. We people do all kinds of evil things nowadays, and we're gonna be punished. That's what they told the people. "If you pick berries on Saa'jutsham, Sunday, or you eat meat on Djuutka'ásḵ, Friday, you gonna be punished." And the Indians will get after you. The chief will tell you, "You're wasting the food! You're not supposed to do that."

You see, before the coming of Europeans we had many things. We had the days of the week, and the moon was the month. The days are Djiipsha'áskt, Opinatsha'áskt, Katsha'áskt, Moosha'áskt, Djuutka'áskt—that's what they call a Friday—Chiitsha'áskt, and Saa'juútsham, that's Sunday. They call it Saa'juútsham because on that day they tie a different knot. Every Sunday, on the date string.

There's a different knot for each month, and each six months. All families would keep a knotted string calendar in them days. Every old person before. I seen my grand-aunt do it veeeeeeeeery much.

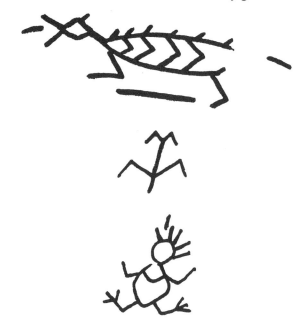

Fig. 81. Rock Writing at EbRk 2: Ts'ets'ékw.

Annie:

You see the little figure at the bottom, and the plant above it? Look at the feet and you can tell. Bird's feet! That's when the bird was created. I seen that in the other life. When it was first created like that it was so clumsy it couldn't fly. So the man drew this drawing here, above. He said, "From now on, this plant will be the model for a bird that can fly. This plant will represent the birds. The plant represented the bird, and they made the bird just like that. It holds its leaves out like wings.

Up on top, that's another early form of an animal. Afterwards it has a feather, but different colour. It was a long bird. It was unsuitable. A long bird can't fly. So that same person who wants the bird, he says, "I don't like that. I like to see a short bird that flies." That X̱wekt'x̱wektl asked that person all sorts of questions about the bird he wanted, because he was sent by God to be like an instructor, but he didn't do it quite right with the bird, so he was taken away from here. You never seen such a long bird in your life. It was just when they were starting.[31]

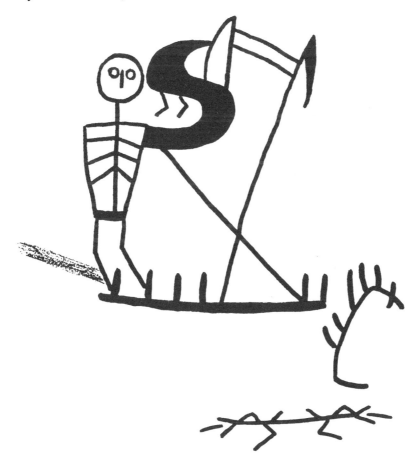

Fig. 82. Rock Writing at EbRk 2: Ts'ets'ékw.

Oh, that's cute! What you see at the bottom, that tells you the time of the weather. That's the one! It's a long line with a kind of tongue at each end. The right end is north, the north wind blowing, and the left end is the south wind blowing. You see, one leans this way and the other one leans that way.

East and west would be the other way, upright, vertical. If I'm going north on Indian writing [draws] I put this mark [a direction arrow with a pitchfork sign for north]. You can use a pitchfork sign or a tongue sort of coming out of a vee. It's the same thing.

If you look at the top side of the long line, it tells you how many days are involved. Start at the south end [left end]. There's a slanty line coming down to the left end of the line [like an upper jaw], then a hump and a slanty line going up from the line toward the right. Well, that's Day One. Then between the next two lines, slanting opposite ways, that's Day Two. Then there's two slanty lines going in opposite directions—again with a hump in the middle of it—that's Day Three. Then you see the two dividers under the long line, like legs.

Those show that for most of the first day it was stormy and windy; then from that evening and through all of Day Two and into the morning of Day Three, it was good weather. Then it blew up again in the afternoon of Day Three. You see, as well, when a day is stormy, it's written above the line too, as a hump. So there's a lump of storm in the first day, and another in the third. Down below shows how long the bad weather really lasted.

The horizontal one is always north and south in a straight line. East and west in a straight line is always written up and down. You'd see *hundreds* of them in the rocks if you went up Broadback. All different kinds. [Can also make them with branches and set them in the rock crevasses. There is often an arrow marking the direction taken by the person who has left this sign.]

When you have a horizontal north-south line like this, I'll tell you something. The wind for a storm there, it's always from the north, cold and bitter. You see, the old people say that the south wind is warm and soft. You get a chinook. That's not a real storm and it wouldn't be written down. So on the north-south line the storms are north wind. Bad weather. Cold. On the east-west line, the storms are generally from the west.

I guess what this is is the weather, while this man was dreaming his dream. That Indian writing, I tell you, you gotta be pretty clever to know all those, but that's the symbols of it. It took me three years to learn that from my grandmother.

Above the timing of the weather is the half-finished man. To the right of him is the sign that tells six days—that arc with the six lines coming out of it. Six days it took to create all this. You count from the left: one, two, three, four, five, then the six is a half day. It's partly below the arc.

This is one of the drawings for trying to make a man. He's got a head and a skeleton. See his spine and his ribs. But he's got no feet, no arms, no hands, and his head's not finished. You see, Xwekt'xwektl tried to make it and his creator said, "No, that's not so good. We want hands and arms and proper legs."

When he was being invented it was like that. His spine's down the middle here. And he needs proper breast bones and a collar bone. Not straight like here. I seen people who's square up here but they never live long.

It was the first one and he didn't know what he was making. They were developing it.

You see why he needed arms and hands? All the stuff coming out his side is the tools he needs hands for to use. The part against his shoulder, the part that's all coloured in, is that smuuts'k we talked

about before. Like a square, for measuring the s'kútsamen corners of a house. I seen the old chief using it. Boy he can *really* use it!

The smuuts'k can be used in canoe-making too. See those two prongs sticking out of the smuuts'k at the bend? That's for gauging the thickness of the sides when you're making a dugout canoe. They stick that over the side and check it. My father made one and he started at the centre where it was thickest and he kept doing it all the way down to the end. They watch that marker as they go down. The side stays about that thick [about 1.5 in., or 3.5 cm.]. Some's thicker, but that's normal size.

You see, they know all the proportions. When they go to cut down the tree, they cut a *big* tree and they put that smuuts'k on each end and calculate. They count the—the proportions to get it balanced from both ends. When they are very, very finished, they fill it with water and put in hot rocks to steam and spread it a bit. Then they prop it out.

Fig. 83. Late Lil'wat elder Charlie Mack making a cedar dug-out canoe at Mt. Currie, 1975. Photo by Dorothy Kennedy. Courtesy Royal British Columbia Museum PN4623-9.

The long pole that runs out under where his arm should be, under the smuuts'k, that's the *tsúu'kwamiin* for poling your canoe. And if you fit it with a hook, it's used for gaffing fish too. The other one, to the right, is a little different. You know Indians got a different tool for everything before. It has something on the end. You put that down and use it for feeling what the bottom of the water is like, so's you won't snag your net or your fishing line. It's—I forgot what they called that. We used it when I was small. You know, I almost grew up in a boat, down at Pitt Meadows. My father called it *n'muushiax'sten*. You know, you can use it too, for poling your canoe, like the tsúu'kwamiin.[32]

Between that feeler and the smuuts'k is the tool they use for digging out the canoe. The adze.

The strong line below, with the prongs on it, that's the log, and the bottom of the canoe. They reason it that way. One, two, three, four, five, six little holes along the canoe log when they start. They dig a little pit at each of those points. They use a peg with friction to make a fire. There's no good tool for hollowing so they use fire. When the fire's going they put in pitch to make it burn. I seen the old chief doing it. Then they carve it out to where the next one is. They gradually go down. They use more fire as they go. It's fast that way. That's the way they make their canoe.

You have six of those, but you only dig out and make fires at four in the middle. The ones on each end are pegged there to tell you not to go any further. (All that knowledge is up here on the petroglyphs in the hills across from Spuzzum. It's all up there in that writin'.)

So the Creator says to X̱wekt'x̱wektl, "It's no good if you have no arms. You can't use any of these tools with no arms."

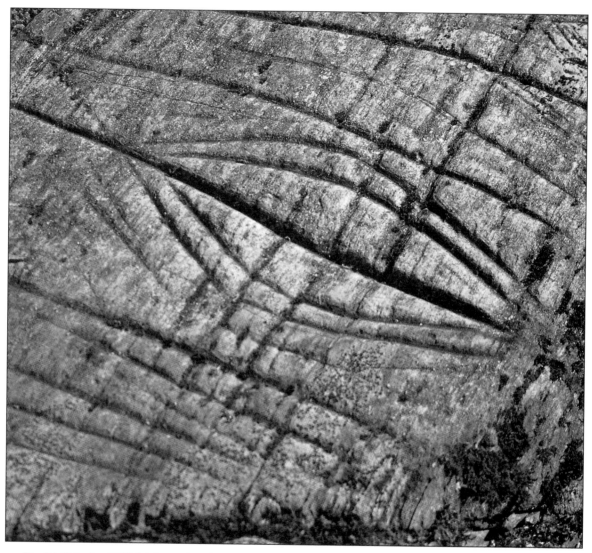

Fig. 84. This site, DkRi 6, is located at about 1,000 m. elevation, above the east bank of the Fraser River, near Spuzzum. It consists of many near-parallel lines and some schematic linear figures carved into the horizontal surfaces of a rock out-cropping. Many of the markings are similar in appearance to Marshack's Paleolithic notations (see Chapter 4, below). Chief Henry James of Spuzzum said that this was a very powerful and sacred site, one of three in a certain configuration. Once non-Native police officers had carved their names over a section of the site, Chief Henry James refused to discuss the other two sites with anyone. Since the chief's day, the site has been further damaged by a logging access road and a high-tension hydro-electric transmission corridor. Photo by Richard Daly.

Fig. 85. Rock writing at EbRk 2.

Oh, look at that one! He's got his arms this time! But you see, that's still when the man was first created. He's got such an ugly shape! Honest to goodness that early man was like that, sort of pear-shaped, with legs like that, short. And he never had enough ribs so he's lumpy and his face—his mouth, his nose and those eyes. So X̱wekt'x̱wektl—his name means "Young Bear" and sometimes he's called Smiley—he looked at him when he was created and said he wasn't good enough like that.

But you know, it would be nice to have that one in embroidery work. They say when they made the man first, he wasn't complete. X̱wekt'x̱wektl was chosen by the Creator to go and inspect the

people. If they weren't quite right he was to see if he could fix them. The Creator carries the first pattern with him.

This man's got legs like an animal, far apart. Got no hair. Can't tell if it's a man or a woman. He's only got three fingers on each hand and he can't hold that stick properly. That stick you use for everything, but if you're really digging, X̱wekt'x̱wektl told him, "What you'll need is something strong like a piece of horn."

The two deer in the circle is the snare.[33] Back in those times the deer wasn't a fast runner. They used that snare to catch them. The first men dreamed of catching the deer in a snare and they wanted to get them two at a time, and without using the bow and arrow. But X̱wekt'x̱wektl said, "No, well you can, with a snare, but not two at a time."

Fig. 86. Rock writing at EbRk 2.

The circle, you see, it tells the earth and the directions. The little circle at the top, right is North. Opposite is South. Lower right is West, upper left is East. East is the sunrise, West is the sunset, North is midday and South is the middle of the night. You must pray at those four times and to the directions.

The big circle is the earth that travels all the time without end. The living earth never has an end. Nothing that travels and has the circle has an end. That's the way they figure that out, the Indians long time ago. The circle tells them, "Look, you're living on this earth, but the whole earth is round and it has no end." The directions were given to them to tell them where they divide the people out. It tells them there's other peoples, not just you on this earth.

Indians know the earth was round because when the earthquake comes it whirls around that way. It comes and pulls you around in a circle. It opens the earth with a sort of circle motion. The reason why they know it wasn't flat was because of two things. When the moon changes, the earth and the moon tell each other when to have a tide, and when to have a low tide. The circle of the earth and the circle of the moon. And our life is a circle too. When you go up out of the valley into the mountain, that's when you know the earth is a circle all around you. You go up there and your life changes. You don't feel the same. You can see things that other people never see. If you sleep there by yourself you can see anything. Up there, the trees can speak, water can speak. The rocks talk to you when you want to know from them. Your life changes up there. It's like a circle. It has no end. When you train, you learn that life is a circle with no end.

When you are up there sleeping in the mountains, it's a different world. You're alone but it's like you got a half-dozen people looking after you. You never get scared. You are more scared down here among people. Up there you could say your prayer and go to sleep. You got a director in what you do. If you can't find berries in a certain place, you ask God to direct you. You'll soon find it.

One day I started up late from here. I made my fire and made my supper. I was gonna pick berries. I walked around and couldn't find nobody. I had to stay up for the night. And Auntie said I have to stay in the mountain. So I did. I said my prayer before I slept. I woke up and I found this little slope where I found berries like I never seen before. Berry bushes three feet high and berries as big as that. I picked them and had to put my basket aside. It was full. I filled a pail. Two pails. Then I looked at the sun. It was about three o'clock so I eat my lunch and I walk down. I'm back at five. Auntie said, "People went up yesterday and said there was no berries!"

So that's the way life is, and life never dies, as far as I can see. Never.

Old people teach that to the young who's going up the mountains to train. The direction, you see, is very important to the Indians when they pray. Powerful. You got to pray the four directions with the sunrise, midday, sundown and the middle of the night. You work your whole life to that movement of day and night, sun and stars. Today a lot of people don't do that. They say they go to the mountains for sweathousing but they don't do that. You got to work your whole life into the directions and the times of day. Then your life is good and it has nothing to do with evil things. You have to believe, and your life must be clean. You're not supposed to touch drink. And a woman, she's not supposed to be sleeping with a man either!

That lady asked me, "How did you learn to be the way you are?" So I told her what my grandmother said to me. "If you want to keep your life clean, then you go to the mountain. You have clean clothes and a clean life. You don't take no silly stuff with you. God is going to direct you, and if you do it, anyone who does dirty things to you, it won't stay on you. He cleans that from you. He's the one that does that."

The figure above, on the right, is one of the tree people. Also the man who dreamed of the power

of that tree. He is leaning against the tree, his back to the trunk. They call that the Tree of Life. The old people had quite an idea that that Tree of Life was the cascara. You see, the cascara—you must never fool with it when you're gonna drink it. You drink that first before you go up there in the mountains to train. It cleans your insides [strong laxative properties]. That was done to me first, before I went up there.

That's why the Indians reverence very much that tree. They really don't want to fool with it. You can't chop it same as any other tree. That's not right. You have to cut it for your own use. Or you bark it, and you put that away. When anybody's sick, you give that to them. And the leaf they use for the bones. You squash it and poultice it for sprains, bad feet, back backs. You can boil it and put the mash on the pain. Afterwards, you feel a little better. The Bible people has that Tree of Life too. The Jehovah's Witnesses do. But they don't know it's the cascara.

That man has a loooooooooong cascara leaf in his hand, a leaf of the tea he makes for purifying himself, and he dreams about the start of life. That thing beside him is the egg that starts human life, and the hands and feet. The egg is also the developing head. I seen the beginning because I've been a midwife with a doctor. They come out at first like an egg and then they develop a little body. That's how it starts out, human life.

X̱wekt'x̱wektl met this man who had no generations, no descendants. He said to X̱wekt'x̱wektl, "I'd like to have a son and a daughter in one egg."

X̱wekt'x̱wektl told him, "No. Later that will be, but now you must learn that in the beginning, life is like an egg." They call that the formation. He believed that, and he prayed after he got married. He prayed for children. He had children and he found out that a forming baby is just like an egg.

Look at them now! They take that egg and fertilize it and put it in the woman and they have a baby. Artificial insemination, yeah. I seen a couple who wanted children. Whaaaaaa—he was saying his prayers. I seen it. He got some water and put it on the woman like this, because that woman never had

Fig. 87. Cascara. Photo by Chris Arnett.

children. She'd like to have kids, but she couldn't. So they fixed her, blessed that water and she had a kid—he's old now. Blessed the water first, then give her some to drink, and that's it.

A woman was asking me here, "Why does an Indian never commit abortion like a white person?" There is a great story behind that. An Indian never commits abortion before. They never kill a baby. They know how, of course! But they also know how to space out the babies and arrange for boys and girls. Look at us. My brother and my other brother is each two and a half years apart, then I'm

six years younger, then my other brother is seven years younger than me, then my sisters—five and six—way down the line.

That woman asked me this. She had kids one after the other. Three sets of them from different men. I told her my grandmother was an oooooooooold woman, born before the whites come into this country. She don't give my mother no medicine to commit abortion. No. They fix all that when you go to have your first baby. Say they have a boy and then they want a girl, they just turned the afterbirth around the other way. Then you'll have a girl. Soon as the baby's born they give it a solution. First one, they give it a medicine to drink. Then they make a solution for the mother to sit on it in a tub or a bath in the rocks. They pour that over her. And she must sleep by herself too. Not like the modern doctor instructs you now! I laughed when I took a woman to the doctor. The doctor told her, "You can sleep with your husband right up to the time you have your baby."

Fig. 88. 'Nlaka'pamux mother and child. Photo by Richard Maynard. Courtesy Royal British Columbia Museum PN14217.

You know what the Indian says if you do that? "Your child's gonna be sloppy. Slobber. Always saliva if you do that." Yeah, that's their teaching. But the old Indian never has to go to the doctor. The Indian doctor never takes the baby out and kills them. No.

After the baby is out, they go and look for an ooooooooooooold scoop net. (After this it can never be used again.) They take the afterbirth into it and they fold it like this. That's what they do when they don't want no child anymore. They fold it in the net and take a bone awl and stick it through that, up there to dry. They hang it up somewhere. They don't bury it. That just dries there. And no more kids.

For cutting the navel, you measure with the width of your fingers—little finger, fourth finger, middle finger and where the index finger is, that's where you tie it off and cut it. You watch it until it dries and comes off by itself. You take that and you put it in a nice little buckskin container. If you sew it up and leave it in the house they say that kid stays there. Never likes to run around everywhere. Now the doctor just ties that, cuts it and throws it out. I watched it! But that was the old Indian style, waaaaaaaaaaay back.

And when you're pregnant, there's lots of food you can't eat. You shouldn't eat a lot. If you do, you and the baby get big as a pig. Soapberries is one of those things you can't eat.

So anyway, in the dream this man dreams of a child, but he just dream it as a bunch of parts, not the whole thing, and they tell him, no, he can't have it like that. That's not the thing to pray for. I guess he thought if he could dream a child without a backbone it wouldn't have aches and pains. But you need it! Your spine feeds your whole body.

Over on the left side are two hunters. Both men have water carriers in one hand. One carries a bow, the other carries a spear. In the early times they always carried water because it was dry. Water was not close the way it is now. It's a water basket, a *sikwáak'aseken*. I used to have one as a basket. It has a cover and it has ties so that you can pack it.

The lines at their feet show they are standing on the earth by a stream. The four little lines show you can't go more than four days without water. You have to have water.

You see, when your life change, you have to go without water. When a girl becomes a woman or when a boy's voice changes, they tell you you mustn't drink water.[34] Yeah, for five days. If you do, you're going to have bladder trouble in your life. There's a girl who paid no attention in our family. At fifteen she still wet her bed. Lots of people always wants to go to the bathroom. But if you are trained at that change of life to go without drinking water, you don't have that trouble in later life. In women, if they don't do that as girls, they grow whiskers! Hahaha, ha, ha!

My grandmother made me a hollow wood, like a straw, when it was my time to be a woman. I could only suck a little water to wet my mouth. That's so you don't get all whiskers later on. And they tell you at that time, that if you wash your face before the four days is over, then you gonna have a bad eye in life. I did it, you see! Hahaha! And I got my cataract. When my grandmother wasn't looking, I sneaked and washed my face. And I also nibbled some of her dried peaches. You not supposed to eat anything.

There's lots of things you not supposed to do. You must sit those days with your feet each side of you. If you stretch out your legs, you gonna be veeeeeery tall and ungainly. One lady I know done that and she's taller than you are!

These men have the bow and arrow and the water. The bow and the water is life. You can't eat without water. And you can't live without your bow.

This is a dream and it's an old story of the early times too. The man with the purifying leaf, the dream of the first child, and the very important water and the bow. I heard about it many, many times.

There was special reverence for the water. You come to a stream. You don't just go there and put your hand in and drink. You cross yourself to the four directions, and you say a prayer. That came with the creation of the first person. You do that before you wash your face or drink the water. That is far older than the preacher's teaching. You do the same before you pick berries. Everything. You acknowledge the moving sun, the directions and the Creator's help.

The power of the water comes from its purity. Water keeps you pure and clean.

Fig. 89. Bone drinking tube from Spences Bridge area (?), with incised "writings." Native people told Teit that the crosses on the holes of the tube "represent stars while those at the ends represent crossings of trails" (Boas 1900:379). Drawn after Teit (1900:Fig. 284a).

It runs through your life. It runs your mind, your brain, everything. Without water, even your brain won't work! The best water is the water high up in the stream with nobody to pollute it. High in the mountains, that's where it is clean and pure.

But that man in the painting, he doesn't know enough to pray for a full, whole healthy child. A complete one. You've got to ask for a complete one.

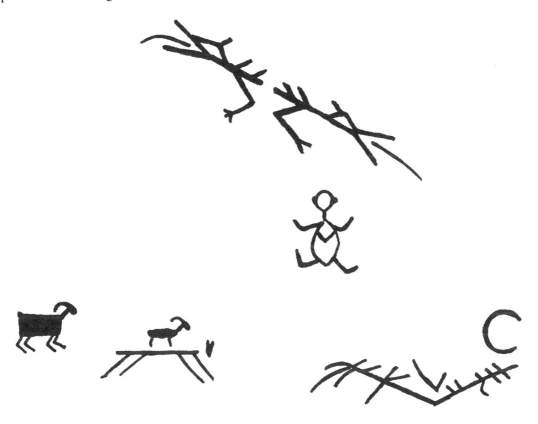

Fig. 90. Rock writing at EbRk 2.

Over on the left there comes this mountain goat. Is he ever going to be mad! That's the goat the man is praying for and dreaming about. Over here the goat is standing on top of a trap. He's going to fall through. It's a pit snare trap. They gonna catch him. The goat is always up on the steep hillsides and hard to get at, so they use that snare. It's goin' to fall through it. The first man said, "I don't know how to catch him." So the Creator told him.

The little thing at the side of the snare is a rock to hold that snare. You tie it to that rock. As soon as he falls in that thing is held there so he can't get out. It's used the same for trapping bears. He can't move to come up any more.

That's the way the Creator taught him.

On the right side, that's different. It's a bridge. That's the way you draw a picture of a bridge. You see, his Creator told him to fall a tree. He told him, "That's the *only* way you'll get your bridge. You fall the tree across the creek."

When he done that, see? He crossed over and went up the hill like that.

That's a long tree over a creek. And the cross lines are wooden props so it wouldn't roll. If you don't prop it, it twirls, that log.

There's a sort of vee at the end of the bridge. That's a trail sign that tells you you're gonna go up there. At the right end of the bridge, and up against it, that's a ladder up the cliff. The little lines are the rungs. It's the only way up there. The rungs could be the chopped off branch butts of the tree. It was just like that at Picky Mountain at Yale [what the Sto:lo people refer to as Momates, the warning finger]. That one used to have a ladder.

The difference here between the tree bridge and the tree ladder is that the bridge has props on each side at each end. The other one has to be a tree ladder, and he's trimmed the branches. If you ever done it, you'd know. We done that too, up Spuzzum Creek. Me and Arthur. We fell a tree up the hillside, then we climb up on it. You get up that way. One place we had a hard time to get to the top. We made it by falling a tree like that.

There's the moon there because you have to read your moon when you're going to make a tree bridge. Certain stage of the moon and the water in the creek is high, and the other stage, it's low water. You have to know for a good bridge, so that it's not washed away while you're on the other side. If it starts raining a lot, you have to remember your bridge.

There's that silly man again, up above! Like the big one we just looked at [Fig. 85]. This time he's got a long neck and ears. He's walking toward that thing. I think maybe it's a kind of tree.

Richard:

Isn't it one of those two-headed creatures with legs?

Annie:

Some trees look like that. Maybe. Sometimes on earth they see a two-headed snake thing. Maybe that's what it is! The one my father seen down here, it's got two heads. Gee, it was queer. You know, the people reverence that very much. If you happen to see it, you must *never* look at it.[35]

There was that snake creature with the two heads. It tells that on that rock at Lynn Valley. The creature across that Capilano River. It was a drawing something like that. And with that one, that man had to practice up on the mountain a long time before he could get rid of it. If that's what this dream is, then this silly man isn't walking toward it. He wants to get rid of it![36]

130

Fig. 91. Rock writing at EbRk 2.

Well, here she is! Here, see? And the man, he was there, helping with the birth. But you can only see his arm. The baby thing is completed. They turned her upside down. She wept.

Richard:
Where? Where, Annie?

Annie:
Over here on the left, the circle thing. Her head is toward us. She's crying and she's looking down at that bug in front. The arm that's helping is between where her legs would be, and there's the baby on the left with the navel string on it, and the afterbirth is on the right of her.

Remember what I said? That first man prayed and said, "I don't know what to do with my wife because she's going to have a baby."

And this X̱wekt'x̱wektl come along and says, "Okay, I'll show you how." That's when he took the cherry wood, cut it like this, pulled it. He hit her right in the stomach with it and the baby came out head first. That's why from then on, if a baby comes out leg first it's no good. Most of the time they kill their mother.

That navel string, if you got to wait for a doctor, you have to keep that always wet. If it goes dry it kills the mother.

That's all what X̱wekt'x̱wektl told him to do in that legend. From then on, that's the story of birth and life. How you come to this world.

You see the insect? Every creature, even the insect, every creature on this earth was born. Doesn't matter what it is. X̱wekt'x̱wektl was telling that person, "You can't do anything else. All the creatures is going to be like you."

And that's the way it goes.

Richard:

The three parallel lines on the right?

Annie:

Those show three days. Maybe the three days it took to create the earth. It was finished on the fourth. If the parallels are up vertical it means three people. If they are horizontal it means three days.

But that creature below. It's got the three-days marking below the earth line, but it's also a half and half sign between sunrise and sunset. At the same time it's a kind of serpent in his dream.

That thing at the bottom with the three little lines below it, that one fools me. I don't know what he's dreaming. I think though, that it's something that he wants to throw away.

The thing in the middle that's done in solid paint, that's a kind of bird, but I don't know the dream there. It's a bug or a bird.

Above that are those two arches. To me, that shows the beginning of making things, creating them. When you go to write an arch, that's also a beginning. The branches between the arches is a sign for the beginning of the earth. On one side, see? Three days it took to make the earth.

At the end of the arch there is the creation of fruit and seeds. And below that a little animal, maybe a squirrel because of the seeds. You have the fruit with its seeds, the woman with her baby, and even the bugs and little animals the same.[37]

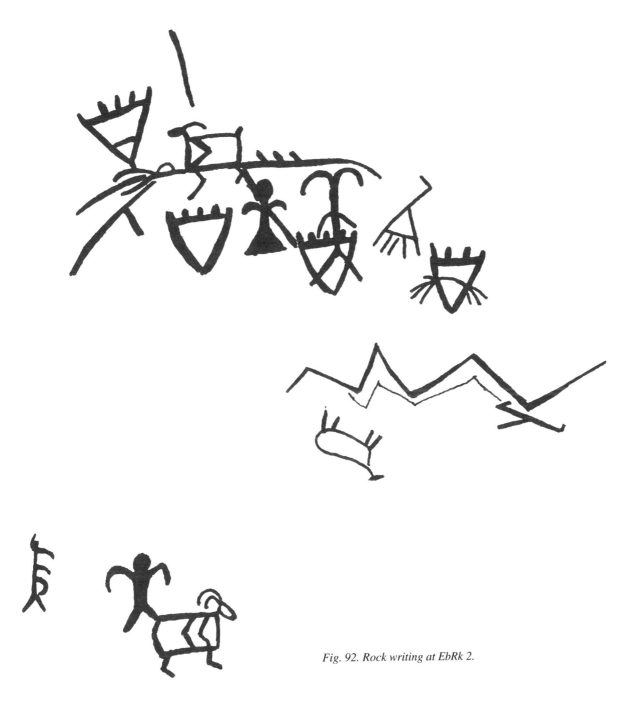

Fig. 92. Rock writing at EbRk 2.

Look at that upside down animal! [The figure Annie describes, at the centre, is actually painted "upside down" on the underside of a rocky overhang.] He's lazy. He dreams he can kill goats and get them to fall down the mountain to his feet.

Over on the left at the bottom, that's the spirit talking to the man that's dreaming. He says to the man, "You can't do that!"

You see, the man is trying to stand on the tail of the mountain goat. When the goat was first created, the man wanted to be able to tame it to catch him easy. But he was told. "No." He wanted something,

I guess, like a tame white horse. That's the difference between Indians and whites. The Indians had it all created for them. I guess the whites, when the Creator said, "No," they just went out and created it for themselves. But the Indians, they prayed to their Creator to have everything completed for them. That's why they got lost.

He's trying to control the goat by standing on it and this spirit tells him, "No." He can't do it that way. And above, he wants the goats easy. He dreams he could just go up in the hills and chase the goats down off the mountain so they can be taken without much effort. The goat upside down is a sign of capturing it, killing it, taking it as meat.

That spirit told him, "The goat is going to be always hard to get, always in the high mountain, because you get too greedy all the time."

The thing on the right side of the mountain is the goat snare. The Creator said he had to work hard for goats, with the snare and the bow and arrow.

The drawing above is different. Of course that's the bear! The two prints in the middle are the bear. Maybe the heels are pointy enough to be grizzlies. But the one at the top *is* the grizzly with the narrow heel. In the middle there, it's a lady and she wants to catch a goat too. *Gala'Inehuuw*, the goat. She wants to use the stick—above the goat—to kill it with, but she couldn't do it. They told her, "No, you can't, because you are a woman!"

That was the rule. That's why women *never* goes out to hunt in the olden days. Never.

You see, he has these footprints in his dream because he wants all of these animals.

Above the woman you see the three marks on the earth line? That's a three-day dream. The things you dream in three days you can never get. It's like a woman wanting to hunt goats. Or a man wanting to get all these animals at once.

In front of the goat on the earth line is the sun, the full daylight sign. That's when they wanted to get the goat.

And the footprint down to the right, that's not a bear. It's a buffalo. He even dreamed that! Buffalo prints are thick and you see the wavy line? Those prints are sort of woolly looking. That's a buffalo.

[Annie may have been deceived by the drawing because on the actual rock this "hairy line" appears to have been part of an earlier painting. Without the "hairy line," it is likely that Annie would have read this print, too, as a bear track.]

Annie:

Beside her, is the big barbed spear she dreams. She wants to get all these animals with it. They tell her, "No, you can't use it. You use it only for fish. Never for animals."

Next to that is a lighter footprint with five toes on it. It might be a cougar, but usually they write those fierce animals with a generally heavy impression, so it's probably some light animal.

Oh, and you see? She has the stick with her that she wants to use to kill the goat. When they tell her, "No," she throws it away. There it is, up in the air above the goat.

134

Fig. 93. Rock writing at EbRk 2.

The lines on the left side is telling time. Six prongs on the left one, and five on the other. Eleven of them.

You see, the figure next to it, that's the sun in eclipse. It changes the sun, you see. It comes up from the bottom and makes it dark. The whole thing is the sign for the eclipse. When an eclipse comes, you always see that sticky black towards the sun. Before I was smart enough, I used to take something like a cone, and I watched the eclipse through it.[38]

Those eleven marks, that's all the eclipses the dreamer can remember in his life when he sees this one. It might be the real thing, or it might be he has dreamed of eleven eclipses while he's up in the mountains.

And over here, look at all these animals. Every one of those animals that they hunt, you see, is different. The little one on the end is a deer. The next, big one. That's an elk or a moose or a caribou.

Richard:

No, Annie, I don't think that's a moose.

Annie:

Well, an elk or a caribou. Looks like one. And the next two or three—you can hardly tell—but they are deer. Over on the right is a goat, and there's animals above, probably goats too. A baby goat.

It's a dream of all the animals that are good to eat. It's also that legend when <u>X</u>wekt'<u>x</u>wektl come around and says to this man, "How many animals you like to eat?"

He answers that he'd like to get them aaaaaaaaall.

So <u>X</u>wekt'<u>x</u>wektl says, "That's a little too much. You are going to get just one at a time."

The marks above the animals— one, two, three, four, five, six—they show it took the Creator six days to create all the animals good to eat.

To the right, with the animals is the trap again, to drive them in and club them.

<u>X</u>wekt'<u>x</u>wektl says to him, "Here, I'll show you how." So he showed him. And here, above the trap is his club. When he gets them in the trap, he hits them with the club. He told him not to kill a lot at once because he couldn't use them all. If he killed them all, he'd be sitting there with that pile of meat, but he couldn't eat it all.

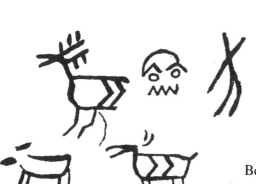

Down below on the right it's a stick man hunter and more game animals. A caribou, a deer and a moose. But those ancient animals, they had different shape and colour from today, so it's hard to tell. You know, that first man even wanted a red-haired animal but they don't let him. "Red is a fierce one," they told him.

Behind the animals is his dream mask, for preparing to go out hunting. He was told it in his dream, that mask. You see, before, when they go hunting, first they sing. They put their costume on and their mask, and they sing. That's what they do.

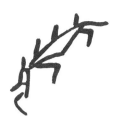

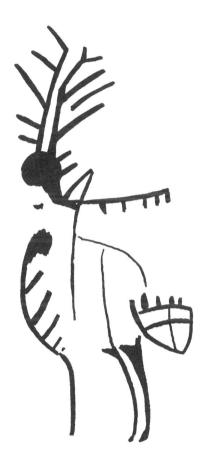

Fig. 94. Rock Writing at EbRk 2: Ts'ets'ékw. The body of the main figure is painted on vertical rock, while the head and antlers extend up beneath an overhang. The smaller painting, probably a grizzly track, is superimposed over part of the larger painting.

That's a model for a game animal from the ancient times. Like Arthur's book on the dinosaurs. Animals hasn't always been the same. They change. When X̱wekt'x̱wektl was creatin' the first animals he made that, and he says to these people, "How d'you like that?" Of course they sure are fussy. They says they don't like it like that at all. They look at it and some of them really don't want it. He could never satisfy all of them.[39]

You see, this hind part [indicates hind legs and foot print], sharp like a blade? X̱wekt'x̱wektl took that after they rejected his animal, and he threw it out into the ocean. Oh, it was a huuuuuuuuuuuuuge thing! It's in the legend. They claim that body part that was rejected and thrown out, it makes queer things happen out at sea. You know, they say a boat suddenly comes out once in a while. You see it, and then it just disappears. They claim that blade is a kind of animal, and he still lives under the sea. He's got tunnels down there, and every once in a while he comes up and when he goes back down he takes a boat or a ship down with him. You can definitely see that here in the hindquarters.

The thing like a backbone that sticks out to the right? That tells you how *strange* it must be, the first animals. They got all these funny teeth things that stick out [points to right side of neck]. What happens is, with these strange things sticking out, they goes into the bush and they get all caught up. So X̱wekt'x̱wektl says to the people, "How do you like that? I myself don't like that either." So they changed that and the animals don't have those horns coming out of their back.

And you see the mix up. This animal's got hooves, and that footprint's not a hoof. Looks like some other animal's. It's the foot of a digging animal, like the bear.[40] The bear digs this way [clockwise] and the grizzly digs opposite [anti-clockwise], and when the grizzly breaks a branch, he does it that way, in that same direction. Opposite to a bear. A syux'nam up in the mountains reads all those signs. Like the hunter, he always knows when Mr. Grizzly is around. I've seen it!

That little animal up on top. She's odd too. She's got one, two, three, four, five legs. That wasn't comfortable for the animals, so they made that different. You can see that on those Eskimo legends too. I seen one. Somebody copied it for me. It was a polar bear made with a long tail, and the Maker asks them if they want it. No. That's why all the bears got no long tail. When she goes downhill, he curls himself up and rolls and rolls! All bears do that. It's easier to do that having no tail. That animal up top, it's an ancient version of a bear. It's got five legs and a long tail.[41]

138

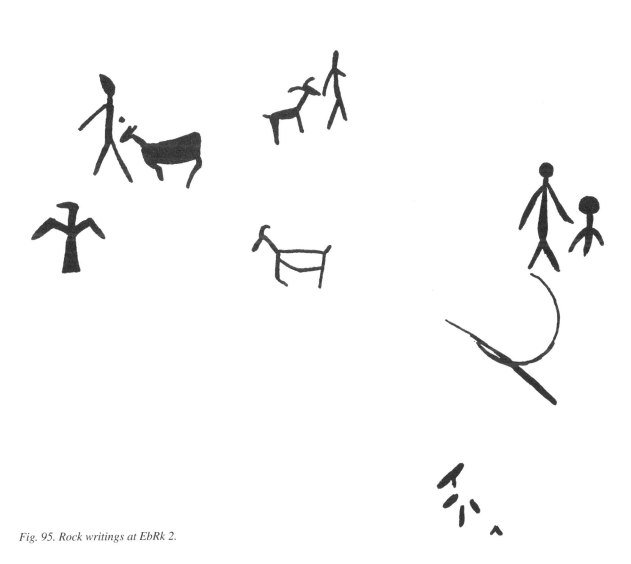

Fig. 95. Rock writings at EbRk 2.

The bird on the left is the eagle. To the right is a goat. Above it is a man and a goat, and a man and a deer. That tells you in those days that a person can talk to an animal. It was his dream and only he knows what he said and what he's gonna do. There's an animal print up on top. All this is his hunting dreams. That's all parts of different times that he dreams these hunting things. You dream it and you remember. You can write it on the rock or somewhere else. Old Paul, that old man, every time he dreams when he's old, he says to his daughter, "You draw it for me!" And she writes it down.[42]

Over on the far side, here, you can see that it's a person. And a little child. The kid doesn't have legs but it has arms. That thing below them is what he's gonna drag along with him. There's a stick and a tumpline string. He's gonna drag that stick for what he's gonna build.

The child's head shows he's also a plant. It's a kind of writing that indicates plants—the round head like that, and the curve to the arms. They call it 'Ngwitshgen, that kind of plant. It's funny. I've seen it at Ashcroft. No, at Lillooet. It's white and fluffy. I think the whites call it Bear Plant. 'Ngwitshgen—fluffy head. I've seen it as well at Seton Lake. There was an old lady who had some of these things on her basket. She told me it's a legend, thousands of centuries back. When they go up there and dream it's their own, and it has old teachings in it, and it always talks about what's going to happen in future too.

Down at the bottom, looks like prints. Print of a little animal on top, and a bird underneath. Could be it's the marking they make to show it's their dream. A man showed me once. He said the mark they made was like a rock with writings inside. The one that man told me about was signed with the earthquake sign. It wasn't on a hillside. It was in a cave so we can see it for thousands of years.

These are the animals the man plans to hunt all his life. He dreams and gets to know the animals. Like he cuts a blade of grass and blows on it to call the deer. I saw Tommy Johnson call out a deer one day while I was picking berries back here. He blew on a blade of grass. Little while, the deer comes out of the bush.

140

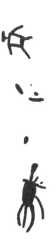

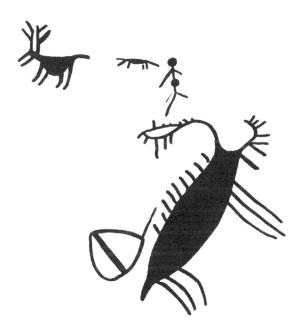

Fig. 96. Rock writing at EbRk 2.

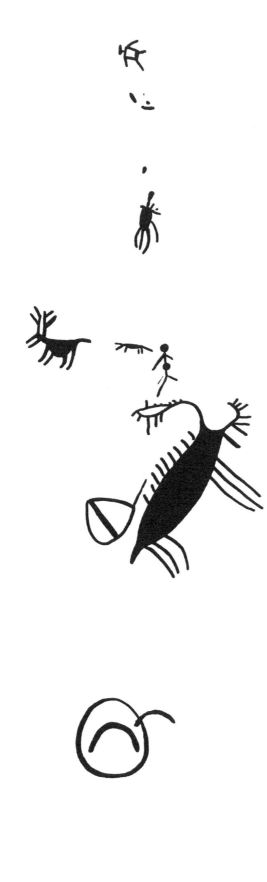

At the bottom there's the writing of a goat with only the back legs. Like an ostrich! The first man dreams his animal this way but X̱wekt'x̱wektl says to him, "No. That's not comfortable for an animal to run like that." So the ostrich is the only one that has that.

Above that goat is a caterpillar. Beside the caterpillar is the moon and it tells of an eclipse. A man *always* goes by the moon when he's hunting. There's a certain time in a moon, if you go out, you can't get nothing. Same for fishing. Even the caterpillar goes by the moon. All the insects appear and disappear by the moon. The crickets go by the moon, the moths, the flies, all of them.

The arch inside the moon is the shadow of this earth. You can see it before an eclipse. It's funny to see it. You see once in a while, that star—what's its name? It casts its shadow to the land. And the shadow of this earth, it goes into the moon.

For this man the best time for his hunting is when there is that shadow on the moon. He knows that's when he's going to be lucky. It's the same when you're going to trap. They go by the moon and the year. If you do it wrong, the animals don't come out right.

They know that shadow's over there. The side of this earth slopes and makes the shadow sometimes on the moon. And now, you know, they found a planet with two moons. It shines on the side of the earth. The Indians knows that. They can tell from the look of the moon and the stars themselves. You see, there's that big star that shines part of the night now. They read the stars to know what to expect on earth.

142

The Indians know that one star is going to the sun but they don't know what's going to happen when she gets there. They claim if she gets close to the sun, she's going to be burned out.

Old people never does anything against the moon's order.

The big creature in the middle, that's an ancient bug. You see, it was let out of somewhere. It was in a container with all the others and this young man comes along and monkeys with it and lets them out. It's a history.[43] This boy, this young man, was adopted by two women. These women were looking after all these things, like you do with honey bees. They had each one in a basket. They told the little boy, "Don't you ever touch that!" He gets suspicious. Why shouldn't he open the baskets?

These women always goes to gather roots and stuff. Once he got bigger, and the two women were out, he goes and opens *every one* of them! He opens them and here comes all the flies. Then he shuts it up. The first one was a deer fly. He didn't say nothing to those women. After a while he lets out *all* the different bugs. Then he runs away.

It tells it right there on the rock, see? That's the container beside the bug. But that one, we don't have it any more. You see, the bugs change. Everything changes. My grand-aunt says the dragonfly used to be a foot across. No more though. There's pollution and there's roads. Things change and the living things change too. Like there used to be lots of June bugs here. They're beautiful but you don't see them any more. I used to see lots of frogs before, in the pond down here. Down at the point there used to be always a big toad. Not any more. They change their species and they change their shapes. Like a person does. Like the women down in the Fraser Valley. When I went to school, you ought to of seen them. They were tall and straight girls. Not any more, ha,ha,ha! They are all inter-married and changed. Nowadays, they're biiiiiiiiiiig! One's part Filipino, one's part Honolulu. All mixed and changed.

That's an ancient little man up above. Round head and round stomach and sticks for arms and legs. When man and woman was first created they were different. They said the ribs showed up and they was clear like glass. You can see the heart and everything, but afterwards, it changes. They put flesh over it.

That's the boy that ran away after letting out all the bugs. He's chasing animals. He let them out of the baskets too! That's part of the old history.

Above the animals is another of the bugs he let out. And another bug on top. Before he let them out the people ate only vegetables, fruit, roots and berries. I myself come from a vegetarian and fish family. But once he let out the animals, the Creator said, "Okay, people's gonna eat flesh from now on." So the Indians for thousands of years now, been eating deer meat and fish. That's what they do.

When they scattered the bugs and the animals, they didn't leave them alone in one place. It was like scattering the parts of that cannibal man. They throw some of these bugs, some of the worst bugs to other countries.

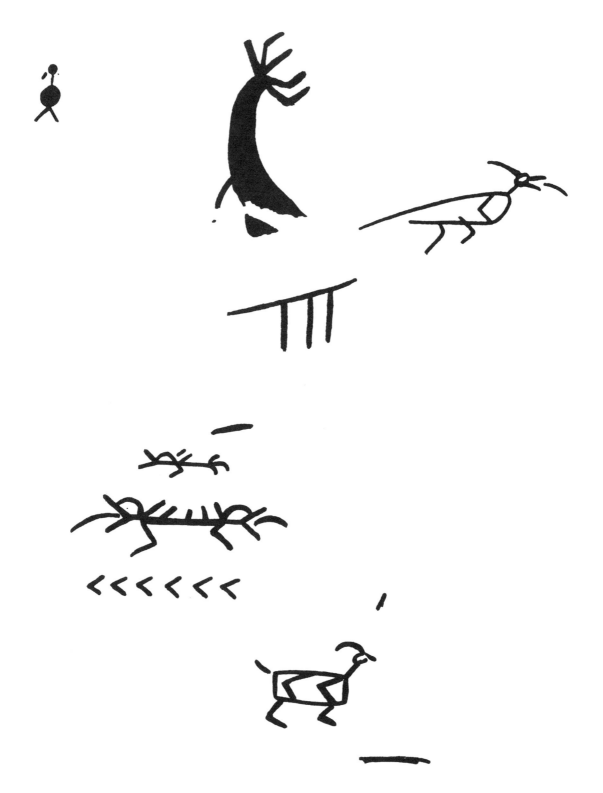

Fig. 97. Rock writing at EbRk 2.

See, there's the same thing again, ha,ha,ha,ha! It's a goat that's completely formed this time. The flat line in front of the goat, that's when they take the goat, you see. They said to that first hunter, "Okay, you like this animal but he's not gonna stay down on the flat like you want." So they took the goat and throw him up on the hill. That's why it's like that. You go up there in the hills and see if you can see them down on the flat. No, never—always up the side-hill.

Above that is a line of vees. You know, you follow that. They are trail markers. You follow them. That's what it means. If I write that up on the hillside, they'd know what it means. At the front of it if they put a big arrow point, then that's where I went, the direction, but this one is just following, it's the sign for following something.

Above that is the two-headed serpent again and it's baby like a lizard. That two-headed creature, that was on this earth at one time, right from the beginning. It has a head at the back and one at the front. There's an Indian name for that but I've forgotten what it is.

Richard:

Not the *silh'qey* that the Sto:lo talk about?

Annie:

Silh'qey. Well, I heard that name before. My grandmother told me, "You will see it once in a while in the lakes." Some snakes are like that too. They got heads in both ends. Anyway, this two-head, he's got a head at each end and he can run both ways, run backwards or forwards. He's got spines on his back and that's why people don't like it. But it's a creature that goes with a water dream. It's a serpent thing. Associated with water, yes. You see tiny little ones like that in the water sometimes. It's a thing like that that's got lots of legs.

Its baby, you see, has only one head. The second generation is like that, it changes. I don't know the name of the two-head, but this one I know. My grandmother was telling me a story about that kind. It can bite you if they want to. Lizards can bite you. Oh sure! Grandmother said you have to be careful what you do in the water. I tell you, it's weird! Arthur and I, way up there in the mountain, we went there, and there was a pond just as big as this. You never seen anything like it. You know, it's got a head and eyes just like a baby. Just like that one we was looking at. It was big right here in the centre. It's got legs and hands just like us, and the flesh is something like us. The head is about the size of a baseball. And it was splashing in that water. Some of them has two heads, one in front, one behind. That's how I know what it is.

Richard:

The slanted line above?

Annie:

That means just one. One and its baby.

Richard:

Above that?

Annie:

That's counting. Hmmmm. It's counting and it's a fence. You see, that man seen all these creatures

145

being kept in captivity by that cannibal. X̲wekt'x̲wektl says to the cannibal, "You not gonna be able to keep them all in captivity."

Then that little boy came along and after they fought the cannibal, he let all the creatures go. They were covered and he took the top off and let them go.

You see, that cannibal had so many heads and so many arms, and the old man said to the boy, "You hit him on the other side while I wrestle him. Bagissssssshw! Hit off his heads and his arms. After a while that boy got rid of all these hands and heads, neck and everything. So you see, that strong figure is a cut off arm.

That cannibal was trying to block them.[44] He said, "You can't go through here. You gotta battle with me first, and if you win, you can go through."

The young man did and the power of that mountain helped him. He got rid of it [the cannibal]. He hits the heads and arms every time. He pushes more and more, and kicks him down off the clifftop into that hole at the bottom of the waterfall. Everytime the cannibal attacks the old man, the boy uses his swan's feather to fly like this, "whoosh, swish, swish" and he gets away. That's up Nkáx'omen Creek. You cross that creek and you look over there, before you get to Munroe's entrance, and you see that long waterfall drops straight down into Nicomen Creek—it's real name is Nkáx'omen—and that waterfall hits that pond with a splash. We went by there on the way to Merritt if you remember. Above Gladwin.

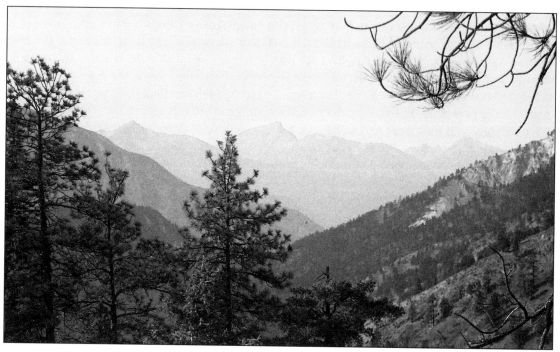

Fig. 98. View westward from top of Nicomen Falls. Ndjimkaa can be seen as the peak on the horizon (the peak like a gable roof), with his gargling neighbour, Rumble Mountain, beside him. Stein Peak is on the distant right. In the middle ground, the mountain on which Ndjimkaa laid down his smoking pipe, and from which he drew power during the battle with the cannibal man, Opia'skáy'uuxw, is visible. Photo by Richard Daly.

The cut-off arm shows he freed the penned-up animals, like coming out from a museum, a zoo. That's why the edge of the basket that they were kept in is there, and the arm. That bird there is one of the creatures he let go. He's got a long tongue, but it's not a tongue, it's his song. Like pheasants and peacocks. They go "Wheee-aa!" It's like a pheasant. When he released it, Xwekt'xwektl said to him, "You are a beautiful bird, but because they done such mean things to you, they are not gonna have you." So he took that bird to China and let it go there.

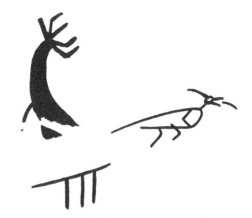

You know they've tried to bring that pheasant back here but Xwekt'xwektl didn't agree. You know they always get killed. I seen them at Chilliwack. It's a shame, they let them on the road and the cars run over them.

The little figure at the top [left side], is that thing on the sea. A spider. It's a water spider. Mrs. Thompson says there's lots of them in Honolulu. You see, that boy lets out the spiders too. At that time he let out a lot of birds and a lot of bugs. Some are hard to tell. But this one's a bug, a water spider. If it hits you in the water it's like a leech. It never heals. I did that and I talked to old Annie Lee. She said, "Here, Tommy, go and get me some blue clay!" That's the way those old people healed it in those days. It's peculiar looking. Water spider.

Fig. 99. Rock writing at EbRk 2.

Aaaah! Here it comes, you see. That's the different animals that's supposed to have only two legs. The Creator says to him, "How do you like that?" He didn't like it. Some of those animals had two tails as well, and some of the early people had six fingers too. That's the same.

There's three of them in there with two legs. An animal and behind it a kind of fish with feet. Some are strange. There's one that looks like a flower and swims like a jellyfish. The other figure is an animal, but of course it's not complete. The line over them shows

these animals are going to live on the mountain. He sticks that in the ground at the right, and leans it over the animals. It stands for the mountain. All these creatures are going to live up in the high country when they are formed.

Over here is another half-finished game animal like a goat. Again it shows the flat where it won't live. It's gonna live up high. The lines above the goat tell you when you can get it. To the right that line is the sign for going up. The goat is always gonna go up. It's a trail sign for running up.

Down there, you see, the rays coming from the sun. The top is all electric with little rays and

the long rays coming down. It's full time, when the sun is directly overhead. They have that a lot in Africa. Here, it is the fullest time of the sun. It concerns all these things, the sun does. All these animals, the bugs, everything. When the sun comes out they all come out too. They have times with the sun. They time themselves with the sun. Any bugs, anything—fish—they time with the sun and moon, everything they do. You know, when the moon comes out bright over the water, all the fishes will move down.

The goat goes out to eat when the sun comes out. And before the sun sets, the goat goes to eat again. And when he's full, the goat goes into sunshiny places, and just like a human being, goes there to warm himself. Lies down and warms himself.

Fig. 100. Rock writing at EbRk 2.

Annie:

There's that serpent with two heads again.

Richard:

And the figure like an owl, below the serpent?

Annie:

That's not an owl. It's—I shouldn't say.

I've seen it *many* times out here and in the mountains. It's that superstition snake. You ever seen that? Sort of like a snail or a slug. If somebody's going to die, oh boy, it never misses. Arthur went down there last year and walked right over it. I saw it but I didn't tell him. I said to myself, "You'll only worry if I tell you."

It was a little one about as thick as my hand. Some of them are long. I seen it. I was hanging out clothes. Then after that, Len died. It happens every time you see those——

One time up the mountain I saw it and I felt real bad. I said in my heart, "Why do you have to do that to me for? Why don't you just keep out of my way because I'm just a poor person travelling round the hills just like you."

So I went to sleep and my mind was still on this. The sun was just beginning to shine when I woke up in my dream. That thing, it says to me, "Look, never be scared of me. When you see me, you must see me the way I am now." I looked at it. Oh! It was a beautiful lady! Her hair was down like this. Her hair was yellow. He says to me, "That's the way I am. You are foolish to be scared of me. Nothing is going to happen to anybody. Whenever you see me, you talk to me and I will never bother you. But never look at me too long, because I don't want people to stare at me."

It's called *klu'biíst* That's its name. I don't know if it has an English name. Last year Arthur seen it two or three times. I didn't see it, but he did. It was running across that garden. I went out there when he told me. Same thing happened before my brother died. It is terrible to see it. Sad.

Richard:

Does Arthur talk to them?

Annie:

Naw. You talk to them in Indian. He can't do it. He'd have to talk Chinese, ha,ha,ha!

Fig. 101. Rubber boa (klu'biíst). Courtesy Royal British Columbia Museum.

Arthur:

What? Did you ask if I talked to the marmots?

Annie:

No. That thing you always see, remember down at Alexandra Bridge?

Arthur:

There's a patch of them out here. I don't always tell you about it. We see each other lots of times. I don't bother them, they don't bother me.

Annie:

You know what they're fond of? That green and blue stuff you use for cleaning the cesspool and the septic [toilet tank cleaning pellets]. My Special Friend let me know about that. I used to put it in the toilet tank until they started coming out under the floor. So I quit.

Arthur:

Our neighbour has it too. It was on her doorstep one day. I don't know what it is in English. It's thick in the middle and it tapers toward both ends. Some of them look almost like they have no head. They move sort of sluggish, like a leech maybe.

150

Annie:

Some people take a stick and throw it over their shoulder when they see it.

Arthur:

Me, I take a shovel to it![45]

Annie:

This is written on that rock because the teacher came to the man in his dream in that form, and he taught him all about the spear and how to use it for hunting the mountain goat that's there below him. You know 'Tsem, our beautiful mountain? Well, the hunters learned to drive the goats from behind there with stones, toward the snare. On this side there's a little game trail over the rocks and they put the snare in there. Grandpa says they had a big pole with like a harpoon spear on it. When the snare catches them and they jump around, the hunter goes there and kills them with the spear.

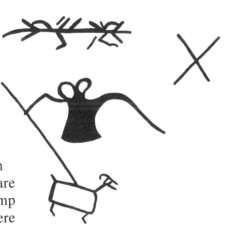

That slug-snake comes to people in their dream, and it tells them, "This is what you do. You do it this way." It gives power and knowledge in your dream. There's lots of those messenger things when you dream. I know it myself. I can tell many days before, when a person is going to visit. I never sleep if I'm going to get a dirty person coming or doing evil stuff. I can never sleep if one of them is coming. I stay awake until the daylight, because, you see, my body is different from other people's. I never married and my body, I always kept it clean.

People who lead messy lives and run around with a lot of different people, if they are coming to see me, I can feel it in advance. Anyway, the person in this writing, he dreams that.

The big cross on the right of that thing, that is trail language. It says, LEAVE IT ALONE. KEEP AWAY. You see, if I buried something and wanted to warn people away, I'd put that sort of a cross [an "X"] on it.

All the goats here, they are ancient goats. They say that in the early time the goat had a square body like that. Then when the young man let them out of that evil man's cage, they got the bodies they have now. And they weren't as big as they are now either. Indians don't like captivity. You know that man used to have a little zoo in the canyon beside the highway [north of Boston Bar]. Well, they let out all the animals! Raccoons, lynx and things. Indians did it!

What about the three little parallel lines beside the upper cross?

Annie:

That says you must stay quiet for three days, then on the next day you can get what you want. You will be able to do what you want to do. The squiggle above the parallel lines is the fourth day when you can carry out what you want. That cross shows the power you get during those quiet days. It is the power of the universe. When you are praying you always cross yourself. If I'm gonna drink from a stream, or pick medicine, I always cross myself and ask my prayer. God's power is here. Through his power the water gives strength and the medicine works.

The little arrow figure to the right of the cross is a bird, and the other vee is the direction of its flight. It's a sign for the first bird, which was very long. It's called the *she'átewan* and it's extinct now. It's a beautiful bird. I've only seen it once, when I was little—two or three of them in Pitt Meadows. The head and the back is a beautiful beautiful blue, and they are big birds something like a geese. The sound they make is, "Oo'iiii'oo, iiii hew, iiii hew ho!"

Grandmother said, "Don't scare them because that's an extinct bird." They said the Indians finished them off. You know why? The crazy Indians used to go out in the swamp and gather all the eggs, and after a while they died out.

The markings in the goats show the markings the goats used to have long ago. Women who wove the goat blankets went up in the mountains and dreamed the old life of the goats and they wrote their dream in their blanket. You seen that one in the Centennial Museum in Vancouver, of Susan James? Yeah, and you saw the purplish thing on it, and the black? That was the way the goat used to look. Her and her husband, Old Paul, they would go s'le<u>k</u> [train for psychic power] together up the mountain and they dreamed the blankets together. You ought to have heard them sing! Beautiful voices. They had they own special prayer too. I shouldn't teach you that. It was a different prayer that they sing. They don't say it, they sing. They sing for the trees, the animals, the berries. Different prayer songs for cedar, spruce, pine, maple, rock maple, berries of different kinds. Old Paul was a *beautiful* singer! I know it, but I won't sing it for anyone. I'm not allowed. I can sing it to myself though. If a woman is going to have that power and training in the singing and weaving, you are not allowed to marry a commoner. That's why my mother went up and hit the roof when they suggested in 1914 that I marry that breed from Yale who worked for the railway.

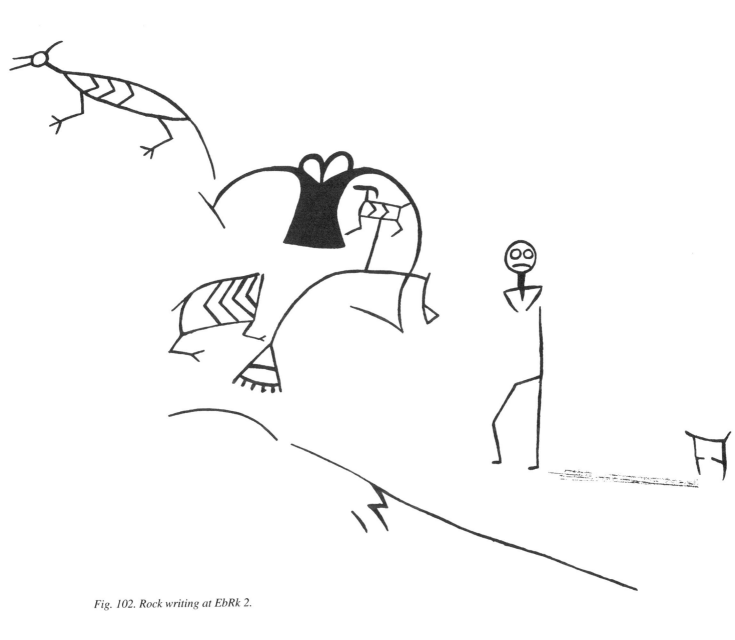

Fig. 102. Rock writing at EbRk 2.

Annie:
There's that thing again. It's always there, you see, in the dreams.

Richard:
Is it the same or could it be the owl?

Annie:
Sometimes it's the owl, but it should be more formed than this one [see Fig. 109]. Here it's the same as the last one. These strong powers, when you stand in the mountains long enough they can take the form of a bird, or other forms.

Richard:

It helps the dreamer get what he wants?

Annie:

Yeah, it can. It can be that two-headed snake on this earth, but it has a dream form. This, here, is its dream form. Those two big eyes see everything. That old man, Old Paul Yo'ala, that was his. He got it in his dream. It was his own. If you know people who have that kind of thing, never sit with them. Don't let them walk behind you. They watch. You should hug the wall. That's why we don't go to a party. That thing can be used in different ways.[46]

You see, this man, he dreams all these things, and that's his special power. Its form on this earth is that yellow thing, like a slug-snake [klu'biíst].

The man who's dreaming must be a trapper and hunter. He dreams with that power to help him find the animals. You see there, under his arm is an animal, the goat, and below, you see, it has no head. He was taught never to eat that animal without first cutting off the head. A young person *never* eats the head of a deer or anything. That's *very* restricted.[47]

All the sergeant stripes on the animals show their colour. Even the goat used to have fawn and grey—not pure white like now.[48] The line from the goat to the grizzly paw, and the headless goat— that's him dreaming of using goat meat to lure the grizzly into a snare.

Hunters' power, and trappers'—they all have a form of that creature. It helps them go out and gather everything they want to hunt. It gathers what it wants under its arms or its wings.

To the right is an ancient bird, from the time when they were growing from that serpent thing, like a lizard. The old people told me that those early birds had long tails like a mouse, a string tail. That's what this one seems to have. The Creator didn't like the way it looked. It was weird. So he changed it. These ancient animals can come in the dream and be your power too.

The man on the left, he's the one who did the dreaming. He put himself in the dream of all the things that he's going to have in his power. The thing behind him is a sign for talking to each other. In the dream he was told he was going to be able to talk to any animal. An Indian can do it!

The long slanting line is the earth, and the zigzag is an earthquake. He's dreamed that too. And you can see it in the stars too. The legend time of <u>X</u>wekt'<u>x</u>wektl was when they were forming people and animals. Then the earthquake ended that and devoured them. Afterwards the new people came up and they were smaller like today.

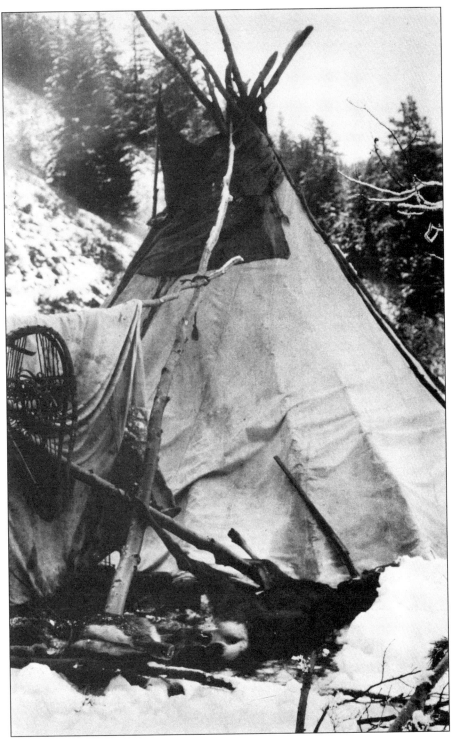

Fig. 103. 'Nlaka'pamux hunters' camp in Tsek'iéx'tcen Valley, 15 miles north of Spences Bridge. Photo by James Teit. Courtesy Musée Canadien des Civilisations/Canadian Museum of Civilization.

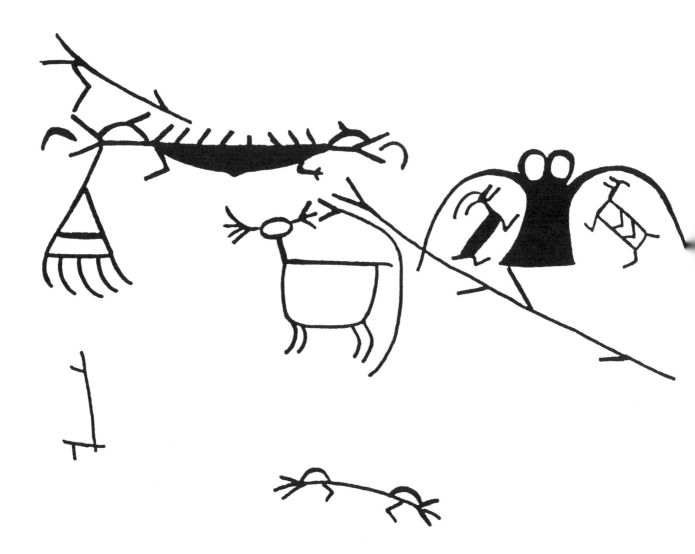

Fig. 104. Rock writing at EbRk 2.

This is a nine-day dream. See? All those parallel lines on the right. It means he didn't eat for nine days while he had his dreams.

That deer in the middle and the figure above it with wings around the animals, those are separated by sort of forked sticks. The one around the deer is just to show it's not part of the dream above. They use that fork a lot. We seen it already [Fig. 99] where it penned the animals into the high mountains. There it was rooted in the ground, keeping them in place. The fork holds it there. But it can be used just like the wings of this hunter creature, to capture the animal in the dreamer's mind.[49]

Under the wings of that spiritual thing is the goat on the right and a moose or deer. Could be the bighorn sheep with those horns. The next one over has the deer, the buck on one side and the doe on the other.

That hunting spirit, like the owl or that yellow snake, the hunter sends his dream first before he goes hunting. When he gets there, whatever animal he wants, they are right there for him, and he kills

156

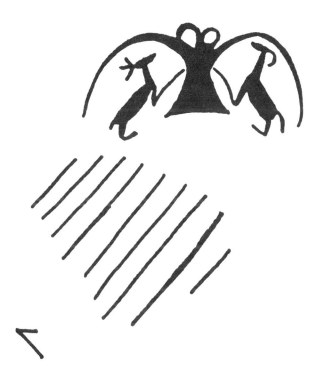

them. Tommy Johnson did it that way. I was up there with Mrs. Patrick and the girls once when we saw him. He didn't go very far. And he got two deer. He has that power.

There are two different two-headed serpents in this dreaming.

At bottom left there's the tool for dividing your work in sections. They use the size of the hand in that. The length is measured in hands. Two hands side by side is one unit. One hand width is half a unit. That thing was used to divide things in half. It's here, I guess because of the two-headed snake. Like that giant one that stretched from Lynn Valley to Brockton Point and Siwash Rock at Vancouver. [In most versions this two-headed snake extends across the First Narrows at the entrance to Vancouver harbour from Prospect Point in Stanley Park to a rock on the beach formerly in front of Saint Paul's Church on the present day Mission Reserve in North Vancouver.] Blocked the harbour and the Indians tried to get rid of it. The young man went up the mountain there and dreamed *everything*. Then he came and tried to get rid of it. He tried to chop it in two to get rid of it, but it just separated and stayed. It said to them, "Okay, because of this, from now on, lots of times people are gonna die at sea. Once in a while when it's windy, you gonna get in a accident." The old people said that if that man had been able to defeat it then the whites never would have come to this country. Whenever you were going past there, out to sea, you'd stop and say a prayer and touch that rock with your paddle. It's a religion. Everybody knew this, on the coast, upcountry, Lytton, Lillooet, everybody. That's why it's on the rock up that Stein.

That print below the big two-head serpent, that's the man's hand print. He put up his hand to stop the creature. You see, they don't like it. They were going to grab his head like this and pull it over, but no, it pulls toward the other side.

You can see that big serpent has cut the ground line. He blocks your work. That's why the old people say he stopped the Indians from having the intelligence of the whites in the old times. Because he blocked our work. He blocked the knowledge. That's why we can't make a car or a chair. We have all the hunting dreams but not about fixing and building things. My old people told me, and Joe Capilano was telling that story exactly the same to Pauline Johnson.[50]

That snake breaks the long level of the ground in the dream, the long level with the little branches on it of all the things that change. They didn't completely defeat that serpent so the changes stopped. *Everything*. That snake broke the development of the Indians. He shrunk when the boy cut him in half, but he didn't disappear. That's why Indians classify snakes as Satan.

The only thing left to talk about is this little arrow-head shape at the bottom. He dreams you have to look in that direction, to the left. You go to the left and you come to the dream creatures. But that shape is common in the mountains for directions. They build trail markers like that of rocks too. They build them up in a point. They all have that mark. You follow them and maybe you'll end up in their camp.

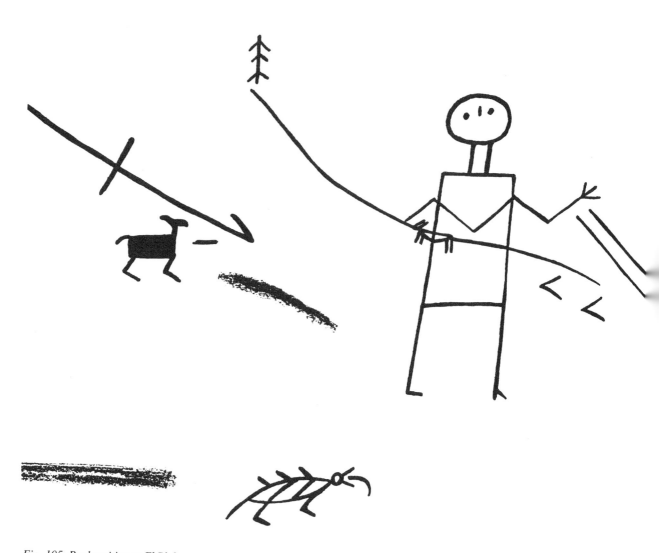

Fig. 105. Rock writing at EbRk 2.

There's a lot of goats and deer here, and the Creator's in the middle. He says to the man, "Would you like to have hunting easy so you can go straight up without having to walk?" That's the straight road to the mountain that the man dreams. It's those two lines by the man's hand. He wanted to be

able to get it easy, to walk just on that straight line and get that big animal. But the Creator says to him, "No, you can't. You're gonna have to walk all over, jagged. The line across the Creator's body with the tree up at the top and the animal along it, and the two direction arrows, that's the way the Creator said he had to go to find the animals. The tree there is the place the animal will go to chew the boughs. The tips of the fir tree. That tree comes into his dream because before he dreamed, he had a steam bath and they steam themselves with those fir branches. And the thick smudge line on the left shows the dream is about springtime when everything is really green and wealthy. The smudge line higher up is fall time because it's getting weaker, not so strong. And you see, the deer go higher in the fall when things down below are getting poor to eat. The deer is there, in solid colour. Above the deer is the sign for bow and arrow. The long line is the bow string and you can just see the corner of the bow. The cross line is the arrow against the string.

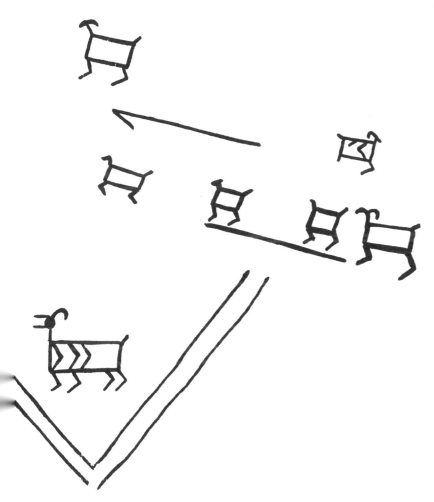

When the person dreams this, he's allowed to see through the Creator's eyes about how it was in the beginning. The Creator gives him the gift of seeing it.

At the bottom is the horned lizard. They came here at the beginning but there wasn't enough for them to eat and they disappeared. You see a small one like that sometimes. The dream tells them all these things, and that's what I say about that place, its really history of the very beginning of people's life on this earth.

Richard:
 Why is the zigzag on the Creator?

Annie:
 That's the way the man saw him. It's really the shoulder and chest structure. Without that frame none of us can exist. There's more goats and deer on the other side and the line under them shows another trail to reach them. The upper line shows the direction the hunter has to follow.

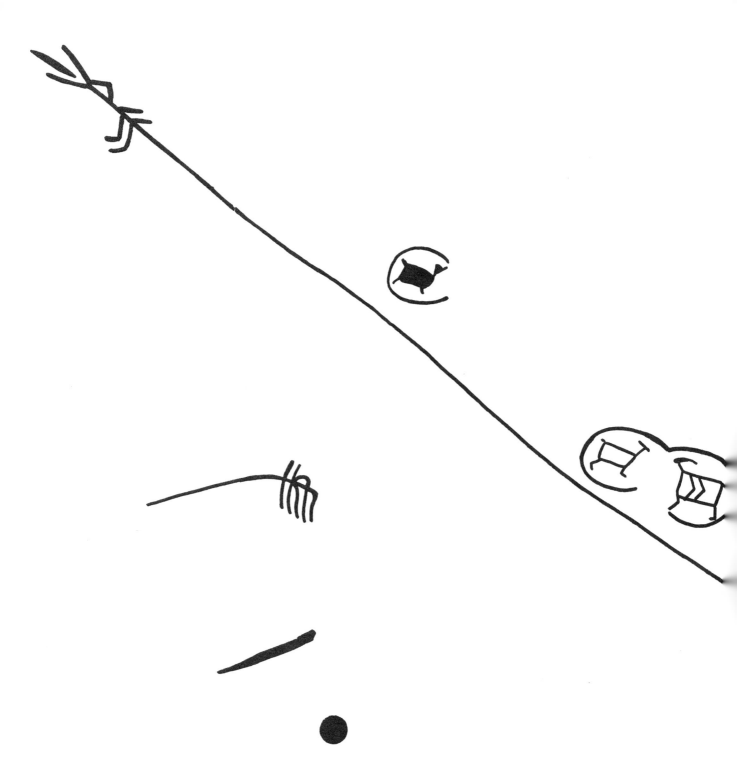

Fig. 106. Rock Writing at EbRk 2: Ts'ets'ékw. The two-headed snake figure here is more than 3 metres long.

There's the two-head snake again. Long, long one, dividing the worlds. It divides the sea, the salt water from the fresh water, the animals from the fish. Everything.

Below the serpent divider is one, two, three, four, five—five days to divide the salt water from the soft water when the earth was formed. At the bottom, it's the season sign of the dream again. It's not rich like the last one. Thinner, towards fall.

The other side shows what's been divided from the water side. Animals. Deer and goat, the things that the hunter wants. The deer and goat are not in a snare. That's the way you write it. It shows he has caught them in his mind. That's what his mind sees, like inside an egg. The animal higher up he's wanting too. When they have long hair they generally colour them in solid. It's the same with that goat, a goat with long thick hair all coloured in.

The two-head is the spirit of dividing, and it is his luck. It turns everything halfway. Up at the top it looks to me like two small birds. The one on the left is definitely a bird. He's drawn two little feet there, like my little wren. But the one on the right might not be a bird. I think it's the Creator teaching them to make a nest. In that story, when Xwekt'xwektl came along those chickadees went "Chickadee-dee-dee! Chickadee-dee-dee!" Told him everything, "There's a man coming that creates everything!" Xwekt'xwektl came and said, "What are you people gossiping and tattling about?"

So he took one of them and throws it this way, and he took the other one and threw it that way. He says, "From here on you're a bird and you're gonna have a grass nest when you go to have your babies." That Xwekt'xwektl, it mentions him a lot in there at the Stein. He did this teaching to the birds up there. This old woman tells that story up Coldwater. She tells the story for two nights before it was finished. Too bad there wasn't no tape recorder then. Her name was Kwasta'zéxtko. She was Virginia's great great-aunt and she was a *beautiful* storyteller! I heard her when she was telling that story the night before a funeral. In the first place, she said the animals were changed *ever* so much! Some of them had heads at both ends. When the people didn't like this, the Creator cut them in two and fix them in the natural way.

By the way, Stein is really *Stl'yen*, kind of a hidden place. You can come right by it at 'Nkamult'bap and you can't see it.

'Nkamult'bap means sort of like a horseshoe. You have to get right on top of it to see it.

Fig. 107. Rock writing at EbRk 2.

Along the bottom here is a row of little animals, and in front of them, a bird and its nest. X̱wekt'x̱wektl told the Bird People, "From now on you are going to have eggs." And to the Animal People he said, "When you have little ones, it's gonna have a full shape, complete with legs, eyes, nose—everything." So it's sad for that bird because it has to hatch the eggs and raise the young while the animals, after they hatch they can run and eat in a short time.

Those little animals, you see, are not like the earliest ones we saw, all square. They are natural shapes like real animals today, completed whole. These animals in the dream were created in two days. He put those two little lines over their heads, then a long line. That's different. It's the line of the earth, the surface of the earth, and the cuts on it are the four days that it takes to hike in to where those animals are.

The two strong parallel lines half-way up. That shows the straight, direct way to where you are going for the animals. It is very hard to follow it straight. And the upright line in the middle, that's a hard place you've got to go through to get there. The little slash line beside it shows one man follows this. One man's dream.

Beside it is the goat that the dreamer has speared. Behind it, one, two, three, four, five, six—you have to dream for six days before you will get there to where your goat is. Your dream completes after six days.

He also dreams that animal at the top, and it's talking to him in the dream, but the Creator says he can't have it that way, the square animals have lots of meat but it's very hard on the animal to have to run around all square.

Fig. 108. Rock writing at EbRk 2.

The big animal is a bighorn mountain sheep and the dark sergeant stripe shows the summer season. You see it loses its white in the summer. The long line is his spear and the arrow that crosses it says he has to have an arrowhead like that to hunt with. It also points to the tracking signs that lead to the sheep. You follow the tracks and then, if you want to catch him, you have to use your spear.

Down at the bottom on the left is what is going to come to this earth. It's written in the stars too. It's a helicopter, shaped like a kite. It says in the dream that it's going to come to earth someday. It may be something else, but what it is is the drawing of what is to come to this earth.

Over the spear is his serpent power and the eye-shape below it is an egg. Snakes have eggs, you know. From the egg comes that serpent. Above that is the time markings. Four days, then on the fifth the dream is completed. When I write something I've finished, I write it like that, sort of fallen over.

On top he's dreamed about something new he wants to use to kill the game and the fish with. It's something of this earth. It's painted dark on the end to show how powerful it would be. His dream weapon. It goes back to that old story when X̱wekt'x̱wektl was creating the shapes of all the animals. He told the people when they wanted a powerful weapon to kill with, "In the end you will have a very powerful weapon. It will be the bottle with horrible stuff in it. You're gonna take it and it will save the animals, but when you take it, you're not gonna save yourself." That was known long, long ago, and this dreamer sees that too.

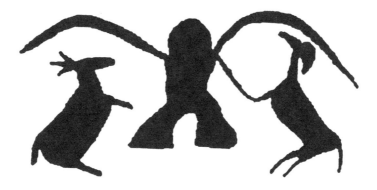

Fig. 109. Rock writing at EbRk 2: Ts'ets'ékw. This figure, adapted by John Corner from figures at EbRk 2, became a popular symbol for the cultural heritage of the Stein River Valley. It is commonly known as the "Stein Owl."

Richard:

This one is called the "Stein owl," a symbol of the importance of the Stein Valley.

Annie:

There she is again! But this time she has completed herself in the dream. She's got legs, wings and everything! So they call it the owl now? Well, that's part of it. That thing has different shapes. You see, a person staaaaaaays up in the mountains, and if some bird comes to them, that's their power. This one is part man—see the legs—and yet it's an owl. The others we saw are the same power but in the form of different creatures. This man changes himself into an owl when he dreams and he flies around and notices the deer and goats and animals he wants. When you do that, you notice exactly where it is. You can send that power to find your deer for you.

The reason it's painted like this is that the darker the paint is, the stronger the power. It's a *real* powerful thing. But this is drawn different. If he's trying to find those animals, they're just standing there under the wings. But these are jumping up at him. They want to get him. Somebody is trying to go at him with these animals but they can't make it because his power is strong. He has the power like a syux'nam, Indian doctor. Oh boy! Sometimes they are *wicked!* This is about transforming, and power fighting, yeah.

In the beginning Owl was the first person to eat meat, back in the days when he was in the human form.[51] He'd gather bugs and worms and things in his basket, to eat. This little boy was *naughty!* He made trouble so they put him out of the kiikwilee house and said, "Let Owl take care of him!" So Owl put him in the basket and carried him away.

The old people went looking for their grandchild, but the other people said, "Augh, it's a good thing we got rid of that kid."

Owl goes out sometimes and gets meat for the boy but the boy can't hunt for himself. After a while the people moved out from that village and left his grandmother alone.

Owl said, "I'm sick and tired of looking for meat to feed you. I think I'll take you back to your grandmother." He put the boy in the basket and flew him back. He dropped him down the kiikwilee hole and said, "You can look after yourself now, you and your grandmother. If you can find your grandmother."

The owl went home.

The little kid's cryyyyyyying! He went into every kiikwilee house. He finds his grandmother sitting, trying to weave. That old woman was ready to starve. The boy walked in. He was crying. His grandmother took him in her arms and he told her, "This Owl feed me with every dirty thing! Snails, frogs, snakes, everything. I got hungry all the time. I didn't eat it up."

All his grandmother had was berries and roots. So she cooked them. At that moment the heavenly thing happened. And that's what this picture is.

The spirit of Owl said to the boy, "I'm going to fly all the deer in, to a place where you're going to get them, but there will be none, *nothing*, for those people who left your grandma all alone."

This was the Creator's messenger taking the shape of the owl because Owl used to do that. He would fly around, picking up snails and frogs and things. So that owl messenger brought the gift of the deer to the people. The man that came down to bring this was like a bird. He brought the buck and the doe. He told the little boy, "By the time you're old enough this spring, you are going to see these deer."

The little boy didn't know what to think, he was so rejoiced. He couldn't hardly wait for the spring. When the spring came he could go to that gulley where he was told the animals would be. He went there and seen his first deer, a small one. He killed it with his bow and arrow and spear. He tried to cut it up the best way he could. His grandmother give him a little knife she always had. So he took that and the old lady went with him and they cut it up, butchered it, and they packed it home. They cooked it.

The sun came out and said, "I'm gonna tell you. I'm going to have trees. The pine, the cottonwood, there's the poplar tree too, the one that carries fire. You're going to chop one of those and you're going to make a hole in it, and you're going to have fire. Then you are going to cook the meat."

That was the first time this boy ever cooked meat in his life. They showed him the barbecue stick too. That's why, till today, if it wasn't for the sun, nothing would ripen.

Well, I guess this kid, when he was sleepin' in the Stein, he was thinking about that thing, so he went and drawed it. Those deer, gee, aren't they cute?

Fig. 110. EbRk 7. Photo by Chris Arnett.

A short distance beyond the largest Ts'ets'ékw rock writings, the trail passes between a group of large granite boulders, one of which, on the river side of the trail, is four metres wide and two metres tall, with rock writings that face the trail.

This site was identified in September, 1979, by Rousseau and Howe, who sketched half of the paintings visible on the boulder. They noted that part of the panel had spalled off the boulder, the result of a campfire having been built against it. This resulted in the loss of some of the original paintings.

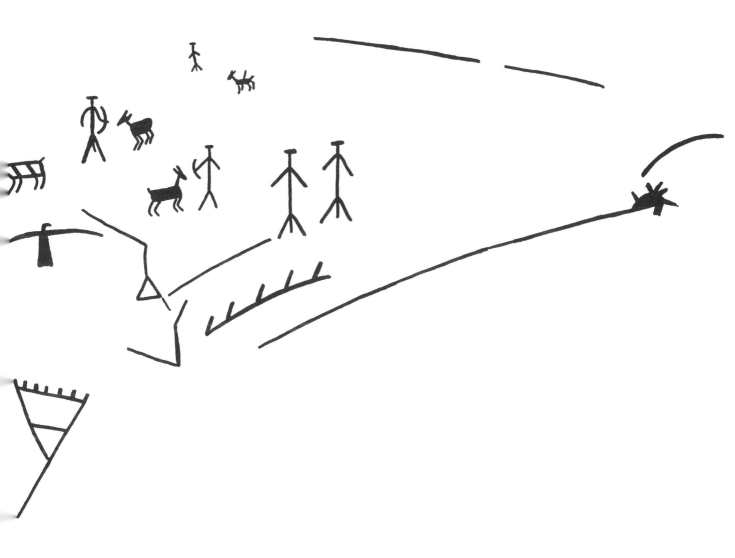

Fig. 111. Rock writing at EbRk 7.

Annie:

This is a dream about the boy who went up to the moon. The little man in the circle? Of course that's him, coming back from the moon. Nglíksentem.[52] After the Creator created space, Nglíksentem was the first to go to the moon. He got there because that guy keeps telling him, "You just reach a little further for that girl. She's a little further, further up." She was somewhere in there above him.

When he got to the first universe he felt himself in the space. He just kept on going until he reached to the moon. When he got there, he seen a lot of things. Baskets. He wanted to steal it. He couldn't do it because all that stuff fell on him and he got tangled up with it all.

167

After that, he reached these *ooooooold* people. A man and a woman, and their name was Spider. That was the one he stayed with there, and all the time he feels lonely for his family. He faces to the wall and he cries. Finally the old couple says to each other, "Don't look." Nglíksentem went out hunting, bring wood and everything. They told him, "I think you're homesick."

They were working, you see—doing this with their hands [weaving gestures]. They said, "We'll see that you get home." Old Man Spider says, "You see this thing that's over in the corner?" The old lady was working on that. She works making that basket. They call it *stúukxw* in Indian, and they worked on that every day. The old lady put in moccasins and everything: bags, bow and arrow, arrowhead, food, basket, materials, everything that he's supposed to know about on this earth. That's why you make the basket according to the moon. You work everything according to the moon. You even plant your garden according to the moon.

So then he got up there on the basket. The old people cried. They said, "If you hadn't got up here we would have disappeared. But you'll be all right. You gonna take all these patterns with you. When you get down to that place, you're going to use them, you, your wife, your children, are going to use all these patterns that we're giving to you."

Then they dropped him down in the basket.

They gave him patterns for baskets, hammers, spoons, wooden dishes—all these things. Also patterns of how to use a fish, how to fix it, those pots for fish and how to barbecue it, and how to make an Indian blanket. But at first, as soon as he saw it, he wanted to steal it. He couldn't see the old people watching. Every time he touched something it fell down on him. He got jammed under, and a voice said, "DON'T DO THAT!" So he lets go.

When he got settled down with these old people, that old woman fixed baskets; she tends to buckskin, makes threads for those moccasins—all the things he needs. They gave him these patterns and said, "There you are. If you want to go home you can take that package with you."

They opened that basket and told him, "You go in there." He went in and the old people closed the lid. They told him what to do. They had put in an old hammer and they said, "You're going to hit four spaces on your way back, and each one you have to hammer to get to where you have to go."

So he did it and each time he swung back and forth in that space. While he's swinging, the old people are singing a song, "Zekazee heh! Zekazee heh! Zekazee heh!" Until he hit the ground. Ha!

When he hit the ground he opened his stúukxw. He unpacks *everything*. He takes his packsack out and did exactly what the old people had said. He knelt down and prayed and thanked God that he came back to this earth. He cried. He wept in there and the Creator told him, "Okay. You went up there and now, from your tears it's going to storm and rain because you feel so bad." So he run around in the rain in a circle, dragging his space ship basket. That place was near Thompson Siding and you used to be able to see that flat stone with the impression of his foot on it. I think the highway took it, or the railway. You could see the marks from him dragging the space ship.[53] Then he let it go back into the sky. When it landed back on the moon, it hit the side and made those impact marks up there. You can see it like a rock in the face of the moon.

Richard:

What would that line be, at the bottom left, with cross lines on it?

Annie:

Well, of course that's the universe. You see, that man, he hit the universe first when he came down.

They say at that time there was four. He hit the first, then the second, third, fourth. He's the one who made the hole in the universe.[54] That hole's been there for many, many, many centuries. So that line at the bottom is his route down through the four universes.

Richard:

What's the little thing above that?

Annie:

That's the tree where Coyote did that to him, shot him up to the moon. So they shoot him up. All these things has been a legend—maybe we'll come to that place with the ice lady.

Richard:

What about the bear paw figure to the right?

Annie:

Really, it's not paws. It's that thing he travelled in. You see, it has a string. That basket has a footprint shape because that old lady who made it was so big that she put her foot on it while she worked. So that was the design! They always go by their own feet. That stúukxw is like a foot. There's seven markers on the end because it took seven days, maaaaaany days to come to earth. That basket, that's sort of the shape you can see in that gouge on the moon.

On the right side, that's Spider, and the line over his head shows him talking to Mrs. Spider. The long line running out from him is what he used as a measuring stick for the space ship. That really tells the legend, that part. After weaving that big basket, the Spiders started making loooooooong measurements.

So Xwekt'xwektl came along and said, "Look, you're not supposed to do that. You're not supposed to do these things."

So he took the big spider and throw him down into the ground of earth. Xwekt'xwektl said, "You can't do that any more, but you can web, and make lacings there on trees, and you're gonna trap, make long lines. You are going to be wonderful!" I seen the spider work here. He laid out that web line on the ground, all the way from the window across to that tree. Then he pulled it up.

Spider goes and says to his wife, "You haven't got enough yet. Still more web is needed yet. Still more." He keeps measuring that stuff.

The long line at the top is the ground of the moon. Beside Spider's measuring stick is an angle, and a line with five marks.

That's the corner of the space ship going back up to the moon. The stick shows the time. It only took five days to go back up.

Richard:
There's another diagonal line with two stick figures at the end of it.
Annie:
Yeah, that's the Spider People, him and his wife, and their web. <u>X</u>wekt'<u>x</u>wektl told them they were not supposed to use their power to made that basket to let the boy back down. They put a stick between their legs and let that basket down their web, all the way.

The scene up there beside the Spider People, one man, two, three men shooting deer, that all took place up there in the moon world when Nglíksentem went there. That legend tells that story. You see, he never saw deer hunting before this. Those old people made an arrow for him and told him, "There! Now you can go and shoot them."

Those animals he had *never* seen before, and that big bird. Its wings spread, they say, as big as a house. Nglíksentem was thinking of trying to kill one of those birds and attach the wings to himself to get home. But the old people told him, "No, my dear son, you can't do that. We'll fix it for you."

H. Rock Writing at EbRk b

This rock writing site consists of a much-weathered painting of a single figure on the side of a large, three-metre-high granite boulder near the trail, close to the river's edge. So much pigment has fallen from the painting that it appears at first glance to be a natural iron oxide stain several of which appear on other large boulders in the vicinity. It was identified in July, 1988, by the author and Brian Molyneaux, who verified the existence of the painting by close examination of the rock surface with a 50 mm. magnifying glass. The painting appears less than two metres from the trail and would have originally been clearly visible to all passersby.

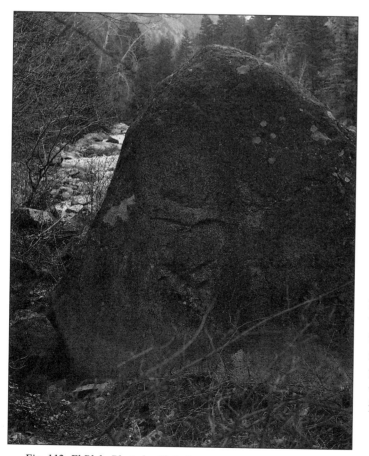

Fig. 112. EbRk b. Photo by Chris Arnett.

170

Fig. 113. Rock writing at EbRk b.

Annie:

Here's that thing again [the hunter's power figure]. He's got a headdress and his bowl or cup. When Xwekt'xwektl was on this earth and Nglíksentem went up to the moon, that's when Nglíksentem said to the old people, "I want a cup."

The old people says, "We'll make it for you out of basket." So they did and they even put it in that stúukxw for him. Later on, Xwekt'xwektl said to him, "You are not going to sleep in the house. You are going to go out and pray. Then you will see your life and what the future is going to be."

He did that. He went up in the mountains. He spent his time there. After that, he seen his own power before he came back. That's where the syux'nam power comes from. Nglíksentem wants that cup to drink from.

Richard:

Is that why it would be painted beside the river?

Annie:

Yeah. You see, he wants that for power too. A syux'nam will always do this to the water [stirring]. Then they put their hands in it. Then he throws it away. He puts some in his mouth and he sprays you. I used to watch that. My granddad let me. One time this old lady climbed on top of the cold kitchen stove. I guessed that's the mountain. And then she come down. I was afraid she was going to get caught in the lid. She came down and she had this thing from the mountain closed up in her hand. She said it's this spiritual life thing, her friend. She was gonna use it to doctor with. She put it in a bowl of water and sprayed the water over this man who was sick. She got this power from the other side of life, and put it on this man. Sprayed it over. I waaaaaaatched it, you know! She put this mat over her head and it's got four bones; she sang a song under there.

This painting on the rock shows that man who went to the moon, in his power from the other side of life. He wants a cup for water, and he has three feathers in his hair to remember that big bird that he wanted to use to get back home with.

Those old Spider People told him, "No, you can't kill that bird and use it. You're to go up in the hills by yourself. You are gonna pray and you're gonna go without eating. That bird is going to give you strength when you get down to this earth."

Afterwards, when the old lady had made him that basket cup, she told him, "You go down to the water, and that's how you are going to use it." He used that inside the stúukxw, along with knowledge of everything—the tanning of rocks, the frame for making an Indian blanket, and the needle for making mats.

Richard:

Tanning rocks, Annie?

Annie:

Painting on rocks. They told him, "This is what you're gonna use when you get there." They also showed him the scoop net because he had to do fishing while he was up there. They showed him the fish fence and the traps, how to scoop the fish, cut the fish. The pattern for that knowledge was in his cup. He was told to put it away where no one could walk around when he got back.

When he got back he found his wife gone to live with his own father [Coyote]. This was the time he helped that old man [Ndjimkaa] with that cannibal with all the heads. Then he crossed the river and looked up the hill toward Botanie Mountain. He saw his wife and children. His *own* father was living with his wife. Some people said to him, "You see what your wife did when you left her?" He cried.

So Xwekt'xwektl says, "Okay, I'm going to punish them." Xwekt'xwektl flew over there and pushed the rock down, and every one of them turned into rock. That's why you see the rock all bare and eroded there.

Fig. 114. EbRk 10. Photo by Chris Arnett.

I. Rock Writing at EbRk 10

At the base of a rock talus slope, close to the river's edge, is a massive granite boulder four metres long by three metres high, with a small cave beneath it. This cave has been formed from the way the boulder came to rest at the base of the slope, as well as by the action of water and rock. Inside, above the cave entrance, and along the east wall of the womb-like shelter, one finds bright red, well-preserved rock writings and the omnipresent voice of the river.

EbRk 10 was identified and recorded in the fall of 1985 by archaeologist Ian Wilson

during his survey along the right-of-way for the proposed logging access road (Wilson 1985). The site, located only metres below the proposed road at the base of a talus slope would, like other Stein sites, be seriously affected by road construction.

People of many cultures—from the Chumash caverns of southern California to those of Lascaux and Marsoulis in France—consider caves to be ideal places to meditate, and in which to record these meditations. "They sleep in there," Annie explains, "and they dream and then they write their dreams."

Fig. 115 Rock writing at EbRk 10.

Annie:

This is dreaming of the spirit history in the river. Look at that fish. It's ancient. They created the alligator from that. That ancient fish is swimming to the fish trap in the river. The fish goes in and he can't go past. He just stayed there and after a while they scooped it out. That fish fence goes right across to the left.

173

Fig. 116. 'Nlaka'pamux fish weir. These were built in shallow rivers to catch salmon which, when obstructed by this enormous fence across the river, were speared by the hundreds. Drawn after Teit (1900:Fig. 235).

There was a very selfish man, like the serpent we talked about. He made that fish trap and guarded it with his helper, that alligator fish, so no other fish could go up the river to spawn. He said, "I don't want any other people to eat fish!" He kept everything penned up for his own use. Even animals. You see the deer and the dog behind the alligator fish? They were penned too. And up on top, all those little things that fish like to eat. He penned them too. The man used these things to feed his fish. Worms. Bugs and microscopic things. The fish stayed there to eat those things and never went upriver. When Xwekt'xwektl came he liberated them and scattered them on the water and the land. He told that man, "You're selfish!" And he kicked that man's head off. That ancient fish, he later turned it into the alligator fish. He scattered everything. Then the fish could go up the river.

That selfish man lost his head and his life at the cannibal place, Nkáx'omen Falls. They call it Nicomen now. His spiritual life is still around there, even though he has no head. Some people dream him still. His spiritual life walks around like that, with no head. My grandmother seen it, when they were girls.

174

There were two other guys involved too. They said, "We don't like the way things are, because we're not allowed to get fish." So they went up the mountains and praaaaaaaaaaayed. They learned how to make the weir and the trap. So it was made by humans after that. They used their power to get that selfish man defeated.

Above the headless man is another of the animals that person wanted to keep penned up for his own use too. X̲wekt'x̲wektl said to him, "You are not doing that any more! Everything is going to be shared with everybody!"

That man even penned up the spiritual creatures of the river. You see that one with the twirly thing on his tail? It was called Xa'xa'étko. Later, people called it Ogopogo.[55]

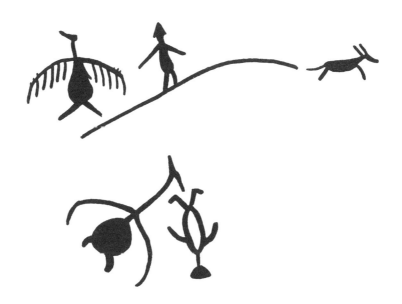

There's also that very spiritual life person beside him, with antenna-things, and that bird talking to him [right side]. There's a legend about that too. This young woman was waiting for him [the spirit man] by the creek, and she sang a love song. People thought she was singing to a fish. She sang, "Ni kwodikwa dikwa dikwa..." X̲wekt'x̲wektl came along and thought she was wait-

ing for a fish. He turned her into a fish. He asked her what she was doing. She said she was singing a song for her boyfriend. He said, "You're not! You're waiting for a fish!" He *threw* her away.

Then he said to the people [about the girl's lover], "You see that man? He turned himself into a big fish and kept all the others away. He doesn't let them out." That alligator fish looks a bit like a sturgeon.

The biggest of those fish food things above, it looks like a slug! You see, the idea for penning up the creatures came when that little boy let all the bugs out of the basket. He gathers all that and wants to use it to feed the creatures he's gonna keep in captivity. The man who trained in the mountains to get rid of this, he got strong and scattered all those bugs and things. Some became mosquitoes and some bother trees. All that kind of thing.

Fig. 117. Rock writing at EbRk 10.

There's an animal running. And a man wearing a hat. *Yúkwaastat* is the name of that hat. It's the woven root hat of the man who dreams.[56] The bird is his *sh'náam*. His power. You don't see that kind of bird on this earth no more. You don't see it yourself. It's in his dream, a spiritual bird. He's going up a hill to chase this animal.

Down below is a big bird talking to this insect. You can tell it's a bug because it has a horn. The bird says to him, "Look, you're gonna be a small bug, and once in a while we're gonna eat you."

The man [one of the first humans] didn't like this bug, but his Creator said, "That bird's the one that's going to help the people clean out that bug." He creates everything for a reason. That bug would be a beetle and the bird cleans it out of the trees. That's why he created the squirrel too, to clean up the trees. And he's gonna do all the [tree] planting too, that squirrel.

Fig. 118. EbRk 8. Photo by Chris Arnett.

J. Rock Writing at EbRk 8

Not far beyond the ruins of the trappers' cabins at Skwelakwil, or Earl's Creek,[57] the trail dips close to the river's edge, and cuts across a rock outcrop of unstable, rectangular granite slabs which overlook the rapids. Writings appear on vertical rock faces along seventy-five metres of the rock face. They are clustered into two groups, one oriented downstream, the other facing upstream. Until recently, the furthest upstream writings at this site appeared high above the trail on a vertical rockface, above a ledge that permitted fine upstream views of the valley and the river rapids. This section of the site broke away from the cliff face during the winter of 1991-92, and slid to the edge of the river.

The first non-Native to record this site was C.J. Hallisey, who sketched some of the paintings during his trip up the Stein in the early 1920s. In September, 1961, Andrew Johnny of Stein guided the archaeologist David Sanger, to this site which was eventually designated Site EbRk 8.

In July, 1988, in the vicinity of the downstream painting, Brian Molyneaux identified a fallen slab which, when partially excavated, revealed a painting on the buried face of the slab. This painting is identical in size and composition to another on the now fallen, vertical rock face at the upstream edge of the site. The slab remains buried; Molyneaux suggests that the organic matter covering the slab might be analyzed using radio-carbon dating to determine a relative date for the fallen slab and some indication of the age of the painting it contains.

176

Molyneaux also found a 1934 Canadian nickel on the site, which may have been left, at some point in decades past, as an offering.

One painting at this site shows what appear to be two figures in a boat. This has consistently attracted the attention of non-Native "interpreters" due to its perceived resemblance to a European two-masted schooner (Fig. 125, left side). As long ago as 1925, trapper Young Easter Hicks, whose mother was half-sister of 'Nlaka'pamux Chief Cixpentlam,[58] theorized that this painting represented a European sailing vessel and could be used to date the writings. Adam Klein accompanied Young Easter Hicks on his 1925 trapping expedition. He made mention of the rock writings at EbRk 8:

> On the way down to Lytton, Hicks pointed out the Indian paintings, telling me that he believed they were about 200 years old. Hicks said, "It can easily be determined. One drawing showed a two-masted ship. So, all one had to do was look back into history, and find out when such kind of ships sailed by the land." (M'Gonigle and Wickwire 1988:103)

Later observers made similar interpretations. John Corner, who made drawings of these paintings in the mid-1960s as part of his survey of Interior rock paintings, wrote: "Few of the pictographs encountered have stirred my imagination more than these" (Corner 1968:16). Corner thought that the paintings "might be a two-masted schooner complete with crows nest, figurehead and furled sails." Another observer, Corner noted, "interpreted it as two men in a large Nootka or Haida dug-out canoe." This interpretation has worked its way into the contemporary ethnographic and archaeological literature (Wilson 1988:72), and into a recent survey of the rock art of the Columbia Plateau and surrounding areas (Keyser 1992:59).

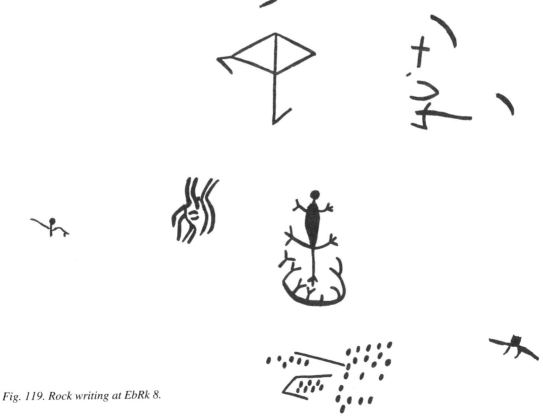

Fig. 119. Rock writing at EbRk 8.

Annie:

 All those little dots down at the bottom. He was told, "You're going to see this once in a while over the heads of the earth." That's the stars. That's the stars when it's first formed on earth.

 Stars on the right show their formation. The ones to the left are the dense ones, like steam. They are called <u>k</u>usten, steam-like. That originated when the women were steaming wild sunflowers [balsam root][59] on Botanie Mountain. They were shoved up there as stars. That's a legend too.

 Beside that is a bird flying in the sky too. <u>X</u>wekt'<u>x</u>wektl says, "The earth needs some company. Without birds it's too quiet. I'm gonna create birds for the people." That's when he transforms those two gossipy people—Ho'ho'hiiya and Chickadee—into birds. He just throw them around and makes birds out of them.

 There's a bird in the star formations too.[60] Sometimes you see it there on a *clear* night. And you can hear it too, when it's quiet weather and the stars are clear and blue. That's when the creek sings with the stars. Yeah, that's what they do.

 Above that, there's that serpent lizard again. This time he's only got one head. <u>X</u>wekt'<u>x</u>wektl says to him, "You're a serpent anyway. You're not going to live by keeping things to yourself and keeping people away from everything. You're gonna live in the bush."

 You can see it there, the ring of bush to fence him off from the people.

 To the left is a water vegetation. That's its roots. It grows close to lily pads and its flowers is pink. You can see it when you're going to Ashcroft. They say it's poisonous. He could have dreamed it as his power. It's called *'nglíkskaliyúmpxw*, and that lily pad it grows with is *letsk'étko*. He'll use it for a certain purpose.

Richard:

 And the lizard or serpent—does the dreamer use that for his power too?

Annie:

 No, he won't use that for power. It just comes up in the dream. Beside that [to the left] is a little flying bird.

 The next set of pictures above, they show the creation of earth. They teach that that cross comes first. Here it means when death comes. Nglíksentem brought death to the earth. There was death there on the moon. After he came back there was never any more life there on the moon. The upright cross shows the death that Nglíksentem brought back, and that sideways one shows death's sign on the ground.

 The little shape in between is a pile of dirt that you gonna put on the grave. The two sort of eyebrow marks to the right, they mark who owns that grave site. If I put that near a grave here, the old chief could have read it.[61] Different people have slightly different marks for that.

178

X̱wekt'x̱wektl went up to the moon and threw Spider and his wife down for giving all that help to 'Nglíksentem. He taught them to cry at the time of death. Death came from their actions. But really it's from the dream planet in outer space that death really came from. It went from there to the moon.

On top is another picture of 'Nglíksentem's space basket. The stick at the bottom is going to be his landing feeler. He uses that to steer, and once in a while he uses his hammer. You can see the formation of that space basket in the stars on a clear night.

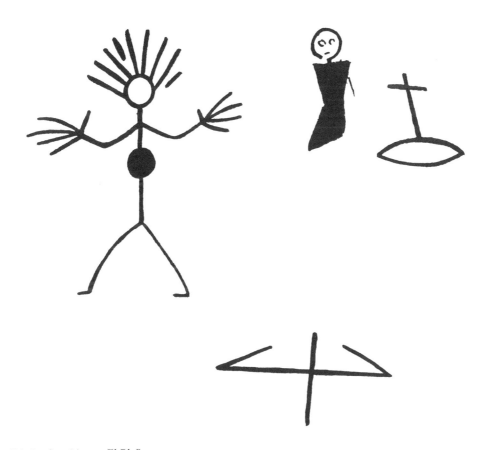

Fig. 120. Rock writing at EbRk 8.

Annie:

At the bottom, that's about when they formed the bow and arrow. Above, there's your grave and cross.

Richard:

Annie, it looks like a priest standing beside the grave!

179

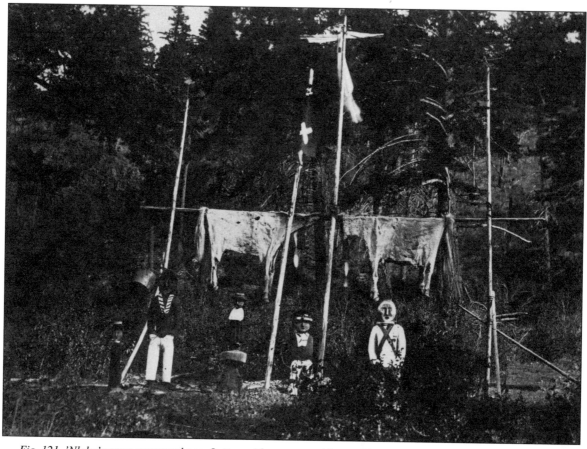

Fig. 121. 'Nlaka'pamux graveyard near Lytton, with crosses and horse skins. This burial place may have been used by the family of Chief David Spentlam. The Columbia Mission report of 1860 noted: "At Lytton was a burying place, where was the figure of a man, and near him, hanging up, the skin of a horse. This was to represent the son of Spirithum [Spentlam], the Indian chief, and the horse he loved to ride." Photo by F. Dalley, ca. 1867-70. Courtesy Royal British Columbia Museum PN881.

Annie:

Ha,ha,ha,ha,ha! You see, the cross is there as an indication for thousands of years. Indication of death.

Richard:

But why the cross?

Annie:

You always cross yourself. It shows the right and the left and the strength of God's life. The Father, the Son and the Holy Ghost.

Richard:

The Christian cross?

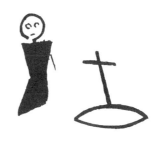

Annie:

Christian. Well, it's exactly the same. *Skuuzak gotsak huupii.* The cross is God's strength. The cross wasn't used for crucifying. It's an indication and a protection. It scares off the evil. The cross was always here on this earth. My grand-aunt, she told me about where my great, great grandmother was buried. My grandmother's grandmother and grandfather. They are buried under a pile of rocks and the cross is sticking there in the rock pile. It's the same when you kill a rattlesnake. You

bury it and put a cross on it. And they do it for a bear. For a bear you also say a special prayer and there's a special song you sing too. And if you're not gonna use the four paws, you take them and put them up in a tree where they won't be messed with. They are sacred. You are even supposed to sprinkle a cross of water on a bear before you cut it up.[62]

If you see a person in your dream in dark clothes, that's an indication of evil. That man beside the grave is the guardian figure of that place. It's written like that, dark, to scare you, so you have respect for the grave.

The Sun Man is standing there to the left. You can tell he was human once. One, two, three, four, five fingers like a human being. The sun was a man on earth. The Creator said to him, "You are always wanting to be bright, so we're going to give you a job." That man was thrown up from here into the sky. His wife told his children, "You're always going to see your father up there."

Fig. 122. Rock writing at EbRk 8.

That's Hwo'laák, the raven. And down below, the boy, Hii'hii'ha, is being pulled with a stick, by that bear. It's a story. He's up in the sky now. He was a bird in the mountains, like a pigeon. He says, "Hii'hii'ha! Hii'hii'ha!"

That kid was abandoned. He took the biggest animal and he led it along. The animal says, "Okay. I'll help you, little boy."

You see, that Sun Man, he's in the story too. It's about the boy that sold his blankets to the sun, for the colours of the sky.

The people didn't like this boy because he was rough, a bully. You know what they did? They put pitch on his eyes and abandoned him. The people kicked his grandmother into the corner of the kiik-wilee house. The boy couldn't get the pitch out of his eye. But his grandmother, she prayed, and her power went out to look after her grandson.

The bear, this animal here in the picture, pulled him along to direct him. He got home to the kiik-wilee house and he was crying there, trying to get the pitch out of his eye. The people took this big basket and threw it on top of the old lady. But the old lady said to herself just before this happened, "I might survive." So she got a clamshell that they used for carrying fire, like I have there. She scooped up some fire in the shell and put it under her arm.

These people don't like her because her grandson's a roughneck. They threw the basket on her. She was saying her prayers and that animal, the bear, went and got the little boy home. He was weak when he got home and he had a hard time getting down the ladder into the house. He couldn't see. He got inside the house. He was mad and he kicked the basket.

The old lady went "whish, whish, whish!" She said, "My dear, don't kick me. I'm abandoned too, like you."

She took her little grandson and give him love. She took that oil stuff, like fish oil, and put it on his eye. Finally she wiped it off. She sat him down. His head was nothing but grass and twigs. I guess he was out there for two or three days. The other kids blinded him with pitch.

The old lady wiped that off and washed his hair. He could see then. She said to him, "You go look for something to eat in all the kiikwilee houses."

He found four rabbit legs, all dried up there. I guess they had been boiled several times! So she took her clamshell with its coals from the fire and put in some stuffing grass. She made a fire. She had some saskatoon [berries] and some roots, and her little cooking basket. She cooked and the little boy got wood and heated the rocks. They made a soup of everything. He ate that and got his strength. Then the old lady ate what's left.

She went into the corner and pulled out some blankets she'd weaved and hidden. She wrapped him in the blanket and showed him how to make a snare for grouse, out of rope she was braiding from scraps of old buckskin. He trapped grouse to eat and she made them a blanket out of mouse skin. It was grey. And another out of jay's feathers. Blue.

One day he went out and hang up his grey mouse blanket. He had another blanket that was black. And one he'd painted red. He did this several times. One morning a man came. The sun got blackened out. The man said, "Little boy, why do you always cry? I like your blanket, the grey one, the blue one, the black one and the red one."

He said, "I like that orangey one too."

182

The little boy managed to snare grouse and shoot it. So they had grouse soup. When they finished, the old lady dried what's left.

That Sun Man came up again and said to him, "Look, you're not going to cry, I'm going to help you." He gave him a *nice* bow and arrow and said, "This is it. You're going to use it when you shoot deer to live through the winter."

They made a deal. Sun said, "I need it very much, that blue one and the grey one and the black one and the red one and the orange one—because my brother always likes to have his colours too. That's Moon."

The man just waved and the sun came out. He said, "I'm the Sun Man."

The little boy was so happy, he ran inside and told his grandmother. "Look at this bow and arrow! It's such a beautiful thing!"

Before he went out to hunt in the morning his grandmother said, "You use your prayer. Kneel down before you go to hunt."

He got up early and he bathed. He chased all the deer to that gully, the Stein place,[63] and he shot one deer. Sun Man told him, "Don't be greedy. Shoot one deer and then bring that home. Your grandmother will cook it and look after the other part." That's what he did.

Raven was one of the people who had abandoned the little boy and his grandmother. After they left the village the people couldn't get any deer because they had all been hidden in that Stein. One night, Raven says to his wife, "I think we're going to starve."

But the boy had lots of deer. He even had scaffoldings *all* of dried meat. He keeps bringing the deer to his grandmother. They have packs of hides and *nakwa*, tanned skins with the hair on. This Raven went there. Ran around and looked. He flew there and looked. He said to himself, "That's queer. It smells like someone's cooking something."

The old lady was barbecuing deer legs. And she got lots of kidneys and poured fat on them. She filled the bladders with fat and hung them up. That bird was picking at the grease at the edge of the house. He said, "Aaaaaaaaaaaughk!!!!"

So the old lady goes out and says to him, "You better come in." He went in. He was just skin and bones. See what he looks like there?

She was cooking nice ribs and legs. Everything. "You better come in and sit down," she said. The boy came in with fresh meat. He was grown now into a big man. Hwo'laák, Raven, told them that the people that had abandoned them were all starving. They couldn't find the deer. He said, "There's no deer. Nothing."

That's where that word StI'yen, or Stein, comes from. A hiding place, for deer. That boy drawed lots of deer in there somewhere on a rock. They haven't discovered that one yet.

The old lady fed Raven because his family had left her that dried rabbit legs. She cooked nice pieces of meat and fat for him. He got a pack of meat and went home.

He whispers to his children, "Don't say anything!" The kids were *hungry!* And he took out the nice barbecued meat and that fat in the bladder. He opened that up, stirred up the fire, and fed all his children. When they got filled up they went to sleep.

The old lady had told him, "Once in a while you come back and I'll give you some more." He does it twice. The second time he was caught. He told the old lady, "All those boys that your son is avenging, they're almost dead now, starving."

The old lady give him a nice pack again. He went home. It was getting dark. He fed his kids. One of the kids ate too fast and he got choked. Go<u>k</u>! Waaaaaaaaaaaaa! (You know how once in a while a raven makes that choking sound?) Well, somebody heard it. Someone says, "That's funny, there's nothing to eat and someone's choking!" Mr. Crow went and grabbed the kid who was choking. He said, "It smells funny in here." But the old Raven woman says, "Naw, it's only cactus we're cooking. We choked on it."

But Crow doesn't believe this. He chokes her and gets that meat out. "You're lying. Where did you get this nice meat?" Crow takes their meat and drops it in every house so that everyone can eat. Some are just starving.

The next morning Raven broadcast the story. He said, "That little boy we abandoned, he's got lots of deer meat in his house. The kiikwilee houses are filled with his hides and meat."

The people packed their stuff and they went back. They stole all his meat. And they eat it. That's why this picture is there. You have to know legends to find these things out. They are really not legends. No. That's the story of life. The history of life.

Fig. 123. Semi-subterranean pithouse (s'iistken) *or kiikwilee house at Merritt, occupied until 1882. Photo by Maurice G. Armytage, Aug. 1907. Courtesy Royal British Columbia Museum PN1437.*

Fig. 124. Rock Writings at DlQv 16: Skaha Lake, B.C. When Annie was shown these drawings from the Okanagan area, she said that this was a depiction of a dream based on the same story of the little boy, the grandmother, the raven and the penned-up game. Drawing from Corner (1968:69).

Here's that story again. Ⱨii'hiï'ha. In this picture he's showing the people where all the animals are. After they abandoned him he chased aaaaaaaaaaall these animals into a gully, and those people were starving. Couldn't get nothing until he showed them where the animals were. That is all one person's dream, all that writing.[64]

185

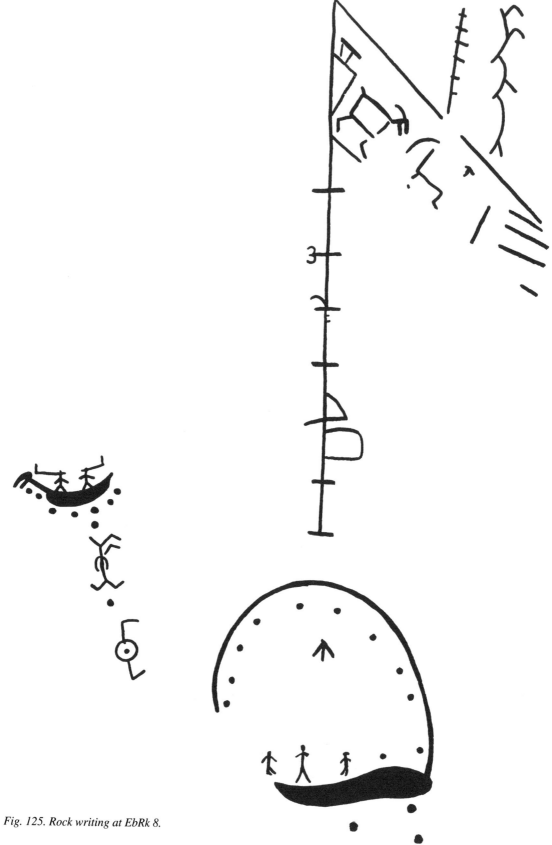

Fig. 125. Rock writing at EbRk 8.

Down below, you can see the Indian astronomers. They go to sleep outside and watch the stars. That's the way they learn the moving of the stars. The arrow shows the evening star. That's the star that can tell you the earthquake too. I relate everything with it.

If I seen that star, and the moon over here, racing with her, and she has a slight rainbow colour on her ring, I know there's going to be an earthquake. The bad weather, the moon tells that too.

Those people stay in the Stein, you see. That's the history. These people used to go out at night time to watch the stars. The Creator said to them, "What you do that for?" Then Xwekt'xwektl come along and said, "Yes, you watch the star. You're going to always watch it, and people is going to draw pictures of you, and the pictures is going to be seen all the time."

And it's there, all the time. That one down at Hope, that one that tells when there's an awful earthquake. Whoever was there, wrote it down. So that man down there, stood in that cave and put his marks on it. He wants to tell the people that he was there when that earthquake came.

There's a story behind those people watching the stars. It's a story of the legend time, of Wallítz and Netáka. They was the Devil's sisters and they knew that Xwekt'xwektl was comin'. These people, they *always* watch the stars, and they feed them too. Wallítz says to her sister, "There's a man coming but we don't know what he is."

Then Chickadee comes and says in a high voice, "This man is gonna do you something!" They just laugh at this. When Xwekt'xwektl came he woke them up. He says, "This is what you *have* to do. You're not going to lie down and watch the stars. You're gonna *stand* and watch it. But, I'm gonna show you something. Your picture's gonna be up here on this rock, watching the stars!" He draws them on the rock, then, ziiiip! He transforms them into one of those foam stars.

He tells them, "You're not going to live forever. You're gonna come apart, and come back, bit by bit, to this earth." And they do too. You see the foam star gathers foam and other stars hit it, bang! You'll see them coming down, the meteor.

Xwekt'xwektl says to them, "You can't watch the stars *all* the time. I'm turning you into star and people's gonna watch you!" He did that because the Creator send him to this earth to watch what people are doing. These people were overdoing it and he didn't like that. But he himself overdid it sometimes.

This happened in that Stein, you'll find it there. The tall one in the drawing is the leader. He's the one that goes all foamy. There's a white sort of sodium up there and that's why he gets foamy in the sky. They call them The Star Watchers. The others are the woman and the boy. The dots are the stars and the circle is the sky.

The other writing, beside that, that's Xwekt'xwektl and his brothers, with Ndjimkaa and the canoe. They've got the canoe poles on their heads, and the little dots are those little fish with the sharp teeth. Xwekt'xwektl carried them in his pocket! He put them in the water after they crossed the river, and he said to the old man, "Now you can go get that lady"—who was actually Grizzly Mother who's chasing them. The old man didn't know why he had made that hole in the canoe, but Xwekt'xwektl did. Those fish was waiting for that woman.

The boat has a head like an animal because that old man, Ndjimkaa, he's an Indian doctor and that animal is his power. Afterwards he went up that mountain. His Creator said to him, "You must never do that to animals! You shouldn't have gone out there and bring that lady sitting in that hole." He fixed the old man for committing a sin like that. He says, "You're gonna stay there as a mountain, and you're gonna smoke once in a while." He was turned to a mountain after he and Nglíksentem killed that cannibal.

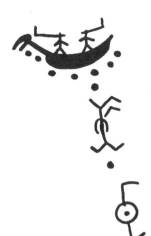

They were midget people in those days, the size of children. That's why they kept the canoe poles on their heads.

Below the canoe is Ndjimkaa's other power, the power of smoke. He used it against Grizzly, but more later, against that cannibal. You see, it's got a hat on the top. That was Ndjimkaa's hat. Smoke came from his hat. He was a syux'nam. It was through the smoke of his pipe that he could tell that the boys were coming. He says to his wife, "The poor boys is coming because Grizzly tries to kill them." He says, "Giiiish! If I'm weak those boys is gonna die."

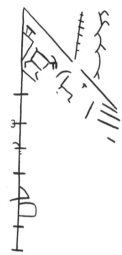

The bottom figure there tells you how the boat was like. That's the rib with the hole he made. And the plug in the hole. He blocked that hole before he went across with the boys. Before he took that lady, he pulled out the plug. He sat in one end and the other end, with the hole, was in the air. He told that woman, "You're big and I'm small, so you sit on that hole."

Those little fish attack her and eat out her insides. They tell it that she says, "Ouch!" And that old man hits her on the head every time with his pole. He says, "You sit there!" And she died in that canoe. When he got to the other side he poked her into the river. That was the end of her, that one![65]

The writing up above is different. That's a big fence. You see the goat, and another animal that's stuck, not finished. The shape near the bottom of the fence is his gate.

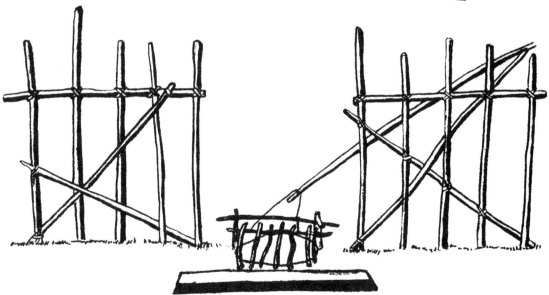

Fig. 126. Section of 'Nlaka'pamux deer fence. These fences could be up to a mile or more in length. Every eighty or hundred yards was an opening wide enough for a deer to pass through. There it would be caught in a snare that lay on a number of sticks placed over a shallow pit. When a deer stepped on the sticks, a trigger released a spring pole that sprang up, tightening the snare around its leg, and suspending the animal above the ground. Drawn after Teit (1900:Fig. 228).

That's the story I was telling you yesterday, about the boy that was abused by the people and he got mad. So he took all the animals and he corralled them. Nobody can get them and the other people get so *hungry.*

The other thing, just above the gate is where Hwo'laák, Raven, looked in and said, "Gee, that's a funny thing! Someone has two gates. The big one is locked, but this little one is open." So he goes through.

The cross lines on the fence are the props. The thing up the top corner, that's the boy's kiikwilee house. He asked *all* the animals to come in there, so the others won't get them. Those little straight lines down at the end, that adds up to one, two, three, four and a half days that he and his grandmother were abandoned and had nothing. That is an old way of writing numbers. With several horizontal lines and one vertical. That adds up to four and a half. But if you put two verticals there, it would double it to nine. That's when the animals all talked to each other, and they said, "That little boy is poor. He wants to get us but he don't know how yet. Still, he has us here in the corral."

Afterwards, the little boy said to himself, "I'm going to let them out for a while." They go out loose, and he lost them. Then he grew bigger and the Sun Man gave him the weapon.

The little mark above the unfinished animal is to remind him never to eat meat, or go hunting without saying his prayers. You have to respect the animals.

On the upper side there is a hole in the fence, where he let the animals go. When he let them go, he let them into the Stein. That curvy row of lines is the outline of those hills and mountains along the Stein. You can see the different creeks between the mountains. Where there is two rows of curves it shows that the mountains are higher.

Fig. 127. Rock writing at EbRk 8.

This one is the lesson that was first written in the Stein by the man in the sun. That's the bow and arrow that Sun gave to Hii'hií'ha in exchange for his blankets.

Sun Man is talking to Hii'hií'ha and telling him, "I could teach you. Animals is going to come all your way. I'm going to take your blue blanket." That's what the blue sky is. And the grey sky, when it's clouds. He told the boy, "Your mouse blanket, that's going to be the clouds."

And the black one too. The white is the snow clouds. It was made from the white weasels and the rabbits that he was catching. The other one is the red clouds. That was the painted one. He used those blankets for the changing weather.

He told Hii'hií'ha that there was going to be a road from the sun to the earth sometimes. "That's to give our sister a nice bright light into the earth!" He talked about the rain and the stars, the rainbow. He even spoke about *stix'yé'e*, the thunder. He gave the boy a lesson from what he did when he got back to the kiikwilee house with pitch on his eye. He was so mad, he kicked that *ská'osten*, the rock that anchors the ladder—the ladder is *hunóoxw*—into the kiikwilee house, and it *BANGED* into the s'kútsamen [one of the four structural posts of the pithouse]. It missed his grandmother but it made an awful roar. He footballed it right in there.

Later Sun Man told him, "When you do that, once in a while you're gonna hear that roaring noise and see a hail and snow and rain. Once in a while you'll see light flashes because, when those boys pitched your eyes out in the bush, your grandmother took burning pitch wood and plunged it into water. She prayed outside after that, and got that animal to go look for you. That was her Sign of Lightning."

Not many people have that power, but my grand-aunt can do it. You put that burning pitch fast into water. Then you light it again.

So that's thunder and then lightning.

Him and his grandmother had been out there about two or three years now. Abandoned. That's when Sun Man came to him and said, "Now that you're getting older, I'm gonna tell you something. You're gonna go out and hunt. Everytime you go out you will see different animals. Never shoot two. Always shoot one. Don't be greedy."

Then Sun Man wrote down pictures of all the animals. He said to the boy, "Look. You see this? Those are the animals you're gonna get once I give you this bow and arrow."

That line shows the different animals, like an elk, a deer, a *xooya'aken* (mountain goat). The first one is a fainter drawing because that's from the time of the beginning of animals. The stripes show all their different colours.

He told the boy, "You must never abuse that bow and arrow. It is for hunting. *Never* for war." The Indians are not supposed to use it for human fighting. Of course the people *did* use that against each

other. That's why they were given no new knowledge from the Creator. That's why Indian people doesn't have mechanical knowledge now unless they go to school.

The old people used to train the young in the mountains. All that old knowledge is connected to the origins, the creations, and they teach them that. They teach them about the red paint and how to put it on the rocks, and how to mark yourself with it for protection. If you're going to where there is lots of people you do that. From the writings on those rocks they teach the young people how to live. They have to follow that. That's the way that the Nahliis learned. Like John Nahlii, Paul Nahlii, Moses Nahlii and William Nahlii from Lytton. They told me. They said, "As soon as you're old enough they'd take you up there to learn."

They told me this story about the Sun Man writing this on the rock. It was one day when we were coming in on the train. Some people say this was written beside the railway and it got blasted away. No. It's in there, in the Stein.

Fig. 128. EbRk 11. Photo by Chris Arnett.

K. Tree Writing at EbRk 11

This is the only known arborgraph, or tree-writing in the southern interior of British Columbia. It consists of three charcoal drawings on the scar of a bark-stripped cedar tree, growing on the north bank of the Stein River, just downstream from Stl'imíín, or "Wade Across Place."[66]

There are two scars on the tree, made by the removal of patches of bark. The scar on the east side of the tree, facing downstream, has numerous tiny, shallow marks on it, made with a dull knife, possibly to create a design. The charcoal drawings are found on the scar on the west side of the tree, facing upstream.

These drawings were identified in the summer of 1986 by Thom Henley. The tree was subsequently examined as part of the 1987 study on culturally modified trees (CMTs) in the Stein Valley. This study was funded by the Western Canada Wilderness Committee. The site was officially recorded later in April, 1988, by archaeologist Ian Wilson. It was subsequently designated EbRk 11.

James Teit noted that if an 'Nlaka'pamux person who trained, had been unable to find a suitable rock surface near the place where he or she had experienced a dream or vision, the person would record that experience "on debarked trees" (Teit 1918:2). Teit's account of Stl'atl'imx (Lillooet) culture mentions paintings "made on rocks and trees by adolescent boys and girls as a record of their observances, but also by men as a record of their dreams" (Teit 1906:282). Teit also described at Stl'atl'imx custom concerning certain rocks and trees upon which a drawing had to be made by people passing by for the first time. "In some places," he recorded, "persons passing by for the first time would paint or carve figures on trees instead of rocks. When the tree was to be painted, the bark was removed" (Teit ibid.).[67]

Tentatively, core sampling and analysis of tree ring data from this cedar tree in the Stein Valley indicates that "the bare scar on which the pictographs are painted was caused by bark stripping that was done after 1875 and before 1907" (Parker 1988:9). The charcoal drawings, therefore, may date from this period, or later.

Fig. 129. Tree writing, or arborgraph, at EbRk 11. Charcoal writing on a cedar tree from which bark has been removed.

Annie:

Here it is again! This time he's got a funny top. He's propping himself there.

Richard:

Annie, these are on a tree. They are not drawn on the rocks.

192

Annie:

Yeah. In the beginning, they say, some of the animals had two heads. This end's got antlers and the other end is different. Then you have that boy again, grown up now, and he's got his forked walking stick through his pack so his hands are free to climb with. You can see the ends between his legs and over where his head would be. He's got his head down. I often do it that way myself. That's another instruction. You always put it straight up and down through your pack or your belt, so it doesn't get caught on something.

But back in the ancient time he had this Two-Head working against him. (My grandmother told me, "That boy is religious, but the other people there, they aren't. They send out animals to try to get him.")

The old lady told her grandson, "Those peoples are going to watch you and do you a dirty trick, and you will never be able to hunt again."

And that's what happened. The people were envious of his good luck. They sent this animal against him. But his grandmother was *very* powerful, and she kept the animal going away from him, in the other direction.

The other thing there is grandmother's arm. She threw her arm at the power sent by those people. She threw her own arm to protect her grandson. She sends it out to catch this animal and stop the attack. It's a protection story and it goes with the Hii'hii'ha legend.

The old lady said to her grandson, "There are other people who are just as powerful as you're going to be. They are going to do you all kinds of things."

Well, people today do that too. I could tell you some things, but I better keep that to myself! Haha! The person that fixed it, took that stuff, broke it into pieces and threw it into an animal. [This action refers to the shamanic practice of causing illness by psychically shooting a foreign substance into one's victim.] That's jealousy. That's what jealousy does. You researchers, you sometimes fight with one another, but I tell you, the ones you talked about, the ones that sold the people's stories to the government, you watch out for them because they got old people protecting them too. They say those people is *wai'áx shelaxt!* So watch out! Hahahahahahaha! *I heard them saying that!* They gonna——oh, I tell you, don't think an Indian in other places is weaker than here! Some of them is very, very powerful!

Fig. 130. EbRk 3. Photo by Chris Arnett.

L. Rock Writing at EbRk 3

This rock writing site is found on the north side of the river in the vicinity of *Stl'imiín*, the "wade across place," the ancient ford where the trail crosses the river from the south bank and continues upstream along the north bank.

The faint, lichen-obscured rock writings are found on a low vertical face of a large angular boulder, measuring 4 by 7.5 metres, at the base

of a talus slope, directly adjacent to the trail on the north bank of the river. The area around Stl'imiín was one of the places in the Stein where 'Nlaka'pamux women came to harvest cedar roots to make baskets. The place was especially favoured because of the sandy soil and relative shelter from the wind, factors which allowed the cedar roots to grow long and straight and made digging them easier. We should bear in mind that Teit was told that women's writings were often found on boulders. The site was identified in September, 1979, by archaeologists Mike Rousseau and Geordie Howe.

Fig. 131. Rock writing at EbRk 3.

Annie:

These are women's things here. That's a digging stick on the left. That Sun Man told them that a woman's instrument is not going to be the bow and arrow. It's just a stick like a hoe. That was his design but it wasn't comfortable to dig with. The next picture is the one designed by X̲wekt'x̲wektl, with the hilt on it. I got one *exactly* like that.[68]

The two little dots below, they're the stuff that she wants to dig up. The next one to the right is another digging tool. It's shaped like a letter "P." Above that is the sign for prayer, like two curlicues, back to back. That X̲wekt'x̲wektl told the old lady that she must pray and talk to that tool before she uses it. He says, "You kneel down and talk to it before you start." Old people do that. I seen them. I saw my grandmother do that, digging up in that flat basin across the river.

That stick line below shows the intervals. She was taught that you don't just dig them all at once. They ripen on their own time. You don't pick *getúwan*, the wild potato, the same time as the *s'kámets*, that dog-tooth lily root.

Richard:

How do you tell that, Annie, from just one line?

Annie:

Because it is such a thick line there. And X̲wekt'x̲wektl teaches that first old lady about the species when he teaches about the digging tool. And he teaches her to talk to her basket too, before she goes

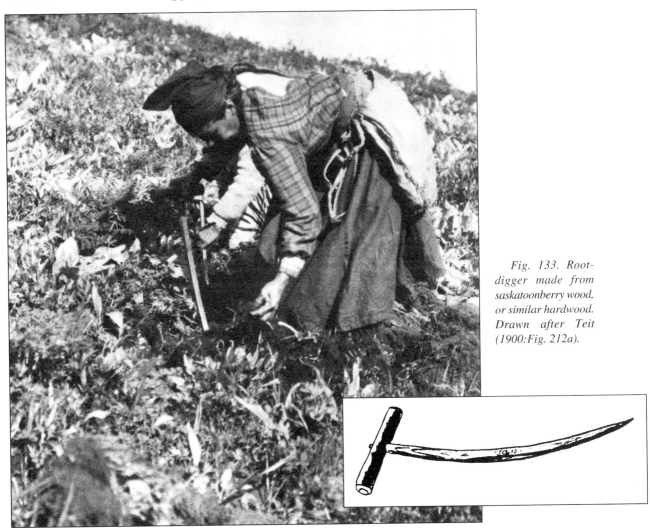

Fig. 133. Root-digger made from saskatoonberry wood, or similar hardwood. Drawn after Teit (1900:Fig. 212a).

Fig. 132. Kokowátko, a 'Nlaka'pamux woman, digging roots of the yellow adder tongue lily at Botanie Valley, near Lytton. Shown here is the method of loosening soil with the root digger, and lifting out the roots. Photo by James Teit, 1917. Courtesy Musée Canadien des Civilisations/Canadian Museum of Civilization No.39755.

up to pick berries. If you do that, no matter how heavy it gets, you won't feel the weight of it. The old people does that. I think those Sto:los do too.

The men too, they were taught to talk to their tools, the bow and arrow, the fish trap, adzes, everything! They talk about what they are going to do, and they ask the tool to help.

Fig. 134. EbRl 6. Photo by Chris Arnett.

M. Rock Writing at EbRl 6

One of the most inaccessible and well-preserved writing sites discovered to date in the Stein River Valley is a painted cave located on the south face of a mountain 1,600 metres above the river in the middle valley. The cave overlooks that region of the Stein known as *Shkli'hiíl shklahóws*, a place-name which referred to the former practice of travelling this portion of the valley by canoe. (The original cottonwood dugouts were later replaced by canoes built from whipsawn boards.) These canoes were made in this part of the valley and used so as to avoid the swampy, brush-filled riverbank trail (the late Andrew Johnny Sr., p.c.). Andrew Johnny said that in times of high water this area of the Stein was "like a lake," with the river navigable for ten miles. This is the place of the legendary painted caves described by 'Nlaka'pamux elders.

The spectacular cave was located by helicopter in January, 1986, by pilot Gerry Freeman with anthropologist Wendy Wickwire, Ken Lay and 'Nlaka'pamux elder, Willie Justice. Together with archaeologist Dana Lepofsky, Wickwire, Freeman and I visited the site in November, 1987. In April, 1988, the cave was located by archaeologist Ian Wilson while he was under contract to British Columbia Forest Products. It was subsequently designated as EbRl 6 (Wilson and Eldridge 1988:2-3).

The cave is 3.75 metres wide, 6.5 metres deep, and 1.9 metres high with a commanding view of the transition zone between the lower canyon and the middle Stein River Valley. Writings are found

Fig. 135. Rock Writing at EbRl 6: on the rockface, beside a cave entrance.

outside the cave on a vertical rockface west of the cave's entrance (Fig.135), on a panel directly over the entrance (Fig.136), and inside the cave on the walls and ceiling (Figs. 137, 138, 140). Annie commented on the different locations of writings inside and outside the cave: "Maybe some guys sleep in there and other guys don't want to sleep in there, so he slept outside and he draw his dreams outside."

Inside the cave the floor is covered with mountain goat dung and at least eleven goats are portrayed on the walls and ceiling. A well-worn natural stone seat just inside the entrance gives a magnificent view of the valley below.[69]

Annie:

That's a legend too. The bird is the one I was talking about, *She'átewan*. I don't know its English name. I seen it a couple of times when we lived at Pitt Lake. It's sort of like a goose. They live on the lakes. Douglas Lake used to have them by the galore. They have a grey breast, blue—pretty blue—on the back, and green on the wings and head. Those birds flies back here in the spring. People used to eat all their eggs. After a while the bird's extinct.

She'átewan sings all the time. He was practising and he says, "Me, I know what I'm going to do. I'll just lead any animal anywhere. I'll get it that way."

So he leads them with a song stick. He spirits it and walks it around where he wants. You see, the picture of the bird and the goat, that's him taking an animal from one place. The other picture is the place he takes them to and lets them go.

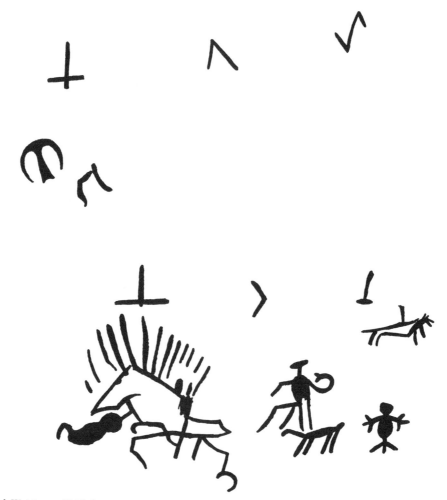

Fig. 136. Rock Writing at EbRl 6: cave site.

That's the way he pulls them all over the place.

Because he done that, it gave people the idea of following animals' footprints around, from place to place. Those are the idea of following footprints that you see on the top.

X̱wekt'x̱wektl didn't like this and he took that bird and drew its picture on the rock. Then he kicked it and said, "From now on, you gonna be a lonely bird on a lake." They were something like a loon, but bigger, and they sang lonely, "Oh-haaaaaaaa, oh-haaaaaaaa, oh-haaaaaaaa, oh-haaaaaaaa!

Now that one, you see, is about building a house [Fig.136, bottom left]. But first, you must pray. See here, up above? [The double right angle or upside down "T" figure.] That's a prayer sign, for guidance in the work.

It's a frame house. The lines like rays are the roof rafters. And here, under the roof is his drying rack and a big wad of meat [the heavy bulbous form] hanging from the rack to dry over the fire. The rack is the straight line, and the squiggly lines at each end are its ties, for tying the rack to the walls. If you gonna fix your meat you got to hang it up like this, and you make a little fire and dry it. That's what that man was told in his dream.

He asked, "Where's my door going to be? That house is going to need a shutter for shutting it up."

They told him, "You gotta make that yourself." So this is what he was figuring out [right side of house figure] over here. He thinks a grass-mat lean-to roof against that side of the house, and below it you can see the door and the rock he's got to prop it open or shut. The doors were made with slats and cross pieces. You prop it open and that prop, the rock, is called *ngachinex'ten*. You see, it isn't a kiikwilee house [earth lodge]. No, it's a summer house. They use grass mats and they smoke their fish and meat. I seen that made. They use poles for it. They weave ties through the poles to prop the walls. That's all tied that thing, the drying rack, and the walls. And the door is tied on. That rack has a special name something like the word for bed. But it's not the same. It's not *gush'a!*

That boy we were talking about, that's who's outside that house in the dream. With his dog. The sign over his head, like a sergeant stripe, that's to do with his prayer. It connects him to the Sun Man, who told him, "You're also going to have a dog. I'll see you have a dog. Your dog will follow anything and help you to hunt, and gather your stuff."

That sign over the boy is his director, Sun Man. The bird is the little boy's power. Him and his grandmother was starving and his grandmother told him, "Go and wash your face down at the water." He did, and then he had the power, same as any other person. It's the power of his grandmother. She was a *powerful* woman, and that was given to him. Of course that's an eagle. That's why he can hunt and gather food. People who has an eagle power, they can sure gather food and deer! Yeah, and you know, a person who has eagle power, he can just shoot anywheres and hit a deer, no matter how far away it is.

That's one of his game animals up above. It's got an arrow in its back. This sign over his back, you see, this boy was told, "You are going to shoot an animal, with a bow, with your bow and arrow. One shot will get him, and that's it. But you are also going to have a club to hit him with, to kill him altogether." That's the club, beside the animal.

Up on top [actually outside on the lintel of this cave] is about praying. The first one, it's a cross of course. That shape of cross means when he prays, his prayer's going to go up above. The next one, like an arrow point, that means I'm talking up above, I'm praying to up above. The third one, the zigzag, it means I'm talking. Again, it's in the direction of up above.[70]

Now, let's do those last two figures and then we'll have our tea. The one on the left is a bird, and the one on the right is the boy's eagle power that he uses to capture that bird. He hypnotizes that bird.

Fig. 137. Rock Writing at EbRl 6: cave site.

The thing at the top is part of the sun. It shows the time of day. Rays going to the right of the sun mean it's the early part of the day. Rays going off from all sides of the sun is full day, and rays going to the left mean late afternoon and the end of the day. This one is the early, early morning, before the rays shine out, or after six o'clock when the rays shine in instead of out. Real early sun and late sun looks as though it's still shining inward on itself.

This is more of what Sun Man taught that boy. He said, "When you take your bow and arrow and go out after animals, if you can't find them, call me and I'll help you. I'll show it to you." The best time, when animals is moving around is in the early morning, and from late afternoon until about midnight. In the day and the night you don't hear them moving around.

Down at the bottom you got a deer, an elk and a goat. And the one under the sun sign is a goat moving around. The other is a deer that he's dreamed that he killed. That's when that little boy was told, "When you kill a deer, you have to take his head off first." It tells it right there. The white man don't do that. He stabs it right here and bleeds it that way. Leaves the head on. The Indians all do it the other way.

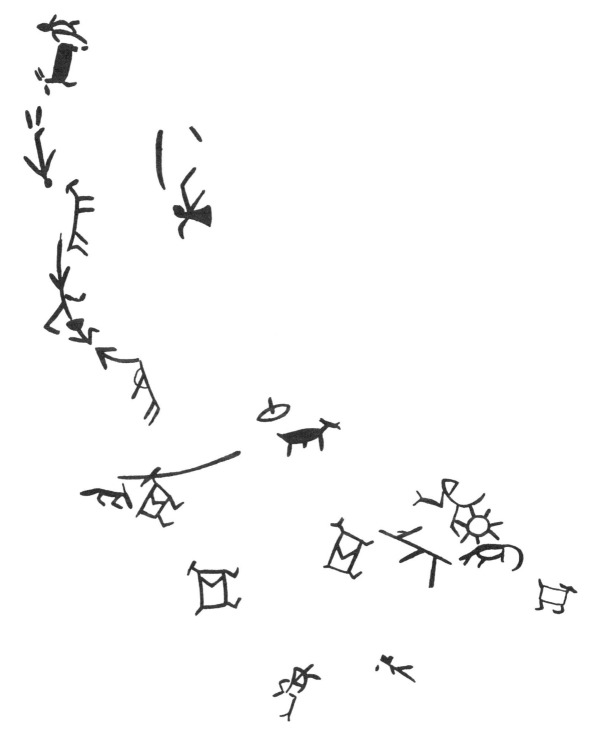

Fig. 138. Rock Writing at EbRl 6: cave site.

Annie [Reads this panel to herself, then speaks]:

Just look at them! Here they go! That one's looking into this one. But that isn't the thing about it. This thing, you see, [right side, near sun figure] he's making the indications of the times of the sun. The sun is there right beside his indicators. This kid, he gets so used to that, that he can talk to the sun

while he sleeps. When he gets up in the morning an Indian *always* faces the sunrise when he washes his face. Never the other way. He dreams that, about the sun and washing in the morning. He must talk to the sun while he is washing his face. He tells what he wants to do that day and he asks for help.[71]

Down there on the left, I guess that's a fat mountain goat. Look at him. Below that is a man hunting with his bow and arrow. There's a bird flying over him.

Over there, under the sun is a browsing animal. Sometimes they do eat when the noon sun is up, but it's not usual. Could be it's a cougar or a lynx, because of the length of the tail. It wouldn't be grazing then of course. It would be going after mouse and rabbit. Could be that, because that goat on the far right is running away.

Below that, those sticks are his barbecue frame for when he's going to cook the meat over the fire. I seen grandfather make that one. You cut the meat, you open it, and then you flip it over and prop the sides so the meat don't fall when you put it over the fire. The long stick, here, in the middle, that's what you put right through the meat. The other sticks hold it so it won't fall in the fire.

Below the barbecue rack is a little animal. The line from his leg shows he was snared. It may have been that weasel that watched the boy when Sun Man came to him that time and taught him to hunt.

Higher up, the one that's all coloured in is a strong animal, wicked. Either it stands for Grizzly or Lynx. Other animals that are wicked like that are the wolverine, wild cat, cougar. The cougar can destroy your whole camp. And that lynx is a *terrible* animal, an awful thing. The sign above this fierce animal show the hunter's eye. How you must close one eye to sight before shooting the arrow.

Behind that wicked animal he dreams of putting his spear through the neck of the goat. The little fox is following along behind. In the story, Fox used to run races with the others.

The figures up above, they go up a sharp angle; they're hunting. [These figures are on the ceiling of the cave.] It tells you to start with that arrow that points up, to the left. It's a trail-marking arrow. It's pointing to the game. The sort of tail on that arrow is what you use. Every hunter used that to tell the others the time he left. It shows what the sun was doing. The sun is shining down on two people. So it says that two hunters went off this way in the morning. When you are going to read these signs, you start at the bottom. First there's the two lines for two people, then the rays of the sun coming out of that half circle and shining straight down.

Those hunters went uphill in the mountains, like it's written there on the rock. Above the arrow you can see the hunter turning his mind into an animal. He transforms himself into an animal. A lot of those dreams are like that. They dream about animals and transform themselves into something.

Fig. 139. Cooking sticks at Skonkon Creek camp near Botanie Valley north of Lytton. Photo by James Teit, July 1917. Courtesy of Musée Canadien des Civilisations/Canadian Museum of Civilization No.39758.

Above that is a stick goat, a stick man, and a goat and a man. That shows that they find the goats when that man transforms himself. Then the two of them drive the goats toward the snaring place. That is called ḵai'hwuum. It means "you chase them together." Sometimes the goats turn on you to try and get away. They can bump you. This man got bunted by the big goat, I guess. And he fell down the hill.

You can tell that the guy who dreams is belittling his friend for getting bunted. He draws him and his goat like sticks, and he draws himself and his goat very strong and big. Hahahahaha! He sees himself like the little boy. The other guy is too confident, so he gets knocked over! All that knowledge originates from what Sun Man told the boy about going hunting. The one who's dreaming this, he knows that too. You see, in the story, when the boy came back with his game, they all belittled him too.

To the right of that hunting is his grandmother's power again. She put power in those two sticks. One is the stick he walks with and uses as his spear. The other is his barbecue stick. She threw that long stick and said, "Let my grandson be lucky." The strong figure below that is her power. You can't see it itself. It's invisible, but it comes up in the bat, and it's woman's power too. She's using *yewiínt*. They use it for hunting. It's strong but it's not always evil. Some yewiínt is wicked, some is not. Some's for hunting or sickness. That's all. They doctor their gun with that power. They grab their gun, do it like this, and from then on they can't never miss. Grannie does that. People who has those things sure can do it!

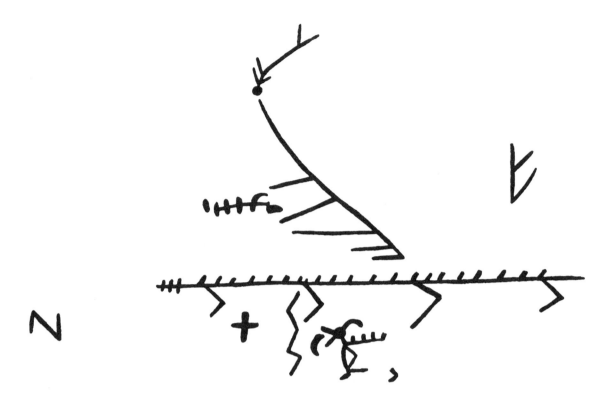

Fig. 140. Rock writing at EbRl 6.

At the bottom, in the centre, there he is again, the dream boy, talking in his dream as he goes along. In his dream life he's a little animal and he's singing. The line out of his mouth shows he's singing. He is carrying his rake for smoothing the trail and raking the fire. You make a rake by cutting a small tree and leaving branches on one side of the pole. Then you cut the branches short for the rake. Behind him, that little mark is his power bird that follows along to protect him. It looks like my bluejay. He follows me when I go up in the hills. I feed him seeds, and if a deer comes close, he tells me. He goes, "Chickle, chickle, chickle, chicka!" Uncle Henry always said you should chase a deer away from you because somebody might see it and end up shooting you.

The long line is all about crossing a swamp. The four vees or sergeant stripes show the direction to go. He was taught to throw a stick down ahead before he walked on swamp. There's three little cross marks on the left end of that. He was told to always anchor down the end first. And the prayer is there too, the cross near the left end. You must always pray for success before you start something like this.

Over on the left is a writing. When you write, you use that kind. That means: I'm going up and down. I'm going up here and coming back down here to this place. That's the sign the boy would leave behind him when he started out. If I did that, anybody could read it and they would know I was coming back down. And whether the lines on it are thick or thin tells you what the ground is like, where he is going. And it sort of follows the up and down of the ground.

The zigzag line in front of the little boy show the layers of the earth. You have to think about that in the swamp, the soft earth.

204

We made a stick trail in the swampy ground up at the Frozen Lakes. You keep throwing down the sticks until you get across. Keep doing it and after a while it's dry enough to walk on. It looks like a ladder. You are supposed to add pieces when you cross it every time.

Above the swamp ladder, on the right, that shows the branches they use for that. But the thing going up to the left, that's another piece of his trail. There he climbs up, up, up in the hills. That comes after the swamp. Then it gets too slopey. You can't climb on a real slopey hill. So we often chop a big tree like this. We trim it on one side and tie it down so it won't move. You see, you chop that tree so it falls against the cliff. Then you can climb it. Arthur and I did that up Spuzzum Creek. You use trees to help get up.[72] So the picture here is one of those logs with the branches to help you climb.

The thing off to the left is his willow compass. You see, you can tell your direction with it if it's misty and there's no sun. Willow seeks out the water. You tie down one end of the willow rod, and the other end will point toward water. It helps you find your way. You use it to help you up and it gives you a footrest when you're up near the top of the tree against the cliff, and the branches are too small to support you. You use it to get up in different ways. You can tie it with a long string on the end. You cross on it, then pull the string like a shoelace. It comes loose and you pull up the rod and use it again. Arthur and I done all those things. Up in the mountains you sure will have a use for it.

The last piece in the drawing is another tree ladder, further up the cliff. We don't know what's at the end of his trail because this is just a dream about getting there.

N. Rock Writing at EbRl 4

At the base of the same mountain, almost directly below the painted cave, are writings in and near a rock shelter located beneath a massive 3 metre by 4 metre granite boulder at the base of a talus slope. Part of the entrance to the shelter is covered by a decaying palisade of willow logs deliberately placed to give added protection or concealment. Two sets of writings are found at this site, one inside the shelter (Fig.142, top), and the other on the east face of the boulder (Fig.142, bottom). The site was identified in the fall of 1985 by archaeologist Ian Wilson during a survey along the route of the proposed logging access road which, judging by the survey ribbons and tree blazes nearby, would pass directly in front of the shelter, between the shelter and the river.

Fig. 141. EbRl 4. Photo by Chris Arnett.

Fig. 142. Palisade of willow logs placed against rock shelter. Photo by Richard Daly.

Inside the shelter, at the centre of the ceiling, is a large natural, iron oxide stain. On a light-coloured rock which props up the massive rock roof on the west side of the shelter are faint paintings (Fig.142, top). These paintings include two faces, each with connecting eyebrows and noses, large eyes and open mouths, and single-arm gestures. These mask-like faces resemble rock carvings or petroglyphs, such as those found along the south and central coasts of British Columbia, and at the large Stl'atl'imx rock writing site at Gibb's Creek on the Fraser River near Lillooet.[73]

With this striking similarity of form in mind, we showed Annie a drawing of coastal petroglyph faces to see if she confirmed or denied the similarity (Fig. 145). Her discussion of Figs. 143 and 145 revealed a rich knowledge of spiritual beliefs and practices common to both coastal peoples and some of the Interior Salish.

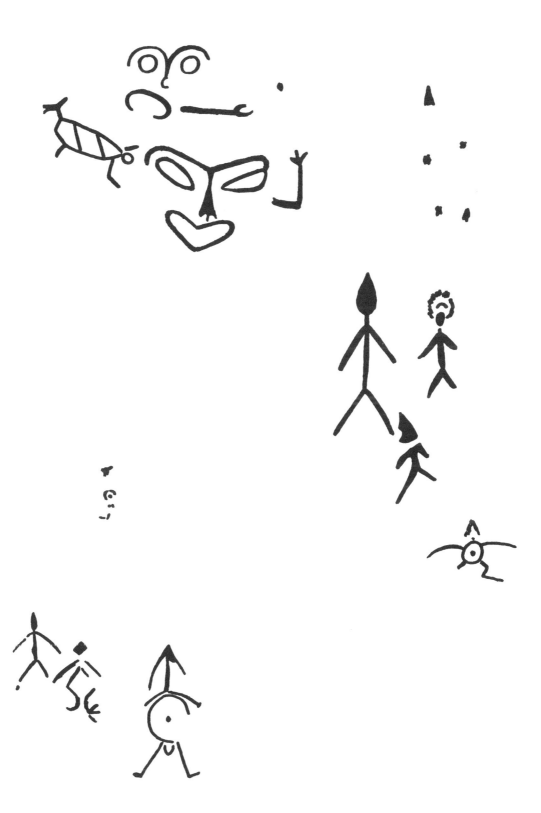

Fig. 143. Rock writing at EbRl 4.

Annie:

There's three men at the bottom. The biggest one is Sun Man again. He tells the boy, "Some day, your enemies are going to come back and run after you. If you ever get stalled somewhere, look at me, say your prayers, and I'll help you."

Sun Man has his *stets* on his head. That's his time, that time at midday when he stops moving for a feeeeeeeew seconds, then moves on. That's the time of day when he left the boy and went back to the sky.

The boy, Hii'hií'ha', is standing beside Sun Man, and he has his bird with him, a dove, Kilkulá'kik.

Beside the boy is one of his enemies, one of those people who abandoned him and his grandmother. They *did* come back, and they moved aaaaaall his goods and meat out of the kiikwilee houses. The whole thing.

The tiny marks above that enemy show the village where those people had moved to when they were starving, and where they had nothing to eat except cactus. In the middle, with the dot in it, you can see their kiikwilee house.

Sun Man packed up the boy's stuff to take back with him—the swan blanket, the jay blanket, the black cloud blanket, the white one and the red, painted one.

Raven—he always says, "Gwaaaaaak!" That's why he's called Hwo'laák—he found the old lady and got food from her. After that, this man followed him back to spy on the boy and the old lady. He ransacked their place. And the others came too. They took the meat and the tools, and they copied his bow and arrow.

On the right side is those [gossipy] people who were always getting into trouble, so Xwekt'xwektl turned them into birds. The biggest of those figures is that boy, Hii'hií'ha'. Here he's in his syux'nam form. Beside him, with the fluffy head, is Kilkulá'kik, Dove or Pigeon Man. Kilkulá'kik mimicked the boy crying: "Hii'hií'ha'! Hii'hií'ha'!" when the boy was blinded by that pitch and was crying in the forest. After that, when they were turned to birds, that was his bird call. I've heard it at dusk, up Broadback. Following him, down below, is Huu'hw'hii, the chickadee, and the little one trying to keep up, is Hoxwex, the wren. He never can fly very fast.

Huuwii'hii', Chickadee, always tries to follow the boy, Hii'hií'ha'. Huuwii'hii' says, "I'm going to tell on him!" But Kilkulá'kik turns around and says to him, "Keep quiet!"

Hii'hií'ha' has that syux'nam's headdress because he had become a very powerful hunting man. Those who have the skill and take a lot of deer, they are called *bex'hamuuxhl*—powerful people. His head is this shape because he's wearing a pointy hat. He can wear that once he's a master. It's his master degree in syux'nam, ha,ha,ha!

So these Bird People were following Hii'hií'ha and gossiping about the boy, who went around crying when he was little. He got that name because he went around sniffling, "Hii hii ht, hii hii ht, hii hii ht!" That's when Xwekt'xwektl come along and turned them to birds and said, "You're gonna go up in that forest and make all that noise." And they do it.

Above the Bird People, those dots—that's the stars that the four of those people (Hii'hií'ha' too) became after Xwekt'xwektl turned them to birds. The arrowhead in the sky shows that those four people were put up there. February's the time you can see them best.

These pictures are the beginning. You see, it's not a legend, it's the beginning of life. It about what these people do to each other before. That's why there's something like magic that draws the Indians to the Stein.

The pictures up on the left, they're spirit faces.[74] The top one is Skaí'yep, from the cedar tree. You just try it some day in a lonely place. You sleep under the cedar. The bigger the tree, the better it is. It'll come to you. It's a beautiful song.

Cedar has other spirit forms too. Arthur and I seen the Xai'kazeh. That's a cedar root that looks human. It has a human-sized head and arms that hug the cedar log. It reminds me of a ginseng root. We seen that way over on Sasquatch Creek, near Sasquatch Lake. It's got legs too. But some *crazy* person went up there and cut it for firewood. Xai'kazeh, she comes to you when you're sleeping there, after Skaí'yep has visited.

Then a third of the Cedar People might come to you too. Tsakwai'íken, and she has the form of a golden snake. She cries, just like a kid too. If you hear her singing, she's gonna follow you around. Not many people see that one.

The one written here is Skaí'yep. He always has his mouth like that, on one side. And he's telling the dreamer, when you dig cedar roots you use this digger—that's the tool with the hook on it, beside his mouth. In the beginning, Skaí'yep sharpened the first digging stick in his mouth.

That cedar dreaming is where the real winter dance, the s'lek, comes from. Power comes out of that cedar in winter. That was the *real* power of Grandpa Paul, Híx'hena. His stuff is *very* religious. He uses cedar, and that whatja'macallit, the

tamarack. (You know, you burn old tamarack pitch and mix the powder ash with your paint and it'll stay forever.) That other power Old Paul had, that other tree [tamarack], was Sukimak'gak. They go with that winter dancing. And there's another one, *Shikshíkt'nuus*. That one cries aaaaaaaaaall the time! It's always made with tear marks under the eyes.

This is how you gotta practise if you're going to do the *real* Indian dancing! You gotta be trained as a s'lek person. And you gotta go out and sleep in the mountains. It's very expensive to become a dancer.

So there it is. Now I've told you. These are very religious things.

Arthur slept under a cedar with his cousin. But you got to do it *alone*. That Skaí'yep wanted to come to them but he couldn't because they were two. You know, they got nightmares! When Arthur's sleeping he talks a different language.

Arthur:

Yeah, I also tend to speak a different language when I'm working on something, specially when I'm under the old car and something goes wrong! It's what they call a blue language.

Annie:

There's a deer figure and another power face below Skaí'yep. That one is Sto:lo. It comes from Five Mile Creek [the boundary area between the Sto:lo and 'Nlaka'pamux cultures]. This spirit is that slate mask from the water of Five Mile Creek that I told you about. That's why the old people told us, "*Never* swim in Five Mile Creek!" But I used to swim there. It didn't bother me! Hahahaha!

It must have come to a young man from Five Mile Creek while he was training in that Stein. He dreamed that thing that happened long before, and he wrote it on the rock there.

Basketmaking is connected to that s'lek too. To be a basketmaker, you must connect with that cedar power. That's why, when a basket is made, it's made for a special person. You must never take it away from them. Women practice that. When a woman makes a basket for her grandchildren—and Grannie was one of them—they don't give it to the girl right away. They take it up in the hills. They take that basket and they say their prayers up there. They put your own good luck into that basket. Then they take it back and give it to you. And nobody is ever to touch that. If you do, you're gonna have bad luck.

The slate mask—I can't remember it's name—is there in the writing with Skaí'yep because it comes from the cedar too. There were big cedars at Five Mile Creek. It comes from long ago when all the people there died. You see, that cannibal man took a woman from there and killed her. So this other woman said she would fix that cannibal. She tried to poison him, but all the people ate her poison by mistake and everybody died except for a young man. He stayed there and practised by the mouth of Five Mile Creek, where there is a pool.

That spirit came out of the water and it said to him, "Look, young man, you are going to make a slate face like mine. You are gonna do your dancing, and your power is gonna be the water. You're gonna own the fish and everything."

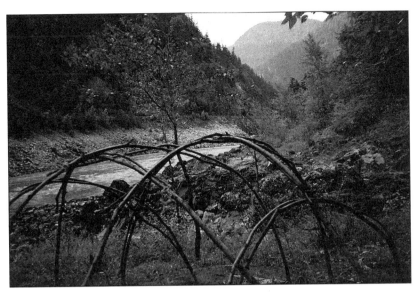

Fig. 144. Sweatlodge frames alongside Five Mile Creek, 1992. Photo by Richard Daly.

I tell you, if a person has that power, and he wants to, you *can't* get a fish! Uncle Henry took me down there when I came back to Spuzzum. He said, "I'm gonna show you something. You can see a bear walking in the water, down at the bottom of the water. I seen him doing it. One day a white who worked in construction, he said to me, "Did you know there's a half-dead bear in that water?" He seen it. I didn't say nothing to him. I just laughed, and I told him somebody must have shot it.

So that young man dreamed this in his sweathouse. He came out and the mask came up out of the pond at the mouth of the creek. This thing come out of the water with the mask and the costume. He says, "You're going to dress like that." So he made the costume and carved that slate mask. There was a place across the Fraser where they got pipestone. It was a slate. The CNR buried it with their track. That's where the slate come from for the mask.

I saw it about 1914 here at Spuzzum. A lady had it who originated from Five Mile Creek. She was visiting at Uncle Bill's. The mask was thick and looked kind of heavy. She had it on. Her name was Statsala. Her English name is off my head. That family all died. Arthur's fish basket came from her. That old lady was Sto:lo but she didn't speak the language because her mother was from here. Now I remember. Her dancing name was Statsala. Her regular name in our language was Nox'shuuta—means "Run By Herself." She was also known as Mrs. Myers.

I tell you, when she was Statsala and she danced, it scared you. She would jump up and cling to the wall, and she sings just like a squirrel. She goes, "Deedeedeedeedee!" I don't like her when she starts that. It scared me. And there was an old man there from Chehalis. They called him Jiijikt. I forget his name, he uses swan feathers. He puts it all over his head and face and everything, and he puts paint here. He carried a pheasant feather. After he died, they gave it to my mother. Whenever something strange was going to happen, that feather made a noise, a chuck-chuck-chuck noise. She didn't like it at all.

That old lady painted that red on too. She has her hair braided with a stick out of that slate. And you see the arm in that drawing—she danced with her arms bent that way, and her hands up. Her song was not as nice as the cedar song.

And that animal in the drawing, beside the slate mask. You see, that's a deer, and that power eats a bit of raw deer meat. Every one of those powers has a favourite food. That other one, the Su̲kimak'gak, he does it too. I seen him. They get a meat, half-cooked, and they just chew it. Blood runs out the corners of their mouths.[75]

211

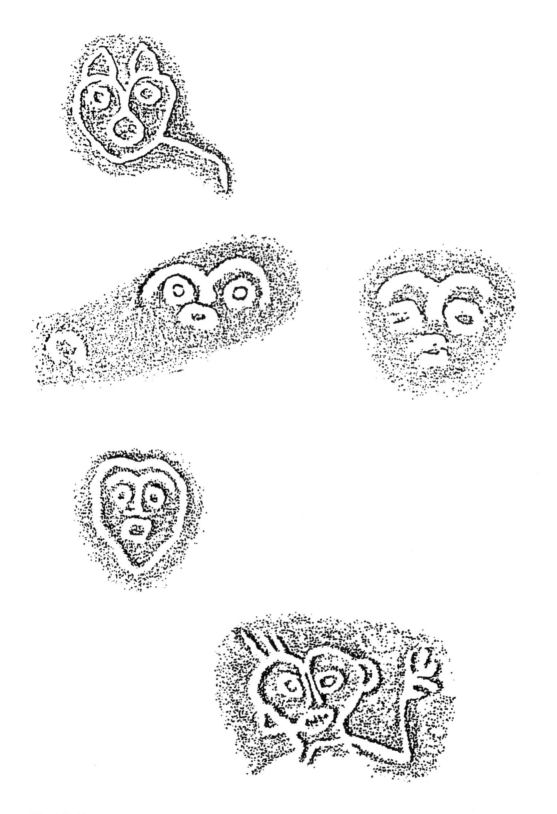

Fig. 145. Sketches of Coastal petroglyphs, after Leen (1981). Figures found near Nanaimo and Puget Sound.

Richard:

Annie, this page is not from the Stein. It's entitled "Coastal Petroglyphs." I'm showing this to you because the faces here are similar to the ones we've just looked at.

Annie:

Well that's a mask too. You see this one? [one up from the bottom (Leen 1981:Fig. 31c; site located near Nanaimo, British Columbia)]. That's the one that came out up here too. They are supposed to be Sturgeon. Did you know Sturgeon has a mask too? You know, they eat sturgeon before. You can't make them dance unless you bring out the stuff that they are going to eat first.

At the bottom you got this man with his arm raised and his feathers in his hair [ibid.:Fig. 31e; site near Nanaimo River, British Columbia]. That's the mask that wears that grass thing. I seen one of those in the University, a grass mask, with a sort of handle on. I don't know its name, but I guess it's Sto:lo because Sturgeon is a Sto:lo mask.

That one is the seal [on right side; ibid.:Fig. 4k; from the same boulder that the other two upper figures have been taken from, Hartslene Island, Puget Sound, Washington]. People who has the power of the seal, they make a mask like that out of sealskin. I seen it at Coquitlam, long years ago. These old people carries it in that bag. That's how I seen it. They used to visit my mother a lot because we got fish from them.

The one beside the seal is Otter [ibid.:Fig. 4j]. It's not quite the same as Seal [face is wider and shorter] and it always has a long costume with it. Those little signs to the left show his ways of dress. Some of them have a belt and some has a wooden carved thing.

I seen that man—I think he came from Nu'shk'gaiyaas. He has a thing like that. That was Auntie Mally's husband, George McGuiness. Kwi'olten, that's his name, that man. He was here in 1914 too. My mother gave him a trunk after my brother died. He had that seal one. I don't know who owned the otter.

The top one is tall. He's got sharp ears. That's the wolf. That's the white-faced wolf [ibid.:Fig. 4g].

Richard:

Why white-faced?

Annie:

Because I seen it here. I seen people dressed like that.

Fig. 146. Wooden mask from Secwepemc burial site (EeQw 1), near Chase. Existing examples of masks from the southern Interior of B.C. are extremely rare, although they are described for the nineteenth-century Lil'wat and Secwepemc (Teit 1906:253, 286; 1909: 578). Drawn after Sanger (1968:Fig. 10).

Approximately twenty-seven kilometres from the confluence of the Stein and Fraser Rivers, in the thick woods of the middle valley, the trail passes by a large, yet inconspicuous, granite boulder 3 metres long, 2 metres wide and 1.5 metres high. This boulder has faint writings along its base. This site was located in September, 1979, by archaeologists Mike Rousseau and Geordie Howe. It is the furthest upriver of the known writings, and the closest site to the traditional boundary between the 'Nlaka'pamux and Stl'atl'imx peoples.

This boulder and its writings may have served as a protective boundary marker, similar to those described by James Teit's informants, and by Annie York, particularly the darkest symbol, the *yewiínt*.[76] Writings such as these—dream records made by powerful persons—were painted on rocks at the boundaries of territories, as protection against outsiders. In some people, this worked as a system to warn the painter of the physical or psychical approach of an intruder, someone, as Annie put it, "who wants to do you dirty things." Annie had heard that some of these writings were so strong that such people "could never pass it."

I admit that every time I have gone to photograph or sketch this site, I have lost personal belongings there. In March, 1992, I lost camera equipment at EbRl 1, and Richard lost his favourite shirt.

The site is located a few kilometres downriver from the confluence of the Stein and Cottonwood Creek. An aboriginal trail follows Cottonwood Creek, giving access via its south fork, to Blowdown Pass, from which point the trail continues along Blowdown Creek to *Tuk*, or Duffy Lake in the territory of the Stl'atl'imx people.

Fig. 147. EbRl 1. Photo by Chris Arnett.

Fig. 148. Rock writing at EbRl 1.

Annie:

Here's the Sun Man again. He's the sun, with a dot in the middle. That means an eclipse is coming. The man beside him is that boy who gave him the blankets, Hii'hií'ha'. That's the special hat that he's got to wear if he wants to talk to the sun. And he has to write a sun sign, and the sun is going to look down and find out what that little boy likes. That's it on the left. There's his writing again, on the right, that wide up and down line. It shows he wants a prop to prop it with.

Richard:

A prop?

Annie:

He's going to build a bridge, this little boy. And the Sun Man had told him, "Anything you want to build, you must use that mark like my head on it." See? He's propping up his sun bridge. The marks at each end of the bridge are the anchors.

That little boy, afterwards he grew up. The people don't know what to do. But he was the one who knows what to do. He built that bridge for the people, and so they said to him, "In Stein, we are going to take that in the pictures."

Xwekt'xwektl said to him, "Why did you put that bridge here? I don't want you building bridges all over the place in the wild country."

So he tore off a picture of that boy, on that rock, and said, "See what you look like!"

And there's the bat. The thing at the top. That has to do with the yewiínt, the witch. When you go up there and s'lek, there's four kinds of power—the one that heals, the one that protects the family, the one that gathers things, and the one that does *bad* things! THAT ONE IS THE YEWIÍNT. And that person uses the wicked kind of power. The yewiínt uses two kinds, the lizard and the bat. The red ones and the black ones. Old Henry showed me and he told me that's what it's for!

215

That bat is here because the same time X̲wekt'x̲wektl came to check up on the boy building that sun bridge, he caught the woman doing those wicked things. So he turned her into a bat.

And he drew her on the rock.

He also put her up in the sky. She's a black star and she doesn't stay there. She breaks. The boy with the sun bridge is up there in the stars too. You can see it on a bright night.

P. Petroglyphs at EbRj 4

We end this journey by circling back to a point near our starting place. On the west bank of the Fraser River, near its confluence with the Stein, is a dome-shaped granite boulder 1.5 metres high and 1.5 metres wide. This boulder has rock writings carved into its west and south faces. Nearby is a flat, spalling granite rock, with a series of four holes pecked in it. Each hole is about two centimetres in diameter. This is the only known rock carving, or petroglyph on the Fraser River north of Spuzzum and south of Lillooet. The site was identified in September, 1961, by David Sanger, from information provided by Andrew Johnny of Stein (Sanger 1961:20).

Petroglyphs and pictographs may be distinguishable on the basis of site function. Along the Fraser River, petroglyph sites are only found in the vicinity of important salmon fishing localities (Lundy 1978: 23-25). As Lundy points out, "the valued salmon resources of the Middle Fraser appear to have been a major motive behind the creation of the petroglyphs of the region" (ibid.: 23).

Unlike the well-known petroglyphs at Gibbs Creek where Interior and coastal styles appear together, the images on the single Stein boulder contain no overt coastal influence. Stylistically, the carved figures are similar to painted writings. There is some evidence to suggest that petroglyphs were originally filled with red paint. Annie York was told by Chief Henry James of Spuzzum about an Utamqt (Lower 'Nlaka'pamux) rock art site near Yale. This site was called *Tsaxalis*, where writings pecked into the rock were originally filled with paint. "Yeah," Annie reported, "It started out, they scraaaaaatch, and then they fill it with the paint...That's what the old chief told me, Chief Henry...Yeah, he says, all those things are painted in the first place, but he says so long that the rain hits them that they got washed out."[77]

In addition to the carved figures, a number of simple pecked holes, four and two centimetres deep, are found around the top of the boulder, as well as in the nearby flat granite slab. These markings are often found at petroglyph sites in other parts of British Columbia. According to information recorded by James Teit in his 'Nlaka'pamux ethnography, these may have been hollowed by males during their puberty training:

He made round holes in rocks or boulders with a jadeite adze, which was held in the hand. Every night he worked at these until the holes were two or three inches deep. When making them, he prayed, "May I have strength of arm, may my arm never get tired—from Thee, O Stone." This was believed to make the arm tireless, and the hand dextrous in making stone implements of any kind. (Teit 1900:320)

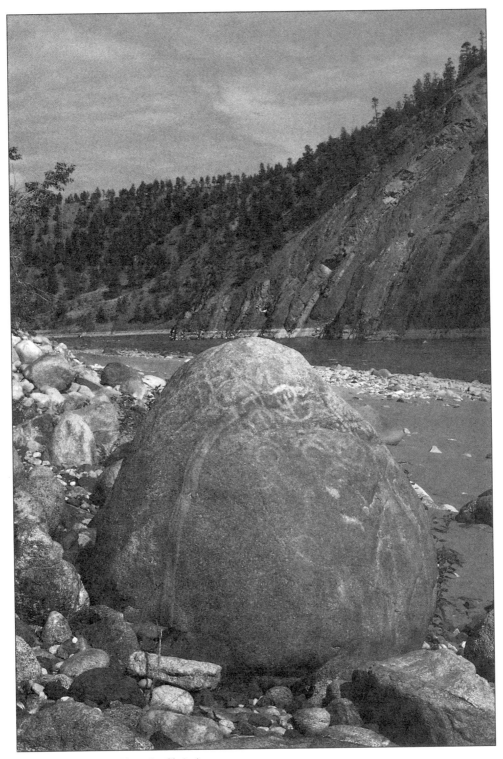

Fig, 149. EbRj 4. Photo by Chris Arnett.

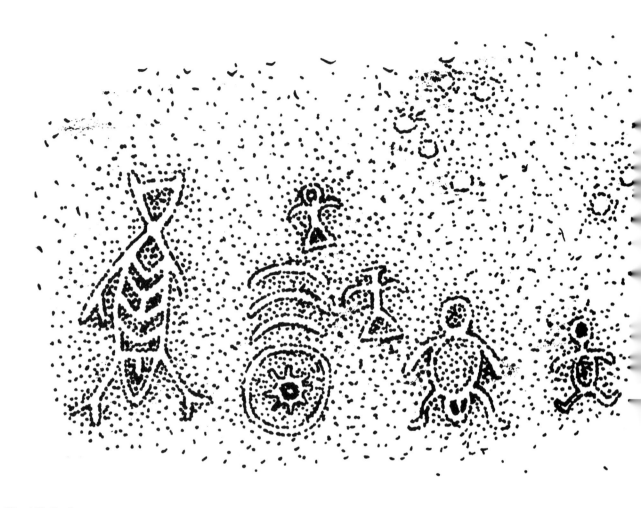

Fig. 150. Rock writing at EbRj 4.

Annie:

Isn't that beautiful! Aaaaaall the different animals. You see, these here [far left figure and third left figure] is beetles and birds [two angel-shaped figures between the beetles]. But this is all one story. You see, here [right side], the eyes.

The boy's grandmother said, "My eyes will be far out to watch over you." She was blind, that old lady. She had power and when you have it you can see things other people can't!

The figure on the right [head, neck and chest] is her eyes and her frame, her skeleton. She told him, "You're going to get weak, and you will be left as a skeleton. Oh, these old things! I seen that written in a *lot* of places!

To the left of that is the eye and eyebrow of the other people, looking at her, trying to kill her.

Richard:

And what are all these crescents, like eyebrows?

218

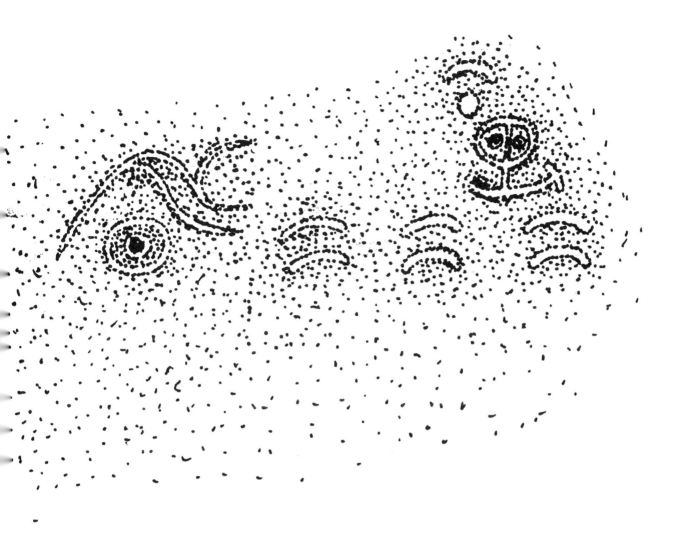

Annie:

That's in the dream. It's the envy from all those people. Enviousness. You see that old lady was partly blind, something like me.

Richard:

And those envy lines are like lines on someone's forehead?

Annie:

Yeah, like that! And then there's another eye over there. On this side of the picture [right] it's his grandmother protecting him from all the envy. Then beside that is a picture of a little child. It's not a bug or a bird. It's a baby. After a while people are going to have a child. That's the child.

You see, that boy, Hii'hií'ha', he grew up after a while and went out looking for a wife. They had a child and that child went astray, reaching another people. He stayed with a couple of women who

had no children. They adopted him just like Moses. It was just like what happened to Moses. These people who was envious of Hii'hií'ha' was so *jealous* of the kid that they put him in a wooden dish and threw him into the river. He was floating around. Those women picked the child up.

Afterwards he was the one who let out all those bugs, beetles and everything into the world. That's the child that did it. When he let that stuff loose, the Creator come down and said, "My, my, you're doing all kinds of silly things! You're letting flies and everything loose. It's going to be bad for the people. And it's going to be bad for my trees. See what my trees is like?"

And that thing between the beetles [left side]78 is a cut through the tree, and he shows the boy the way the rings go as the tree gets bigger and bigger. There's layers and layers in it. On the left here, this is the bug that kills the tree, but these little birds above that tree slice, they love the tree too, and they eat the beetles. That's what I'm going to write to Forestry about. You'll see.

Those birds love the trees. God said, "Why did you people loosen them bugs and stuff like that? That's the tree I created for all the birds to sit on."

The little circles up above, those are the different places that little boy landed when he was floating down the river in that wooden dish. There's eight of them, and the eighth place is where he went to. That's where the two women took him and raised him, and where he let the beetles go. Those circles really stand for the kiikwilee houses in each place he stopped.

Richard:

Well, Annie, that's all there are at the present time. They have located another cave, but we haven't got any pictures yet.

Annie:

Oh, don't thank me, I've enjoyed it all! I wish I could have made it up there. Maybe that new cave is the one they talked about. There's supposed to be music up there. That mountain is supposed to sing.

Richard:

Annie, they say that there are woven mats in the cave, and bags of things hanging over the remains.

Annie:

Yeah. That's the syux'nam's belongings. The woven mat and the paint. That's what I was telling the people, "If you're gonna take this to a law suit, be sure to mention that you had your stuff in there." You see, if I live in a place and I go out one day, if I don't have my stuff there, I can't prove it's mine, and they can kick me out. You mention to them that you had your stuff there since long before the European people is there.

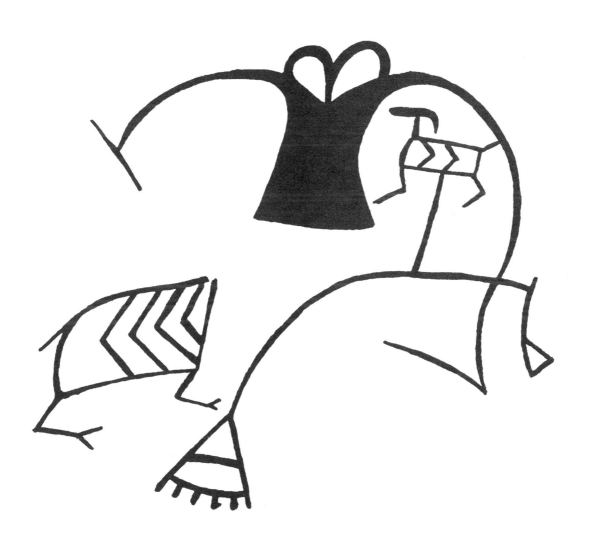

Fig. 151. Front of woman's buckskin dress with painted "writings." Photo by James Teit, 1917. Courtesy Musée Canadien des Civilisations/Canadian Museum of Civilization No.35913.

4. Writing on the Landscape: Protoliteracy and Psychic Travel in Oral Cultures

Richard Daly

A. Dreams and Writing in an Oral Culture

The bold images carved in the sedimentary rock, in aboriginal Coast Salish territory, a few miles south of Nanaimo, British Columbia, are the central focus of the heritage site locally called Petroglyph Park. Beneath its canopy of Douglas fir and arbutus trees, the orientation area in the park informs the public that these striking figures "were a means of commemorating important events among a people with no written language." To accept this statement is to limit inquiry into the question of the origins of human writing. Virtually every culture in the world, for several thousand years, has devised some form of writing. The existence of culturally significant and standardized forms of writing is older and more extensive than the development of alphabetic sign systems for recording spoken languages. While the latter comprises our common understanding of writing, the former is, in many ways, its foundation. Rock writing is one manifestation of this older, non-literate form of writing.[1]

Images executed on rocks by human agents are generally classified as examples of naïve art; they are often included within the taxonomy of "aboriginal" art, "ethnographic" art or "primitive" art. In the present book we have purposefully deviated from this point of view. We feel that pictorial inscriptions on rocks are best regarded as a standard form of written communication occurring in many oral cultures over many millennia. We feel that the functions of these images inscribed on rock transcend those of a work of art. Even though some rock imagery is highly aesthetic and exceptionally well-executed, the phenomenon is more plausibly viewed as a form of non-alphabetic literacy.

Pictorial literacy is important to the formulation of ideas and concepts in oral cultures. As in art, the rock writing imagery is mnemonic and acts as a prompt to human expression, both in the writer and the reader. Indeed, it is argued that early writing in Ancient Greece—as it had developed by 700 B.C.—supplemented traditional oral recitation, and only much later did it transform oral culture to "literate" culture (Havelock 1986). The units of such writings are pictures and notations which often

possess common cultural referents that pay little heed to linguistic boundaries. These images can unite people from different languages by means of visual cultural commonality, but unlike alphabetic writing, they do not unite a population linguistically. Such pictorial messages left on rocks are a baseline from which two more functionally specific activities could have evolved in human history—namely, art and literacy.

State societies that developed writing often continued to use it much as rock writing has been used: to supplement everyday orality. Until well into the present century this has been the case with classical Chinese writing. This "logographic" writing functioned as "true writing" (as notation of a linguistic code) in a very restricted sense; it could be read aloud by a few mandarins. More importantly this script functioned as a common visual system of transcription whose combinations of signs and symbols were readable and writable, though not pronounceable, by people of different languages, dialects and cultures for centuries within China. The struggle to standardize the Chinese language and develop a phonetic script is only now being codified as part of the process of standardizing the spoken language and thereby strengthening national cohesion (Goody 1987:36-37, 64, 283). It is also interesting to note that Chinese characters developed out of divination notations on the scapula bones of large animals. Like rock writing, the Chinese characters appear to have been a consequence of the rich spiritual experiences that are central to virtually all non-state-organized societies.

Such visual, non-linguistic units of literacy were created, read and exchanged as a form of everyday existential communication between people in oral cultures. They transcended the usual practice and function of art if indeed art is, as the Oxford English Dictionary suggests, "skill directed toward the gratification of taste or the production of what is beautiful."

The iconic images were learned by children in the course of their daily lives. Most, if not all, citizens could use these images effectively to convey messages to others, though the complexity of the message probably varied with the training and social standing of the writer or reader. In 'Nlaka'pamux country these messages were inscribed on rocks beside the hunting trails, on household tools, on one's clothing, skin, or territorial boundaries, as well as being markers of sites where violent or spiritual events were, and still are, remembered.

The "rock art" imagery we have focussed upon with Annie York was probably known to other peoples along the northern portion of the Interior Plateau, as well as on the adjacent Pacific Coast. The reader will recall Annie's familiarity with the narrative associated with one of the Okanagan rock writing figures near Skaha Lake (Fig. 124) and the Coast Salish petroglyphs from Puget Sound and the Gulf of Georgia (Fig. 145). Of course the stylistics and the narratives informing the images varied from region to region, but they were read, used and understood over a broad region; they communicated experiences in the overlapping fields of spiritual, political, economic and social life.

By treating these images as the products of the "writing down" of human experiences on the surface of the landscape, the researcher is able to explore the phenomenon in a manner which is at least partially in accord with the peoples' own perceptions. This is less true of analyses that examine such elements of a culture, and then compare them with a model derived from the cultural standards of the analyst's own society.

I admit that when I approached Annie York about the Stein Valley figures I initially regarded the rock messages as examples of an ancient art form. However, I learned immediately that Annie treated the images as something much more—as *texts* composed of *pictorial representations* of items having cultural and personal significance. These pictorial images appear together with commonly understood *symbols* and *notations* denoting such concepts as direction (up above, down below, to the left), number

(five days, three hunters who passed by), the passage of time (solar phases of the day, the passage of storms, days of fasting), as well as indicators of actions (talking to one's self, singing) or of relative importance (solid red figures being more powerful than those merely outlined). Annie was able to recognize various culturally standard meanings from the trail signs on the rocks, some of which were artistic, while others were not.

As I suggest in the final part of this chapter, the iconography which Annie was eager to read and interpret is remarkably widespread in terms of human geography and human history. The stylized realism of the images has been recorded in many lands since the period of the last Ice Age. It is an integral part of our human history of thinking, conceptualizing and writing down our physical, social and psychic experiences. This iconography has been a medium not only for 'Nlaka'pamux people but also Europeans and others to record aspects of their history for thousands of years.

The meanings of the rock writings explained by Annie York draw upon economic and spiritual matters, psychological and technological lessons, moral philosophy and apt examples drawn from the rich experience on the land by both writers and readers. Rock writing was an integral part of the many-sided cultural life of nineteenth-century 'Nlaka'pamux society. It was an important set of codes of communication. What was encoded was not spoken language but, rather, situationally specific experiences made meaningful in relation to an ancient and locally rooted cultural tradition and cosmology, as well as to a relatively stable, bountiful and sedentary economic life.

It can be argued that this is the stuff of art—and to some degree it is—but the stylized iconography of much rock writing/rock art is more highly standardized and widespread than many other forms of artistic or aesthetic communication. Any member of society could and did produce this imagery as a socially understood form of communication. Those who are talented or otherwise spiritually endowed tend to execute the form with greater subtlety, legibility and artistry than those not so endowed.[2]

Critics who object to our adoption of Annie York's term, "rock writing," to describe this non-alphabetic inscription point out that there is always a linguistic code at the heart of true writing, one that operates through the fundamental components of all languages (minimal units of sound or sound meanings and their rules of combination). For instance, D.L. Schmidt, who kindly read and commented upon a draft of this chapter, is of the opinion that:

> This seems not to be the case with the 'Nlaka'pamux inscriptions. I think it is more useful to see your rock "writings" as rock "art" with a set of specific literary functions: to act as a prompt for oral performance, interpretation or creation. Vaughan Williams' tone poems or the symphonic *Peter and the Wolf* strike me as more apt analogies to rock art than does any form of writing. (D.L. Schmidt, p.c.)

By way of reply I would say first that the rock art embodies not only a reader who may use the images as a prompt, but also a writer who inscribes, on the rock, his or her experience during spiritual quests, raiding parties, or hunting and gathering forays. These are not simply performance arts: they are the concrete results of living people having written down their—often inspirational—messages from their dreamings. Second, we do not claim that this phenomenon is "true writing" in the linguistic sense. Indeed, alphabetic writing does have as its core a linguistic code. However, can we say that such a distinction between true and untrue writing assists us when we want to explore the origins of writing? Such distinctions measure the inscriptions made by non-state-organized societies against the true writing of state societies, and finds them wanting. They become a foil to the seemingly more complex inscriptions produced in our modern state societies but suggest little to us about how this state of affairs came about.

For those who ponder the question of origins, as most rock art researchers do, such a definition of writing is insufficient, not to mention ethnocentric. To limit "writing" to "true" or alphabetic writing is to be unconcerned with the development of the link between the visual convention and the linguistic sound system. Annie York's "writings" are more than elegies or tone poems attesting to ecstatic experiences. They are standardized notations and inscriptions whose meanings are composed of physiological, cultural and ancient subconscious representations of meaning that have allowed human beings to record and communicate their experiences for at least the last thirty thousand years. Relegating these images to a category of art, or even proto-art, does not assist in the pursuit of origins.

If, for the present, we regard "ethnographic image-making" as a communications' code of inscriptions (based not on linguistic sound units, but on the stylized images of everyday life—fundamental images drawn from the system of social meaning which is generally referred to as culture) then we remain sensitive to the possible development of writing from a number of related sources: the optical component of the human nervous system, the altered state of consciousness associated with religious or meditative experience, the relationship between the active, tool-making human hand, the growth and development of the brain, and the appearance of speech, as well as culturally significant objects and situations of everyday perceptual social living.

Over time, abstract notations and pictorial representations may become associated with definite speech sound units in specific languages and language families. An evolutionary perspective is not an exercise in establishing a pecking order of sophistication; rather in this case it is an inquiry into the common origin of a ubiquitous human activity, the physical recording of experience on the surface of objects. (In English, the origins of the words *write* and *writing* have to do with tearing, scoring, drawing, rubbing, outlining or incising something in order to record or transmit ideas.)[3]

The suggestion that there is a connection between pictographic scripts and the formation of letters denoting speech sounds is not a new approach. Herbert Kuhn was a scholar who investigated many European and other rock art sites during the 1920s and 30s. Kuhn came to the view that pictographs were antecedents of European alphabetic signs:

The very names of our letters—and still more those of the Greek alphabet—are of Semitic origin. Thus the Semitic word for an 'ox' (*aleph*) is clearly represented in the oldest forms of our letter 'A', that is an ox's head and horns, though our aleph is now printed upside down. The Semitic word for a 'house' is *bet*, and our 'B' still shows the contiguous quadrangles that once depicted the ground-plan of a dwelling with two rooms. There is an Egyptian hieroglyph for the leaf of a door. It is formed by a perpendicular stroke and an attached rectangle. In the Semitic scripts a similar sign (called *daleth*, that is, a 'door') is used to express the consonant 'D'. From this the triangular Greek *delta* derived, of which our Latin 'D' is only a modification. Our zigzag shaped 'M' goes back to the old hieroglyphic sign for 'water', the word for which, in northern Semitic, is *mem*. The hieroglyphic picture of a snake lives on in our 'N'. (Kuhn 1956:101)

What Kuhn suggests here is the transition and derivation of "true writing" from non-alphabetic forms. I would argue that these earlier pictorial forms were already organized as texts capable of inscription on material objects and developed over the millennia. For many thousands of years human beings have sought to improve and supplement the oral recording of their experiences and ideas by "writing things down." This activity constitutes a form of literacy, whether it be executed on people's bodies, their tools or the landscape around them.

This chapter explores some of the features of non-linguistic writing in oral cultures and suggests

that not only are the seeds of literacy to be seen in the rock writings of the Stein Valley of British Columbia, but also that they were sown long, long ago in pre-literate human history.

The 'Nlaka'pamux culture of the nineteenth and early twentieth centuries, as described by Annie York, and before Annie's birth by ethnographer James Teit, had no alphabet. It was an oral culture, but like all cultures it had forms of writing and recording; it had its system of writing images that communicated meaning between members and across ethnic and linguistic boundaries.[4]

All oral cultures are equipped with a rich store of visual symbols and images. These images, used in conjunction with social actions and "performed words"—words spoken, sung or danced—provide meaning and cultural identity to a community of users. Visual images supplement the performance of words to communicate more fully the flow of meaning between persons. In such cultures, the meaningful visual symbols and images are taught by the old to the young; they are learned, standardized and passed through the generations. Sometimes these images are the subject of artistic expression, other times they are "written" on the surface of the natural environment, or in the immediate domestic world.[5] In the domestic realm these images were written on one's body, one's house, tools, weapons and equipment. In the natural realm they were written on the rocks, near the flow of water, or in the shelter of caves. They are "read" by those literate enough to appreciate their significance. They function much as a written language does. They supplement and assist the story-telling, the spiritual worldview, the dominant oral forms of cultural communication. Like the totem poles and painted house fronts of some cultures, these writings are located along major avenues of communication. They have been made to be read by others.

Often these systems are marked by a differential access to their meaning. A certain level of meaning is communicated by the symbols of an oral culture to all members, but fully elaborated meaning is restricted socially only to certain members, certain families, or certain experts. As well, the system is generally not used in all aspects of life; rather it is restricted to certain activities or spheres of social activity. It is commonly utilized to convey information involving social upheaval, natural disasters or the meditative and psychic experiences of the individual writer. Such communication systems constitute what has been called "restricted literacy" (Goody 1977, 1987).

Frequently, such forms of literacy, particularly in kinship societies, are restricted and confined to certain members of the social elite, whose authority is derived partly from their control of access to this esoteric information; as well, these "leading families" generally control the interpretation and dissemination of this information. This was the case among many of the cultures of the coast, adjacent to the 'Nlaka'pamux.

As discussed briefly in the Preface, the 'Nlaka'pamux exhibit some of these features as well, even though there does not appear to have been a pronounced social elite, at least in the nineteenth century. We should remember that the social stratification at any particular period in time was probably much more flexible and fluid among the 'Nlaka'pamux than among their coastal neighbours. For example, all young members of 'Nlaka'pamux society were encouraged by their elders to s'lek̲, (train for psychic expertise) in the mountains, and thereby receive their personal power and individual confidence for future endeavour; but the families of gifted hunters, warriors, shamans, weavers, carvers and dancers tended to elaborate the training of their descendants, and maintain the most complete tellings of the ancient narratives and teachings.

Annie York's sister, Kathy, who was raised at Merritt, in Cawa'xamux or Nicola territory, says that her Nicola elders were appalled by the unregulated sexual mixing and intermarrying between regions, as well as between proper and improper families, and between Natives and newcomers (generally

itinerant labourers) that occurred along the Thompson River, especially around Lytton, Thompson Siding and Spences Bridge following the gold rush of 1858, and during the subsequent period of railway construction. Kathy, like her sister Annie, and their cousin, Arthur Urquhart from the Lower or Utamqt"Nlaka'pamux, implied that this social change upset an established social structure in which the young deferred to the old, and the leading families were responsible for the proper conduct of the kinship alliances and other social, economic, political and religious aspects of life in their immediate community. There was probably some division between "decent" families who did things properly, and other families who were not so fortunate.[6] Control of information, in such situations, tends to follow control of status, even in societies without a rigid social hierarchy. In such situations, the protection of the good fortune of leading families probably involved a close husbanding of the type of esoteric knowledge which is the subject here.

Fig. 152. Man wearing 'Nlaka'pamux shaman's headdress made of wool and horse hair, adorned with two eagle feathers with tips painted black, and red "writings." The standing figure represents "the shaman himself wearing a feather headdress." The solid circle is a "star" (Boas 1900:381). Courtesy Department Library Service, American Museum of Natural History Neg. No.11674.

Although her thinking was undoubtedly coloured by long residence at Spuzzum, a village located on the cultural boundary with the coastal peoples, Annie was taught by elders from various parts of 'Nlaka'pamux territory. They told her clearly which were the "clean" families, and which were the "dirty" ones. She said that some cultural information was only passed to those of the appropriate blood lines, such as the chiefs' language, with which she teased and tantalized the linguists. (The existence of a chiefs' language has been mentioned in relation to coastal societies, but little is known about it in the 'Nlaka'pamux region, beyond the information given by Annie York.)

Annie's words in my last recorded discussion with her tend to corroborate the existence of this restricted access to the knowledge of rock writing (4 Apr. 1991):

228

Okay, you're young, and when you're about ten or fourteen or fifteen, your grandfather worries about you, if you're a boy. He doesn't just like you to be an ordinary person because, when you grow up to be a man, you going to be a hunter, fisherman, doctor. So they have to go up in the hills to learn aaaaaall the different animals, their ways. And they have to go up to that Stein. Those that can, make it.

Those who have been educated on the land, with the degree of detail and cultural elaboration common to their respective family fortune in the society, are able, within their own level of competence, to "read and write" the imagery on the rocks. They do so on the basis of their own specific existential history and cultural knowledge. Perhaps the most informed readers were specialists, such as the shamans, leading hunters and warriors. For such persons, the text they read was understandable in terms of the general theme or story portrayed, and was made immediate by virtue of the reader's training and personal experience with life on the land.

In such a system of restricted literacy, no two readers will arrive at exactly the same interpretation of the writings, even though the general theme and iconography may be known by both, and even though the general subject of the discourse may be known by everyone.

For other members of the society who lack the training associated with 'Nlaka'pamux rock writing, however, to contemplate these images in red ochre or charcoal is to challenge their mystery and thereby expose oneself to unnecessary psychic danger, possible misfortune or ill-health. The inscrutability of the writings for these persons, as for the foreign backpacker or researcher who comes upon them in our present era, adds to their mystery and hence their emotive power.

Such writings are examples of restricted literacy in a broader, linguistic sense as well. They have not made the leap to full literacy: They are direct visual transcriptions of life's experiences. They are not alphabets—those systems of visual signs which stand for the spoken word. Alphabets enable the members of vast urban state societies like our own, to re-encode the codes of speech, to capture them on paper in a precise, standard form, and hence to store vast quantities of information in the form of written documents, magnetic tapes, or electronic diskettes. Writing, in oral cultures, does not document the relationship between the written sign image, and the sound units of spoken language. Its dominant feature, like that of art, is its ability visually to communicate shared human and cultural experience.

As we have seen in Annie York's portion of this book, the rock writings of the Stein River Valley are more intimately associated with the altered states of consciousness of certain young persons of the 'Nlaka'pamux and surrounding societies than they are with the recording of specific hunting or raiding expeditions. Instructed by their mentors, these young people underwent training in this secluded valley, and at other lonely places to find their own unique road through life. It was not simply obedience to their elders; these young people undertook this training to develop their talents, to understand the world of nature and the world of the mind, and to share this understanding with other persons— including future generations—by writing on the rock near the place in which they did their dreaming. These dream sites were typically at locations within sight and sound of the rushing waters of the lower Stein River.

The dreams of one initiate, or one seasoned healer, or warrior or hunter, are unique and cannot be conveyed *in toto* to others. Yet these dreams have at least three things in common. First, they are the products of common physiological processes associated with different types of thinking. Second, the dreams of all initiates possess a common tradition of hunting, gathering and fishing on the land occupied by their forebears, with a technology shared by cultures across the world in the late ice age and the

post-glacial world that followed in the human history of the northern hemisphere. Third, they participate in a common regional culture and cosmology, and a common artistic tradition.

Among those who know the cosmological stories, genealogical histories and trail language—and, in earlier times, a continent-wide sign language of gesture, as well as the iconography of tool, utensil and body decoration—and who have been exposed to psychic training as part of their life on the land, the rock writings can be read in a meaningful way.[7] This is not to say that anyone other than family members of the actual dreamer/writer will be able to read the intended meaning in detail, but it does suggest that the general subject of the dream can be grasped by others familiar with the way of life, and the dominant social and cultural aspirations of people living in the ethnographic area. The lack of knowledge about the specifics of the dreams adds mystery, and hence power, to their message, and leads the unschooled "reader" to contemplate and wonder at the veiled realm of other people's dreams and subconscious journeys.

C.G. Jung, one of the founders of the field of dream psychoanalysis, maintained that a dream should be treated as fact, with its own logic, and be seen as a specific expression of the unconscious. Jung thought that dreaming was the process by which the unconscious, a-rational mind produced the wealth of collective human symbols which cultures find so useful for categorizing and organizing meaning in social life. Jung's studies led him to conclude that while the *conscious* mind is able to focus on only a specific number of items at any point in time, the *unconscious* mind stores away all of the unfocussed and forgotten phenomena which we have experienced either directly, or through stories and images pertaining to previous generations. The conscious mind thus has rich psychic associations both spatially (below the surface of the collective mind of our species) and temporally (stretching back through the history of our species). These associations, normally hidden by rational thought processes, become partially revealed in our dreams.

Both Annie York and Carl Jung maintain that the unconscious contents of the mind comprise a museum of human history:

> Just as the human body represents a whole museum of organs, each with a long evolutionary history behind it, so we should expect the mind is organized in a similar way...This immensely old psyche forms the basis of our mind, just as much as the structure of our body is based on the general anatomical pattern of the mammal....The experienced investigator of the mind can similarly see the analogies between the dream pictures of modern man and the products of the primitive mind, its "collective images", and its "mythological motifs." (Jung, et al., 1964:57)

"The dream pictures of modern man" of which Jung speaks refer to experiences of humankind everywhere in the last few hundred years. "The primitive mind" refers to the human mind, everywhere, thousands of years ago. The idea that the dreaming mind is a museum of human experience is implicit in Annie's explanations. Speaking about Fig. 105, above, Annie said:

> When the person dreams this, he's allowed to see through the Creator's eyes about how it was in the beginning. The Creator gives him the gift of seeing it.

> At the bottom is the horned lizard. They came here at the beginning, but there wasn't enough for them to eat and they disappeared...The dream tells them all these things, and that's what I say about that place [the Stein dream places]—it's really history of people's life on this earth.

The explanation of 'Nlaka'pamux dreams which have been revealed to us in this book are not simply a quaint remembrance of the nineteenth century; rather, they speak to all of us who dream and have

been born of dreamers, no matter which culture or technology we hail from. These dreams, written on the rocks, are an integral part of the history of human thought. Those of us who have been formed by the worldview of a state society have had the psychic side of our brains beaten back behind a sharp boundary line. The half-grasped associations and the mystical powers which objects have in our mind's eye have been stripped away from our conscious, rational mind:

> Because, in our civilized life, we have stripped so many ideas of their emotional energy, we do not really respond to them any more. We use such ideas in our speech, and we show a conventional reaction when others use them, but they do not make a very deep impression on us. Something more is needed to bring certain things home to us effectively enough to make us change our attitude and our behavior. That is what "dream language" does; its symbolism has so much psychic energy that we are forced to pay attention to it. (Jung, et al. 1964:33)

The European scholarly tradition has long been steeped in empirical rationality. It often finds itself ill-at-ease when confronted by human and cultural phenomena such as dreams, which appear to be at once non-material and irrational. Instead of grappling with the inner logic and materiality of such aspects of culture, scholars generally slot them into analytical categories which denote irrational or dissembling acts and beliefs. By so doing, they avoid actually analysing these phenomena.[8]

The rich life of the mind in non-industrial societies and cultures is often described as "magical" or "supernatural," and is subsequently categorized into typologies of exotic beliefs and behaviors, which researchers implicitly consider irrational and misguided. The English word *magic*, for example, is frequently used by scholars to explain the meditative, dream-like, and hallucinogenic forms of thought which are so integral to the rock writings. *The Oxford English Dictionary* defines *magic* as follows:

> The pretended art of influencing the course of events, and of producing marvellous physical phenomena by processes supposed to owe their efficacy to their power of compelling the intervention of spiritual beings, or of bringing into operation some occult controlling principle; sorcery, witchcraft.

Labelling something "magic" is thus a way of distancing the scholar and reader from the phenomenon so described. What is a "pretended art" in our society may have a tangible reality in another; indeed, according to psychologists, this phenomenon may not so much be pretended in our society as it is repressed. To apply the "magic" or "pretended" definition strictly to practices and beliefs in a non-European-speaking, non-industrialized culture—not to mention to the world of dreams which we all experience—is to continue to evaluate both non-state societies and the phenomenon of dreaming on the skeptical, philosophically positivist basis of European industrialized society and culture, rather than to analyse seriously the common and the unique ways of being human in different societies, in different epochs. Jung held the opinion that our modern skepticism is born out of fear of facing up to our unacknowledged archetypal thoughts and images. He said, "We have stripped all things of their mystery and their numinosity; nothing is holy any longer" (op.cit.:84).

What is required to understand the rock writings is a willing suspension of disbelief, a respect for our own subconscious experiences, and an ear for the practical "this-sidedness" of Native explanation. In my experience, Native people tend to regard both their conscious and their subconscious experiences with great practicality. For instance, even after giving elaborated explanations of the spiritual creation of the original dream images, Annie remained firmly rooted in the practicalities of life. When I asked her if any of the rock paintings in Stein Valley caves were said to have been created by spiritual beings, this was what she had to say:

Q: Were they spiritually made?

A: Yeah, the cave, you see, sometimes an earthquake can make a cave.

Q: No, I mean the drawings inside them.

A: Oh, the drawings, sure! It's a human work. They sleep in there and they dream, and then they write their dreams.

Later in the same interview I asked Annie if it was the spiritual or supernatural strength of people that was credited with maintaining the visibility of the drawings over long periods—something I had been told in other regions:

A: Well, sometimes these people too, young people, they go and sleep there. They get strong, and they refilled that writing. That's why that writing never gets faded, never.

Q: So it's not a spiritual thing. It's the dedication of the young people?

A: Yeah.

When he or she writes signs and symbols on rocks, a person from a non-state society uses both sides of his or her brain, just as a member of a state society does when committing a thought or an experience to paper. The 'Nlaka'pamux and their Lil'wat neighbours, who live where their ancestors lived, along the canyons of the Thompson and Fraser Rivers, used their rational, "this-sided" brain when they communicated to one another on the land. They did so by writing and reading trail signs that had to do with hunting, fishing, gathering, or war; or they recorded, with common everyday pictorial symbols, historical information about battles or natural disasters. They also used widely-known, standard gestures when they employed a common sign language in order to communicate with citizens of other nations.

However, when the 'Nlaka'pamux travelled along the obscure trails of the subconscious mind, they used the other, more intuitive side of the brain. On these occasions, they "wrote" not with signs, but with primordial symbols—animal and human, natural and artificial objects—what Jung called the archetypes which every society translates and expresses in terms of its unique form of myths and ancient narratives. These symbols abound in the written records of the psychic experiences of the 'Nlaka'pamux, and they have come to be written not only on the rocks, but also on the bodies, tools and utensils of the people. While state societies tend to minimize the intuitive, primeval images of the subconscious mind, non-state societies seek out these images and give them centre stage in their cultures.

B. Altered States of Consciousness and Rock Writing Scholarship

The task of determining the meaning of pictographs and petroglyphs, from the European caves of Altamira and Lascaux, to the inscribed rocks of Africa, Russia, Scandinavia, Ireland, Siberia, China, Polynesia, as well as across North and South America, has challenged researchers for well over a century. In most cases, the elders of the indigenous cultures have revealed to researchers little information about the meanings and functions of the rock writings found in their respective regions. Nonetheless, researchers have gleaned some ethnographic data and, to some degree, have tried to explain the writings

by assuming that those who created the ancient Paleolithic rock art were following practices analogous to those noted in the nineteenth and twentieth century ethnographic records for that particular region.[9]

Rock paintings have been approached from the perspective of *animism*, the technical term for the belief that all natural phenomena are endowed with life or spirit. From this perspective, ancient paintings of game animals functioned as a "magical" component to their capture by hunters (Tylor 1972; Breuil 1952, 1962). These writers assume that non-state peoples wrote animals on the walls of caves in order to capture them more easily. This simple explanation reflects the rather naïve and primitive analytic nature of much research in the fields of "naïve" and "primitive" art, which persists into the present era (Breuil 1952; Leroi-Gourhan 1982; Bihalji-Merin and Nebojsa-Bato 1984). Also, scholars attempting to classify the images into a visual language of representation have analysed pictographs and petroglyphs on the basis of perceived consistencies of form and style.[10] Often, as Molyneaux (1977) and Duff (1976) point out, this form of analysis restricts itself to the qualities of the imagery, at the expense of physical and cultural context. Another approach, followed by many archaeologists as well as other researchers, is to record patterns of rock art distribution by type, regional style, subject matter and site description.[11]

Some approaches, based on ethnographic data, have focussed on the use of hallucinogenic substances by rock artists/writers,[12] while others have studied the shamanic features of the imagery.[13] By associating shamanism and altered states of consciousness with rock art, some researchers have suggested that certain design elements reflect common neuro-psychological phenomena that all human beings are capable of experiencing in a mind-altered condition, no matter what culture they hail from.[14]

As the foregoing sections of this book attest, the shamanic aspect and the altered state of consciousness are integral to Annie York's "reading" of the Stein River Valley rock art/writing. A number of the images in the Stein are consistent with the shamanic transformation process noted in rock art in other countries (Lewis-Williams 1980; Lewis-Williams and Dowson 1988); with the portrayal of the dreamer's transformation into his/her spiritual identity by means of half-human, half-non-human figures which are called therianthropic beings. These images combine the form of a beast with that of a man, and they reflect the dreamer's journey to other places and times. In light of Annie York's explanations, these transformational figures need to be viewed with an understanding of the 'Nlaka'pamux sense of psychic reality. The world revealed to the questing 'Nlaka'pamux is a shimmering, luminous place, filled with moving, changing visual images. This is the real world in the old 'Nlaka'pamux culture, the world behind the more superficial world of objects we see around us every day.

'Nlaka'pamux youths sought entry into this ever-changing world of images and narratives, by following the dream training of their elders at power places along the vibrant Fraser River, or in the purity of the mountain country. The world that the dreamer entered was meaningful in at least two ways; first, in neurologically-produced, non-representational images (generally geometrical patterns of light and colour); and second, in the culturally-produced imagery of dreams which are subsequently interpreted in terms of everyday "common sense" experience. In relation to the art of the northwest coastal neighbours of the 'Nlaka'pamux, artists and scholars alike continue to ponder the dualistic and transformational nature of this state of mind.[15] In this tradition, human intellect and animal instinct and power interact and transform one into the other in the shifting images of the dream.

This is a world alive with energy, a life force made meaningful to the dreamer by anthropomorphic means. The dreamer "sees" human actors incarnating trees, stones, rivers, insects, fish, fowl and animals. These apparent humans take the form of animals as the human dreamer learns the animal

forms of his or her unique power. These are said to be the creatures of the ancient mythological age when all things had animate human forms. Some of the resulting imagery is half-human and half-non-human, such as the therianthropoid creatures mentioned above. Other images are humanoid forms of non-human intelligences. In the rock writings we have covered with Annie York the therianthropoids are "Shemitz" or Deer Man (Fig.58), the Sun Man/Beaver Man (Fig.74), Cascara Man (Fig.86), "Ngwitshgen" or Plant Child (Fig.95) and "Stanax'hew" or Sun Man (Fig.120).

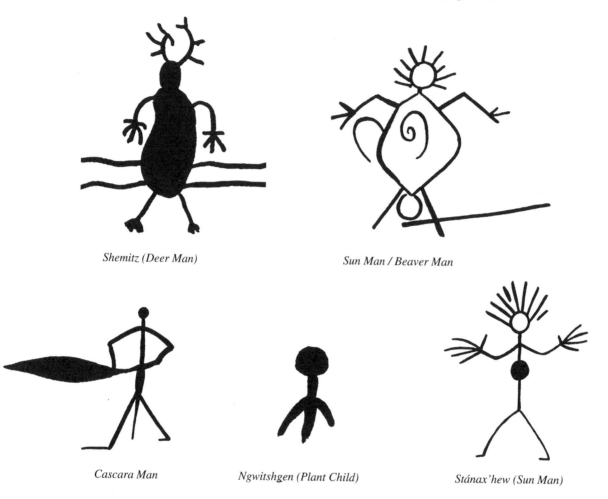

Shemitz (Deer Man) *Sun Man / Beaver Man*

Cascara Man *Ngwitshgen (Plant Child)* *Stánax'hew (Sun Man)*

Fig. 153. Stein River therianthropoids

We learn of the transformational nature of therianthropic figures when we recall Annie's explanation of the Deer Man, "Shemitz" (above, p. 91):

He's a man, yet he has a deer horn on his head. He's a deer in the time of that legend life. He's called *Shemitz*. In the beginning he just walks like a human being. Some people don't eat meat on Friday because he used to be a man. Walked upright.

If you're gonna dream a deer, or a bear, and that's gonna be your own power, then you're made to go and wash your face in the water of that stream. Then you can use that. Then you can dream it.

Examples of the human forms of non-human beings are the Earthquake Twins (Fig.80), the Spider People (Fig.111), River Spirit Man (Fig.115), and Bird Boy (Fig.122).

Earthquake Twins Spider People River Spirit Man Bird Boy

Fig. 154. Stein River human forms of non-human beings.

Some of these beings are shown in their shamanic form: the Bird People (Fig.143), Sun Man (Fig.143), Skaí'yep, or Cedar Man (Fig.143), as well as the petroglyphs in Fig.145; for example, Sturgeon Man and White Wolf Man.

Sun Man Skaí'yep (Cedar Man)

Bird People

Sturgeon Man White Wolf Man

Fig. 155. Stein River non-human beings in their shamanic form.

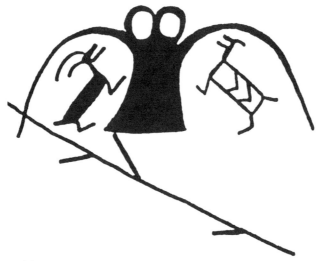

Fig. 156. Dream form of the hunter's spirit helper (right).

A more intellectually complex visualization is found in Fig.156, (see Figure 104, also in Fig.54, as well as in the body language of the man with the goat in Fig.92; the image appears as well in Figs. 100, 102 and 113; also, it has been adopted by common usage as the Stein Valley "owl" logo, Fig.109).

This is the dream form of the hunter's spirit helper. Annie explained this image as the dream form taken by men who have a well-developed hunting power. Their specific power may emanate from a natural creature such as the rubber boa, the eagle or the owl, and then, in the dream, it can transform itself into the directed will of the hunter, portrayed in its dream form as a semi-human, semi-bird encompassing the game.

The dominant shape of this figure is a strong vertical body and two arched and encompassing arms. It is strikingly similar to the forceful image of the joined eyebrows and nose in many petroglyphs, such as Fig.145, and in the famous Tsagaglalal petroglyph portrayal of a face, at Long Narrows, Columbia River.

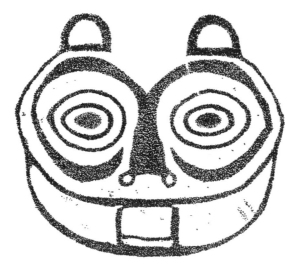

Fig. 157. Drawing of a Tsagaglalal Face, Columbia River. After McLure (1984:Fig. 19a).

236

Annie explained that the petroglyphs were spirit mask faces. If we superimpose the hunter's dream form over these masks, we are able to read the same mental concentration in each. The arches embrace the uncompromising eye of the spirit in one case, and the hunter's game animal in the other.

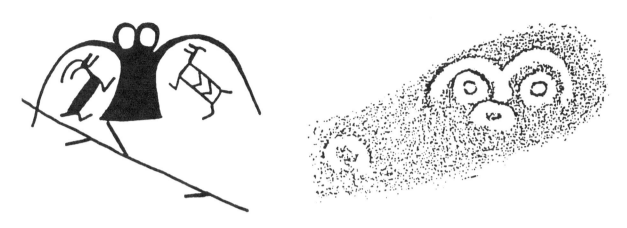

Fig. 158. Details from Figs. 104 and 145. Similar forceful configurations of body/arms and nose/brows have strong connotations of focussed mental concentration. The former has to do with spiritual transformation in the winter dance season, and the latter with hunting.

A feature of the rock writing which is less explicit is the identity of geometric images which denote common neuropsychological features of altered states of consciousness in the brains of the rock writers/artists. Lewis-Williams and Dowson (1988:202-04) have argued that both altered states of consciousness and hallucinations are a function of the mammalian, not just the human, nervous system, and that the content of human mental imagery in altered states of consciousness is of two basic types: that which is informed by cultural expectations, and that controlled by the nervous system itself. These authors go on to suggest that while it is usually not possible to crack the codes of the cultural components of such states—as manifested in rock art—it is possible to understand the neuropsychological components. The presence of such components in rock art across the world, they postulate, indicates a substantial connection between shamanic practices, altered states of consciousness and rock art, from the Paleolithic era to the present.

These neuropsychological components consist of shifting luminous, often changing visual systems of geometric shapes that are subsequently portrayed as grids, zigzags, dots, spirals, catenary (nesting) curves, and meandering filigrees. The cultural components consist of representational figures from the animal, human and metaphysical world. Lewis-Williams and Dowson (1988) consider the former to be *entoptic phenomena* (meaning visual sensations derived from the structure of the optic system anywhere from the eyeball to the cortex); they consider the latter, the cultural components, to be *hallucinations*—more complex iconic visions called up by the presence of these changing, illuminated geometric shapes.

These writers go on to describe the processual nature of entoptic formulation: the replication, fragmentation, integration, superpositioning, juxtapositioning, reduplication and rotation of the basic geometric images experienced. In this context it is interesting to remember that different states of

mind are dominated by different brain-wave frequencies and that the Alpha wave frequency, which is integral to dreaming and meditation, was first observed in the occipital or posterior brain, that portion usually associated with vision, generally the strongest of the senses utilized in altered states of consciousness.[16]

Entoptic researchers claim, from their clinical studies, that mental imagery progresses from geometric entoptic images, to "making sense" of these, by elaborating them into rationally and culturally-known iconic forms that can be invested with socially recognized meaning and signification; a move from the entoptic building blocks to hallucinatory images which are capable of cultural interpretation. Furthermore, the specific representational image that one "builds" from the geometric movements and shapes are determined by previously established emotional states, preoccupations, wishes and desires. From this perspective, entoptics are the building materials used by prophets, meditators and dreamers, both to divine and to construct their messages.

This process has been recorded in laboratories with subjects who have ingested mescaline and LSD. It has similarly been described in some detail among the Tukano of Amazonian Colombia in their *yaje*-induced visual experiences (Reichel-Dolmatoff 1978b). Figure 159, taken from Lewis-Williams

ENTOPTIC PHENOMENA		SAN ROCK ART		COSO	STEIN
		ENGRAVINGS	PAINTINGS		
A	B	C	D	E	F

Fig. 159. Six categories of entoptic forms, displayed cross-culturally after Lewis-Williams and Dowson (1988:351, Fig. 1) with Stein Valley examples added.

and Dowson (1988), compares six entoptics (I-VI). Columns A and B are variations derived by psychologists working with subjects in altered states of consciousness; Columns C and D are, respectively, engravings and paintings found on the rocks in the ethnographic region of the San ("Bushmen") peoples of southern Africa; Column E has been compiled from rock writings in southern California; and Column F is compiled from the Stein Valley examples.

An examination of the Stein Valley rock writings reveals some of these entoptics in their classic forms, and others as design elements in the painted figures. The following is a description of some of the occurrences of these phenomena in the Stein material. Category I consists of grids. The images found all the way from Fig. 43 to Fig. 150 contain no fully developed grids, although many iconic images appear to have been suggested by grid elements. Multiple intersections of one or more lines are found, for example, in Figs. 47, 55, 82 and 125. The "cross" component of the grid is evident in Figs. 49, 55, 78, 100, 125, 127 and 136; and a number of drawings include four-sided "box-like" container images bisected by one or more straight lines: Figs. 80, 94, 105, 108, 119—respectively: Annie's weather symbol, the rejected prototype for a game animal, the Creator, the helicopter that will be invented one day, and the space basket. Also, Fig. 68, the prototype canoe, is interesting in so far as it contains a gridwork of zigzags.

The parallel lines which make up Category II, are found in a number of drawings such as Figs. 54, 93 and 102. The shimmering dots and dashes of Category III are evident in Figs. 50, 86, 125, 135, 143 and 150. Category IV's zigzag forms are found in Figs. 43, 54, 68, 71, 80 and 92. Modified zigzags—the chevrons internal to animal and insect forms, and game tracks—are prevalent as well (e.g., Fig. 99, 102, 127). The catenary curves of Category V are most evident in Fig. 149, the petroglyph site on the bank of the Fraser near its confluence with the Stein River, and this form is strikingly evident in the dream form of the hunting spirit and the spirit dance faces already discussed. This entoptic form is also evident in Figs. 47, 95, 106, 108, 119, 131 and 148. There is no clear example of Category VI, the meandering filigree lines, although the earthquake tails of Fig. 80, the sun's rays of Fig. 99, and the contorted lines of the "house model" in Fig. 136 may have evolved either from the zigzag or from the meandering line form. The presence of entoptic forms in the Stein adds support for the view of 'Nlaka'pamux people of a century ago (Teit 1900; 1918), as well as Annie York's explanation that the Stein River rock writing is closely associated with dream states.

Fig. 160. "Conventional Thompson Designs." These designs are replete with entoptic forms, with the exception of filigrees. We see the cross, the grid, nesting curves, zigzags, circles and radiating lines. Drawn after Teit (1900:378, Fig. 298).

239

Altered states of consciousness can be induced by various means, including flickering lights, hypnosis, psycho-active drug use, fatigue, sensory deprivation, intense concentration, auditory driving (with drums and rattles), migraine, schizophrenia, hyperventilation and rhythmic movement.

Jilek (1982:36-39) outlines the various Salish forms of physiological change used to achieve altered states of consciousness in the course of the spirit quest. The first method involves a condition of social isolation, together with prolonged nocturnal vigilance, expectant alertness and monotony. The second set of conditions combines hyperactivity and mental excitation in conjunction with prolonged anxiety and emotional stress. This condition is frequently followed by exhaustion and fatigue, due, among the 'Nlaka'pamux at least, to running and dancing all night in the mountains.

The third set of conditions involves six possible types of what Jilek has called "somatopsychological" factors, namely: sleep deprivation on vigils and spirit quests; hypoglycemia due to food abstention; dehydration due to abstention from liquids:(a) from forced vomiting,(b) from the application of purgatives (note Annie's description of novices taking cascara before leaving for the mountains), and (c) sweating which, in the daily sweatlodges is accompanied by a type of monotonous singing conducive to slowing the brain wave frequencies. The fourth form of "somatopsychological" deprivation is found mainly on the Pacific Coast: hypoxaemia, or hyperventilation and light-headedness caused by deep diving and prolonged underwater swimming—to the point of semi-asphyxiation by drowning. The fifth method is exposure to extremes of temperature: sweatlodges and icy rivers. There were, as well, instances of self-inflicted wounds, cuts, scarification and stinging nettle burns to alter one's rate of brain waves.

The primary method associated with the Stein Valley rock writings is sensory deprivation by fasting, loss of body fluids by not drinking, the use of purgatives, by sweating, and also by song, dance, vigilance, cold temperatures and sleep deprivation. Annie York explained the procedure which young people were instructed to follow to achieve, after several days of fasting and sleep deprivation, revelatory dreams:

Q: Could you tell me again the preparations for going up into the mountains, Annie?

A: You have no blanket, nothing to eat, nothing. You can't drink water even. All you do is chew the very top of a fir tree. Take it whenever your mouth dries, and chew it. And you going to sleep. So you gaaaaaather all the boughs, and you put it towards the sun. You make a sweathouse for morning.

Q: The boughs face between sunrise and sunset?

A: Yeah, and you sit and you sleep. Your fire, you pile as high as you like, and you do like this.

Q: So that you can lean back as though you have a pillow behind you?

A: Yeah! And you put the boughs around you, and that's the only blanket you have. You see, even when it's cold you do it. But you know? It's warm after you do that for a while. And you sleep. If you do it two or three times or more, you never get scared. It's just like as if there are people talking around you. That's all. That's what I'm telling people and they think I'm crazy! One time I went up there and it was wet and starting to shower. I didn't come home. It was getting dark, so I put boughs all round me, behind me and over my head.

When I went to sleep it sounded like if I had lots of friends talking to me...That's what they

do. You fix your sweathouse the same way...like this, with the boughs going the same way. You takes your rock in there. Then you spends the night in your sweathouse! No more you sleep in a bed you can lie down in. You put your *hot* rock in there. You put it in there and you put a little water, sprinkle it. And then you sing with it. You said your prayer [to the sweathouse power] before you went in...You stay all night. And you do what you do in the morning. You wash that rock and put it away...And you wander around the mountain, look around the country. When it's toward afternoon, about four—five o'clock, then you start again. You make a fire and you heat that rock, and you take out the old boughs and put in fresh ones.

You mustn't *never* do it where people's trail is, because it's a regulation. It's just trees all over and waaaaaater runs out of a little stream. Usually we do it in a lonely forest, not where people are. The first one I had was a sweathouse. It was above this waterfall, but I had my aunt with me. After I get initiated I go up and do it myself. (11 June 1990)

Annie explained that after adhering to this procedure for at least four days and nights, the trainee—or the specialist—will begin to experience culturally important dreams, which he or she will be expected to record on the rocks, or in some other way.[17] These training procedures, as practised in the early years of the nineteenth century, were explained to ethnographer James Teit, by the 'Nlaka'pamux elders of the late nineteenth century. After explaining the puberty training of girls in some detail (Teit 1900:311-17), he wrote:

She made a record of her offerings, and the ceremonies she had passed through, by painting pictures of them with red paint on bowlders and on small stones placed at the ends of her trenches. This was believed to insure long life. The pictures were generally all of the same character, and consisted of fir-branches, cross-trails, lodges, mats, men, etc., and were put on toward the end of her period of training. She painted pictures of men, symbolic of her future husband...

...In rare instances the girls sweat-bathed toward the end of their training period, if that period extended to six months or a year. They used a sweat-house constructed of four wands or of four fir-branches, which were covered over, of course; and they used four stones for heating the house. This was done by girls who wished to be shamans or to become wise.

Teit then proceeded to describe the puberty training of boys (ibid.:317-21). Again he stressed the specialist nature of the training:

If a boy wanted to develop into an extraordinary man, the ceremonial isolation and practice were extended over years, which he spent alone with his guardian spirit in the mountains, fasting, sweating, and praying, until he gained the desired knowledge. (ibid.:317-18)

Again, in describing the male puberty training, Teit noted the importance of recording dream revelations:

Lads painted records which were pictures representing their ceremonies and their dreams, on bowlders, or oftener on cliffs, especially in wild spots, like canyons, near waterfalls, etc. These were generally pictures of animals, birds, fishes, arrows, fir-branches, lakes, sun, thunder, etc. Figures of women symbolized their future wives. It was believed that the making of rock-paintings insured long life. (ibid.:321)

In relation to the training of both boys and girls, Teit explained that all youths received some degree of training, and those chosen by their families to excel in life trained intensively over a long period

of time. The "basic training" consisted largely of sensory deprivation practices such as going with-out food, water and deep sleep for lengthy periods of time; engaging in trance-inducing repetitive tasks such as girls picking needles off fir boughs and boys pecking holes in rock. Boys would sing their song and dance their dance over and over again, often through the night. There were, as well, creative visualization techniques for focussing upon, requesting, and practising the many skills required for success in life.

We have seen, to this point, that according to the cultural tradition of the 'Nlaka'pamux and other Salish peoples, the non-human world has been animated much the same way as the human world. Young people have been trained to achieve altered states of consciousness in order to explore their own relationships to this animated world through dreams and hallucinations. At the completion of each psychic exploration, the Salish practitioner generally wrote the theme and salient features of that exploration on the rock with red ochre (and sometimes other adhesive ingredients); or pecked or ground the relevant images into the rock before painting them, so that others could witness that these things had been learned.

C. The Language of Rock Writing: Entoptics, Archetypes and 'Nlaka'pamux Iconography

In the previous section I have suggested that the altered state of consciousness that accompanies dreaming and hallucination is associated with a change in frequency of brain waves from the rapid Beta waves of normal rational thought, to the slower Alpha waves of the dreaming or meditative mind. In this section I would suggest that the process of visualization in an altered state of consciousness includes both entoptic and archetypal phenomena that award significant meaning in relation to the cultural tradition of the dreamer.

Following one or more of the many techniques for inducing this changed state of mind, the sub-ject reaches a condition in which flickering geometric images, or entoptics, appear to the optical por-tion of the human neurological system. I would suggest that these geometric entoptic images dis-cussed by Lewis-Williams and Dowson (1988) become associated with, or transformed by, the subconscious mind into ancient, primeval images and symbols—what Jung calls the instinctive aspect of the human psyche. Indeed, Jung explains archetypal dream images as phenomena akin to biolog-ical instinct:

> They [the archetypes] are, indeed, an instinctive *trend*, as marked as the impulse of birds to build nests, or ants to form organized colonies. Here I must clarify the relations between instincts and archetypes: What we properly call instincts are physiological urges, and are perceived by the senses. But at the same time, they also manifest themselves in fantasies and often reveal their presence only by symbolic images. These manifestations are what I call the archetypes. (Jung, et al. 1964:58)

Not only do we find entoptic visuals in all human dreaming, we find archetypal imagery as well. The former could be classed as a physiological response to certain stimuli, and the latter, an automatic conceptual response to the entoptic pheonomenon. This dimly perceived imagery, in turn, is given strength and definition by culturally informed symbolization. The imagery is made socially symbolic, and hence meaningful by analogy to the myths and cosmologies of the dreamer's specific cultural background. Archetypal images are made rational and meaningful in subsequent wakefulness by

242

means of their ability to symbolize the ancient narratives of one or other cultural tradition. These experiences are written on the rocks. Subsequent generations see the images and refer to them in the course of interpreting, and giving meaning to, the events of their own personal dream quests, and to the preparation they have received from their elders.

How, then, do archetypal images become meaningful 'Nlaka'pamux symbols that can be written on the rocks and read by passersby? What are the coding principles that build and convey meaning through the use of entoptic and iconic images and image elements? To answer this question requires further understanding of the cultural use and context of these signs.

Fig. 161. 'Nlaka'pamux coiled baskets. Lower trays, left: arrowhead or necklace design. Centre and right: arrowhead design. Centre trays, left: big bead or embroidery design. Right: cow's foot. Upper basket, left below: morning star or cross design and Indian rice design. Right, below: snakes on big bead design. Upper: star; mid-upper: pine cone design. Right: arrowhead, star and blue clematis flower design. Courtesy Musée Canadien des Civilisations/Canadian Museum of Civilization No.39763.

One of the striking features of 'Nlaka'pamux culture has been the propensity of its members to paint, draw and engrave images—similar to those found on rock faces—on their bodies, faces, tools, weapons and utensils. This has been noted in some detail in the ethnographic work of James Teit. The main body of Teit's 'Nlaka'pamux material was carried out for the Jesup North Pacific Expedition, under the direction of anthropologist Franz Boas. As Chris Arnett explains (Chapter 1 above), this was a scientific expedition, mounted from New York at the turn of the century, to study cultures of the North Pacific region, from Siberia to North America. The studies which resulted reflect the research interests of the project director, Professor Boas, such as his fascination with systems of artistic communication, of what we might call today restricted literacy. This research revealed that writing with images was not—

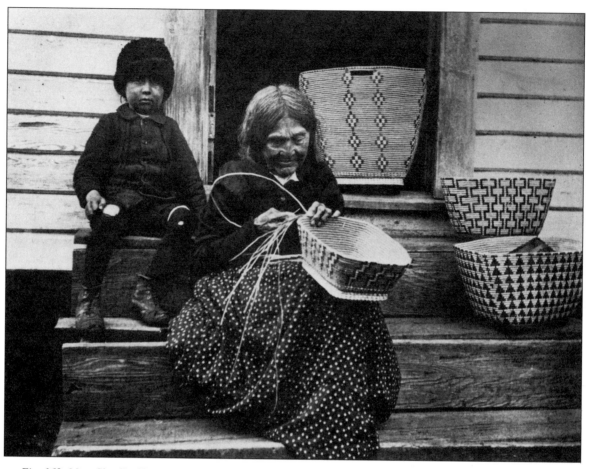

Fig. 162. Mrs. Charlie Chapman making large coiled burden basket of split red cedar root imbricated with stepped design of dyed black and undyed red strips of bitter cherry bark. Photo C.F. Newcombe, 1903, at Crow's Nest, just upriver from Spuzzum. Courtesy Royal British Columbia Museum PN6706.

for the 'Nlaka'pamux and their Lillooet, Shuswap and Okanagan neighbours—confined only to rock writing.

Some of Teit's ethnographic information on basket-making and basket design, particularly material relating to the Lillooet/Thompson region, were subsequently written up for the Jesup Expedition by Farrand (1900). Farrand writes that basket-makers necessarily reduce iconic images to conventionalized geometric patterns, an adaptation of imagery to the demands of basket construction. Many of these stylized, geometric images on baskets are also found in the rock paintings: arrowheads, stars, zigzags, boxes, eagles, snakes, bird tracks, bear tracks, flying birds, beaver, deer, man, stone hammer, root-digger, canoe trail, stream, lake, mountain and lightning (Farrand 1900:392-93).

Teit himself, in his discussion of tattooing and face and body-painting among the 'Nlaka'pamux (1930b), describes and illustrates body decoration his informants remembered from the middle of the nineteenth century. Tattooing was a form of body ornamentation used to make oneself more attractive to the opposite sex; it was a sign of fidelity to one's spouse; it was carried out at puberty, connected

to vision quests and dreaming. Tattoos also served as records of ordeals of courage, as protection against bad luck, and for identification of property in the form of slaves (op.cit.:407). The iconography of the tattoos was very similar to that found on the rocks in the Stein Valley.

The examples of body tattoos which Teit presents (1930b:411-15) are entoptic-like forms which his informants interpreted as earth lines, snakes, rattlers, worms, mountains, stars, sweathouses, the sun, moon, rainbows, bear paws, the four directions, crossed trails, digging sticks, lahal (gambling) bones, sweathouse stones (portrayed as entoptic-like grids of four or eight units), fir branches, paddles, men, baskets and bows and arrows.

Elsewhere Teit (1900:228) reports that facial paintings and tattoos consisted of grids, dots and rounded zigzags, that "Men painted their faces according to their dreams." His examples of body painting designs (Teit 1930b:421-23) included figures associated normally with either men or women: clouds, grizzly dens, loons, lakes, a gulch, sunlight, the sky, antlers, eagles, a cliff, the moon, stars, the morning star. Teit noted that several of these designs were related to the nineteenth-century pan-Native ghost dance movement; images that had to do with the sun, clouds, stars, rain, and shadows on the mountains. He also recorded body paintings of guardian spirits and dream figures (1930b:427-28).

Many of the same iconic images seen on the rock surfaces of the Stein have been displayed not only on basketry, in tattoos and body-painting, but also as written messages on clothing, utensils, tools and weapons. War parties painted their faces according to what they saw or were instructed in their dreams (Teit 1930b:268), clubs and armor were painted with animal and geometric designs originating in dreams (ibid.:265), and the object on which the weapon was used frequently appeared, pictorially, on the instrument itself:

Fig. 163. 'Nlaka'pamux man in warrior's dress. Note the shield with "writings." Photographed at Nsqa'qualten, near Spences Bridge by James Teit, 1903. Courtesy Royal British Columbia Museum PN324a

Some warriors named their arrows after fierce animals or birds, whose pictures they painted on the shafts. Figure 245 [Fig. 164 here] represents a short spear with stone point. It is painted red and white with the design of a skeleton. The white spots on the blade represent the orbits; the middle line, the nose of the skull; the red and white rings and the shaft, the ribs.(Teit 1900:263).

Steatite pipes were incised with images from important dreams, especially their "first important dream in which they received their manitou" (Smith 1899:157, Fig. 112). Gambling sticks were decorated with the owner's dream animals or birds (Teit 1900:272). Burial boxes were inscribed and painted with designs in red (ibid.:335). Shamans' staffs were painted with lightning signs, snakes and other guardian spirit insignia (ibid.:360). In the course of her puberty training, a girl painted designs on smooth stones and drank from a drinking tube—which doubled as a flute—with carved designs. After four days she donned a hide apron with red painted designs that signalled her training experiences. Similar writings were part of the boys' puberty training as well:

> Boys painted their faces afresh each day, according to their dreams, and did not let any person see the painted design until after they had obtained their protectors....(Teit 1900:318)

Part of a boy's training was to work away at night during the training seclusion in the mountains, carving holes in rocks in order to develop strong, dextrous hands (ibid.).

Teit also outlines the 'Nlaka'pamux knowledge of eighty-seven different hand signals which were part of the region's sign language (ibid.:283-87). He also describes the way people read trail signs left along the hunting paths:

> Signals were generally left at camp-fires or on trails, as notices to parties who were to pass that way. For instance, four small wands were stuck in the ground to denote that four persons had left that camp. These were placed slanting in the direction in which the people had gone. If one stick was placed behind the other, and all slanted in the same way, it meant that they had all gone in the same direction. A longer stick, placed at the side of the others, pointed to where the sun was when the party left. Fresh leaves were placed near the sticks to enable the next party to tell about how many days previously they had left. If bones or hairs of any animals were placed near or tied to the stick, it indicated how many of these animals had been killed or captured, according to the number of hairs or bones. (ibid.:287-88)

Fig. 164. Stone-point spear with skeletal image on point and shaft. Drawn after Teit (1900:263, Fig. 245).

Annie York explained that rock writing was also used to convey concepts of ownership, and threats of psychic retaliation against trespassers. She explained that rock writing images were sometimes used to denote a form of territorial proprietorship, and simultaneously to protect that territory psychically against intruders:

Q: I don't know if this applies here, but up north a powerful person was said to put his guardian spirit at the edge of their people's territory as a form of—

A: That's to protect them.

Q: And they could feel that, when a stranger passed their painting?

A: Yeah, sometimes if they want, they can never pass it.

You can't pass it.

Q: Why? Is it too strong?

A: Too strong. One person that looks after an area. Too powerful for anybody.

Q: So it would make them sick, would it?

A: Yeah, ha! A person that wants to do dirty things. That person watches out for it. (4 Apr. 1991)

Annie then recalled that there had been one such protection figure on the rock between 'Nlaka'pamux and Sto:lo hunting territories up Five Mile Creek, between Spuzzum and Yale.

As we have seen in the course of Annie York's reading of the rock writings, trail signs are a component of many drawings. As for the hand sign system, at least one researcher has argued that the basic communication forms in rock art are derived from a form of international gesture language (Martineau 1973).

Franz Boas, in his concluding chapters to Teit's monograph (Teit 1900:376-90), notes a basic difference between the Interior Salish design forms and those of the adjacent northwest coast cultures. The coastal cultures, he argues, adapt symbolic animal figures to the form and function of the implement which they adorn—such as seal-shaped bowls, frog-shaped bags, crane-shaped spoons—while the Interior Salish appear to have placed symbolic figures on the surfaces of their goods without regard for the form and function of the item. As we have seen in Fig. 164, this is not strictly true, at least with regard to the relationship between painted image and implement function. However, Boas' point is that the fundamental theme or idea of the Interior Salish images is symbolic, stating: "For this reason by far the greater number of designs may be described as pictographs rather than as decorations" (Teit 1900:377).

Boas raises a further question—that of multiple meanings associated with a single image. He suggests that where pictures are executed on human-made objects, the function of the object is to assist the explication of the images. Where this is less clear, he argues, often a close contextual reading of the juxtapositioning of one image with another will distinguish the appropriate meaning:

It will be seen that some of the conventional signs are ambiguous. When found on implements, the use of the latter often determines the meaning of the designs, because they are always symbolic of the use of the implement; while in ceremonial implements they represent the dreams of the owner. In other cases the accompanying figures define the significance of the ambiguous design. On the pipestem shown in Fig.306 [Fig. 165 here] we see on the left-hand side of the

247

Fig. 165. Shaman's pipe (from Teit 1900:382, Fig. 306). Boas identifies the figures as follows: "The shaman's pipe shows inlaid in the stone stem the loon necklace design which signified the necklace with pendant loon's head that was sometimes worn by shamans. On the stem are shown the following: on top, at the left, a lake, and a river flowing into it; a beaver, an otter; two earth lines; a wolf; tracks of the grisly bear; two mysterious lakes of several colors, connected by a river; a mountain with fog on top. On the side is a snake; underneath, at the left, a rattlesnake; then a buck deer, earth lines, and a loon necklace."

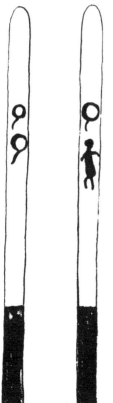

upper side of the stem a circle with a long line. It signifies a lake and a river flowing into it. This meaning is determined by the beaver and otter running toward the river from the right-hand side next to it. On the tongs (Fig.160 [Fig. 166 here]) we see almost the same design, but there it represents a basket and ladle. (Teit 1900:377)

As prime examples of what he calls "ceremonial images," Boas describes a fully trained hunter's cape or blanket, and a painted buckskin dance apron belonging to a youth who had painted it with his dream. The images are entirely meaningful to present-day readers familiar with 'Nlaka'pamux hunting and dreaming procedures, many of which have been outlined in this book by Annie York. They help confirm the cultural contiguity between the rock writing of the Stein, and the artifactual evidence of nineteenth-century Interior Salish cultures.

Boas, using his own knowledge of the region and Teit's ethnographic field-notes, gives a rather full interpretation of the youth's dance apron:

Men decorated their clothing according to instructions received from their guardian spirits and painted their dreams on their blankets...Boys, during the puberty ceremonials, painted their aprons and blankets in the same manner. In Fig. 302 [here Fig. 167] a painted apron of this kind is

Fig. 166. Pair of wooden tongs for lifting hot rocks and fire embers. From Teit (1900:205, Fig. 160).

shown. The central top figure is the lad himself in the attitude of a dancer, with a feather head-dress and his apron. The bow and arrow painted at his side are symbolic of his future professions of hunting and war. Two moons and six stars painted around him suggest his nightly travels. He must become familiar with the deer and salmon, the pursuit of which will occupy much of his time in future years, and furnish him with most of his food; therefore the figures of a buck or elk, and of a salmon are painted beneath him. Under them is painted a lizard, of which he has dreamed, or which he has already obtained, or is anxious to obtain, for his guardian spirit. On the left of the apron is a picture of the Dawn of the Day, to which he prays, and which he awaits daily in his solitude. The light-colored, cloudy portion is the daylight rising from the dark line, which means the horizon. Underneath are pictured four mountains resting on an earth line, with a lake between two of them. These are the mountains over which he travels. At the bottom are the principal mountains where he resides while trying to obtain a guardian spirit. The short spikes around the edges represent trees; and the long lines inside, gulches[...]

To this class of designs belong most of the rock paintings found so frequently in the country inhabited by the Thompson Indians. Almost all of these were made by boys and girls during their puberty ceremonials. (ibid.:379-81)

Fig. 167. Young man's painted apron. Drawn after Teit (1900:380, Fig. 302), described above by Boas.

In terms of anthropological tradition, this ethnographic explanation by Franz Boas is a satisfying and elegant "reading" of the iconography of puberty training and the masculine pursuits of hunting and war. However, it is also a picture that reveals a detached, outsider view, devoid of the riches of everyday experience that we would expect of nineteenth-century 'Nlaka'pamux or even of contemporary dreamers. Boas' explanation remains an abstracted account of the generalized, ideal-type behavior of members of the culture under investigation—albeit by a highly perceptive and sympathetic outsider.

I would suggest that the knowledge we have gained from Annie York's reading of the other aspects of this dance apron's message can further enrich our reading of the images, even though we, as the readers, may be outsiders too—and what is more, outsiders looking back to a way of life lived more than a century ago. The dance apron was worn by the young man only after he had undergone a long, hungry, solitary, and often cold basic training which, now complete, allowed him to return to social life. He could return to social life. He would now be called upon to use his newly-acquired labour skills to stalk, kill and give thanks for the deer revealed in his dreams. He would pray and give thanks that this animal provided its life force and its very skin in order that he might feed and clothe himself after his period of fasting. After eating, he would have tanned the hide, made his apron, and written the message of his quest on it, hinting at the nature of his power. The dance apron shows the public that this young man has fully dreamed his own way of capturing game and focussing his talents and skills for life. Thereafter, by means of meditational procedures, he would be able to locate and concentrate his power, strength and well-being whenever needed.

This apron stands for his graduation, his victory, and his manhood. What is the form of the apron? What is its function? This garment is a skin, an exterior. It reveals the life map of the wearer to the public. It is an envelope covering the masculine power of the man who wears it. The apron is tied around the hips before the wearer dances his new-found power and strength for his community. The dominant image at top centre—his self-portrait in its potent, male, shamanic posture—is worn directly over the genitals. As the young man dances, the painted mountains and canyons, which symbolize where he travels, will slap against his strong, flesh-and-blood legs that will carry him over those mountains for the rest of his life.

The above reading of the images, too, is limited to the general, abstract, other-sided understanding of the iconography and its context but, fortunately, we have shared an insider's reading of the hunter's dream. With Annie, we journeyed back to her own youth; her training under the instructions of her elders; her anecdotal experiences in the mountains; her memory of the oral narratives of creation, and of the establishment of human knowledge, wisdom and technology; her memories of youth and childhood, when she learned the stories behind the generalized images.

As a result of the privileged experience shared with Annie in this book we can take another look at this dance apron and "read deeper," to reach across the hiatus of otherness. We can appreciate the similarity of the youth's feather headdress to the rays emanating from the Sun Man when he came down to the little boy inside all neophyte hunters who must learn from the strong and the powerful who have preceded them. The Sun Man: the numinous father who taught him the art of the bow and arrow; who revealed to him the power of the Dawn of the Day and the Sunset; who showed him the replication of human history in the stars; who led him to the ways of the game animals of the forest and the fish beneath the waters; who chided his desire to maximize his returns and obtain things the easy way; who may even have taught him the strong but dangerous powers of the yellow lizard who, the moment you lower your vigilance, slips in through the anus and eats your guts. Beyond all of this,

beyond the ephemera of skin clothing, there remain the rock writings, the repositories of the ancient narratives, the first teachings written on the rocks by the creator forces.

For Annie, rock writings had a definite connection to the Creator and the spirit power of all things:

> Moses Nahlii told me about these people that paint. There's all of these—but he said that it was God's servant that did most of the first painting. And the people that learns to be medicine man, they do it too. (4 Apr. 1991)

However, we still long for new insights. After all, Annie York did not visit the Stein Valley in her lifetime. She learned of the images and their stories from old men who had dreamed there. Being a woman, she did not have precise knowledge of the special procedures, symbols and anecdotes associated with the training of a hunter, but extrapolated from the conditioning undergone by women in their training to become healers, herbalists, weavers and soothsayers. She sought reconciliation between the old teachings, stories from the Bible, various trappings of European colonialism, and the new industrial technology in order to make sense of the path back into the past, and forward into the future of human evolution.

Not all of Annie's readings of the Stein images are the same as those of other informants, even though her interpretations are much more extensive than earlier accounts. For example, Teit's informants told him that at the Asking Rock (Fig.58), what Annie read as earth lines were hunting trails, and her hammer for getting marrow out of bones was a symbol of two lakes joined by a river. The context of the accompanying images enable a case to be made for both interpretations. Similarly with the extension of these drawings: to the left of these images, in Fig.55, Annie correlated the hunting of deer with the need for barbecue sticks with which to cook the meat, and the need to teach the hunter the importance of the tree. Jimmie, the 'Nlaka'pamux man hired by archaeologist Harlan Smith, suggested this was the complex game trail which the deer in the picture had followed. At our present level of understanding there can be no definitive reading of these writings, although when we have available a healthy body of ethnographic information, as is the case here, alternate explanations make sense in relation to the nineteenth-century Interior Salish way of life.

The reading of Fig.74—one lone figure—gave Annie trouble. No doubt she was somewhat disoriented, because in that location there was only one image on the rock, with few clues to contextualize it, other than the sun rays around the head. I had presented Annie with one figure on a piece of paper—a piece of paper she had to make culturally meaningful while sitting in her Spuzzum living room, far from the evocative environment of the Stein Valley. Annie gave two different readings of this figure, and preferred the second one for its humour, and also because she had experienced a little epiphany of her own with the beaver and the frog on the point of land between the Fraser River and the mouth of Spuzzum Creek, at the old burial site of her Spuzzum ancestors.

Certain components of the writing—the instrumental trail talk and sign language, the recording of historical events and natural catastrophes, whether made on rock, human skin, buckskin, bone or basketry—are readily understood by the members of the culture, while other images—those that come from the revelations and visions of each individual dreamer—can be read only in a general way even by other members of the culture. Individual experiences make for imperfect understanding; the incomplete message attracts us to the tantalizing mystery encoded in each individual message. In Jung's terms, the numinous mystery of the archetypes remains fresh and challenging to our conscious minds, eternally familiar and eternally mysterious.

D. The Roots of Literacy

The media research of Marshall McLuhan at the University of Toronto, together with his colleagues and successors, has concluded that the most important watershed in human history was the invention of alphabetic writing. According to these scholars, writing initiated analytic thought, great strides in scientific, analytic investigation, abstract conceptualization and speculative philosophy (see, for example, McLuhan 1962; Innis 1951; Havelock 1986; de Kerckhove 1986). The problem with this perspective lies in its binary assumptions about the world before and after the development of writing; for instance, oral cultures were characterized as having concrete, action-oriented thought, well-developed memory, and no abstract or deductive thinking: no objective distance from the other which would allow reflection; and literate cultures were characterized as abstract, complex, historical and scientific by virtue of a change of communicative technology. This position is further enhanced by comparative studies of the oral and written registers used by literate English speakers (Drieman 1962; Portnoy 1972) which confirm that written English, compared to spoken English, uses more abstract terms, exhibits a greater choice of words, less personalized and hence contexualized usage, greater explicitness, greater syntactical elaboration, greater formality and greater reliance on a dead language.

Undoubtedly, the creation of alphabet writing, together with the creation of monumental art and the formation of hierarchical, urban, civil society, was part of a qualitative change in the nature of human thinking and recording thought, but this momentous transformation did not occur out of a vacuum. It was built from pre-existing components within human society and the human psyche. One of the components was the pictorial recording of experience on the material surroundings. Native North American pictorial records were a form of writing which, while not linked phonetically to language, was connected to language by the constant need for verbal explanation. Recording cultural narratives and personal experiences in pictures, often with entoptic elements probably derived from psychic experiences. The recording of these experiences presupposed a readership and necessitated oral explanation. Functionally these picture writings oriented human society toward the development of full writing. In North American "rock art" the pictorial images were often further supplemented by more abstract signs derived from body ornament, gesture "sign language," "trail signs," such numerical records as units of time, and items of produce.

These components in turn helped to elaborate abstract conceptual thought about time and space—to record it for the future and to comment upon the depth of human history, whether it be a record of events a few lunar cycles back, or speculations about an earlier era of Ice Age hunting, or references to an even earlier "Mythological Age" when animals and humans were one.

Comparative ethnography shows that there are many examples of oral cultures that use different registers of voice and language to signal different levels of formality, informality, abstraction and everyday concreteness. These attributes of human thought and language did not have to wait for the development of full writing. They have been components of human conceptualization for a long period of time. They were also spread over a wide area of the aboriginal, non-state world, at least as far back as the ethnographic record of the past few centuries is concerned. For instance, the Ilongot of the Philippines use an elevated register called *purung*, with a special vocabulary, intonation, grammatical pattern and set of highly complex metaphors when engaged in negotiatory dialogue (Rosaldo, M. 1980; Rosaldo, R. 1980). Annie York spoke repeatedly about a similar register, or "chiefs' language" among the southern, Utamqt 'Nlaka'pamux as discussed earlier; as well, elders Rena Bolton and Ellen White (p.c.) have confirmed a similar phenomenon among the Halkomelem-speaking Coast Salish

peoples of the Gulf of Georgia area, pointing put that there were rules as to which register of speaking was appropriate for different types of political and ceremonial gatherings. My data concerning the Gitksan of the Skeena River suggests that here too the difference of register to express ways of thinking and speaking about thinking, was an integral part of the potlatch feasting complex until quite recently (see also Rigsby n.d.).

Another "protoliteracy" feature of oral cultures is the ancient nature of numerical accounting, particularly in relation to calendrical records and enumerations of produce and wealth. These are significant components of early writing systems. All the early states developed numbers and accounting notations regarding taxes and tithes. The writing tablets of the Maya and other indigenous Central American states also focussed upon calendrical events, as did the Dakota "winter counts" painted on bison hides to chronicle a family's seasonal events (Mallory 1893), and as do the practitioners of the Ojibway *mide* cult on birchbark scrolls to mark their progress through the successive levels of initiation and proficiency in their long psychic journey to spiritual strength (Dewdney 1975:13). we have already seen Annie York's description of her great-aunt's knotted ball of calendar string which recorded family history up to the time of her death, and her frequent explanation of markings for the passage of time in the dream writings of the Stein Valley.

Working in France in recent decades, Alexander Marshack has helped to document this phenomenon back into the last Ice Age in Europe (Marshack 1972). Examining artifacts with microscopes and microscopic photography, he has assembled data on very early notations and image-recordings which indicate calendrical concerns from the Ice Age and on into the Mesolithic and Neolithic millennia which followed the recession of the ice.

Marshack has studied both pictorial and non-pictorial images inscribed millennia ago on stone, bone and amber items. He concluded that rudimentary writing, notably in the forms of notational lines and representational images, has been part of human history for probably more than 25,000 years. Marshack found that these pictorial and non-pictorial "writings" sometimes occur independently of one another, and sometimes together, whether this be on artifacts, or on walls of famous Paleolithic

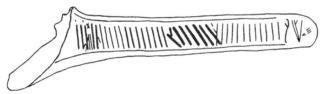

Fig. 168. Baton from Le Placard, France, Middle Magdalenian Period. Marked with lined notations that Marshack correlates with lunar sequences. From Marshack (1971:93, Figs. 21-25)

Fig. 169. Marshack's notational analysis of markings on Fig. 168, comparing the lines on the artifact bottom with lunar sequences he made for analytic purposes.

253

caves such as those of France and Spain. Marshack calls the non-pictorial markings "notations." More than 21,000 years ago, both notational and pictorial records were left in the archaeological assemblages of Upper Paleolithic Europe.

Fig. 168 is a drawing of a bone baton whose markings Marshack studied by microscopic photography. The microscope enabled him to determine the order in which the markings were made in the bone material. Fig. 169 is Marshack's diagrammatic matching of these notations of Fig. 168 with a sequence of two lunar cycles; his moon sequences have notations which match observable phases of the moon. If this is the case, the baton would seem to be a type of calendar of "two moons beginning at last crescent and ending on the first day of invisibility fifty-eight days later."

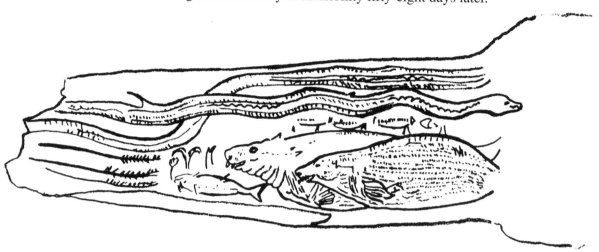

Fig. 170. Engraved Magdalenian reindeer antler from late Ice Age France. The baton is slender, and has one hole drilled at the end. The image here has been rolled out to reveal seasonal images of spring plants, fish and mammals (Marshack 1974:169-73, Figs. 60-64).

He made similar lunar sequence comparisons with notational lines on many, many objects dating to the Paleolithic Era; he believes notations of time-sequencing date back to the early history of *Homo sapiens*.

Marshack found another common form of ancient "writing" in pictorial images engraved on other human objects dating from the Ice Age.

Fig. 170 is a baton from the Late Magdalenian Period at the end of the Ice Age in France. It is intricately engraved with images that under the microscope were revealed to be precisely rendered realistic images. The baton was found at Montgaudier, a short walk from the baton of Le Placard (Fig. 168), and consists of the long slender shaft of a reindeer antler in which a hole has been drilled at one end, with "writings" around its circumference. The illustration here (Fig. 169) has "unrolled" the baton and its images to show the whole composition. Microscopic examination indicates that the figures were probably carved in the following order: 1: a female seal (lower right); 2: a bull seal behind the female; 3: three finely etched plants (left end) to the right of which is 4: a male salmon with a "kype" hook to the lower jaw, which develops before the fish go upriver to spawn; 5: an ibex head, a budding flower and a sprouting seed with leaves and root (these small figures are above the salmon); and 6: two long snakes.

254

Marshack, (after archaeologist J.D.G. Clark) notes that the first spawning run of the Atlantic salmon occurs in late March, early April, when they are pursued into the rivers by feeding seals. This occurs at the highest, full-moon tides. Snakes come out of hibernation at this time, ibexes give birth, seeds sprout and flowers bud:

> They were time-factored and storied images of creatures whose comings and goings and seasonal habits were known, and they *represented* the birth of the 'new year', if not calendrically and arithmetically, at least observationally and probably in story. (Marshack 1972:173)

A final item from Marshack's many examples is a bone baton from La Marche, north of Les Eyzies on the drainage of the Vienne and Loire Rivers in central eastern France, a baton of the Middle Magdalenian Period (Fig. 171).

This object, with complex notational markings and the image of a pregnant mare, contains both types of time-sequenced coding introduced in the last two examples (Figs. 168, 170). Marshack believes the notational marks on both sides of the baton add up to at least ten and one-half moon sequences—roughly, the gestation period of a horse. The precise significance of this item remains unknown, but one of its conceptual functions—recording the passage of time and, possibly, the return of the growing season (horses foal in the springtime)—is strongly suggested. This example incorporates both the pictorial and notational codes for marking human time in the natural world.

Marshack then examined the famous Upper Paleolithic animal images and the less well-known notational markings on the walls of caves in Spain and France. Here too he found evidence of the two coded systems recording seasonality and the passage of time.

The end of the Ice Age was marked by a period of human history which archaeologists have designated the Mesolithic Period. Art historians compare the imagery of this period with the beauty of line of the classic "Paleolithic Art" of the caves, and find it wanting. They refer to it as a "decadent" form of art.

It is not our task here to pronounce on the "art" of the rock writings, but rather on their significance for the history of human consciousness. Examples of this new "decadent" form of rock writing are found in Fig. 172. The images are less realistic, with fewer naturalistic details than found in the earlier Paleolithic Period. They are more schematic; in fact, their style is not unlike that found in the rock writings of the Stein River Valley.

Early domestication of plants and animals entered the archaeological record

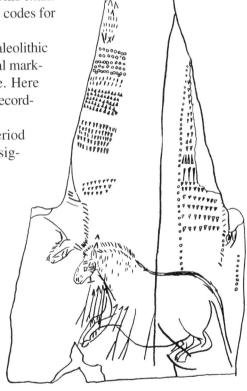

Fig. 171. Engraved bone baton from La Marche, France, Middle Magdalenian Period. Figures include both complex notations and the pictorial image of a pregnant mare (Marshack 1974:192-95, Fig. 88).

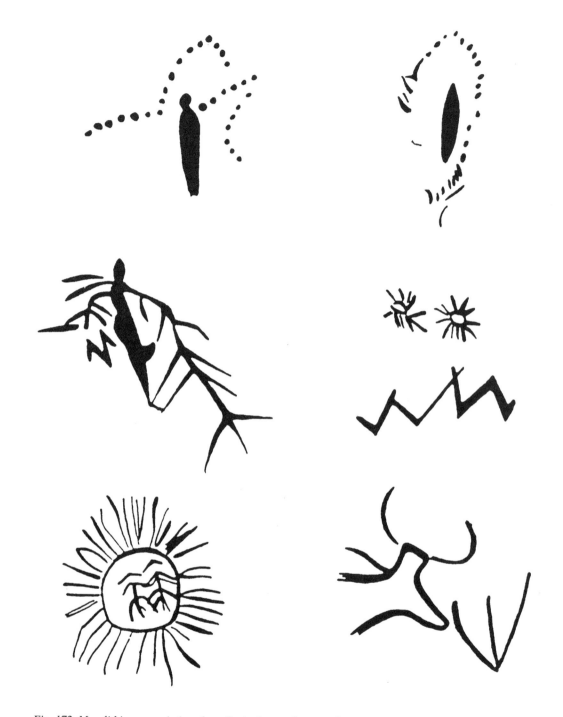

Fig. 172. Mesolithic cave paintings from Spain. Images here are less realistic and more diagrammatic than those found in the Upper Paleolithic Era. Note the similarities to the iconography of the Stein River Valley, and to the entoptic shapes described earlier. From Marshack (1974:342-43, Figs. 203a-g).

approximately 8,000 years ago, and Marshack points out that by that period the northern hemisphere was marked by a changed social and economic identity. In Europe, the bison, ibex, wild horse and rhinoceros had disappeared, and with them, the old hunting practices among the tundra-dwelling herds. The ice melted, the land rebounded, the climate warmed. Many of the old animals of sustenance and legend remained only on rock walls of caves and sheltered cliffs. Marshack argues that these images tell us the minds of people living through the Mesolithic and Neolithic Periods not only counted the passage of time, but also were aware of history, the half-forgotten stories of the game animals hunted by their ancestors on the tundra lands of post-glacial Europe. He concludes, from the evidence of the early Neolithic form of notational and picture writing, that these ancient writers had developed an historical consciousness:

> What we may have, more accurately, is a tradition in which the artist is no longer referring for his models, stories and ceremonies to real animals and plants, as did the old hunter and gatherer, but is working rather with traditional, mythological, geometricized, and abstracted images and concepts, a tradition in which the basic stories and ways of thinking were retained but in which reality and relations had changed...This was a new period, archaic and revolutionary....(Marshack 1972:343)

Again, we have distinct examples of entoptic-type images—part realistic (in the archetypal, symbolic sense) and part geometric. If Lewis-Williams and Dowson (op.cit.) are correct, this is a diagnostic clue to altered states of consciousness. Could it be that the electric world of shifting luminous images was lived in everyday life until after the Ice Age? That during those long millennia of ice and tundra, human beings were entirely rooted in the present, recording time and place by referring to the immediate, everyday world around them? And then, at some point, is it possible that our ancient ancestors lost this conscious presence in life, and began to seek a new concept of time—a sense of human history and a dim memory of the Paleolithic past which came to the surface of consciousness, only briefly, and only in our dreams? In other words, the Mesolithic Period gave rise to more formal, abstract and metaphoric thought with respect to history and time consciousness.

These examples from different cultures and different eras show that the propensity to "write down" experience and concepts on the materials at hand, is at once widespread and very, very ancient. These examples indicate that non-alphabetic writing has accompanied virtually every step in the development of the human cognitive processes. During the Ice Age humans wrote about their finely observed, immediate environment. Perhaps this attachment to the immediate world gradually became tempered by a sense of the great span of history.

Marshack's reading of inscriptions found on mobile antler, bone and stone objects, and on the walls of caves across Europe, indicates an evolving form of recording human experience, a "writing down" of signs and symbols for objects and ideas important to human beings that goes back more than 30,000 years. Marshack postulated definite developmental stages of human cognition—moving from the Ice Age cultures to the settled Neolithic world, through the transitional Mesolithic stage.

Virtually the same conclusion was reached several decades earlier by Herbert Kuhn, whose work was translated from the original German to English only in 1956. Kuhn found that the representational picture writing of the Upper Paleolithic Era gradually gave rise to symbolic picture writing. Kuhn characterized this change, that lasted through the Mesolithic Era and into the Neolithic, as a move from naturalistic to stylized image-making:

The rock pictures show us Man's dialogue with his circumstances, with reality and with dreams...Goethe once spoke of subjective epochs and of objective ones, and he meant, no doubt, by that statement that there are periods dominated by dreams, by what is thought, imagined and contrived by Man, times of new ideas, of creation. And there are other times when men live in reality and have no feeling for the Beyond, for imagination, for dreams. (Kuhn 1956:217)

Kuhn's point was that rock writing is a diagnostic indicator of the society's understanding of the world, its religion, and its emphasis, in any epoch, on either the interior or the exterior dimensions of human experience:

There are times when religion is derived from reality and these are the times represented by the most ancient Ice Age naturalistic paintings and engravings. There are times when religion is centred in the symbol. These are times such as are reflected in the stylized art of about 2000 B.C. (1956:224)

During the Ice Age, picture writing in Europe was almost devoid of human figures. The images were of animals important for food and sustenance, or animals and plants that signalled seasons and time-sequences. Later, humans became more self-conscious; they placed themselves within their writings about the world around them. Human figures appear along with more stylized images. By this point in history, human thought was able to build sweeping abstractions from the material world in which hitherto people lived without a great degree of self-awareness. Kuhn sums up these changes by referring to Goethe:

Goethe also expressed this when he wrote, "symbolism transforms Appearance into Idea...so that Idea is eternally effective while remaining unobtainable." (ibid.:223)

This long evolution of the idea, of conceptual goals, eventually led to the development of full, written language. It began where socio-economic conditions produced societies capable of sustaining stable, hierarchic societies with an organized intellectual priesthood that could bind definite, fixed meanings to the signs, and pass these systems carefully from one generation to the next. These written signs began to form into alphabetic writings about 5,000 years ago in the Middle East, and into ideogrammatic character language in China about 3,500 years ago. These social developments roughly parallel the Neolithic domestication of plants.

Archaeologists consider that 5,000 years ago, in the region which is now British Columbia, a northern fishing and hunting culture was combining with a southern interior hunting and gathering tradition to form an economy heavily reliant on the salmon runs which, at that time, were becoming stable after undergoing dramatic post-glacial fluctuations. These conditions are thought to have given rise, by approximately 2,500 years ago, to the antecedents of the general cultural complexity which existed in the region when the Europeans arrived (Borden 1975:98-116; Fladmark 1986:Chap.9; Mitchell 1990:352). Stl'atl'imx (Lillooet), Lil'wat (Mt. Currie) and 'Nlaka'pamux prehistory appears to be consistent with these developments (Hayden 1992).

This combination of two technological traditions, a newly stable resource base, and a gradually more effective tool kit, allowed for the development of a degree of cultural elaboration and wealth differentiation unusual in non-agricultural, hunting and fishing societies. However, conditions did not give rise to theocratic states and empires as they did in Meso-America, the Middle East and elsewhere. Nonetheless, material conditions appear to have favoured an intellectual tradition, consistent with that outlined above in relation to post-glacial Europe. This tradition would be maintained by the politi-

cally and spiritually successful, and manifested in the symbolism of the plastic arts, including paint-ing and carving on rock. This esoteric knowledge would have been guarded, stored and transmitted down through the generations by various means including, perhaps, the restricted literacy of a privileged language such as the one alluded to by Annie York. Knowledge and use of such a language or languages would have been limited to those who managed social life, and controlled the flow of personnel throughout the region.

At a later point in history certain peoples, now organized into civil or state societies, began to change their image-making style back toward the material, realistic world that distinguishes the cave images dating to the Ice Age, the period when natural images and notational inscriptions probably began. Other societies, including today's "indigenous peoples," such as the 'Nlaka'pamux, continued writ-ing their dreams on the rocks, using the stylized symbols of the post-Ice Age era, until the advent of European colonialism began to put a stop to these "unChristian" practices.

Kuhn concluded his book with this statement: "[A]ll rock art is founded on religion, that is to say, is rooted in Man's attitude to the Eternal" (1956:223). He refers to rock pictures of the past 5,000 years as numinous—the same term used by Carl Jung to describe the intuitive, instinctual presence of archetypal images in the subconscious human mind—images which stretch back to the beginning of human consciousness.

•

Throughout the history of the human species there is written evidence of the time-sequencing of the seasons, and a keen observation of the natural world upon which human life depended. By the end of the Paleolithic Period there was an awareness of a past, of a history which could be expressed in sto-ries and symbols, of a need to seek out the meaning of life. Then, during the Neolithic Period, while some societies settled into agriculture and industry, others continued to hunt and fish and gather; as they walked the land, these hunters continued to think about this history, about the past and the future. The complex and abstract messages which they left on the rock may yet yield up their codes to crypt-analysis—but never completely.

Rock art research becomes compulsive for most of its participants. How are we to break the code, and read definitively the writings on rocks and in caves? We, and those who come after us, can never crack the code fully. Ancient rock writings have to do with the zone of the human interior: there are infinite meanings and experiences encoded within them. On one level, the code may be cracked by on going research, but knowledge of the cultures that gave life to the imagery used by individual writ-ers is essential to knowing the message. At all times, many codes are at work, at least in the tran-scendental, dream-related examples of rock writing. Part of the function of the images left by a med-itating shaman, healer or hunter is to tease and stimulate the reader to puzzle out the meaning of the message. They challenge readers to tap into their own experience, using not only a knowledge of his-tory, but also their powers of reason, deduction, intuition, dream experience and individual creativity—all important tools for decoding the enigmatic messages among the rocks.

With the rock writings of the Stein River Valley of British Columbia we had the privilege of shar-ing the 'Nlaka'pamux cultural treasury which Annie York revealed to us. For a period of over three years I sat at her feet or looked shamelessly over her shoulder as with great élan she read to me the rock writings of the Stein. I hope that soon others will go down to the local creek, scrub their bodies with fir boughs, drink their cascara, and ask guidance from The Dawn of the Day before climbing

back up along the mountain rivers, and into the high country where they can feel the presence of the Old People, and offer gratitude to the spirit of Annie York, Zex'tko—"Now-You-See-It-Now-You-Don't."

I hope they linger to dream, and to write their dream, as their predecessors have done, on the rocks—forever.

Notes

Preface (pages ix-xiii)

[1]See *Stein: The Way of the River* by Michael M'Gonigle and Wendy Wickwire (Vancouver: Talonbooks, 1988) for a handsome cultural, historical and ecological introduction view of the Stein Valley.

[2]Some of the problems of relating written and oral cultures have been discussed by J. Cruikshank (1992) "Oral Tradition and Material Culture: Multiplying Meanings of 'Words' and "Things' *Anthropology Today* 18(3):5-9.

[3]Mircea Eliade explains shamanism as a religious phenomenon found on both sides of the Pacific Ocean, Oceania and over much of North America and Siberia. The shaman learns to leave his body at will to embark on quests for psychic power. Dreams are an important part of shamanic work and training:

> In the dreams and hallucinations of the future shaman may be found the classical pattern of the initiation: he is tortured by demons, his body is cut in pieces, he descends to the nether world or ascends to heaven and is finally resuscitated. That is to say, he acquires a new mode of being, which allows him to have relations with the supernatural worlds. The shaman is now enabled to "see" the spirits, and he himself behaves like a spirit; he is able to leave his body and to travel in ecstasy in all cosmic regions. However, the ecstatic experience alone is not sufficient to make a shaman. The neophyte must be instructed by masters in the religious traditions of the tribe, and he is taught to recognize the various diseases and to cure them.[...]
>
> The most important function of the shaman is healing. Since sickness is thought of as a loss of the soul, the shaman has to find out first whether the soul of the sick man has strayed far from the village or has been stolen by demons and is imprisoned in the other world. (Eliade 1967:424)

[4]The word for the 'Nlaka'pamux shaman, or syux'nam, was explained by J.B. Goode, Anglican minister in Lytton, as "shookanahm," from shooktena, "I know or perceive a thing" and nahm, "to sing by incantation" (Goode 1861-1890). This specialty has to do with making psychic journeys to find lost souls, whose absence is considered to have lowered the patients' resistance to disease. In the course of the syux'nam's

work he or she kept up a song given by his or her guardian spirit. See Teit (1900:360-65) for detailed look at the 'Nlaka'pamux shaman.

[5]Upriver aboriginal peoples in British Columbia have tended to engage in trade and social relations with both the hunting peoples of the Northern Boreal Forest and the Interior Plateau terrains to their east, and the more sedentary fishing peoples of the coast. No doubt the tempo of these exchanges fluctuated through history.

For the most part, routes of trade and commerce followed the rivers. Thus, nodules of trade-augmented social elaboration and social stratification appear to have developed long before European contact, at least among such peoples as the Inland Tlingit (Oberg 1973), the Tahltan (Emmons 1911; Adlam 1985), the Western Carrier and their more northerly Athapaskan neighbours (Jenness 1943; Dyen and Aberle 1974; Ray, A.J. 1986; Daly 1988), the Stl'atl'imx and the Lytton and Utamqt 'Nlaka'pamux (Teit 1900:289; Maud 1978:43; Hayden, et al.:1985; Hayden 1992) and Upper Skagit (Collins 1974). See also MacDonald 1979, and Fladmark 1986.

While there is evidence for less emphasis on family ownership, social ranking and hierarchy among some Interior Salishan peoples (Wickwire and M'Gonigle 1991; Wickwire 1991; Ray, V.F. 1939; Teit 1900; 1906) than there was among those closer to the coast, with their relatively more stable and abundant salmon economy, these features of social life appear to have existed in pre-contact society at least as far inland as Lillooet, Lytton and the Kamloops (Hayden, et al. 1985; Sanger 1973; Fladmark 1986:139-41; Hayden 1992).

As well, the Stein River Valley, the focus of the present study, is strategically located for trade and other human interactions, set as it is between the coast and the interior. This area is also near the junction of the Fraser and Thompson Rivers—a point of trade with the more easterly peoples, as reported by Simon Fraser in 1808 (Lamb 1960:118). The Stein area is both close to the Stl'atl'imx with their connections to the coast through the Lil'wat and Squamish, and near the Lower 'Nlaka'pamux with their links to the downriver Halkomelem-speaking peoples such as the Sto:lo, Musqueam and Cowichan. It is interesting to note that the lavishly worked Gibb's Creek rock art site in Stl'atl'imx territory contains beautiful examples of both coastal and interior artistic styles.

[6]In July, 1988, Chris Arnett and Brian Molyneaux, an authority on rock art across Canada, surveyed the Stein River Valley sites together. Molyneaux concurred with the precision of the renderings made by Chris at each site.

Chapter 1 (pages 1-26)

[1]Accounts of the origin of land and water mysteries vary (see Teit 1912:278-79; 332-33). Most originated from drowned or dismembered supernatural (X̱a'x̱a') beings. The term X̱a'x̱a' can refer to "a mysterious person, person gifted with mystery, magic, superhuman or wonderful powers, a wizard, etc." (Teit 1912:312, n.1). They often appear as characters in 'Nlaka'pamux oral histories dealing with the Mythological Age (see Teit 1898, 1912). In a broader sense, X̱a'x̱a' "means anything magical, mysterious, supernatural, wonderful, awe-inspiring, or beyond the understanding of the ordinary individual" (Teit 1898:117, n.264). Xa'xa'óya-mux is described by Teit as "a sort of mystery or spirit, more or less harmful, which inhabits certain parts of the country, especially mountains; a haunted place" (Teit 1912:252 n.2). The xa'xa'étko haunt certain lakes, cascades and creeks and, like the xa'xa'omux, can assume a variety of forms. "Some," wrote Teit, "appear in the form of men or women, grisly bears, fish of peculiar shape, etc. emerging from the water....The lakes and creeks in the high mountains to the west and south of Lytton are noted for being frequented by these mysteries. People passing within sight of these places will always turn their faces away from them, lest they might see these apparitions, and die" (Teit 1900:338).

[2]Teit to Boas, 9 May 1898. The Teit Papers. American Museum of Natural History, New York.

[3]Teit wrote that ts'ets'ékw—or as he glossed it, "sts'ûq"—"means a mark or picture of any kind....The Indians of the present day call the whiteman's writing and pictures sts'ûq. They also call paper sts'ûq" (1898:118). Elsewhere he translated sts'ûq as "picture, painting or decoration (1912:250 n.3). Annie's sister, Kathy York, who speaks the Merritt 'Nlaka'pamux language says *s'ekw* is the word for "paper" or "what you write on." Both Kathy York and Lytton elder Nathan Spinks say that *s'ts'ek* means "red" and that s'chukw was the word for a strong red color.

In British Columbia there seems to have been some degree of specialization among those who made writings at specific localities. Shamans, or Indian Doctors, are often identified by native people as the artists responsible for major rock writing sites among the T'souke, Cowichan, Bella Coola, Sechelt, Squamish, Stl'atl'imx and 'Nlaka'pamux people of Southern British Columbia (Smith 1924; Hill and Hill 1978:94, 170; Peterson 1969:193; Willie Nahanee, p.c.; Edwards 1985:53; Maud 1978:48; Rita Haugen, p.c.; Annie York, p.c.). Teit was informed the paintings were made by youths who wished to excel in a particular occupation: "for instance, to be a shaman, warrior, proficient hunter etc. etc." or to obtain "a certain manitou, or certain powers or benefits etc. etc." (1918:2). Other painting sites were determined by gender. Teit and Goodfellow, for example, described rock writing sites at Spences Bridge and in the Similkameen Valley which were used by women only (Teit 1896; Goodfellow 1928).

[4]Not all of the writings at these sites are represented in this book. Copies of the writings in a recently discovered mountain burial cave and a site recorded in 1897 were not available to be shown to Annie York. In addition, more paintings have been discovered at several known sites. One of the sites in this book, EbRj 62, is located outside of the Stein watershed proper, but has been included due to its proximity to the Stein.

[5]For native place names in the Stein River Valley see Weller and Arnett (1991).

[6]Tsul'amen, or Zu'tsumen, also called Vermillion Bluffs, is located on the north side of the Tulameen River approximately three miles upstream from Princeton (Dawson 1891:17; Corner 1968:22; Barlee 1978:26). The name was also given to the 'Nlaka'pamux/Okanagan village and band which formerly occupied present day Princeton (Teit 1930a:204). Allison Flats in Princeton "was formerly known as Yak Tulameen or "the place where the red earth was sold" (Goodfellow 1958:18). See Dawson (1891:17) and Smith (1932:9) for other paint quarries in the B.C. Interior.

Haematite is found in many archaeological contexts throughout North and South America particularly in burials. On the Fraser River it appears in the archaeological record 7,000 to 9,000 years ago (Fladmark 1986:37).

In British Columbia, different materials are said to have been mixed with the haematite to create the paint. Teit mentions that melted animal fat was added to the haematite as a binder (1918:2; see also Corner 1968:21-24). The late Stl'atl'imx elder Sam Mitchell claimed that the pigment used in his area (Lillooet) was made by mixing burnt and powdered haematite with the slime from salmon skin and salmon eggs (Bouchard and Kennedy 1991:299). Annie stated that "burnt tamarack pitch" was added to the haematite both for colour and as a binder.

Studies of rock writing pigments from the Canadian Shield and the Similkameen Valley in British Columbia conducted by the Canadian Conservation Institute have been unable to identify any organic binder substances, a fact which leads scientists to conclude that no organic binder or chemical vehicle was added to the pigment. I. Wainwright writes: "[I]n studying [rock writing] paint by infrared spectophotometric, gas chromatographic, thermogravimetric and fluorescence microscopic methods we have been able to discern only a trace of organic material, which could also be attributed to contamination. By contrast, analyses of Pacific Northwest masks have readily detected the vehicle and showed it to be salmon egg date" (Wainwright 1985:20). He also suggests that the powdered haematite was probably only mixed with water to create the paint. See also Taylor, et al. (1974; 1975) for scientific studies relating to the physical properties of rock painting in Canada.

[7]The colour black, on the other hand, had negative connotations. According to Teit's informants: "Black had a meaning opposite to that of red. It meant evil, death, cold, darkness, night. Probably also the lower world. It appears also to have implied 'the opposite of self, enemy, antagonism, and bad luck" (Teit

1930b:419). An unnamed native person told John Corner that "human figures in black symbolize death by violence" (1968:21). And Annie York tells us: "The black paint, you see, the Indians don't like black. They never use black much for anything." This is certainly true about the use of black paint at rock writing sites. There are only six known sites in the B.C. Interior where black paintings are present, compared to over 400 sites where red paintings are found.

[8]The aboriginal territory of the 'Nlaka'pamux people is divided into five regions each with its own distinctive culture, manner of speech and art style. In my rock art studies I have followed the aboriginal divisions of their territories to classify the rock art found in each specific region. Slaxa'yux, "the upstream people," is the name given to the 'Nlaka'pamux who live along the Fraser River north of Lytton (Teit 1900:170). Slaxa'yux country extends upstream along the Fraser for forty miles, approximately to Skikaytn, "place on top," where the territory of the Stl'atl'imx of the Lillooet area begins. The most important Slaxa'yux hunting and gathering areas are found on the mountain slopes on the west side of the Fraser River, including the watersheds of the Stein, Siwhe, Texas and other smaller, steep-sided valleys. In the upper reaches of these watersheds, Slaxa'yux hunting grounds overlap with those of the Stl'atl'imx and Lil'wat peoples.

The Slaxa'yux country was considered to be full of land and water mysteries (Teit 1898:117, n.259).

Although people from outside the immediate area came to the Stein to train and paint, presumably in the style of their place of origin (i.e. Lil'wat, Spences Bridge, etc.), the homogeneity of style found in the Stein River writings suggests a local origin for much of the rock art.

Most of the known Slaxa'yux rock painting sites are found along the banks of the Stein River where an aboriginal trail led west through the mountains to Lillooet Lake. Other sites are found on the Fraser River, Siwhe Creek and Texas Creek.

[9]In addition to being one of the early ethnographers in British Columbia, James Teit (1867-1922) was also a pioneer in the study of Interior Salishan rock writing. Teit immigrated to Spences Bridge from Scotland in 1884, and he immersed himself in the aboriginal culture of the area almost immediately. His 1896 publication concerning a woman's rock writing site near Skaitok, at Spences Bridge, which was published together with his own detailed drawings of the paintings, was the first scholarly publication on Interior Salishan rock art. During his years of study Teit made drawings of 'Nlaka'pamux rock writings at Spences Bridge, Tsixpaa'uk Canyon, and the Nicola Valley (Teit 1900:Plate XX). He also recorded Stl'atl'imx rock writings at Seton Creek (1906:Plate IX), Secwepemc writings at Big Bar and Dog Creek (1909:Fig. 252) as well as Okanagan writings in the Similkameen Valley, at Keremeos Creek, and on the east side of Okanagan Lake (Teit 1930a:Figs. 21-24) The locations of some of these sites have been forgotten or destroyed since Teit's day.

[10]Teit interviewed many Native elders from all over the B.C. Interior. He talked with these people on a diversity of subjects but only rarely did he record their names in his published or archival papers. Named sources of 'Nlaka'pamux rock writing information were two Spences Bridge elders. One was a woman, Wax'tko or Washko, who was a direct descendant of Tcexe'x, a prominent chief of Spences Bridge. She was born around 1840 and died in 1912. Another informant was an "old man" named N'aukawalix (Teit 1896; Teit, et al., 1917:64; Teit to Boas, 9 May 1898; Kenny 1954:30).

[11]Xwekt'xwektl.

[12] The largest rock writing sites in southern British Columbia are always located along major travel corridors, several miles from major winter village sites. This suggests that the writings along these corridors served both as records of vision quest dreams and as protective paintings. The protective function of rock writings cannot be overemphasized. As noted by Teit in a letter to Franz Boas: "Two old Indians here [Spences Bridge] told me that the chief object of young men and women making rock paintings was to ensure them long life" (Teit to Boas, 20 September 1896). Similarly, Father Morice described a practice among the feuding factions of two Carrier villages on Stuart Lake, in northwest British Columbia: "By painting in such a conspicuous place the totem which had been the object of his dream, the Pintce Indian meant to protect himself against any inhabitant of Na'kraztli, as the intimate connection between himself and his totem

could not fail, he believed, by an infallible presentiment the coming of any person who had passed along the rock adorned with the image of his totem" (Morice 1893:207).

[13]Teit (1900:339-41) describes some of the spiritual entities in 'Nlaka'pamux culture, some of which are described above, in the Preface.

[14]Teit's drawings, copied from these human parts transformed to boulders, are published in Teit (1900:Plate XX, Figs. 1-5, 13).

[15]According to Secwepemc [Shuswap] elders interviewed by Teit: "Ancient rock paintings have mysterious powers and may hide and show themselves at will. They are supposed to have been made by people long ago; but through the agency of the dead, or by the supernatural influence remaining in them, they are, in a manner, spiritualized" (1909:598).

[16]One other painting made by "the spirit of the place" is found at Rocky Point, overlooking Nicola Lake. Teit records that the local 'Nlaka'pamux people passing beneath this ancient writing would avoid looking at it for, if they did, the winds would begin to blow, creating hazardous conditions on the water (Teit 1900:335).

[17]The name Sqlelten, derived from the Secwepemc word for salmon, reflects the emphasis of this tradition on the utilization of anadromous salmon. According to Stryd and Rousseau, "The Sqlelten Tradition represents a river-oriented adaptive pattern that emerged ca. 5500 B.P. [before present] as a result of Salish peoples moving in to the southern Interior [from the coast] in order to exploit improving salmon resources towards the end of the mesic grassland period and the onset of cooler and wetter climatic conditions. The identification of these people as Salishans is based on the continuity between this tradition and the historic Salish-speakers of the area" (Stryd and Rousseau 1988:17).

Over time the Sqlelten tradition underwent a number of changes in technology, subsistence and settlement patterns. An early period of assimilation with an indigenous hunting-oriented people (the Lochnore Phase) was followed by three archaeological horizons: Shuswap, ca. 3500-2400 B.P; Plateau, ca. 2400-1200; and Kamloops ca. 1200-200 B.P. These horizons, because of the presence of pit-houses, are grouped into a single sub-tradition, the Plateau Pithouse Tradition (Richards and Rousseau 1987).

The Plateau Pithouse Tradition which developed approximately 4,000 years ago and continued into the nineteenth century was characterized "by the use of semi-subterranean pithouses as winter dwellings in semi-permanent villages, a semi-sedentary settlement pattern, a hunting and gathering mode of subsistence with a strong emphasis on salmon fishing, and storage of food in earth cellars (storage pits)" (Richards and Rousseau 1987:49-50).

[18]See Richard and Rousseau (1987:58). Radio-carbon dating of paint pigment using the Accelerator Mass Spectrometer (AMS) method is only possible when uncontaminated organic material is present in the pigment as already noted, organic components have yet to be detected in rock art pigment from Canada. However, Annie York's statement that burnt tamarack pitch was sometimes added to the powdered haematite suggests the possibility that some rock writing pigments in the Stein may be dated using the AMS method. This technique has been used with some success in dating charcoal-based pigment from Aboriginal rock writing sites in Australia (McDonald, et al. 1990).

Rock writings in the B.C. Interior have not, as yet, been associated directly with any archaeological stratigraphy although there have been some probes made in the cultural deposits directly in front of some rock writing panels. Gordon Mohs, for example, made excavations in front of a panel of Kutenai rock writings on Columbia Lake (Mohs 1983). He obtained a radio-carbon date of 3160 +/- B.P. from an intrusive layer of charcoal associated with the concentration of red ochre imported to the site. Although he was unable to establish stratographic link between the ochre deposit and the existing paintings, the radio-carbon date suggests an ancient association between the use of red ochre, and presumably painting, and this specific site (ibid.:83-94, 166-67).

One rock writing site in British Columbia, a petroglyph of a killer whale on Protection Island near Nanaimo, has been radiocarbon-dated by analysis of midden material overlaying the carving. The radiocarbon date indicated an approximate minimum age of between 1605 and 1675 A.D. for the creation of the petroglyph (McMurdo 1979).

The oldest known rock writings in the Plateau region are found in south central Oregon, where a carved panel of writings was found partially buried by a layer of volcanic ash dating to the Mazama eruption (Crater Lake, Oregon) which occurred 6,700 years ago (Keyser 1992:18). Keyser also reports that archaeologists working in Hell's Canyon on the Snake River in Oregon, have found a red ochre pigmented spall from the roof of a rock shelter, buried in the floor area below, in a stratum that dated back to 6000-7000 B.P.(ibid.). Richard McClure provides an excellent overview and analysis of dating techniques for rock art found on the lower Columbia River (1984).

[19]Based on personal observation of rock writing sites on Howe Sound, Burrard Inlet, Pitt Lake, Nahatlatch Lake, Mara Lake, Okanagan Lake and the Stein River Valley.

[20]The earliest written record of information regarding rock writings in British Columbia dates to the spring of 1825, when Hudson's Bay Company trader Alexander Ross visited Lower Arrow Lake. He noted: "A number of figures of men and animals have been rudely portrayed on the naked rocks in red ochre...the natives understand these signs" (Ross 1855). This is probably DiQl 3, a large rock writing site near Deer Park on Lower Arrow Lake now flooded by the Arrow Lake Dam.

[21]If Teit's estimation of the age of rock writings is correct then many of the Stein paintings would have been made during the time of the 'Nlaka'pamux/Lil'wat War which began c. 1780 and ended c. 1850. During this period the valley was used by warriors on both sides as an access route to raid each other's territories. In addition to the natural and supernatural dangers encountered by youth training in the valley, there was now the added danger of attack by human enemies—another situation underlining the need for greater protection, and thus motivating the making of protective paintings. A tradition associating the paintings with this war is recalled on the Stein reserve today.

Baptiste Mathias, a Kutenai elder, gave an account on the origin of rock paintings among his people (Malouf and White 1953). Some of the rock paintings he attributed to the *nipika*—described as "guardian spirits or their forerunners"—who were said to have made the writings at the time of the Great Flood in order to assist the coming generations:

Each one of us will put his signature on the rock. And we will put down how we are going to help these people when they come, what we are going to do for them. There must be some way to get them started....

The first to make his mark said, 'I'm going to give this power to them. If they seek me for it, I'll give it to them. And I'll give them a song. I'll put my signature on this rock, and when they come they will know it is mine.'

When the white people came there were diseases, and the Indians that got them went to these places, to seek nipika. They put their names down there, and how many days they were there. Names like Standing Bear, Three Star, Walking Bear. It shows they got their power there. (ibid.)

The nipika of the Kutenai appear to be identical to the xa'xa'óyamux and xa'xa'étko of the 'Nlaka'pamux.

Keyser suggests that rock art found along the Lower Columbia River and related art found in cremation burials, dated between 1700 and 1840, represent a cultural response to successive waves of European-introduced disease that swept this region of the plateau and resulted in a population decline of 90% by 1840 (Keyser 1992:101-02).

[22]The sites they visited were EbRj 5 and EbRk 1 (Stine [sic] Locality 1 & 2, in Smith's notes). The third site which has yet to be relocated, their Stine Locality 3, was "on a little rock at the side of the trail, on the south side of Stine Creek, one and a half miles above the mouth of the creek"(Smith 1932:16). According to his notes, Smith also collected "one boulder with red paint on it. From surface, south side of Stein Creek, three miles above the mouth, at Fraser River, July 10, 1897 (American Museum of Natural History Accession No.1897-27, Cat. No.16-3263). Jimmie did not guide Smith and Oakes to the largest site in the Valley, although he did show them a smaller site a short distance downstream (see introduction to Ts'ets'ékw site). Smith learned of another writing site "high in the mountains" which, due to his inability to secure a guide, he did not visit (Smith: Letter to Marshall, 11 July 1897. American Museum of Natural History Accession No.1897-270).

[23]In a letter to Franz Boas regarding these drawings Teit wrote "I have shown the Stryne [Stein] Creek paintings and others to several of the best informed old men but was not able to get much additional information regarding them. I send them back to you" (Teit to Boas 3 Nov. 1898, The Teit Papers. American Museum of Natural History).

[24]Harlan Smith's photographs of Stein rock writings are lodged in the collections of the American Museum of Natural History Neg.Nos.42818-42823.

[25]Seaman (1967:120) describes a large carved boulder from Wallula, Oregon, on the lower Columbia River which "was used in the training of the young men." He elaborates as follows: "When an Indian boy reached the age when he should be a man, he was put through a course of training to give him strength and courage to teach him to respect his elders. One test of courage was to send him to some marked spot far from the village, where he was required to remain for a day and a night. The spot selected was in the direction of unfriendly neighbors, and this stone marked such a place. The carvings had not been made by the youths staying there, but had been made ages ago and were known to the Indians in that region" (ibid.).

Nevertheless, occasional rock painting and repainting of older paintings continued in the B.C. Interior until at least the 1930s (Smith 1913:36; Harrison 1961:29; Morgan Wells, p.c.).

[26]According to 'Nlaka'pamux elder, the late Louie Phillips, *tsuxwikw* is not a regular expression in 'Nlaka'pamux. It is only used "in a situation relating to a mythological or profound experience" (Bouchard and Kennedy 1988:118-19).

[27]This phenomenon is well-marked in the Stein. Many of the writings are found on vertical rock surfaces with significant water seepage which in season flows over the paintings and restores them to some measure of their original brilliance. In the dry hot summer months however, water seepage is often non-existent and in the glare of the sun the writings are least visible.

[28]The lake referred to is actually the Stein River which, in the middle valley during periods of heavy rainfall, floods its banks and becomes, to the locals, "like a lake." In winter it was a favoured fishing place (Andrew Johnny Sr., p.c.).

[29]This is taken from an interview with C.R. Southwell that I conducted in 1988. Willie Charlie was undoubtedly the same Willie Charlie mentioned by the Reverend Stanley Higgs who was stationed in Lytton at the same time. Of him Higgs wrote, "Willie Charlie had the third place upriver from the Stayne [Stein] at Y'aught" (Higgs 1928-1940:75).

[30]CPR: Canadian Pacific Railway, built 1880-86; CN: Canadian National (Railway), built 1911-14. In 1913, rock debris from railway construction at Hell's Gate in the Fraser Canyon seriously damaged upriver Native fishing for many years.

[31]Southwell told me that when he went to Lytton for supplies shortly after seeing the painted cave he talked excitedly about it to others, but was met with only ignorance and disinterest. "Not a damn soul in Lytton ever heard of it," he said.

[32]At the request of Chief Ruby Dunstan of Lytton it was decided not to register EbRk a and EbRk b with the Heritage Conservation Branch in Victoria, hence their unofficial designation here.

Chapter 2 (pages 27-43)

[1]This catastrophe occurred on 13 August 1905. According to the *Inland Sentinel* of 15 August: "So complete was the destruction that not two boards, nor two logs held together with the one exception of the roof of the church, which carried far from its original site, surmounted the debris and wreckage" (Viellette and White 1977:99).

[2]Archaeological investigations in this region indicate that people have lived and fished here for the past 9,000 years (Borden 1960, 1975; Pokotylo and Chisholm 1989).

[3]Lytton elders Rosie Adams Fandrich and the late Louie Phillips talked to me about the Nahlii/Nahlee brothers. Their descendants live in the area between Lytton and Kamloops today. William Nahlii was the oldest of the four brothers, and a close friend of Annie's father. Moses Nahlii mysteriously disappeared in Hope one night. Louie Phillips is of the opinion that Moses drowned in the river.

Chapter 3 (pages 65-222)

[1]Chief Paul of Spuzzum, Híx'hena, who did his dream training in the mountains behind Spuzzum, and who worked on the Cariboo pack trains with his brother-in-law, Cataline. He died at Spuzzum about 1926.

[2]Rosie Adams communicated the following information to R.D. on 29 July 1993: "Yes, I received that prayer from my grandfather and my grandmother. I always say it before I go in the Stein, or anywhere like that. The Whites call it superstition but our people believe that we must pray and talk to the spirits of all the animals. You know, some of them are big and they can be dangerous. We ask these animals to clear away from the path we are going to take. If we pray, they hear us. If we don't, we might scare them when we just go there, and they could hurt us. We believe that they listen to us."

[3]Annie, as Arthur confirms, led a clean life and had the ability to foresee natural catastrophes and certain human events, especially the imminent arrival of unwelcome guests.

[4]Annie, once she returned to live in Spuzzum, was sent into the mountains by her elderly relatives, to dream and to train to be a healer. In the course of trips into the mountains with older persons, Annie learned bush lore, trail signs, and the rules of proper comportment and respect for the natural world and its creatures.

[5]Annie explained the Spuzzum burials to Gordon Mohs and Sheila Joseph during an interview 20 Dec. 1984 (on file at Coqualeetza Education Training Centre, Sardis, B.C.): "They put the bodies in, like a dugout canoe, with animals carved on there, coffin-like, made like a canoe. The fire came through and destroyed it. Then the Indians made a pit and buried the remains, and they had beautiful carvings, they made a statue and dressed it like a person." In 1808 Simon Fraser made the following observations of box burials he saw at the same Spuzzum burial site on the point where Spuzzum Creek enters the Fraser River (Lamb 1960:97):

Seeing tombs of a curious construction at the forks [the mouth of Spuzzum Creek] on the opposite side, I asked permission of the Chief to go and pay them a visit. This he readily granted and he accompanied us himself. These Tombs are superior to anything of the kind I ever saw among the savages. They are about fifteen feet long and of the form of a chest of drawers. Upon the boards and posts are carved beasts and birds, in a curious but rude manner, yet pretty well proportioned. These monuments must have cost the workmen much time and labour, as they were destitute of proper tools for the execution of such a performance. Around the tombs were deposited all the property of the deceased. (Brackets in original; Lamb, W.K., ed. 1960).

Half a century later, in 1861, slightly downstream in Sto:lo territory upriver from Yale, Miss Sophia Cracroft, niece of Lady Franklin, noted similar burial structures with their red paint, their bas-relief carved crests in black and white. Miss Cracroft laughed at the fact that standing grave figures were clothed in modern European fashions (the custom being to dress the effigy figures whenever the grave boxes were repaired and renewed) (D.B. Smith, ed. 1974:53). Teit records lu'ka as the name for the wooden grave boxes used by the Utamqt 'Nlaka'pamux (Teit 1912:281 n.2). A carved mortuary figure with top hat, collected at Spuzzum in 1918, is illustrated in Wingert (1949:Plate 31). See also Lena Hope's description of the Spuzzum graveyard (Wells 1987:194).

[6]Such string or rawhide notations of local history are mentioned by Sto:lo elders, particularly Chilliwack elder and historian, Bob Joe (Wells 1987:56), who explained that the Tsil'qwe'ukw (Chilliwack) leader, Wileleq, had a sister who kept a string almanac with knots for days, and by Marshack (1972:90) in relation to Paleolithic record-keeping in southern Europe more than 20,000 years ago. See Oliver Wells 1987; Alexander Marshack 1972.

[7]Annie, like many Native people across Canada, was adamant that the cross was a sacred symbol that pre-dated Christianity. In fact, the Christian cross had immediate significance to Native peoples due to their familiarity with the power of the four directions, the four times of day—sunrise/sunset/mid-day/middle-night—and the axes of the horizontal and vertical worlds of the cosmos. 'Nlaka'pamux corpses were often buried with their heads oriented to the east, the rising sun, and their feet toward the sunset (S.Copp and M.Skinner 1986).

[8]Annie's cousin, Arthur Urquhart maintains that the "X" with turned up ends was an ancient Native image, one of its forms being the swastika, which Arthur says "was stolen from the Indians by the Nazis."

[9]Annie is alluding to the winter spirit dancing activities of Spuzzum and the neighbouring Sto:lo. This is a "bare bones" description of the elaborate process, common across the region, by which individuals acquire spiritual guidance and guardians. Arthur reports that his mother, a devout member of the Church of England, would sometimes become possessed in the autumn season, by the passing shn'am ('Nlaka'pamux) or syuwel (Sto:lo) spirits that are central to the Coast Salish winter dancing. See Jilek (1982) and Kew (1990).

[10]Some of these prophets are briefly discussed by Teit who writes: "Some Indians prophesized by means of visions. They foretold the coming of the whites, the advent of epidemics, the final extinction of the Indians, the introduction of whiskey, stoves, dishes, flour, sugar, etc." (Teit 1900:365-66). See also Annie's interpretation of paintings at EbRk 1 (below).

[11]Teit (1900:345) wrote that the mountain called K'ek'áwzik was "believed to possess supernatural power. When a person who had a strong guardian spirit pointed at it, it would rain."

[12]The power of prayer was central to Annie's training. The power of "Indian prayer," says Sto:lo heredi-tary chief, Frank Malloway, who has a smitla winter dance home in Sardis, "is one of the lessons we teach the new dancers." Annie was taught to pray before picking herbal medicines, and to pray to the sunrise, mid-day, sunset and middle of the night. Chief Henry James would go into the Spuzzum church at sundown every day and offer an evening prayer, calling on the Creator "to protect us while we sleep. When your star appears, teach our children, and when we are awake, see that we carry your duty to the end." There were prayers for the return of the salmon, particularly the first spring salmon, and prayers for the ripening time of the berries. When the berries were ripe, Annie said, "You pray: 'Thanks to you, Creator, for the gift of the berries you created; thanks to Sun for the work of bringing ripeness. Thank you for all your gifts of food'." In spring and fall it was appropriate to pray for the protection and safety of all the trees as well.

[13]See Teit (1912:218-24) for a version of the full narrative of the boys, there called "the Little Bears"; also the version collected by Hill-Tout from Chief Mischelle of Lytton (Maud 1978 [Hill-Tout 1899]:21-29).

[14]Annie was an expert on the botanical wealth of the Botanie Valley north of Lytton (see Turner, N., L. Thompson, T. Thompson and A. York 1990).

[15]Annie sometimes referred to Ndjimkaa as a shaman. Smoking was integral to certain forms of shamanic treatment: "Before beginning to treat a patient, the shaman frequently pulled out his long pipe, from which hung eagle-feathers, and took a smoke; for smoking was looked upon as a means of communication, not only between the shaman and his guardian spirit, but also between him and the spirit-world. For this reason many Indians will not use a shaman's pipe" (Teit 1900:363).

[16]In Turner, et al. (1990:287), Annie York refers to this plant as "wild tobacco."

[17]A slightly different version of the following narrative is recorded in Teit (1898:80-83; 1912:254-56).

[18]Annie, in the last interview she made with Richard Daly, 4 Apr. 1991, said that this area above the falls was a favourite training ground for youths, and that the Lytton prophet who foresaw the coming of the Europeans and European technology had trained above this waterfall and near this lake. Teit (1900:339) noted that there were rock writings above this waterfall, said to have been made by the spirits of the place.

According to information obtained by James Teit, Neqa'umin got its name because the water of the falls comes from a lake named Nqaumatko (Nikomen—"wolf water") (Teit 1900:171).

[19]In the Teit version (1912:255), Ndjimkaa's pipe smoke got in the cannibal's eyes. Ndjimkaa wrestled with the cannibal, trying to kill him with a knife, and the boy followed the old man's instructions and cut the

cannibal into pieces while he was occupied wrestling. They threw the pieces to the different nations, thereby giving them their specific characteristics.

The Spences Bridge elder(s) who gave Teit the account of Ndjimkaa and the cannibal located the cannibal's home at *Nxomi'n* on the west bank of the Fraser River between Lytton and the Stein River. The cannibal in Teit is named Tcuisqua'lemux. The fight was said to have taken place on the east side of the Fraser opposite Nxomi'n and north of Lytton where "a number of little hills and hollows are pointed out as the place where this wrestling match took place" (ibid.:117 n.267).

In another version of this story, Ndjimkaa leaves one of the cannibal's heads to mark the site of the contest. According to Teit it "is to be seen at the present day in the shape of a large round boulder (1898:117 n.268). At Nxomi'n is another large boulder believed to represent the body of the cannibal's son who was also killed by Ndjimkaa (ibid.:81).

[20]A version of this dispersal of parts was recounted to Jenness (1955:10-11) by Coast Salish elder, Old Pierre of Katzie in the Fraser Valley. Teit (1906:276) recounts the Lillooet version of this narrative, wherein the Lillooet people received the powerful "mystery" bits of the dead cannibal from which originated many land and water mysteries in their territory.

[21]Chief Paul of Spuzzum, who held the name Híx'hena, had as a youth gone into the mountains west of Spuzzum for his training, and in later life, after years of working on the Cariboo pack trains, he asked a family member to render his dream images in pencil, on the pages of an old ledger book. These drawings came into the possession of James Teit in the early years of the twentieth century. Teit donated them to what is now the Canadian Museum of Civilization in Ottawa where, following Teit's designation, they are known as "The Dream Book of a Stalo Chief." Annie York was adamant that these were not Sto:lo in origin, but rather were drawings of Híx'hena's dreams. Híx'hena was closely related to Annie York's paternal grandmother.

[22]This probably refers to one or both of the two footprints visible on boulders today at the Stein Reserve near the mouth of the Stein River. Near the old mission church there is a small boulder that bears the imprint of a child-sized right foot. Another small print of a left foot is found on a similar boulder a few hundred metres southeast, near the Stein graveyard. The footprints are well-known to many elders, all of whom attribute them to the child-sized Xwekt'xwektl or, as Rita Haugen told us, "the baby." Rita and another elder, Willie Dick, stated that there was also a natural stone seat near the church, where "the baby" sat before he took his steps. Willie said that the seat was called "stein."

Teit recorded an interesting account which described the origin of these footprints by blending 'Nlaka'pamux and Christian narratives:

> Two Transformers, Sesukl'n and Seku'lia [the former is the 'Nlaka'pamux term for Jesus Christ; see Teit 1912:402] came down the Fraser River from the Shuswap country. They transformed those who were proud while they helped those who were grateful for advice and instruction.
>
> They reached Styne Creek at dusk. A number of people were living in an underground lodge just north of the creek and their dogs began to howl when the Transformers approached. A man went out to see who was coming. When he saw the Transformers, he made fun of them. Therefore they transformed him, the house, and the people into stone.
>
> When leaving this place, Sesul'n left the mark of his right foot on a stone. A little farther down the river, Seku'lia left the mark of his left foot. These impressions of human feet may still be seen in the woods near Styne. (Teit, et al. 1917:12)

Barlee (1976) recorded a recent version of this story in which the Christian component is made more explicit. In an article on the history of the Lytton area he wrote of "forgotten villages like Sta'yen where the Indians insist that the Footprint of Christ may still be seen down by the river's edge" (38).

The elders, including Annie, often conflate the prophet, Christ and the Transformers. Annie occasionally called them "The Gospels." In other words, they see their own narratives of origin as consistent with those of Christianity.

[23]A version of this narrative is found in Teit 1912:321-24.

[24]Chief Baptiste Mischelle of Lytton told this story in a very lively fashion to Charles Hill-Tout in the 1890s (Maud 1978:116-17).

[25]Teit confirms what the 'Nlaka'pamux say about the beaver: "[T]here are legends in your bones." Teit was told that beaver entrails represent a man and were used in divination (1900:347-48).

[26]A few years ago, a group of friends and I thought that it would be a nice idea to camp overnight on the sandy ground between the tall cliff and the river. We set up camp with the warm afternoon sun streaming through the trees, excited at the prospect of spending a night there. As dusk fell the place took on an unwelcome aspect. The soaring cliff turned to a brooding black mass, the temperature dropped noticeably, and the sound effects created by the echo of the river from the cliff-face seemed to increase in volume. We quickly broke camp and moved several hundred metres upstream.

[27]The two-headed serpent is important to the Kwagiulth culture on the central British Columbia coast, as the "sisiutl" (Boas 1910; 1925; 1927). See also Albert Louie's description of the "si:lhqey" as experienced by the Sto:lo (Wells 1987:157). This figure is also important to Musqueam culture. Suttles illustrates his contribution to *Indian Art Traditions of the Northwest Coast* with a Harlan Smith photograph (Carlson 1976:82, Fig. 4:12) of a nineteenth-century housepost at Musqueam, near the mouth of the Fraser River. This post depicts *Sxwexwo:s,* the thunderbird, is holding in its claws a two-headed snake comparable to those portrayed in the Stein Valley. Closer to the Stein, a small soapstone bowl found near Lillooet appears to represent another sculptural parallel of this creature (see Fladmark 1986:colour plate viii, left).

[28]Annie was an experienced practical nurse and mid-wife. She was trained by her elders in the delivery and care of babies and their mothers, and she obtained further knowledge while assisting the doctor at Merritt.

[29]Annie also listened closely to her elders on the subject of astrology and astronomy. She explained that she had hoped a mathematician would come some day to be her student because she had been unable to explain the old people's system of reckoning space and time in the sky. I recorded some of Annie's information about the 'Nlaka'pamux constellations.—R.D.

[30]Reading basket designs and their messages was another area of Annie's expertise.

[31]The style of this painting is similar to a well-known antler sculpture excavated from "Grave 13," at Lytton, by Harlan Smith. This grave and its contents date from 1200 to 200 B.P., during that portion of the Plateau Pithouse Tradition called by archaeologists "the Kamloops Horizon." Chief Baptiste Mischelle and others identified the artifact as a dog halter to keep the loop on a leash from slipping up and choking the dog (Smith 1900:442). Dogs were probably leashed at times when used in deer hunting (Teit 1900:245). The informants added that "the carving represents the manitou of the owner of the dog and was first seen in a dream" (ibid.). The coastal influence of this piece has often been noted (Boas 1900:376; Smith 1913). Stylistically the form of the head is reminiscent of carved antler pins and comb fragments from the "Historic Period Stratum" at Musqueam (Borden 1976; Fig. 8:34a and 8:34d).

[32]The Sto:lo describe a long pole with feathered tip, used to probe the river bottom when looking for sturgeon and for rough riverbed surfaces. The feathers were added so as not to frighten the sturgeon (Coqualeetza Elders Group 1979).

[33]Annie gives further explanation of the encirclement of game animals in hunting dreams, in the text related to Figs. 100, 102, 104, 113. This example, from her description, is both snare and a conceptualization of the hunter's focus on his target animals.

[34]This is important as well, if the youth is sent out dreaming at this time. The dehydration which results from the water prohibition, and the hypoglycemia of fasting, are two important metabolic features of sensory deprivation useful to obtain altered states of consciousness in many cultures (Jilek 1982:36-38; and see below, Chapter 4).

[35]In relation to this spiritual snake among the Coast Salish, Barnett wrote: "[I]f an unprepared person saw one or even crossed its trail on land, his arms, legs, and neck contorted awfully and he died (1955:147). The same information was given by Squamish elder August Jack Khatsahlano as well (Wells 1987:144).

[36]There are several accounts of double-headed snakes blocking the way of human beings on the southern coast of British Columbia. Squamish elders—Chief Mathias Capilano (Matthews 1969:408), August Jack Khahtsahlano and Dominic Charlie (Wells 1966)—describe places on Howe Sound and Burrard Inlet where this occurred. Some of these sites are associated with rock writing. Chief Mathias states that "the last [serpent]...was killed by a powerful man up above Dollarton, North Arm, Burrard Inlet, in front of the B.C. Electric power station, where the water comes down from Lake Beautiful (Buntzen); the paint put by the Indians on the rocks of the opposite shore is there yet, I think" (Matthews 1969:408). Five sets of writings—DiRr 2, DiRr 9, DiRr 12, DiRr 14 and a recently found, undesignated site—are located on both sides of the inlet where this event occurred. Many of the paintings feature serpent-like creatures. Closer to the mouth of Indian Arm, where another serpent is said to have blocked the waters before it was dispatched by a shaman (Wells 1966), are four sets of paintings (DiRr 12) with depictions of men and serpents.—C.A.

[37]Fig. 91 may well be a woman's dream with signs for insects, childbirth, seeds and possibly the top figure is a seclusion hut. See explanation given to James Teit by Washko, an 'Nlaka'pamux woman, in relation to a dreaming site near Spences Bridge which was used by women (Teit 1896:227-30). Teit also recorded the narrative of how Coyote was taught not to cut his wife's abdomen in order to deliver her of the first child but, rather, how to assist properly in the delivery of a baby (1912:222).

[38]Teit, in his "Notes on Rock Paintings in General" (1918) explains that the natural events that occurred while a person was dreaming in the mountains would normally be recorded on the rock along with salient features of the dreaming.

[39]Reports of outlandish requests of the first humans have been recorded by researchers speaking with elders in other Salish areas. For example, Jenness (1955:24-28) reported that Simon Pierre told the story of the Transformer being who was disgusted at the first people who were not grateful for his advent and his teachings, but rather wanted to carry on with various impractical pursuits such as swimming and frolicking in the water all day, or fighting each other for pretty feathers, or who grubbed around in the mud instead of going out hunting and fishing. Pierre reported that the Transformer changed these people into water mysteries and "painted the rocks with their customs for all to see" (ibid.). The place where this event is said to have occurred is on the west side of Pitt Lake and it is marked by several sets of rock writings—DiRp 1, DiRp 5, DiRp 6 and DiRp 11 (Lundy 1971:20, Figs. 4-9).

Annie grew up on Pitt River and had been told of the existence of these writings by her parents, but she never saw them. She was instructed to respect their existence. They said, "Always respect those writings. Do not fool with them, because the one that wrote that spent his time on the lake, and his women spent their time [dreaming]. And never deface them."

[40]Annie is correct. This footprint painting is superimposed on the older, large image of the early game animal.

[41]Annie was trained to respect and help the animals. She was always worried about bears getting caught in man-made waste. She and Arthur have made their modest contribution to the bears' well-being by always burning their tin cans, flattening them and cutting out both ends before burying them, so that food smells are eliminated and the bears are unable to get their snouts caught in a jagged can.

[42]As already noted, this refers to the set of approximately forty drawings in the Canadian Museum of Civilization, contributed by J.A. Teit with the notation "Dream Book of a Stalo Chief," a document which Annie identified as recordings of the dreams of her kinsman, Chief Paul of Spuzzum.

[43]The story is part of the Coyote mythology (see Teit 1898:26-27) and Lytton Chief Baptiste Mischelle's late nineteenth-century account (Maud 1978:98) for earlier versions.

[44]This is one of several strong ethical symbols in the general Salish regions that have to do with teachings about greed and generosity, freedom and repression. The two-headed snake denotes a blocking of the way, a fencing of resources, a lack of sharing. The cannibal stands as another negative example of the strong moral value concerning sharing and reciprocity—so too, the story about the lack of charity between the boy and his village, which leads to feuding, including the boy penning up all the game animals so that the villagers starve (Fig. 122). Similarly, there is the story of the man who penned up all the fish in the river (Fig.115).

[45]Arthur told R.D. that he saw this creature again in the months prior to Annie's death, although he did not tell her. The species is the Pacific Rubber Boa, which R.D. has seen below Five Mile (Sawmill) Creek between Spuzzum and Yale, and on the north side of the Stein River, within sight of the Asking Rock; C.A. has seen this snake up the Stein near Ponderosa Creek. The Rubber Boa does indeed taper at both ends, then broadens to its head at one end and a head-like swelling at the other. James Teit too, remarked on this highly encultured snake: "The tail of a snake—called by some Indians the 'double-headed snake', on account of having a thick tail with two small protuberances, resembling eyes, near the end—was worn by hunters as a charm to preserve them from danger when hunting grizzly bear" (1900:371). Among the Stl'atl'imx people, who called the snake *La'piilst* Teit recorded that "men who had the La'pilst [sic] snake as their manitous always wore its tail, or the entire skin stuffed or blown out, attached to some part of their person" (1906: 283). Elsewhere, Teit adds "to see a La'pilst snake foretold the death of a friend" (ibid.: 290). In their handbook *The Reptiles of British Columbia* (1984), P.T. Gregory and R.W. Campbell state: "Because of the similarity of head and tail, the Rubber Boa is frequently referred to as the 'two-headed snake'"(70). Canada's pioneer geologist, George Dawson (1891:39) mentioned this in relation to the Secwepemc/Shuswap people: "The story of the existence of a kind of rattlesnake with a head at each end is common among the Shuswaps and several men I have met actually say they have themselves seen such snakes. The name of this creature is *wha-tloo-sil-i-kin*. To see such a snake is very unlucky and portends the death of a near friend." Teit (1909:619): "To see an axhlusehlken snake (the kind sometimes nicknamed double-headed) foretells death."

[46]In other words, persons with this power are capable of using it in both positive and negative ways.

[47]See Teit (1900:326-327, 346) for this and other hunting rules observed by the 'Nlaka'pamux people in the nineteenth century.

[48]Annie mentioned several times that chevrons indicated the goat colour, and that women dreamed the goat patterns. She also said that Chief Paul and Susan, his wife, dreamed together to come up with the designs for her weavings. This is consistent with Teit's information concerning the meaning of the Okanagan village at Hedley, *Snazäi'st* or "Striped Rock," which describes the zigzag markings on the mountain. Teit (1930:205) wrote: "*Snazäi'st*—A Thompson name (from *snaz*, 'a goat's wool blanket'[these were generally ornamented with stripes] and *äi'st*, 'rock') from the appearance of a big stratified rock bluff behind the village often called 'Striped Mountain' by the whites."

[49]Alternatively, Harlan Smith (1932:17) was told by his 'Nlaka'pamux guide, Jimmie, that such forked lines can indicate visualized trails to the game. In either case these lines lead to, and focus upon, the specific goals and objects of the hunter's psychic visualization.

[50]Pauline Johnson was hosted by Chief Paul James, the Spuzzum chief, and other relatives of Arthur and Annie. This happened in the early years of the century. Pauline Johnson discussed old stories while in the area, according to Arthur. Chief Paul is said to have taken her by canoe as far downstream as Five Mile Creek. In *Legends of Vancouver* (1920:79-86), Johnson cites the narrative of Joe Capilano, about the greedy man named Hawk, who was transformed into the two-headed serpent as a punishment for greed and the refusal to share with others. This snake stretched across Vancouver's First Narrows. It was the spirit of greed, the same spirit exemplified by the European newcomers. Whoever kills the heart of this creature, which is located dead centre along its length, will kill greed forever. It took a young man four years in the sea with his knife to locate the heart and kill the snake. Annie, of course, maintained that the young man failed to hit the heart of greed dead-centre.

[51]The owl is an important creature in Native cultures across Canada. Teit (1900:354) states that for the 'Nlaka'pamux, owls are frequently guardian spirits of hunters and shamans. He recorded owl stories (1912:265) and pointed out that *Tsa'aus*, the name of the boy adopted by Owl in the stories, was a personal name used in Lytton by medicine men and warriors. In Teit (1898:63-64) we find the same owl story, as told in Spences Bridge. The owl is important to the neighbouring Sto:lo people as well, as Rena Bolton explained to Richard Daly: "The soul stays with the body for four days after death. After four days it is taken into the owl. The owl is our spirit carrier. You sit in an owl and you wait. If you haven't finished your work, or ful-

filled the expectations held out for you, you will be sent back again. When you are finally finished on earth, then you are asked to join the elders on the Other Side. You have become an Old One. You can rest, and you advise those who are still living."

[52]According to Teit (1898:103, n.43) the name Nglíksentem means "raised" or "lifted up." "Ngliksentem," Teit writes, "was the eldest son of the Coyote and was noted for his great magical powers and for his success as a hunter" (ibid.). See Teit (1898:21-29; 1912:205-06) for earlier accounts of Nglíksentem. Also see Chief Baptiste Mischelle's account as recorded by Charles Hill-Tout in Maud (1978:87-100).

[53]In the nineteenth-century accounts recorded by Hill-Tout and Teit, the site of the stone is said to be in the vicinity of Lytton. In one of the versions of this story recorded by Teit (1898:25) the place where Nglíksentem landed "was on the top of a large flat stone near what is now the town of Lytton." According to Teit's Spences Bridge informants the site now "was turned into this stone to mark the spot, for the Spider said that the place where Ngliksentem should first touch the ground would be the centre of the earth (or of the Indian's country). The 'Nlaka'pamux hold this stone sacred and at the present day keep it covered over with earth, that the whites may not see it" (ibid. 1898:104 n.57).

According to Chief Baptiste Mischelle, Nglíksentem landed "on a large flat stone, close by what is now known as Lytton Creek...the old Indians point out a stone near the creek which they believe is the stone mentioned in the story" (Maud 1978:94).

[54]On another occasion Annie spoke of the four batons or sticks which a shaman gave a boy in training. The first represented the here and now world. The second represented the situation when one closed one's eyes and recalled the here and now. The third represented the world of the sky, and the fourth, the hole through the universe through which the shaman travels. Hence, her description of four universes may refer to four levels of consciousness in a psychic journey such as shamans are fond of making.

[55]Known to the Okanagan people as N'xa'xa'etkw, this well known "water mystery" of Okanagan Lake was named Ogopogo after a popular song, by early twentieth-century British immigrants to the area (Moon 1977:10-13). As Moon's book attests, belief in the "water mystery" of Okanagan Lake is not limited to people of Native ancestry. Sightings occur to this day.

[56]Around Spuzzum such hats were usually woven from cedar root, while up the Thompson River woven mats were used. Speaking of the shaman, Teit (1900:362-63) said, "Sometimes he wore a kind of mask made of a mat pinned together over his head...Sometimes, if a person were very sick, the shaman declared that the soul had left the body of its own accord, by being sent to the sun by another shaman, or by being drawn away by the dead. In such cases, he put over his head the conical mask made of a mat, and went in search of the soul, acting as if travelling—jumping rivers and other obstacles in the road—searching and talking, and sometimes acting as if having a tussle to obtain possession of the soul."

[57]Named for Freddie Earl, possibly a relation of Thomas Earl, of Earlscourt near the mouth of the Stein, who lived and worked here prior to 1914. In the social tradition of frontier British Columbia, people believe that Freddie Earl "struck it rich" and took the secret of his gold and its hiding place with him to his grave. According to local 'Nlaka'pamux resident Jimmie Johnson, those who sought Freddie Earl's reputed gold cache met with consistent misfortune: "Ever-Ready Eddy fell in the stien [sic] Creek on his way up to look for Fred Earl's Gold Cache. Big Jeff fell down and Broke his Arm in 2 places lookin [sic] for Earl's Gold too" (J. Johnson n.d.).

[58]According to Annie, the great 'Nlaka'pamux prophet who foretold the coming of Simon Fraser was the man Teit called Imentcu'ten, and Annie called Shikbiintlam. He would have been the host and orator at the feast organized for Simon Fraser at Tl'kamtciin in 1808. His son, Shikbiintlam/Cixpentlam also witnessed the arrival of Simon Fraser at Lytton in 1808. Shikbiintlam/Cixpentlam in turn had a son by the same name, who was later known, in Teit's time, as Chief David Spentlam of Lytton. He had several wives, and he was involved in peace settlements at the time of the gold rush disturbances to Native life. Chief David Spentlam, who died about 1888, is probably the Cixpentlam mentioned here.

[59]Teit (1900:231) writes that the Upper 'Nlaka'pamux used this plant. Turner, as well, explains that the balsam root provided several important types of food: from the taproot, root crown and young leaf stalks, to

bud stems and fruits. The roots were boiled and dried, then reconstituted by soaking. They tasted sweet due to the conversion of inulin, a starch, to fructose, a sugar, during the boiling, and were used as a dessert (Turner, et al. 1990:176-77).

[60]Annie is referring to the 'Nlaka'pamux constellations, which she studied throughout her life.

[61]Annie learned some trail writing while working as a translator for the late Chief Henry James who made "bush" notations which assisted Annie to translate his lay sermons and speeches at Church.

[62]See note 7, Chapter 3.

[63]This story gives another dimension to Annie's explanation that the Stein, or *StI'yen*, means the "hidden place" that you generally do not see from a canoe on the Fraser River. Here it is the gully where the boy hid all the game animals. Teit (1912:230) recorded a version of this same narrative.

[64]Martineau (1973:150) might offer an alternative explanation of this scene—as a set of signs, based on the animal postures, that tell of the fortunes of two sides in a dispute. Martineau's analysis of the animal forms as a written language to express non-animal narratives, has been developed from his study of rock writings as coded trail signs. Annie's explanations combine a small degree of readings of trail *signs* with a large degree of explanations of cultural *symbols* common to the 'Nlaka'pamux and, to some extent, their neighbours. One form of explanation stresses the rational, notational message, while the other stresses the psychic and cultural.

[65]See Hill-Tout 1899 (Maud 1978:21-28), where he recounts the version of this narrative told to him by Chief Mischelle of Lytton.

[66]It is a superb example of what archaeologists call "culturally modified trees" or CMTs for short. One can find many examples along the lower Stein River Valley, and as far upriver as Nesbitt Creek. Most CMTs are living evidence of the Native practice, at least of the last century-and-a-half, of collecting cedar bark for weaving and plaiting. This cedar bark was used to make rope, twine, basketry and articles of clothing by Native peoples over the Northwest Coast and adjacent area.

[67]Morice (1893) also describes late nineteenth-century charcoal drawings made by the Carrier people on trees and rocks "as means of communication between different hunting parties" (ibid. 210).

[68]After Annie's death, Arthur gave R.D. two iron digging sticks which he had fashioned for Annie years ago. The shapes are consistent with those shown here.

[69]It is interesting that other caves described in oral accounts also mention natural stone seats or ledges along the inside of important caves (see p. 23, above).

[70]"You see, I learned this language of these signs by going to school with the old chief, Henry James. I'm learning more of our language at that time, and when he starts his prayer, I don't know whether he's singing or talking. So he writes it for me, which it is. Talking's like that one. Singing's like this." To indicate singing, Annie drew another cross. This one had a short vertical stem, and a long horizontal bar. (—R.D.)

[71]The practices of indigenous peoples in many regions and countries to offer prayers at the beginning of the day, and before attempting difficult tasks, as well as the practice of addressing one's game, fruit or tools—asking for their help and thanking them for their cooperation—are sound methods of carrying out one's work. Addressing the tools, the Creator, and the objects of one's needs and desires helps a person to focus on his or her tasks, and thereafter gives subliminal order and direction to the rest of that day.

[72]This explanation reflects the 'Nlaka'pamux tradition of fearless trail building along the precipices of the Fraser and Thompson River canyons, and the steep sides of their tributaries—a striking feature of Thompson/Fraser Canyon life of the nineteenth century. This was noted by Simon Fraser himself in 1808, and half a century later by Commander R.C. Mayne, who wrote:

> I hardly know which is more grand, the view from this spot, or that further on, as we got well into the canyon, in which in some places the trail led up crags so steep that we had to clamber up them with our hands and feet, until we arrived breathless at the top of a projecting ledge, on which we were glad to halt a few minutes, to draw breath and gaze with wonder on the scene...When we could, we kept to the lower [trail], but constantly, on coming to some bluff of rock jutting out into the river, we had to scramble up into the upper trail to pass it. The mode of rounding these cliffs, which literally overhang

the river, is peculiar, and makes one's nerves twitch a little at first. There are two or three of them, the trail coming up to them on one side, and continuing again on the other. The difficulty was, of course, to pass the intervening space. This was managed by the Indians thus: they suspended three poles by native rope, made of deerhide and fibre, from the top of the cliff, the inner end of the first and third resting on the trail, and the middle one crossing them on the front of the bluff. Of course there was nothing to lay hold of, and the only way was for the traveller to stretch out his arms, and clasp the rock as much as possible, keeping his face close against it; if he got dizzy, or made a false step, the pole would, of course, swing away, and he would topple over into the torrent, which rolled hundreds of feet beneath. (1862:105-06)

[73]The Gibb's Creek site (EeRl 42) with over ninety individually carved boulders is the largest known petroglyph site in British Columbia (Lundy 1978:23). Like EbRl 4 in the Stein, the Gibb's Creek writings are noteworthy, as Lundy points out, for the presence of coastal-style face and mask imagery "alongside more typical Interior B.C. rock art designs such as bear tracks, linear humans and rayed circles" (ibid.:23).

[74]We should recall that Annie also indicated one of the images at Site EbRk 2 (Fig. 27) was a hunter's dream mask, or a spirit face.

[75]Another description of the winter dancing of the neighbouring Sto:lo people is given by Chilliwack elder, Albert Louie who explains:

Well, they got all different kinds of dancing. They're not just making it, you see. It's in a dream. Some of them have got a wolf. Some of them have got fish. Some of them got bear. Some of them got that bald-headed eagle. There they had all those different dances like, and it's got a name to it. This fellow, Jeff Dolman dances, you know. Everybody knows his song's a wolf song, see. He-wolf or the she-wolf. They've got two different kinds of songs. Just like a man and a woman. There's different songs for different types of things. That's the songs that they used to sing, you know, when I was a kid. Some of them used to sing that raven, that *skewqs*, you know, the big crow. Raven. They got a song for that too. (Wells interview 1965:42)

[76]Psychic power from guardian spirits and crest figures were used to protect matrilineal hunting territories from intruders among both the Tsimshianic-speaking Gitksan and their Athapaskan Wet'suwet'en neighbours in northern British Columbia, as well as by their more northerly Tsetsaut and Tahltan neighbours. Trespassers, I have been told, have frequently fallen ill after trying to defy these protective powers used to mark boundaries. The protective power is said to be activated by trained spiritual elders whose guardian is the figure painted on the rock.—R.D.

[77]Cain (1950:30, 32) describes two rock writing sites on the Columbia River in the drier climatic conditions of central Washington State, where petroglyphs still bear traces of red ochre paint. As well, Barnett mentions that the carvings on the well-known petroglyph rock formerly at Jack Point near Nanaimo were painted with red paint by a certain family to facilitate the return of spawning salmon (Barnett 1955:89).

[78]These insects could be alternately interpreted as part of the youth's strength and power to defeat his enemies: Boas (Teit 1900:378-79) states that Thompson youths would rub woodworms on their arms to gain the strength necessary for spanning their stiff bows. The woodworm has a somewhat beetle-like appearance.

Chapter 4 (pages 223-259)

[1]Annie York considered all rock writing, whether painted (pictographs) or pecked, chipped or carved (petroglyphs) to be the same phenomenon. Both involved the use of paint to capture for the future the contents of vision quest dreams: "You have to ask God to help you, that you gonna use this drawing in later life—that's going to be your strength too. And any kind of an animal that you dream, that's going to be your power." Later in the same interview (4 Apr. 1991) Annie explained that scratched drawings were also painted: "It started out, they scraaaaaatch and then they fill it with the paint. Same as that one up here in the hills above

Chapman's [the McDonald Petroglyphs]. Chief Henry James says that those things are painted in the first place, but he says so long that the rain hits them and they got washed out." This same technique is reported by Teit in relation to 'Nlaka'pamux wooden stirrups which were incised with designs that were then filled with paint (1900:258).

[2]In my experience with contemporary Northwest Coast peoples, this statement pertains to the regional "Indian art" as well. Many Pacific Coast people "do art." They say that the form-line and ovoid principles are the code that allows *anyone* to express his or her soul with fair precision. Those who do it well become trained and recognized as artists. The community at large considers that this image-making should replicate the work of earlier generations, and pass it on intact. Of course the activity is a process and hence is constantly subject to change, but unlike non-ethnographic art, there are permanent social forces of conservancy and standardization at work which tend to set limits on innovation, at least among practitioners within the rural Native communities (see Daly 1992).

[3]*O.E.D.: writing*: 9. Wording or lettering scored, engraved, or impressed on a surface; an inscription. *Write*: O.E. writan=O. Frisc. writa: to score, write, wear by rubbing. O.S writan: to cut, write. M.L.G. writen, O.H.G. rizan: to tear, draw (M.H.G. rizen, G. reissen), O.N. rita: to score, write. Norw. rita, Swed. vrita, Icel. rita. 1. to score, outline, or draw the figure of something, to incise.

[4]Oral cultures are erroneously labelled "illiterate" or "non-literate"—terms that not only denote a lack of written language, but also a lack of writing and recording. These terms have connotations of cultural poverty in comparison with modern state societies—connotations that have to do with a lack of enlightenment, a limited ability to think and reason, and a lack of historicity and time-sequencing. It is important to remember that all present-day cultures, while possessing different degrees of complexity in their histories, all possess the same amount of lived human experience down through the ages.

[5]Europeans have long nurtured a duality between nature and culture, the country and the city, but this duality is not intrinsic to oral cultures, to societies without cities, states and empires. Wet'suwet'en elders in northwest British Columbia informed me that *their* domestic world was the hunting territory, far from the village. They were born on those territories, and lived there for all but eight or nine weeks of the year, when they would return to their summer village of plank houses to conduct social and political business during the salmon runs. These elders talk about the old times when their ancestors and the animals shared one psychic reality, not unlike that revealed by Annie York as she explained the Stein rock writings.

[6]Teit (1900:289) indicates that chiefly lines existed, but that (a) they were more achieved by socioeconomic means than they were inherited; and (b) their longevity depended upon the family's continued economic good fortune and the personal skills and talents of its members:

The Thompson Indians had neither hereditary chiefs nor a recognized nobility. The rank of each person was determined by his wealth and his personal qualities. Their "chiefs" were therefore men of the tribe noted for wealth, wisdom, oratorical powers, or prowess in war...Wealthy persons also held prominent positions in the tribe. The more liberally they gave of their riches, the more highly were they thought of, hence public feasts and presents were frequently given...Under these conditions the title of "chief" could not be hereditary; but the fact that the man was the son of a chief gained him a certain amount of popularity. If, however, he failed to possess or attain the necessary qualifications, he was not called "chief", nor would he be considered in any way different from the mass of the people. Nevertheless, chieftaincy has descended in some instances, particularly among the Lower Thompsons, from father to son for several generations.

[7]Annie York was fond of explaining the way a certain woman in each 'Nlaka'pamux family would construct a ball of knotted string, along which family history would be encoded with a system of complex knots denoting births, marriages, deaths, sudden good fortune, disasters, eclipses, earthquakes and the tidal waves—which last are occasionally said to have played havoc with houses, canoes and fishing racks even in lower 'Nlaka'pamux territory over two hundred kilometres upriver from the sea—and other events which went in to defining that woman's life history. As the chosen woman aged, her knotted string became a reference point for relatives, and a learning device for the young. Upon the death of its maker, the ball of

family history was placed with the maker's corpse in the funerary container. Annie's great-aunt, Annie Selbénik James, made such a record of family history, according to the knotting codes she in turn had learned from her elders. Against the wishes of the clergy, who considered that nothing that was non-Christian should be placed in a Christian's coffin, and against the fears by Annie's mother that the clergy would disrupt the burial, this item was surreptitiously placed in Mrs. James' coffin before interment.

[8]Jung (1964:80) explains the frustrations of the medical psychologist who deals with the everyday reality of "invisible things" such as psychic disorders: "I know enough of the scientific point of view to understand that it is most annoying to have to deal with facts that cannot be completely or adequately grasped. The trouble with these phenomena is that the facts are undeniable and yet cannot be formulated in intellectual terms. For this one would have to be able to comprehend life itself, for it is life that produces emotions and symbolic ideas."

[9]See Wylie (1985) for a healthy assessment of the uses and abuses of analogy, as used by archaeologists in their search for cultural explication. Much discussion is of course devoted to the problematics of analogy in the field of semiotics as well; see, for example, Eco (1976).

[10]See, for example, Rosvall (1978); Lundy (1976).

[11]For example: Anati (1978); Boreson (1976); Corner (1968); Dewdney and Kidd (1962); Hill and Hill (1974); Kroeber (1939); Lundy (1974); Richards (1978); Schaafsma (1985).

[12]Applegate (1975); Furst (1972); Wellmann (1978).

[13]Garvin (1978); Grant (1965; 1967); Lewis-Williams (1980); Ritter and Ritter (1978); Snow (1977).

[14]This approach is being advanced by Lewis-Williams and Dowson (1988); Blackburn (1977); Reichel-Dolmatoff (1978a; 1978b) and others, on the basis of work carried out in the field of psychology by, among others, Assad and Shapiro (1986); Eichmeier and Hofer (1974); Horowitz (1964); Kluver (1926; 1942); Knoll, et al. (1963); Oster (1970); Richards (1971); Seigel (1977; 1978); Seigel and Jarvik (1975); Tylor (1978).

[15]See, for instance, Abbott, ed. (1981) and Carlson, ed. (1976), for two collections of papers dealing in part with this subject, as well as Walens' discussion, based on Boas' Kwagiulth material, of transformational reality (Walens 1981).

[16]John Balog, M.D.:

It is important to recognize that brainwaves, as measured by the EEG [electroencephalograph], have been correlated with certain experiences...[These experiences are marked by certain recurring frequency ranges of brain wave.—R.D.] The first rhythmical frequency to be observed on the EEG was eight to thirteen cycles per second. It was described by the German physician Berger, and called the Alpha wave because it was the first to be discovered. Considerable interest is now shown because this pattern is associated with calm, alert, pleasant, as well as meditative and introspective experiences. The Alpha wave was initially observed in the occipital or posterior brain, which is usually associated with vision. But Alpha waves have also been observed at other surface locations of the brain. For practical purposes we might say that Alpha is the border line between conscious and sub-conscious activity. Problem-solving conscious activity is usually associated with fast, low-voltage brainwaves commonly called Beta waves. These range from thirteen cycles per second, to as high as forty cycles. The slower, high-voltage brainwave patterns, known as Delta and Theta, are associated with the subconscious activity, and are often mingled with the Alpha, which is associated with creativity, dreams and sleep. (Stearn 1976:ix-x)

[17]As explained above, Old Paul—Chief Híx'hena of Spuzzum—in his old age, instructed his daughter to draw his dreams on paper. She said that he had written his first dreams on the rocks of Mt. Urquhart but these writings instead had been obliterated by a rock slide. She claimed as well that her great-aunt had a dream book in which the figures were painted with red ochre on pages of parchment-like paper made from rabbit skins, and bound with sinew stitching. To me, this suggests that as the way of life and technology changed, the elders did their best to adapt the old rock writing procedures to changing technology, at least in relation to the recording and writing of psychic experiences, and for teaching their descendants.

Bibliography

Abbott, D.N.

 1981.

 The world is as sharp as a knife. Victoria: Royal British Columbia Museum.

Adlam, R.

 1985.

 The structural basis of Tahltan Indian society. Ph.D. diss., Department of Anthropology, University of Toronto.

Anati, E.

 1978.

 Method of recording and analyzing rock engravings. *Acts of the International Symposium on Rock Art, Hanko, Norway*. Oslo: Universitets-forlaget. 145-69.

Applegate, R.B.

 1975.

 The Datura cult among the Chumash. *Journal of California Anthropology* 2:7-17.

Assad, G., and B. Shapiro.

 1986.

 Hallucinations: Theoretical and clinical overview. *American Journal of Psychiatry* 143:1088-097.

Baker, J.

 1970.

 Archaeology of the Lytton-Lillooet area. *B.C. Studies* 6 (Fall 1970):46-53.

 1973.

 Site survey in the Lytton region, British Columbia. Heritage Conservation Branch, Victoria, B.C.

Barlee, N.L.

 1976.

 The Forks: Lytton. *Canada West Magazine* 4(2):33-38.

 1978

 Similkameen: The pictograph country. Box 995, Summerland, B.C. V0H 1Z0. Reprinted 1989, Surrey, B.C.: Hancock House,

Barnett, H.G.

 1955.

 The Coast Salish of British Columbia. Eugene: Univ. of Oregon Press.

Bihalji-Merin, O., and T. Nebojsa-Bato
 1984.
 World encyclopedia of naïve art: A hundred years of naïve art. London: Frederick Muller.
Blackburn, T.
 1977.
 Biopsychological aspects of Chumash rock art. *Journal of California Anthropology* 4(1):88-94.
Boas, F.
 1891.
 Felsenzeichnung von Vancouver Island. In *Verhandlungen der Berliner Gesellschaft fur Anthropologie*, Ausserordentlich Sitzung am 14 Februar 1891.
 1900.
 "Art," and "Conclusions." In The Thompson Indians of British Columbia. James Teit, ed. Publications of the Jesup North Pacific Expedition. *Memoir of the American Museum of Natural History* 2(4):376-90.
 1910.
 Kwakiutl tales. *Columbia University Contributions to Anthropology*. Vol.2. New York: Columbia Univ. Press.
 1925.
 Contributions to the ethnology of the Kwakiutl. *Columbia University Contributions to Anthropology*. Vol.3. New York: Columbia Univ. Press.
 1927.
 Primitive art. Oslo: Aschehoug.
Borden, C.E.
 1952.
 A uniform site designation scheme for Canada. *Anthropology in British Columbia* 3:44-48.
 1960.
 DjRi 3: An early site in the Fraser Canyon, British Columbia. In *Contributions to Anthropology 1957. National Museum of Canada Bulletin* 162:101-18.
 1975.
 Origins and development of early Northwest Coast culture to about 3000 B.C. Ottawa: National Museum of Man Mercury Series. *Archeological Survey of Canada* Paper 45:66-76.
 1976.
 Prehistoric art of the lower Fraser region. In *Indian art traditions of the Northwest Coast*. R. Carlson, ed. Burnaby, B.C.: Archaeology Press, Simon Fraser Univ.
Boreson, K.
 1976.
 Rock art of the Pacific Northwest. *Northwest Anthropological Research Notes* 10(1):90-122.
Bouchard, R., and D. Kennedy
 1977.
 Lillooet stories. *British Columbia Sound Heritage* (Aural History Series) 6(1). British Columbia Provincial Archives, Victoria, B.C.
 1988.
 Indian land use and Indian history of the Stein River Valley. Report prepared for I.R. Wilson Consultants Ltd. and British Columbia Forest Products Ltd. On file at the Heritage Conservation Branch, Victoria, B.C.
 1991.
 Stl'atl'imx (Fraser River Lillooet) fishing in a complex culture of the British Columbia Plateau: Traditional Stl'atl'imx resource use. Brian Hayden ed. Vancouver: Univ. of British Columbia Press. 266-354.
Breuil, H.
 1952.
 Four hundred centuries of cave art. Montignac: Centre d'Etude et de Documentation Prehistorique.
 1962.
 The Paleolithic age. In *Larousse encyclopedia of prehistoric and ancient art*. R. Huyghe, ed. London: Hamlyn. 30.
Cain, T.H.
 1950.
 Petroglyphs of central Washington. Seattle: Univ. of Washington Press.

Carlson, R., ed.

1976.

 Indian art traditions of the Northwest Coast. Burnaby, B.C.: Archaeology Press, Simon Fraser Univ.

Collins, J.M.

1974.

 The valley of the spirits: The upper Skagit Indians of Western Washington. Seattle: Univ. of Washington Press.

Copp. S.

1980.

 A dated pictograph from the south Okanagan Valley in British Columbia. *Canadian Rock Art Research Associates Newsletter* (Saskatoon) 14:44-48.

Copp, S., and M. Skinner

1986.

 The Nicomen River burial site, EbRi7, near Lytton, British Columbia. Heritage Conservation Branch Report, Victoria, B.C. Permit No.1985-4.

Coqualeetza Elders Group

1979.

 Upper Sto:lo fishing, Fraser Valley. Sardis, B.C.: Coqualeetza Education Training Centre.

Corner, J.

1968.

 Pictographs in the Interior of British Columbia. Vernon: Wayside Press.

Daly, R.

1988.

 Anthropological opinion on the nature of the Gitksan and Wet'suwet'en economy. Prepared for the Plaintiffs in *Delgamuukw et al. v. The Queen in the Right of the Province of British Columbia and The Attorney-General of Canada*. Supreme Court of British Columbia, Smithers Registry, No.0843.

1992.

 Anthropology, ethics and Aboriginal art. Paper presented at conference, Aspects of Aboriginal Art: Its Present and Future, 8-11 October 1992, at "Nexus '92," Vancouver, B.C.

Dawson, G.M.

1891.

 Notes on the Shuswap people of British Columbia. *Transactions of the Royal Society of Canada* 9(2):3-44.

Dewdney, S.

1975.

 Scrolls of the southern Ojibway. Toronto.

Dewdney, S., and K.E. Kidd

1962.

 Indian rock paintings of the Great Lakes. Toronto: Univ. of Toronto Press.

Drieman, G.H.J.

1962.

 Differences between written and spoken language. *Acta Psychologica* 20:36-57, 78-100.

Drury, N.

1989.

 The elements of shamanism. Longmead, Shaftesbury, Dorset: Element Books.

Duff, W.

1976.

 The world is as sharp as a knife: Meaning in northern Northwest Coast art. In *Indian art traditions of the Northwest Coast*. R. Carlson, ed. Burnaby, B.C.: Archaeology Press, Simon Fraser Univ.

Dyen, I., and D. Aberle

1974.

 Lexical reconstruction: The case of the Proto-Athapaskan kinship system. London, Cambridge, New York: Cambridge Univ. Press. 383-428.

Eco, U.
 1976.
 A theory of semiotics. Bloomington: Univ. of Indiana Press.
Edwards, I.
 1985.
 Short portage to Lillooet. Mission, B.C.: Cold Spring Books.
Eichmeier, J., and O. Hofer
 1974.
 Endogene bildmuster. München: Urban und Schwarzenberg.
Eliade, M.
 1967.
 Essential sacred writings around the world. San Francisco: Harper.
Elliot, W.C.
 1931.
 Lake Lillooet tales. *Journal of American Folklore* 44:166-81.
Emmons, G.T.
 1911.
 The Tahltan Indians. *University of Pennsylvania Anthropological Publications* 4(1).
Farrand, L.
 1900.
 Basketry designs of the Salish Indians. Publications of the Jesup North Pacific Expedition. *Memoir of the American Museum of Natural History* 1(5):391-405.
Fladmark, K.
 1986.
 British Columbia prehistory. Ottawa: Archaeological Survey of Canada, National Museums of Canada.
Furst, P., ed.
 1972.
 Flesh of the gods: The ritual use of hallucinogens. New York: Praeger.
Garvin, G.
 1978.
 Shamans and rock art symbols. In *Four Rock Art Studies*, C.W. Clewlow, ed. Socorro, New Mexico: Ballena Press. 65-87.
Gjessing, G.
 1952.
 Petroglyphs and pictographs in British Columbia. In *Indian tribes of Aboriginal America*. Sol Tax, ed. Proceedings of the International Congress of Americanists, Selected Papers, 29(3):66-79.
Goode, J.B.
 1861.
 Utmost bounds: Pioneer jottings of forty years of missionary reminiscences of the out west Pacific Coast, 1861-1890. Typescript. British Columbia Provincial Archives, Victoria, B.C.
Goodfellow, J.C.
 1928.
 Pictographs of the Similkameen Valley of British Columbia. Art, Historical and Scientific Association of Vancouver, B.C. *Museum Notes* 3(2).
 1958.
 The story of the Similkameen. Vol.1. Princeton, B.C.: Princeton Centennial Committee.
Goody, J.
 1977.
 The domestication of the savage mind. Cambridge, London, New York: Cambridge Univ. Press.
 1987.
 The interface between the written and the oral. Cambridge, London, New York: Cambridge Univ. Press.

Grant, C.

1965.

The rock paintings of the Chumash: A study of a California Indian culture. Berkeley and Los Angeles: Univ. of California Press.

1967.

Rock art of the American Indians. New York: Thomas Y. Crowell.

Gregory, P.T., and R.W. Campbell

1984.

The reptiles of British Columbia. Victoria, B.C.: Royal British Columbia Museum Handbook.

Hallisey, C.J.

n.d.

The painters. Unpublished manuscript on file with the Lytton Indian Band, Lytton, B.C. See also Appendix L, Lepofsky 1988.

Harris, J.

1949.

Indian pictographs of south central British Columbia. In *Thirteenth annual report of the Okanagan Historical Society* 22-23. Vernon, B.C.

Harrison, P.

1961.

Report on the archaeological survey of the High Arrow Reservoir. Heritage Conservation Branch, Victoria, B.C. Permit No.1961-5.

Harrold, A.P.

1927.

Letter to Harlan Smith. Ethnographic papers of Harlan I. Smith on British Columbia. American Museum of Natural History, New York.

Havelock, E.

1986.

The muse learns to write. New Haven: Yale Univ. Press.

Hayden, B., ed.

1992.

A complex culture of the British Columbia Plateau: Traditional Stl'atl'imx economy. Vancouver: Univ. of B.C. Press.

Hayden, B.M.E., A. Eldridge, and A. Cannon

1985.

Complex hunter-gatherers in interior British Columbia. In *Prehistoric hunter gatherers.* New York: Academic Press. 181-99.

Higgs, S. E.

1928-1940.

That they might have life: An autobiography of the late Reverend Stanley E. Higgs. G. Bramhall, ed. Add. ms. 1332. British Columbia Provincial Archives, Victoria, B.C.

Hill, B.

1975.

Guide to Indian rock carvings of the Pacific Northwest Coast. Saanichton, B.C.: Hancock House.

Hill, B., and R. Hill

1974.

Indian petroglyphs of the Pacific Northwest. Seattle: Univ. of Washington Press.

Hill-Tout, C.

1925.

Letter to T.P.O. Menzies, 5 November 1925. Charles Hill-Tout file. A 26. Vancouver Centennial Museum, Vancouver, B.C.

Horowitz, M.J.

1964.

The imagery of visual hallucinations. *Journal of Nervous and Mental Disease* 138:513-23.

Innis, H.A.

1951.

 The bias of communication. Toronto: Univ. of Toronto Press.

Jenness, D.

1943.

 The Carrier Indians of the Bulkley River: Their social and religious life. *Annual Report, Bureau of American Ethnology* 133(25):469-586.

1955.

 The faith of a Coast Salish Indian. Published together with Katzie ethnographic notes by W. Suttles. *Anthropology in British Columbia* Memoir 2. Royal British Columbia Museum, Victoria, B.C.

Jilek, W.G.

1982.

 Indian healing: Shamanic ceremonialism in the Pacific Northwest today. North Vancouver, B.C.: Hancock House.

Johnson, E.P.

1920.

 Legends of Vancouver. Toronto: McClelland & Stewart.

Jung, C.G., M.L. von Franz, J.L. Henderson, J. Jacobi, and A. Jaffe

1964.

 Man and his symbols. New York: Dell Publishing.

Kenny, M.A.

1954.

 An Indian historian. *Okanagan Historical Society Annual Report 1954*:30-32.

de Kerckhove, D.

1986.

 Alphabetic literacy and brain processes. *Visible Languages* 20(3):275-93.

Kew, M.

1990.

 Central and southern Coast Salishan ceremonies since 1900. *Handbook of North American Indians.* Vol. 7, *Northwest Coast.* Washington, D.C.: Smithsonian Institution. 476-80.

Keyser, J.D.

1992.

 Indian rock art of the Columbia Plateau. Vancouver: Douglas & McIntyre and Univ. of Washington Press.

Kluver, H.

1926.

 Mescal visions and eidetic vision. *American Journal of Psychology* 37:502-15.

1942.

 Mechanisms of hallucinations. In *Studies in Personality.* Q. McNemar and M.A. Merrill, eds. New York: McGraw-Hill. 175-207.

Kroeber, A.

1939.

 Cultural and natural areas in Native North America. *University of California Publications in American Archaeology and Ethnology* 38.

Kroll, M., J. Kluger, O. Hofer, and S.D. Lawder.

1963.

 Effects of chemical stimulation of electrically-induced phosphenes on their bandwidth, shape, number and intensity. *Confinia Neurologica* 23:201-26.

Kuhn, H.

1956.

 The rock pictures of Europe. A.H. Brodrick, trans. Fair Lawn, N.J.: Essential Books.

Lamb, W.K., ed.

1960.

 Letters and journals of Simon Fraser, 1806-1808. Toronto: Macmillan.

Leen, D.
1981.
 The rock art of Western Washington. *Northwest Anthropological Research Notes* 15(1).

Lepofsky, D.
1986.
 Archaeological summary. In *Stein River heritage: Summary and evaluation*. Report prepared for the Lytton and Mt. Currie Bands.
1988.
 Stein Valley archaeology assessment. Prepared for 'Nlaka'pamux Nation Development Corporation and the Native Economic Development Program. On file at the Lytton Indian Band Office, Lytton, B.C.

Leroi-Gourhan, A.
1982.
 The dawn of European art: An introduction to Paleolithic cave painting. Cambridge, London, New York: Cambridge Univ. Press.

Lewis-Williams, J.D.
1980.
 Ethnography and iconography: Aspects of southern San thought. *Man, Journal of the Royal Anthropological Institute*, n.s., 15:466-82.

Lewis-Williams, J.D., and T.A. Dowson.
1988.
 The signs of all times: Entoptic phenomena in upper Paleolithic art. *Current Anthropology* 29(2):201-45.

Lundy, D.M.
1972.
 The Pitt Lake pictograph sites. In *Salvage '71: Reports on Salvage archaeology undertaken in British Columbia in 1971*. Burnaby, B.C.: Department of Archaeology, Simon Fraser Univ. Publication No.1.
1974.
 The rock art of the Northwest Coast. M.A. thesis, Department of Archaeology, Simon Fraser University, Burnaby B.C.
1976.
 Styles of Coastal rock art. In *Indian art traditions of the Northwest Coast*. R. Carlson, ed. Burnaby, B.C.: Archaeology Press, Simon Fraser Univ.
1978.
 Petroglyphs of the middle Fraser River. *Forty-second annual report of the Okanagan Historical Society*. Vernon, B.C. 21-26.

MacDonald, G.F.
1979.
 Kitwanga Fort National Historic Site, Skeena River, British Columbia. *Parks Canada Manuscript Report* 341.

McClure, R.H.
1984.
 Rock art of Dalles-Deschuts region: A chronological perspective. M.A. thesis, Department of Anthropology, Washington State University, Pullman, WA.

McDonald, J., K. Officer, T. Jull, D. Donahue, J. Head, and B. Ford.
1990.
 Investigating 14C AMS: Dating prehistoric rock art in the Sydney Sandstone Basin, Australia. *Rock Art Research* 7.2 (1990):83-92.

M'Gonigle, M., and W. Wickwire
1988.
 Stein: The way of the river. Vancouver: Talonbooks.

McLuhan, M.
1962.
 The Gutenberg galaxy: The making of typographic man. Toronto: Univ. of Toronto Press.

McMurdo, A.
1979.

Excavation of a petroglyph site on Protection Island, British Columbia. In *CRARA '77: Papers from the fourth biennial conference of the Canadian rock art research associates.* Royal British Columbia Museum, Victoria, B.C. Heritage Record 8:213-18.

Mallory, G.
1893.

Picture writing of the American Indians. Tenth Annual Report of the Bureau of American Ethnology to the Secretary of the Smithsonian Institution 1888-89. Washington, D.C.

Malouf, C., and T. White
1953.

The origin of pictographs. *Anthropological and Sociology Papers* 14. Missoula: Montana State Univ.

Marshack, A.
1972.

The roots of civilization: The cognitive beginnings of man's first act, symbol and notation. New York: McGraw-Hill.

Martell, J-M.
1992.

Bowl of bone: Tale of the Syuwe. Film. Vancouver: Turtle Productions. On file at the National Film Board of Canada.

Martineau, L.
1973.

The rocks begin to speak. Las Vegas: KC Publications.

Matthews, J.S.
1955

Conversations with Khahtsahlano, 1932-1954. Published 1969. Vancouver City Archives.

Maud, R., ed.
1978.

The Salish people: The local contribution of Charles Hill-Tout. Vol.1, *The Thompson and Okanagan.* Vancouver: Talonbooks.

Mayne, R.C.
1862.

Four years in British Columbia and Vancouver Island: An account of their forests, rivers, gold fields and resources for colonisation. London: John Murray.

Mitchell, D.
1990.

Prehistory of the Coasts of southern British Columbia and northern Washington. *Handbook of North American Indians.* Vol. 7, *Northwest Coast.* W. Suttles, ed. Washington D.C.: Smithsonian Institution. 340-58.

Mohs, G.
1981.

Archaeological investigation of a Kutenai Indian encampment (Heritage Site EbPw1: Columbia Lake). British Columbia Heritage Conservation Branch 1980 Emergency Salvage Program. Unpublished.

Molyneaux, B.L.
1977.

Formalism and contextualism: An historiography of rock art research in the new world. M.A. thesis. Department of Anthropology, Trent University, Peterborough, Ontario.

Moon, M.
1977.

Ogopogo. Vancouver: J.J. Douglas.

Morice, A.G.
1893.

Notes archeological, industrial, and sociological on the western Denes. *Transactions of the Canadian Institute* 4:1-22.

Mourning Dove
 1990.
 Mourning Dove: A Salishan autobiography. J. Miller, ed. Lincoln: Univ. of Nebraska Press.
Oberg, K.
 1973.
 The social economy of the Tlingit Indians. *American Ethnological Society Monographs* 55. Seattle: Univ. of Washington Press.
Oster, G.
 1970.
 Phosphenes. *Scientific American* 222(2):83-87.
Parker, M.L.
 1988.
 Preliminary dendro-chronological investigations in the Stein River Valley: Tree age, size and modifications by Aboriginal use. Contract report to the Western Canada Wilderness Committee, Vancouver, B.C.
Peterson, L. R.
 1969.
 How to follow the rock painting trail of Jervis Inlet. In *Northwest passages: A collection of Northwest cruising stories.* Vol. 1. B. Calhoun, ed. San Francisco: Miller Freeman Publications.
Pokotylo, D., and B. Chisholm
 1989.
 Paleodiet at the Milliken-Esilao locality, lower Fraser River Canyon, British Columbia. Paper presented at the 42nd Northwest Anthropological Conference, 24 March 1989, Spokane, Washington.
Portnoy, S.
 1973.
 A comparison of oral and written behavior. *In Studies in verbal behavior: An empirical approach.* K. Salzinger and R.S. Feldman, eds. New York.
Ray, A.J.
 1986.
 The early economic history of the Gitksan-Wet'suwet'en-Babine Tribal Territories, 1822-1915. Prepared for the Plaintiffs in *Delgamuukw et al. v. The Queen in the Right of the Province of British Columbia and the Attorney-General of Canada.* Supreme Court of British Columbia, Smithers Registry, No.0843.
Ray, V.F.
 1939.
 Cultural relations in the Plateau of Northwestern America. *Publications of the Frederick Hodge Anniversary Publication Fund.* Vol.3.
Reichel-Dolmatoff, G.
 1978a.
 Beyond the Milky Way: Hallucinatory imagery of the Tukano Indians. Los Angeles: UCLA Latin American Center.
 1978b.
 Drug-induced optical sensations and their relationship to applied art among some Colombian Indians. In *Art in Society.* M. Greenhalgh and V. Megaw, eds. London: Duckworth. 289-304.
Richards, T., and M. Rousseau
 1987.
 Late prehistoric cultural horizons on the Canadian Plateau. Burnaby, B.C.: Simon Fraser University, Department of Archaeology. Publication No.16.
Richards, T.H.
 1978.
 A pictograph survey of southeast Stuart Lake, British Columbia. Ministry of Provincial Secretary and Government Services. Heritage Conservation Branch, Victoria, B.C.*Annual Research Report* 1.
Richards, W.
 1971.
 The fortification illusions of migraines. *Scientific American* 224:89-94.

Rigsby, B.

 n.d.

 A Gitksan Grammar. Typescript. On file at Library of the Gitksan-Wet'suwet'en Office of Hereditary Chiefs. Hazelton, B.C.

Rigsby, E.

 1986.

 Gitskan grammar. Prepared for the Linguistics Division. Copy on file at Library of the Gitskan Wet'suwet'en Office of Hereditary Chiefs. Hazelton, B.C.

Ritter, D.W., and E.W. Ritter

 1978.

 Medicine men and spirit animals in rock art of western North America. *Acts of the International Symposium on Rock Art, Hanko, Norway*. Oslo: Universitets-forlaget. 97-125.

Rosaldo, M.

 1980.

 Knowledge and passion: Ilongot notions of self and social life. New York: Cambridge Univ. Press.

Rosaldo, R.

 1980.

 Ilongot headhunting 1883-1974: A study of society and history. Stanford: Stanford Univ. Press.

Ross, A.

 1855.

 The fur hunters of the far west. London: Smith, Elder.

Rosvall, J.

 1978.

 An attempt at a framework for visual analysis of rock art. *Acts of the International Symposium on Rock Art, Hanko, Norway*. Oslo: Universitets-forlaget. 211-24.

Rousseau, M.

 1979.

 Thompson-Okanagan impact assessment Final report. Heritage Conservation Branch, Victoria, B.C.

Sanger, D.

 1961.

 A burial site survey of the Shuswap, Thompson and Lillooet area in south central British Columbia. Heritage Conservation Branch, Victoria, B.C. Permit No.1961-6.

 1968.

 The Chase burial site in British Columbia. Ottawa: *National Museum of Canada Bulletin* 224.

 1971.

 Discussion. In *Aboriginal man and environments on the Plateau of Northwest North America.* A. Stryd and R. Smith, eds. Calgary: Univ. of Calgary Archaeological Association. 255-56.

Schaafsma, P.

 1985.

 Form, content and function: Theory and method in North American rock art studies. *Advances in Archeological Method and Theory* 8:237-77. New York: Academic Press.

Seaman, N.G.

 1967.

 Indian relics of the Pacific Northwest. Portland: Binfords and Mort.

Seigel, R.K.

 1977.

 Hallucinations. *Scientific American* 237:132-40.

 1978.

 Cocaine hallucinations. *American Journal of Psychiatry* 135:309-14.

Smith, D.E., ed.

 1974.

 Lady Franklin visits the Pacific Northwest, being extracts from the letters of Miss Sophia Cracroft, Sir John Franklin's niece, Feb. to Apr., 1861, and Apr. to July, 1870. *Provincial Archives of British Columbia Memoir* 11.

Smith, H.I.

 n.d.

 Unpublished fieldnotes of Harlan I. Smith. Box 13, F2. Archaeological Survey of Canada, Canadian Museum of Civilization, Ottawa.

 1899.

 Archaeology of Lytton, British Columbia. Publications of the Jesup North Pacific Expedition. *Memoir of the American Museum of Natural History* 2(3).

 1900.

 Archaeology of the Thompson River region. Publications of the Jesup North Pacific Expedition. *Memoir of the American Museum of Natural History* 2(6).

 1913.

 The archaeological collection from the southern Interior of British Columbia. Ottawa: Government Printing Bureau, for the Museum of the Geological Survey of Canada.

 1924.

 The petroglyph at Aldridge Point, near Victoria, B.C. *American Anthropology* 26(4):531.

 1932.

 A list of pictographs in British Columbia. National Museum of Canada, 16 June 1932. Copy in Newcombe Family Papers. Add. ms. 1979, Vol.23. British Columbia Provincial Archives, Victoria, B.C.

Snow, D.R.

 1977.

 Rock art and the power of shamans. *Natural History* 1977(Feb.):42-49.

Stearn, J.

 1976.

 The power of alpha thinking. New York: Signet-NAL.

Stryd, A.

 1976.

 Prehistoric mobile art from the mid-Fraser and Thompson River areas. In *Indian art traditions of the Northwest Coast*. R. Carlson, ed. Burnaby, B.C.: Archaeology Press, Simon Fraser Univ.

Stryd, A., and M. Rousseau

 1988.

 The early prehistory of the mid-Fraser-Thompson River area of British Columbia. Paper read in part before the 21st Annual Meeting of the Canadian Archaeological Association, Early Man in British Columbia Symposium, 12 May 1988, Whistler, B.C.

Suttles, W.

 1976.

 Productivity and its constraints: A Coast Salish case. In *Indian art traditions of the Northwest Coast*. R. Carlson, ed. Burnaby: B.C.: Archaeology Press, Simon Fraser Univ. 67-88.

 1987.

 Private knowledge, morality, and social classes among the Coast Salish. In *Coast Salish Essays*. W. Suttles. Vancouver: Talonbooks. 3-14.

Taylor, J.M., R.M. Myers, and I.N.M. Wainwright

 1974.

 Scientific studies of Indian rock paintings in Canada. *Bulletin of the American Institute for Conservation* 14 (1974):28-43.

 1975.

 An investigation of the natural deterioration of rock paintings in Canada. *Conservation in Archaeology and the Applied Arts*. London, England: International Institute for Conservation of Historic and Artistic Works.

Tcit, J.A.

 1896.

 A rock painting of the Thompson River Indians, British Columbia. *Bulletin of the American Museum of Natural History* 8:227-30.

1898.

 Traditions of the Thompson River Indians of British Columbia. American Folklore Society. New York: Houghton-Mifflin.

1900.

 The Thompson Indians of British Columbia. Publications of the Jesup North Pacific Expedition 1(4):163-392. *Memoir of the American Museum of Natural History* 2.

1906.

 The Lillooet Indians. Publications of the Jesup North Pacific Expedition 2(5). *Memoir of the American Museum of Natural History* 4(5).

1909.

 The Shuswap. *Memoir of the American Museum of Natural History* 4(7). New York.

1912.

 Mythology of the Thompson Indians. Publications of the Jesup North Pacific Expedition 7(2). *Memoir of the American Museum of Natural History* 12.

1918.

 Notes on rock painting in general, by J.A. Teit, Spences Bridge, 1918. Typescript on file at the National Archives of Canada, Ottawa.

1930a.

 The Salishan tribes of the western Plateau. *Annual Report of the Bureau of American Ethnology for 1927-28* 45:23-396.

1930b.

 Tattooing and face and body painting of the Thompson Indians of British Columbia. *45th Annual Report of the Bureau of American Ethnology,* Washington: Smithsonian Institution.

Teit, J.A., M.K. Gould, L. Farrand, and H. Spinder

1917.

 Folktales of the Salishan and Sahaptin tribes. *Memoirs of the American Folklore Society* 11.

Thacker, T.L.

1923.

 Letter to Harlan I. Smith from T.L. Thacker, Little Mountain, Hope, B.C., 23 March 1923. Pictographs of the Interior of British Columbia Files. Division of Archaeology, Canadian Museum of Civilization, Ottawa.

Thompson, D., and R. Freeman

1979.

 Exploring the Stein River Valley. Vancouver: Douglas & McIntyre.

Turner, N.J., L.C. Thompson, M.T. Thompson, and A.Z. York

1990.

 Thompson ethnobotany: Knowledge and usage of plants by the Thompson Indians of British Columbia. *Royal British Columbia Museum Memoir* 3.

Tylor, C.W.

1978.

 Some new entoptic phenomena. *Vision Research* 18:1633-639.

Tylor, E.

1972.

 Animism. In *Reader in comparative religion.* W.A. Lessa and E.Z. Vogt, eds. New York: Harper and Row.

Veillette, J., and G. White

1977.

 Early Indian village churches: Wooden frontier architecture in British Columbia. Vancouver: Univ. of B.C. Press.

Wainwright, I.

1985.

 Rock art conservation Research in Canada. In *Bollettino de Centro Camuno di Studi Preistorici* 22:15-35.

Walens, S.

1981.

 Feasting with cannibals: An essay on Kwakiutl cosmology. Princeton: Princeton Univ. Press.

Weller, A., and C. Arnett
　　1991.
　　　　Stein Valley: Heritage map and guide voices for the Wilderness Foundation. Vancouver. Vancouver Voices for the Wilderness Foundation.

Wellmann, K.F.
　　1978.
　　　　North American Indian rock art and hallucinogenic drugs. *Journal of the American Medical Association* 5.239(15):1524-527.

Wells, O.N.
　　1965.
　　　　Interview with Albert Louie. Typescript on file at Coqualeetza Education Training Centre, Sardis, B.C.
　　1966.
　　　　Squamish legends by Chief August Jack Khahtsahlano and Dominic Charlie. Oliver Wells, ed. Charles Chamberlain and Frank T. Coan, Publishers.
　　1987.
　　　　The Chilliwacks and their neighbors. Vancouver: Talonbooks.

Wickwire, W.
　　1986.
　　　　Ethnographic summary. In *Stein River heritage: Summary and evaluation.* Report prepared for the Lytton and Mt. Currie Bands. 1-26.
　　1988.
　　　　Stein: Its people speak. Report for 'Nlaka'pamux Nation Development Corporation and the Native Economic Development Program. On file at the Lytton Indian Band Office.
　　1991.
　　　　On evaluating ethnographic representation: The case of the Okanagan of south central British Columbia. *Canadian Journal of Native Education* 18(2):233-45.

Wickwire, W., and M. M'Gonigle
　　1991.
　　　　The Queen's people: Ethnography or appropriation? *Native Studies Review* 7(2):97-113.

Wilson, I.R.
　　1985.
　　　　Stein River haul road: Heritage resources inventory and impact assessment. Report prepared for B.C. Forest Products Ltd. Boston Bar, B.C.
　　1988.
　　　　Stein River haul route—refinements: Heritage resources inventory and impact assessment. Report prepared for B.C. Forest Products Ltd. Boston Bar, B.C.

Wilson, I.R., and M. Eldridge
　　1988.
　　　　Report on a brief field trip, Stein River Valley. Prepared for B.C. Forest Products Ltd. May, 1988. Boston Bar, B.C.

Wingert, Paul
　　1949.
　　　　American Indian sculpture: A study of the Northwest Coast. Locust Valley, N.Y.: J.J. Augustin, Publisher.

Wylie, A.
　　1985.
　　　　The reaction against analogy. *Advances in Archaeological Method and Theory* 8:63-111.

Zukav, G.
　　1980.
　　　　The dancing Wu Li masters: An overview of the new physics. New York: Bantam.

Index

299